S0-AKG-777

THE WOMEN'S ATLAS OF THE UNITED STATES

Anne Gibson and Timothy Fast

FACTS ON FILE PUBLICATIONS

New York, New York ● Oxford, England

THE WOMEN'S ATLAS OF THE UNITED STATES

Library of Congress Cataloging-in-Publication Data
Gibson, Anne.
The women's atlas of the United States.

Bibliography: p.
Includes index.
Contents: Demographics—Education—Employment—
|etc.|
1. Women—United States—Maps. 2. Women—United
States—Economic conditions—Maps. 3. Women—United
States—Social conditions—Maps. I. Fast, Timothy.
II. Title.
G1201.E1G 1986 912'.13046'088042 86-675059
ISBN 0-8160-1170-2

Printed in the United States of America

JACKET DESIGN: NADIA FURLAN LORBEK
INTERIOR DESIGN: JO STEIN
CARTOGRAPHY: TIMOTHY FAST & ANNE GIBSON
ADDITIONAL GRAPHICS: OKSANA KUSHNIR

10 9 8 7 6 5 4 3 2 1

ACKNOWLEDGMENTS

Of those who provided assistance and support during the course of this project, we would like to thank:

Tim's employer, IEP, Inc. of Northborough, Mass. for generously allowing us the use of their facilities and for allowing Tim a flexible work schedule.

Anne's mother, Marjorie Hubbell Gibson, for her research assistance.

The many organizations and agencies, public and private, that responded enthusiastically to our requests for information.

CONTENTS

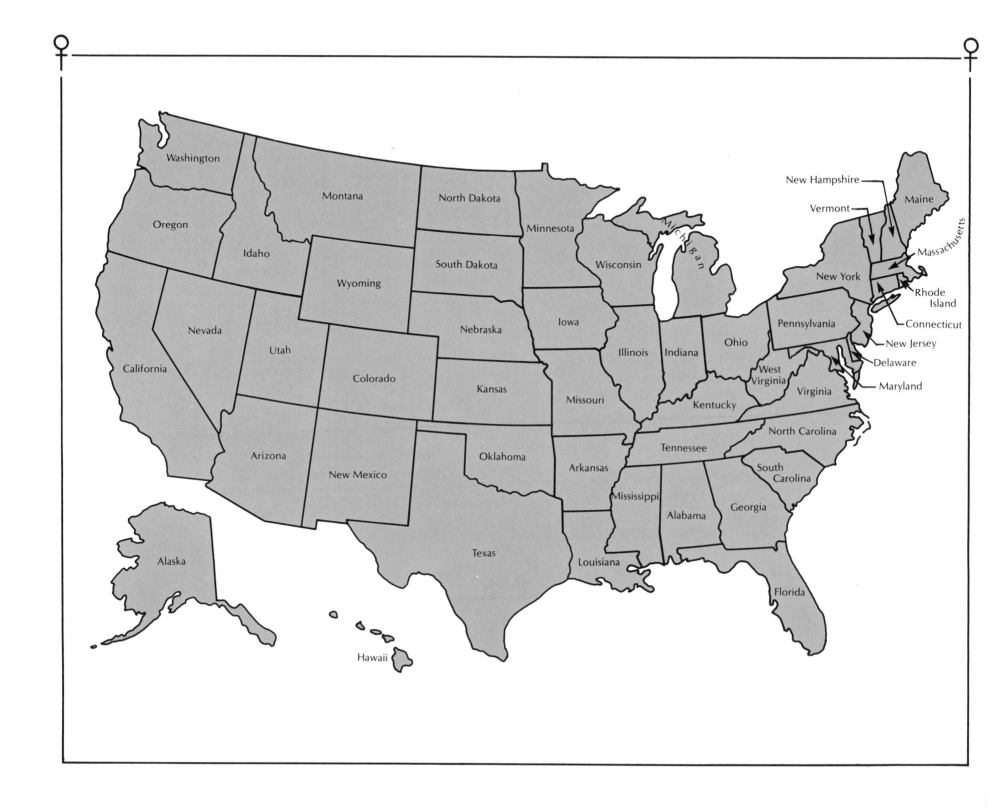

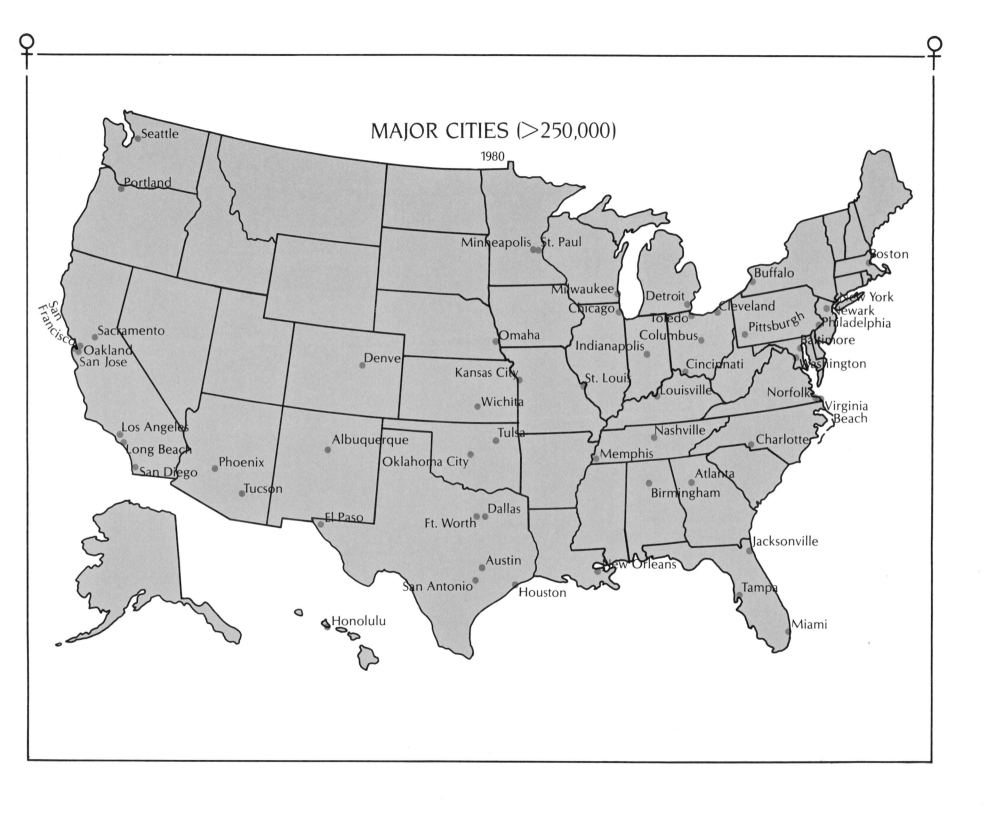

MAJOR CITIES (>250,000)

1980

Seattle
Portland
San Francisco
Sacramento
Oakland
San Jose
Los Angeles
Long Beach
San Diego
Phoenix
Tucson
El Paso
Honolulu

Minneapolis St. Paul
Milwaukee
Chicago
Omaha
Denver
Kansas City
Wichita
Tulsa
Albuquerque
Oklahoma City
Dallas
Ft. Worth
Austin
San Antonio
Houston
New Orleans

Detroit
Toledo
Indianapolis
Columbus
St. Louis
Louisville
Nashville
Memphis
Birmingham
Atlanta
Jacksonville
Tampa
Miami

Buffalo
Cleveland
Pittsburgh
Cincinnati
Norfolk
Virginia Beach
Charlotte

Boston
New York
Newark
Philadelphia
Baltimore
Washington

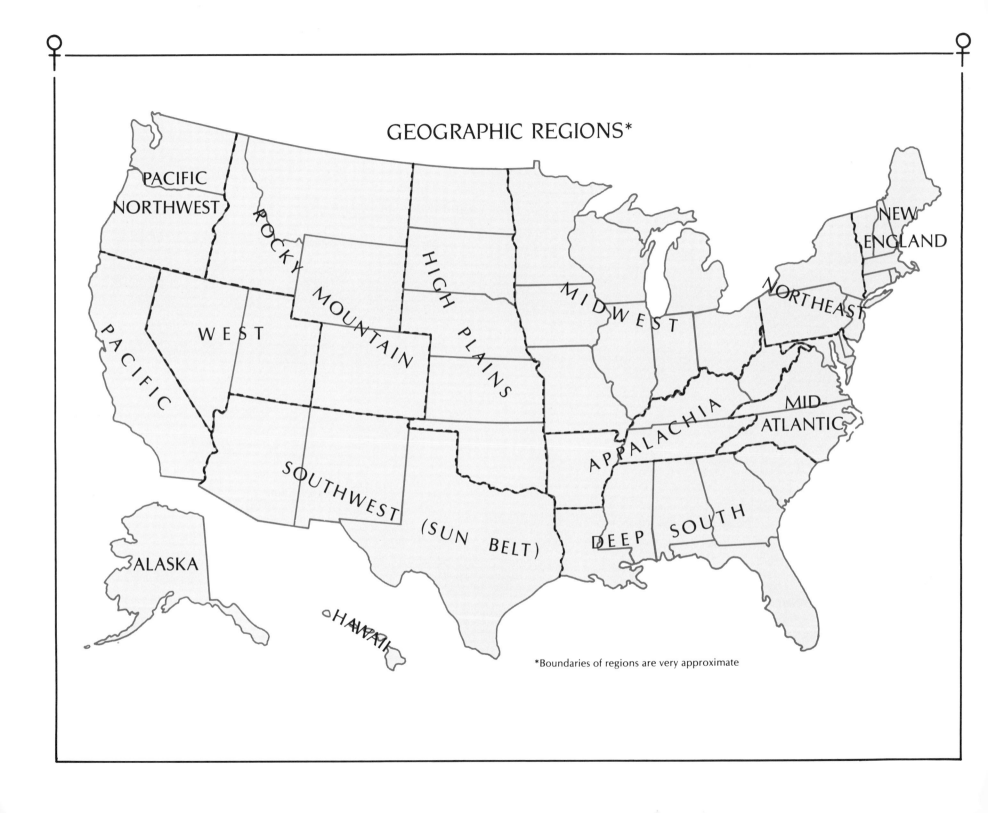

GEOGRAPHIC REGIONS*

PACIFIC NORTHWEST

ROCKY MOUNTAIN

HIGH PLAINS

MIDWEST

NEW ENGLAND

NORTHEAST

WEST

PACIFIC

APPALACHIA

MID-ATLANTIC

SOUTHWEST

(SUN BELT)

DEEP SOUTH

ALASKA

HAWAII

*Boundaries of regions are very approximate

INTRODUCTION

*"The first problem for all of us, men and women,
is not to learn, but to unlearn."* [1]

—Gloria Steinem

We hope this atlas leaves you unsatisfied. People turn to an atlas to answer geographical questions about the world around them. A study of these maps and the accompanying text will tell you where women make the most money, which states have the highest rate of divorce and which states have the lowest incidence of cancer in women. While this atlas will supply information on many subjects concerning women, its primary purpose is to make you ask questions. Why do women in Alaska have such a high median income? Is there a connection between the high marriage rate of Nevada and its high divorce rate? Why is it that the South and Northwest have relatively few women representatives in the federal government?

This atlas offers you a new way to explore the status of women and to understand the relationship between the sexes in the United States. The subjects that we have chosen to map are but a sample of the many topics available for examination. Whatever the subject, the maps

are designed to be provocative. We hope not only to stimulate your interest, but also to shock and surprise you. We hope this atlas challenges old stereotypes and prejudices. We hope to offer a new and different perspective on our country. And we hope you'll continue to investigate these topics on your own and in greater depth.

Male or female, we think you will find something to interest you in these maps. Although this is a women's atlas, what affects one sex must be of interest to the other. If you are a man planning to relocate, you might be interested in knowing which cities have the highest percentage of single women. If you are a woman who is politically active, you might want to know the states that are most in need of female representation. In any case, we have tried to create an atlas that will have broad appeal. Whether you are a geographer by trade or just someone who enjoys looking at maps, be prepared to look at women-related topics in a new light. But be

warned! You will probably end up having more questions about the geography of women than when you started.

The movement for women's equality has been part of the social history of the United States for well over a century. Its fundamental goal has been to promote equality of opportunity regardless of sex, and to insure that each person, female or male, has the freedom to direct her or his life in the most appropriate way. Some progress has been made. The sphere of women's interests and activities is no longer restricted to home and family as it was in our grandparents' day. However, you will discover from the maps that change has come unevenly and in varying degrees from state to state. The experience of women in the Northeast may not be comparable with those in the Gulf States. Differences between women and men may be more marked in some regions than in others. Examination of the maps will give you a picture of the diversity that exists even in a country like ours where equality for all has been a founding principle. The existence of diversity causes one to reexamine a perennial question: Are differences between the sexes a product of nature or nurture? Is biology destiny?

In the last ten years, geographers have begun to focus on a new topic, the geography of women. These researchers describe how various aspects of women's lives differ from place to place, and then try to offer explanations for this diversity. They analyze the demographic characteristics of the female population, including local, regional and national differences in education, income, health, political participation and crime. One geographer might examine the differences between the commuting or shopping patterns of women and men, while another might study spatial patterns of prostitution in cities. Other geographers might be interested in finding out whether abortion clinics and day-care centers are located near the women who need them the most. Still others have tried to rate states according to the quality of life they provide for their female residents.

In this atlas, we present maps about the important aspects of women's experiences in today's society where the differences between the sexes have been most keenly felt: education, politics, the law, employment, crime, health and the family. There are a host of questions that you can bring to these maps. How do women compare with men? How does your personal situation compare with that of others in your state? How does your state fit into the national picture? Is it the same as its neighbors? Is the larger region of which it is a part different from the rest of the country, and how great are those differences? Why are some states different from others? Geographers assume that differences between regions become more pronounced as they get further apart, and that, conversely, areas closer together tend to be more alike. When places are found not to fit that pattern, it is time to explore further to discover why.

Preparation of this atlas has been as much of an adventure and education for us as we hope reading it will be for you. Toward the end of this project, we noticed that one theme seemed to thread its way through all sections, no matter what the topic. The theme is one of participation. It would be easy to see these statistics as indicators of the degree to which women have "caught up" with men, and then to be appropriately happy or depressed at women's "progress" or lack thereof. Such a perspective, however, turns the movement for equality into a contest in which women are competing against men and measuring themselves against male standards of sometimes questionable validity.

Instead, it would make more sense to look at these maps as indicators of women's level of participation in social systems that significantly affect their lives. Is that

level of participation adequate to serve women's needs and to make their voices heard? Are there some regions of the country where women participate more, as doctors, teachers or police officers, than other areas? Are those levels of participation effective indicators of the level of opportunity available to women in that particular state? Every person should have, as much as possible, the chance to shape her life as she sees fit, to represent her point of view and to make decisions or influence those made on her behalf. The richness of participation in all aspects of life should be available to each person, regardless of age, color or sex. These maps, then, can be viewed as an indication of the differing levels of participation by women from state to state.

In case you want to investigate an idea further, we've included two kinds of information at the end of the atlas. First, for each map, we cite the source of our information. Second, we list some of the books we found to be useful reading during the preparation of the atlas. For any subject area, it's helpful to gain a brief understanding of the issues involved from a non-geographical perspective, and then to explore how these issues manifest themselves over space. You will note that there are no books cited specifically on women and geography. This omission is because the geography of women is a new field and most articles can only be found in scholarly journals that are not readily available in most libraries or bookstores. For those of you interested in a more academic overview, we recommend the following:

Mazey, M. E. and Lee, D. R. *Her Space, Her Place: A Geography of Women.* Resource Publications in Geography. Washington, D.C.: Association of American Geographers, 1983.

Zelinsky, Wilbur; Monk, Janice; and Hanson, Susan. "Women and Geography: A Review and Prospectus." *Progress in Human Geography* 6 (1982) 317–366.

Both have extensive bibliographies of journal articles and can be found in the libraries of colleges with geography departments.

DECIPHERING MAPS

Many people find maps both intimidating and confusing. This is especially true of people whose familiarity with maps is limited to the highway variety. Maps, like charts and diagrams, symbolize information in a visual format. But unlike those other graphic forms, maps have the unique ability to associate information with a place. Through the use of symbols, maps can show where something is located, as well as qualitative or quantitative information about it.

If you glance through the sections of this atlas, you will discover that we have used different types of maps to show different kinds of information. Since many people are unfamiliar with the different styles of map presentation, a brief discussion on how to "decipher" maps is in order.

Choropleth Maps

This is one of the most common map types, and one of the easiest to read. We have used it frequently throughout the atlas. In a choropleth map, information is ranked from the highest to lowest values and then divided into several groups or classes of values. Each data class is represented on the map by a different color. To read the choropleth maps in this atlas, simply match the color of the state with the same color in the legend and read off the corresponding data values. Very simple! Usually the colors are arranged from light to dark to parallel the

progression of low to high values. Remember that when looking at a choropleth map you need not limit yourself to knowing the values of individual states. It is more important to observe any broad regional patterns that may exist by looking at clusters of states that share the same color. For example, the map showing the percentage of women secondary school teachers (Education section, page 46) depicts a clustering of states in the Deep South with similar data values.

Two-Variable Choropleth Maps

If we take information from two choropleth maps it is possible to combine them to form a single map known as a two-variable choropleth map. The process of reading this type of map is similar to that for a regular choropleth map, but requires working in two dimensions instead of one. The "Marriage Vs. Divorce" map in the Family section can be used as an example. In this map (page 112) there are two variables, or types of information, being compared: marriage rates and divorce rates. By examining the legend we can see that it is divided into four sections with each section representing one possible combination of the two variables. Since our goal is to merge marriage and divorce onto a single map, we select a color scheme which logically represents the four combinations of the two variables. In the example of "Marriage Vs. Divorce" all of the colors in the legend are different variations of purple. As you probably know, purple is a mixture of blue and red. In this example, marriage rates are represented by red (above average rates = dark red, below average = light purple) and divorce rates by blue (above average = bright blue, below average = light purple). Therefore, the color of each section of the legend is formed by the mixture of the

blues and reds representing marriage and divorce. The table below outlines the mixtures of the colors in the legend.

MARRIAGE RATE	MARRIAGE COLOR	DIVORCE RATE	DIVORCE COLOR	COMBINATION COLOR
Above Average	Dark Red	Above Average	Bright Blue	Dark Purple
Above Average	Dark Red	Below Average	Light Blue	Reddish Purple
Below Average	Light Red	Above Average	Bright Blue	Bluish Purple
Below Average	Light Red	Below Average	Light Blue	Light Purple

As with the regular choropleth map, simply match the states' colors with those in the legend. Further examples of two-variable maps can be found in the Politics section.

Symbol Maps

Sometimes, instead of using color to identify the category to which a state belongs, we use different symbols or different sizes of one symbol placed within each state to represent its data value. It is important to note that the symbol does not reflect an actual location within the state, as with the dot map discussed below, but rather stands for the state as a whole. In several cases we have combined both choropleth and symbol mapping techniques on the same map. An example is the map of "Women-Owned Businesses" (page 95), where dollar signs are used in combination with a range of colors.

Pie Chart Maps

Pie chart maps are a special kind of symbol map. Most

of us are familiar with pie charts from their use in diagrams or charts. A circle is divided into wedges with each representing a percentage of the total "pie." On a map, each state has a pie chart associated with it containing information specific to that state. With each pie chart map, we have included in the legend a sample pie chart divided into several selected percentages to give you an idea of how much each percentage divides the pie.

Dot Maps

Dot maps are very simple to read. Examples can be found in the "Multi-Racial Sisterhood" and "Women's Colleges" maps on pages 15 and 42. In the map of women's colleges, each dot represents one women's college, and the placement of the dot represents the location of that college. On other maps, one dot will stand for more than one "unit," as in the "Multi-Racial Sisterhood" map where each dot represents 35,000 women. In this instance, dots are placed to give an approximate idea of the distribution of women throughout the state. The 35,000 women the dot represents will all be located within that state, but not exactly at the place that the dot indicates. Occasionally, the dot size may be varied to represent different magnitudes of data. Often we have used rings to represent these larger magnitudes. The actual location of the variable is at the center of the ring.

Prism Maps

Some maps in the atlas, such as "Median Income" (page 65), use the prism technique. The height of each state is proportional to the data value associated with it. The higher the state, the greater the value of the variable mapped. A variation on the prism method is a map in which states "float" above or below the base line according to whether their values are positive or negative.

Cartograms

The cartogram is one of the most dramatic map styles. It can, however, be somewhat confusing at first. In a cartogram, the area of a state is proportional to the data being mapped. An example of a cartogram is the "Most Populous Sex" map in the Demographics section (page 12). Since the sizes of the states must be adjusted to match the relative size of the data, their shapes may be distorted to preserve the topological relationships with neighboring states.

In addition to understanding different mapping methods, it is equally important to have the ability to tell one geographic region, state or city from another. For those of you who are a bit vague about where some states are, we have included a map labeling all the states to refresh your memory. Note that Alaska and Hawaii are located in the lower left hand corner. Hawaii is, of course, far west into the Pacific and Alaska is up on the northwestern border of Canada. Actual locations cannot be shown because of their great distances from the continental U.S. Keep in mind also that the scale to which Alaska is drawn is much smaller than that of the other states.

It's also helpful to know the locations of large urban areas. To familiarize you with the location of the major cities of the United States, we have included a map that shows the location of all cities with populations greater than 250,000 as of 1980.

Finally, you will discover that we refer to various portions of the country by regional geographic names. Regions such as the Midwest, Deep South, Great Plains

and Southwest are not well defined. In fact, geographers often disagree as to what areas are included in a given region. The Midwest provides an excellent example. Depending on where people come from and their experience in travel, definitions of the Midwest will vary to a great extent. At one extreme, the Midwest has been defined as an area contained entirely within Ohio, Indiana and Illinois, and at the other, it is viewed as a region covering 14 states from Ohio to Colorado and from North Dakota to Texas.

To give you an approximate idea of our definition of these different regions, a map has been included that identifies 12 geographic regions in the United States. Please be aware that the boundaries between any two areas are *never* exact and that the regional map is to serve only as a guide to the text. Also, note that data for the District of Columbia has been combined with that of Maryland in most cases. For maps in which this is not the case, we have made an indication in the appendix where map sources are listed.

A WORD ABOUT DATA

One of the most important data handling techniques is that of standardization. In many cases, it is not very useful to map data in raw form. If we did, then most of the maps in the atlas would simply reflect the population distribution of the United States. That is, states with larger populations would usually show a greater value than the more sparsely populated states. To circumvent this problem, most of the data is standardized in such a way as to eliminate differences based just on population size.

One way to standardize data is to express it as a rate, or as the number of occurrences for every specified number of units. As an example, City A with a population of 5,000 might have had 100 deaths from cancer, whereas City B might have had 120 deaths out of a population of 8,000. Even though City B had a higher actual number of cancer deaths, data standardization using a rate will show that City A actually had a higher incidence of cancer mortality *relative* to its population. If we establish our unit as 1,000 persons, we can see that City A had 20 deaths for every 1,000 persons, whereas City B had only 15.

Percentages are a special kind of rate. The base population of each state, whatever its actual size, is considered to be 100%. The data is then expressed as a proportion of that amount. 50% of the bus drivers in one state might be women, as compared to 20% in another. It no longer matters that the total number of drivers differs from state to state. We are interested in relative proportions.

In addition to standardizing the data, we have tried to collect data from the same period. The data for the majority of the maps are from 1980. For those maps whose information is for years other than 1980, the date is noted on the map. As much as possible data should be standardized against base populations from the same time period. For two or three maps where data was from a year other than 1980, we had to use 1980 population figures, because female/male state-by-state population estimates for other years were not available.

If you acquaint yourself with the sources of our data, you will note that many are from government agencies. One of the most massive data collection efforts is that undertaken by the U.S. Bureau of the Census every ten years. The decennial census contains a wealth of interesting information about education, employment, income, family structure and ethnic origin for the whole country at the state, county and municipal levels. Census information and that from many other government

agencies are available to the public at many libraries, or directly from the agency concerned.

It is appropriate for people to be somewhat suspicious of the accuracy of statistics and maps. For that reason, we thought it would be useful to offer some cautions of our own in regard to the 1980 Census data. While the Bureau of the Census conducts one of the most efficient and professional data collection operations of this magnitude in the world, it is practically impossible to achieve 100% accuracy. The concerns we mention in regard to census data are applicable to any set of statistical information from any other source.

Census statistics are based on either complete count or sample data. The difference is important. With complete count data, the base population includes *all* relevant persons in a given area. For example, if we wanted to know the percentage of women in New York City who had a high school diploma, we could do a survey in which we personally asked each and every woman in New York City about the status of her high school education. The percentage of high school graduates would be based on the complete population. To the best of our knowledge, no one would be left out. Such a survey, however, would be very time consuming because of the large number of women we needed to question. An alternative strategy would be to sample just 1,000 women. Perhaps we might discover that 730 of those women had high school diplomas. We could then infer, on the basis of our sample population, that approximately 73% of all New York City women were high school graduates.

The catch here is that the sample population *must be representative.* In other words, an accurate cross-section must be taken from all of the women in the city.

If we were not careful to select a representative sample, our data might be very misleading. Perhaps we selected our 1,000 women from a very disadvantaged section of the city. Their level of educational attainment would not necessarily be a good indication of the educational level for women in the city as a whole. Even complete count data, while preferable to the sample variety, is often not 100% accurate if large numbers of people are involved. It is particularly easy to undercount low income people, people in remote areas, or people who don't speak English, to cite just a few examples.

Statisticians at the Census Bureau have worked hard to devise techniques and sampling procedures that minimize sampling error as much as is humanly possible. You should remember, though, that these figures derived from sample data are very carefully designed estimates. Those of you who want to understand the magnitude of possible errors are referred to the technical appendices in the Census publications.

Another potential source of error in any survey lies in the persons answering the questions. A survey is only as accurate as the answers of those surveyed. Sometimes people make a mistake, sometimes they have not remembered correctly, sometimes, particularly when sensitive issues are discussed, they simply lie.

Don't be afraid if at first you do not understand a map. Familiarize yourself with the mapping techniques, carefully examine the legend and find examples of each category on the map. Look at individual states and see where they fit into the legend. Finally, look at the country as a whole and try to get a feeling for any regional patterns that may emerge. Enjoy your exploration of the geography of women!

DEMOGRAPHICS

"What is done or learned by one class of women becomes, by virtue of their common womanhood, the property of all women." [1]

—Elizabeth Blackwell

The American woman is a composite. She is Black, White, Asian, Hispanic and Native American. She is young, old and middle-aged. She is an urban dweller and a rural resident. In short, she is the average of all the individual women in the United States.

The same can be said for the Alabama or the Wyoming woman, although the proportions used may make either of these state composites different from the American woman. In some states, the proportion of Hispanic women will be higher, or the proportion of young women lower. Each state will have its own special combination, and it is these different mixtures that contribute to regional variations.

Geographers are interested in how the "average" woman in one state compares with one in another, and in determining why the differences occur. If we were to say, for example, that one out of every 610 women in the U.S. died from cancer in 1980, we are using a rate that has for its base population all the women in the United States. If we were to restrict that population to Native American women, or to women over 65, we would have different rates. Thus, every rate or percentage that is cited conceals very real differences among the base population, whether at the national, or, as in the case of this atlas, the state level. The more homogeneous the base population, the more accurately the statistic will predict the experiences of any one individual.

For reasons of space and time, we have been, regrettably, unable to furnish maps for women of specific age groups, racial groups and residential locations in the various subject areas. Yet there are important basic distinctions among women. The tables below give an idea of the diversity among women at the national level:

WOMEN BY RACIAL/ETHNIC ORIGIN AND RESIDENTIAL
LOCATION—1980[2]

	U.S. Total	Urban	Rural
Native American	0.6%	52.7%	47.3%
Asian	1.4%	93.4%	6.6%
Black	12.0%	85.8%	14.2%
White	83.0%	72.1%	27.9%
(Other)	3.0%		
All Women	100.0%	74.5%	25.5%
Hispanic*	6.3%	90.4%	9.6%

*Women of Hispanic origin can be of any race.

WOMEN BY AGE GROUP—1980[3]

	0–14	15–44	45–64	65+	Total
Native American	31.0%	49.5%	13.7%	5.8%	100.0%
Asian and Pacific Islander	23.8%	53.2%	17.0%	6.0%	100.0%
Hispanic	31.3%	49.1%	14.0%	5.5%	100.0%
Black	27.0%	47.6%	16.5%	8.9%	100.0%
White	20.2%	44.6%	20.9%	14.2%	100.0%
Total	21.5%	45.4%	20.0%	13.1%	100.0%

A separate table could be done for each state. A statistical average for one state will differ from that in another part of the country because the age structures, racial and ethnic breakdowns and residential patterns of women are different for each state. The geographical perspective challenges the curious to identify the complex of factors making up each regional identity.

Because we could not provide maps for the different sub-groups of women, this opening section is intended to serve as an acknowledgment and reminder of the very real differences that exist among women, despite their common sex. By focusing here on nationwide variations in age structure, ethnic origin and residential location, we are taking an important first step in understanding the regional patterns in such areas as health, education, crime, etc. The maps in this first section should be viewed in conjunction with those in later sections.

Individual characteristics serve as sources of personal identity. When we share characteristics with others, we identify with a larger group. As a women's atlas, this book focuses on the experiences and issues common to people of a common gender. However, it should be pointed out that for many women, differences within their own gender may serve as a more relevant source of identity and shared purpose. For the minority woman, the problems faced as a member of a particular racial or ethnic group may supersede purely feminist concerns. Similarly, a senior citizen may find that the concerns of her age group outweigh any sex-engendered problems.

There is a rich ethnic and racial diversity in this country. Immigrants from many parts of the world have brought with them values, customs and traditions unique to their cultures. The struggle to establish a place within "mainstream" American society, while relatively easy for some, has proved painfully difficult for others. The five groups we have focused on, Native Americans, Asians, Hispanics, Blacks and Whites, each have a different story to tell.

Native Americans saw much of their population and way of life destroyed by invading Europeans. Black Americans came to this country as slaves for those same Europeans. Immigrants from Asia provided a cheap source of labor in nineteenth-century America. More recently many are refugees fleeing from oppressive regimes. The Hispanic population, which can be of any racial origin, now comprises a significant and fast-growing segment of the population. Thousands have migrated from Cuba, Mexico, Puerto Rico, South and Central America in search of greater economic opportunity.

Age structure is simply a way of describing the proportion of women falling into particular age groups. We have divided women into four fairly traditional and broadly defined age groups based on common concerns: childhood (0–14), the childbearing years (15–44), the middle years (45–64) and the elderly (65+).

The concerns of childhood, the period before sexual maturity, are obvious. Ages 15 to 44 mark the beginning of adult life, years when women make major decisions about selecting a life partner, a career, and having children. Ages 45 to 64 are less easily defined. During these years, women cease bearing children. For women who have chosen to raise a family, this can be a period of the "empty nest," when it is time to pursue a new type of life work. Many choose to reenter the paid workforce. For women who have already established careers outside the home, it may serve as a time when goals are reevaluated and new directions defined. Ages 65 and over correspond loosely with retirement, either from one's own job or from a spouse's. The concerns of each of these age groups are different, and the balance between age groups will influence regional patterns in other subject areas.

It is important to realize that age structures fluctuate over time. Ohio's age structure in 1980 may be very different from what it was in 1940. Even as age structures influence regional patterns, they themselves are a product of the attitudes and priorities of preceding generations, or other factors such as climate or the availability of certain services. Ethnic and racial groups will often have characteristic age structures resulting from specific cultural attitudes and the circumstances of their presence in this country. Where those groups of people predominate, so will those characteristic age structures. A relatively large proportion of children in a state may indicate that the preceding generation favored large families. Perhaps the economy was suited to the employment of children, or perhaps contraception was not an accepted practice. A state with a warm climate might have a particularly large population of elderly citizens.

In some maps, we have tried to compensate for variations in age structure by restricting our base population to a specific age group. For example, statistics showing the percentage of women who are married make more sense if we focus only on women over the age of 15 instead of all females. Similarly, the percentage of women with high school diplomas is figured for women 18 and over. Statistics dealing with reproductive issues are limited to women in the childbearing years.

The final variable we examine is that of residential location. There is a vast difference between the urban and rural environments, even within a region or state. It is important to remember that at the state level, the urban/rural difference is averaged out. There may be a great deal of difference between the experiences of New York City dwellers and farmers in upstate New York. Perhaps there is a higher concentration of women doctors in urban areas than in the countryside, or perhaps women in rural areas have a higher life expectancy than their urban sisters. Thus, it is important to be aware of which states are predominantly rural, urban or have an even mixture of both environments.

The maps will allow you to explore these differences in more detail.

THE MOST POPULOUS SEX

In the U.S. as a whole, and in 45 states, women outnumber men. The 1980 Census counted 1,059 women for every 1,000 men; however, this ratio was not constant from state to state. We open the atlas with two maps, "The Most Populous Sex" and "Women Vs. Men," showing the population of women in the U.S. The first,

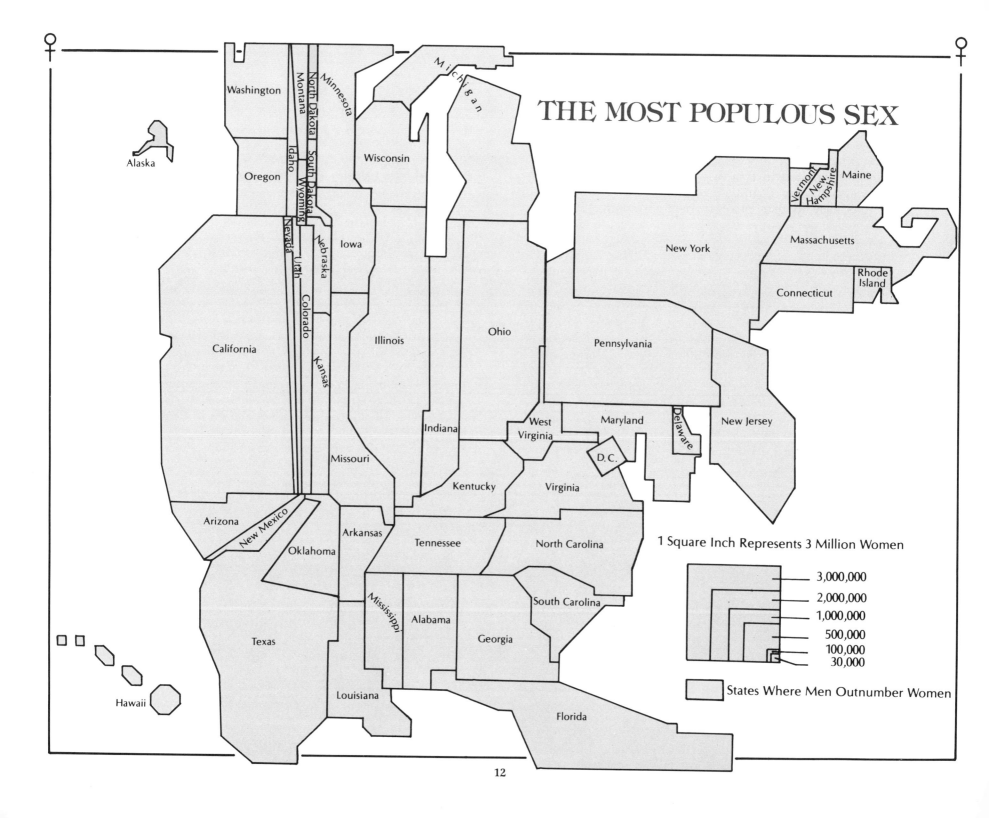

THE MOST POPULOUS SEX

1 Square Inch Represents 3 Million Women

3,000,000
2,000,000
1,000,000
500,000
100,000
30,000

States Where Men Outnumber Women

a cartogram (page 12), represents the size of the state as proportional to the number of women living there in 1980. The relative size of the Northeast has been magnified, while several western states have shrunk to thin slivers. Depicted in this way, California comes out the largest with over 12 million women.

It is easy to pick out, by their contrasting coloring, the five states where men outnumber women: Alaska, Wyoming, North Dakota, Nevada and Hawaii. The "Men Vs. Women" map on page 14 provides information about the ratio of women to men in greater detail. The proportion ranged from a low of 886 women for every 1,000 men in Alaska, to a high of 1,105 per 1,000 in New York. In general, the eastern states had a higher female-to-male ratio than those in the West.

THE MULTI-RACIAL
SISTERHOOD

"The Multi-Racial Sisterhood" begins with a dot map (page 15) providing a quick overview of the racial distribution of the female population. Each of four major racial groups, Native American, Asian, Black and White, has been assigned a different color dot, allowing for a comparison of actual numbers as well as distribution. Each dot represents 35,000 women. Four maps ("Native Americans," "Asians," "Blacks" and "Whites") follow (pages 16–17), one for each ethnic group, giving a more detailed presentation of each group's relative proportion to the total population. The maps are ordered from the least to the most populous group. The population as a whole tends to cluster around major urban areas.

Native American women made up the smallest of the four racial groups. In contrast to the distribution of the population as a whole, this group was more populous in the West than in the East. In 36 states, Native American women were less than 1% of all women. Four states in the continental U.S., Oklahoma, Arizona, South Dakota and New Mexico, had between 5% and 9% of their female populations made up of Native Americans. Alaska, as the home of the Eskimo and Aleutian peoples, topped the list at 17%. Of the four racial groups, the Native American was the only one with almost 50% of its people living in rural areas.

While the Asian-American population is slightly larger (included here are Japanese, Chinese, Filipino, Korean, Asian Indian and Vietnamese), in 36 states it again constituted less than 1% of the female population. On the mainland, their proportion was never more than about 5% in any state. In Hawaii, however, almost one-half of women were of Asian descent. The highest Asian concentrations occurred along the Pacific Coast. In areas around a few large urban centers such as Chicago, New York and Washington, D.C., Asian women were between 1% and 2% of the female population. The very lowest values were found around the Dakotas and Appalachia.

Black women made up the largest racial minority within the female population, although in a few states such as Idaho, Montana and South Dakota they were outnumbered by both Asian and Native American women. Clearly, Black women were most obviously in the minority (less than 2%) in the Rocky Mountain, northern Plains and northern New England states. They were less than 1% of the total female population in only nine states, as compared with 36 for Asian and Native American women. In 19 states, that percentage for Blacks increased to over 10% and in Louisiana, South Carolina and Mississippi, about one out of three women were Black. Black women are concentrated in the South, and, secondarily, in the Midwest and Northeast. These last two regions are sites of large urban areas which served

WOMEN VS. MEN

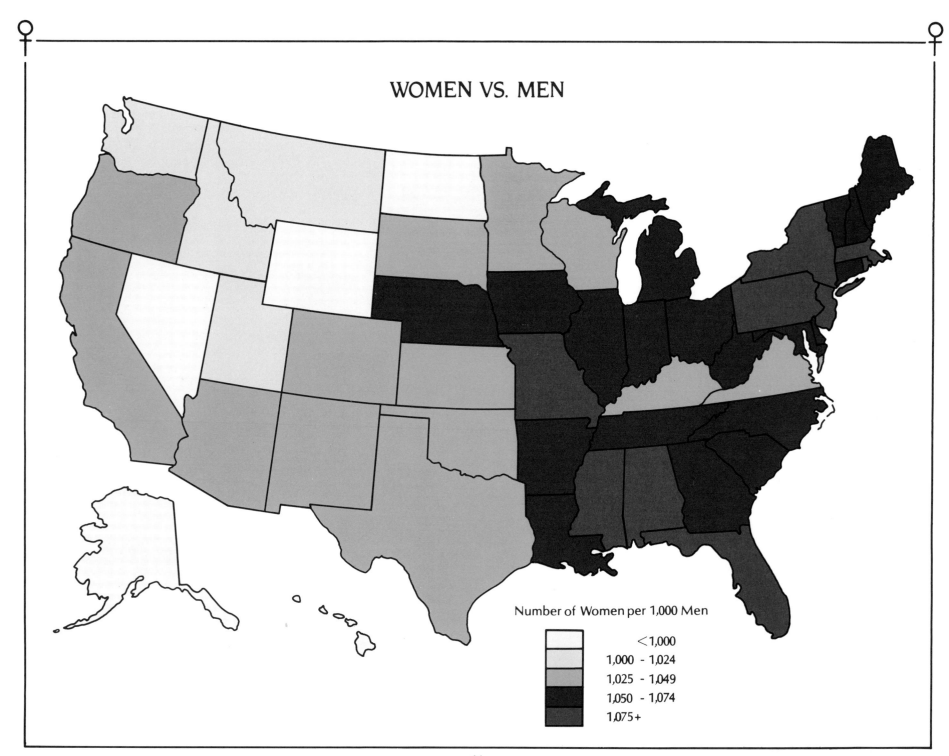

Number of Women per 1,000 Men

< 1,000
1,000 - 1,024
1,025 - 1,049
1,050 - 1,074
1,075+

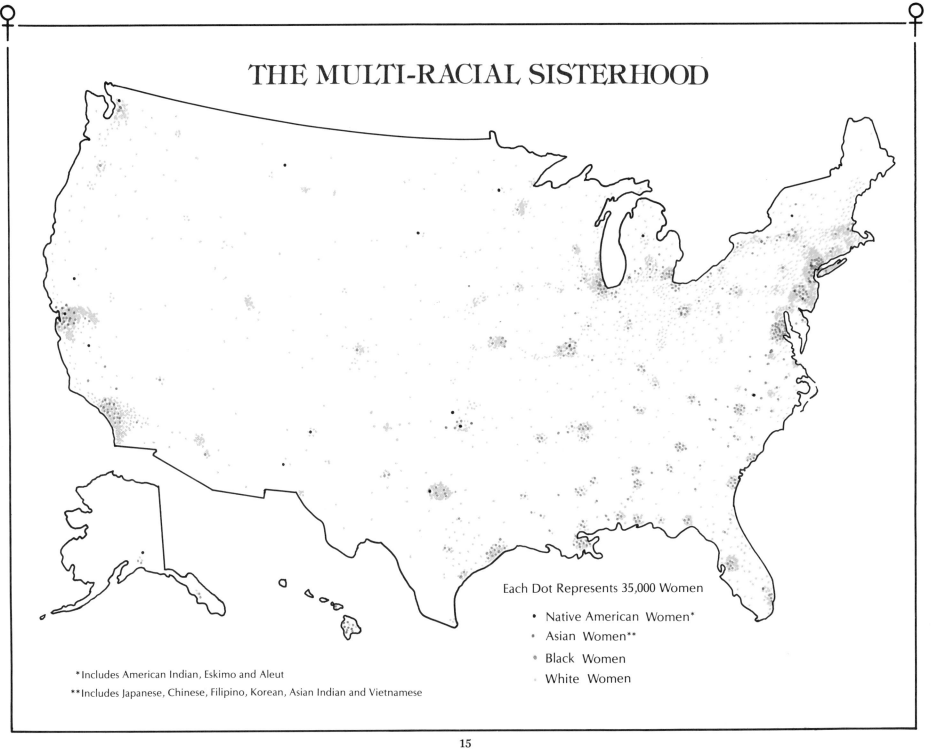

THE MULTI-RACIAL SISTERHOOD

Each Dot Represents 35,000 Women

- Native American Women*
- Asian Women**
- Black Women
- White Women

*Includes American Indian, Eskimo and Aleut

**Includes Japanese, Chinese, Filipino, Korean, Asian Indian and Vietnamese

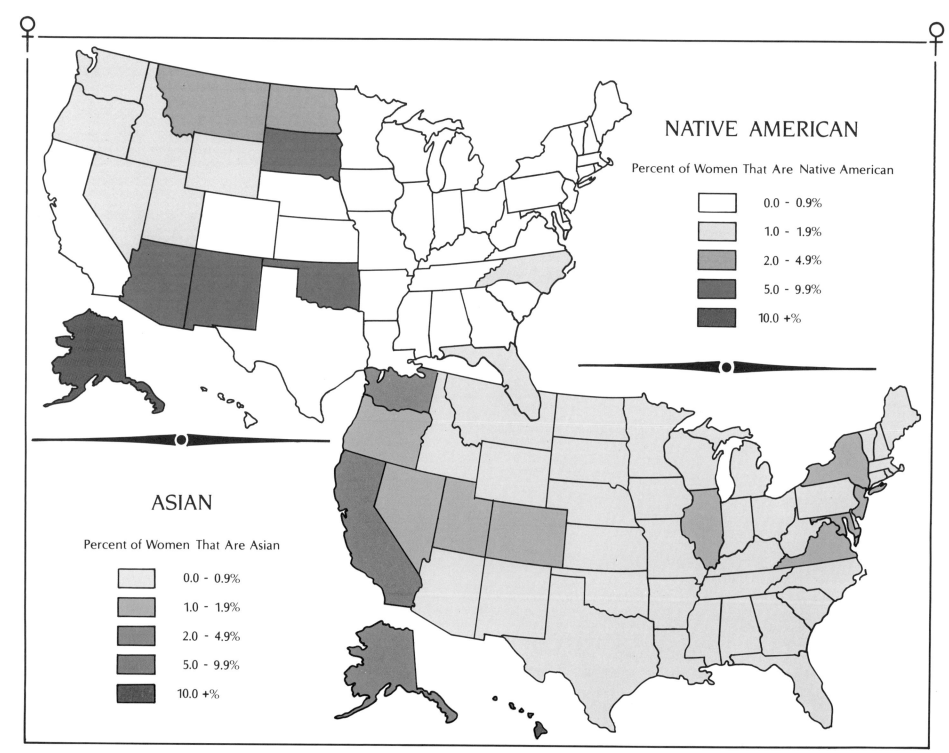

NATIVE AMERICAN

Percent of Women That Are Native American

0.0 - 0.9%
1.0 - 1.9%
2.0 - 4.9%
5.0 - 9.9%
10.0 +%

ASIAN

Percent of Women That Are Asian

0.0 - 0.9%
1.0 - 1.9%
2.0 - 4.9%
5.0 - 9.9%
10.0 +%

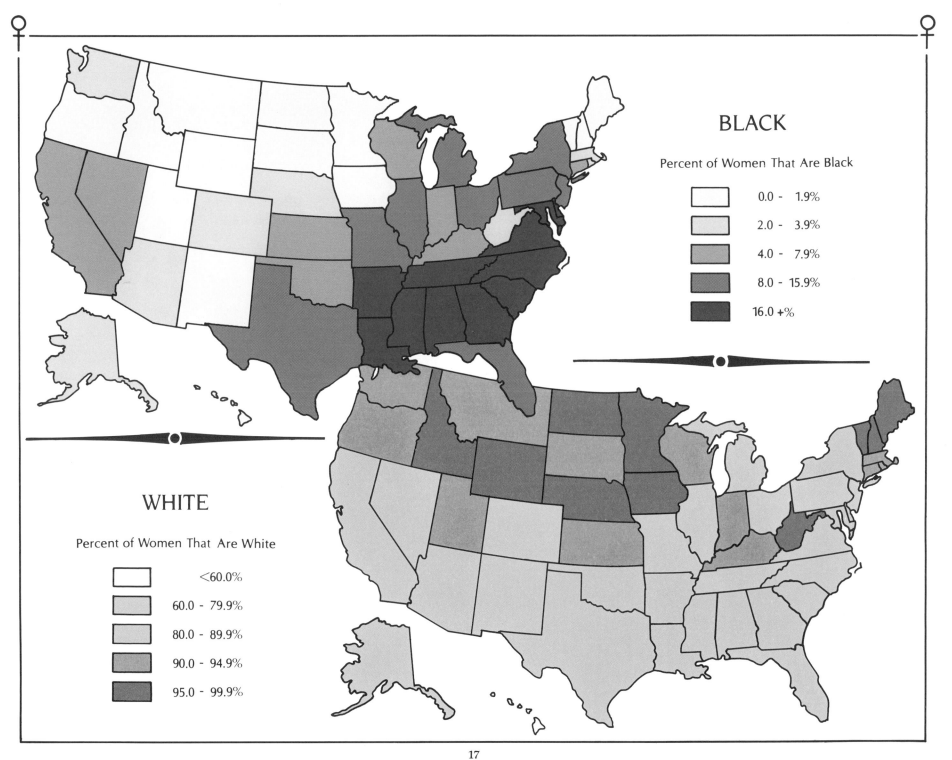

BLACK

Percent of Women That Are Black

	0.0 - 1.9%
	2.0 - 3.9%
	4.0 - 7.9%
	8.0 - 15.9%
	16.0 +%

WHITE

Percent of Women That Are White

	<60.0%
	60.0 - 79.9%
	80.0 - 89.9%
	90.0 - 94.9%
	95.0 - 99.9%

WOMEN OF HISPANIC ORIGIN*

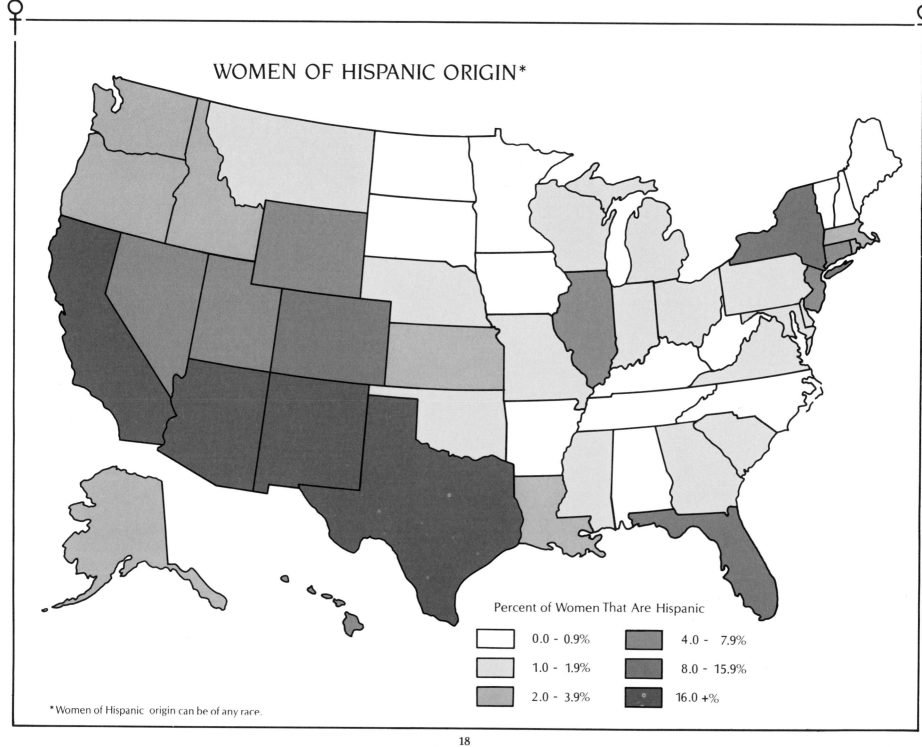

Percent of Women That Are Hispanic

0.0 - 0.9%	4.0 - 7.9%
1.0 - 1.9%	8.0 - 15.9%
2.0 - 3.9%	16.0 +%

*Women of Hispanic origin can be of any race.

as foci for those migrating from the South in search of greater economic opportunity.

The percentage of women who described themselves as "White" in the 1980 Census ranged from a low of 31% in Hawaii to 99% in Vermont. In 10 states scattered from the Northeast to the Northwest, less than 5% of the female population belonged to a racial minority.

Women of Hispanic origin (who can be of any racial group) are part of one of the fastest-growing minorities in the U.S. The percentage of the total population that they represent varies widely, from a low of under 1% in Maine to a high of 37% in New Mexico. In five western states (Colorado, New Mexico, California, Arizona and Texas) Hispanics constitute more than 10% of the population. The high values in the Southwest reflect the presence of those with a Mexican heritage, while Florida is a gathering place for those from Cuba. New York and Chicago also have relatively high concentrations of Hispanics.

POPULATION PYRAMID

The population pyramid presents a comparative age structure for both sexes in the U.S. The number of women and men can be compared by five-year age groups. Notice that men outnumbered women through childhood and adolescence. Then, beginning in the early 20s, the reverse was true. Women predominated, especially among those over 65. A separate population pyramid could be done for each state, and each state would reveal a slightly different age structure.

WOMEN (AND MEN) THROUGH THE AGES

Instead of population pyramids, we have used four maps ("Childhood," "Childbearing Years," "Middle Years" and "The Elderly") (pages 21 and 23) of more broadly classified data to show the variations in age structure for women from state to state. The maps yield a picture of how one state or region compares with another for each age group. The percentage of women under the age of 15 varied from a low of 18% in Florida to a high of 31% in Utah. In five states, New Mexico, Wyoming, Idaho, Alaska and Utah, over one-quarter of the female population were children. The highest percentages were concentrated in the West and South while the lowest values, with the exception of Florida, predominated in the Northeast. Note that for all states, males outnumbered females in this age group.

The proportion of women that are of reproductive age will influence birth rates, fertility ratios, crime rates and the ratio of women to men in the labor force. Women in this age group were proportionately more numerous than any other, making up between 41% of the female population in Florida and 56% in Alaska. Again, the highest values are found in the West, although Virginia and Maryland/District of Columbia were almost as high. The lowest percentages were scattered throughout the country, although a noticeable band appeared from Mississippi to South Dakota. In some of these rural farm areas, women of reproductive age have actually been in short supply, having left to seek economic opportunities elsewhere while men remain behind to farm. The states where men in this age group outnumbered women were mostly in the West. There was a group of four eastern states (North and South Carolina, Virginia and Kentucky) where this phenomenon also occurred.

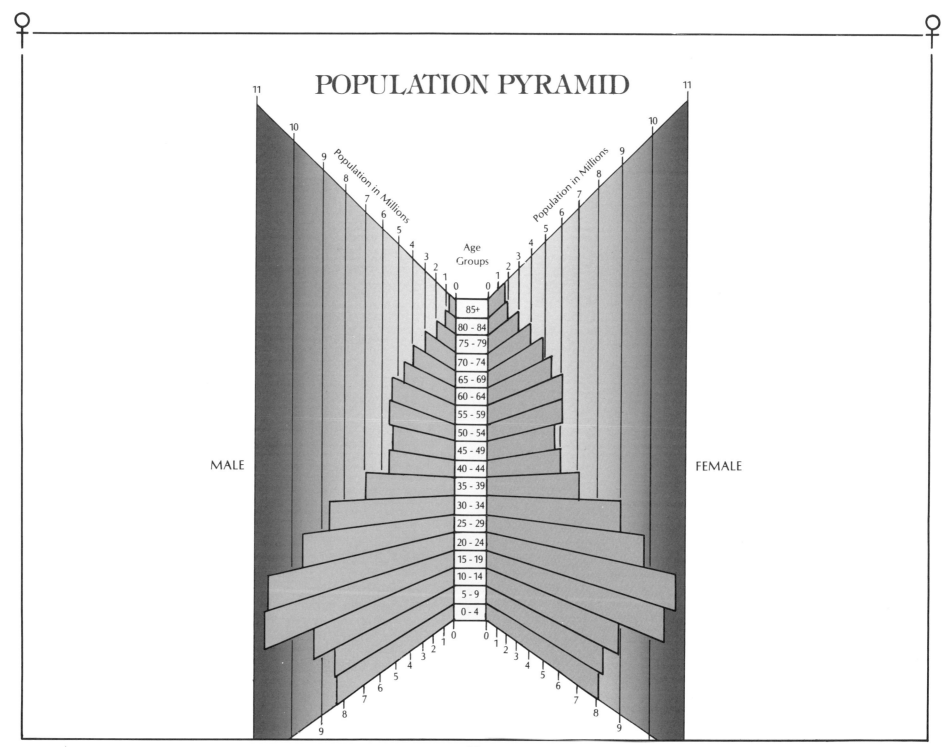

POPULATION PYRAMID

MALE

FEMALE

Population in Millions

Population in Millions

Age Groups

| 85+ |
| 80 - 84 |
| 75 - 79 |
| 70 - 74 |
| 65 - 69 |
| 60 - 64 |
| 55 - 59 |
| 50 - 54 |
| 45 - 49 |
| 40 - 44 |
| 35 - 39 |
| 30 - 34 |
| 25 - 29 |
| 20 - 24 |
| 15 - 19 |
| 10 - 14 |
| 5 - 9 |
| 0 - 4 |

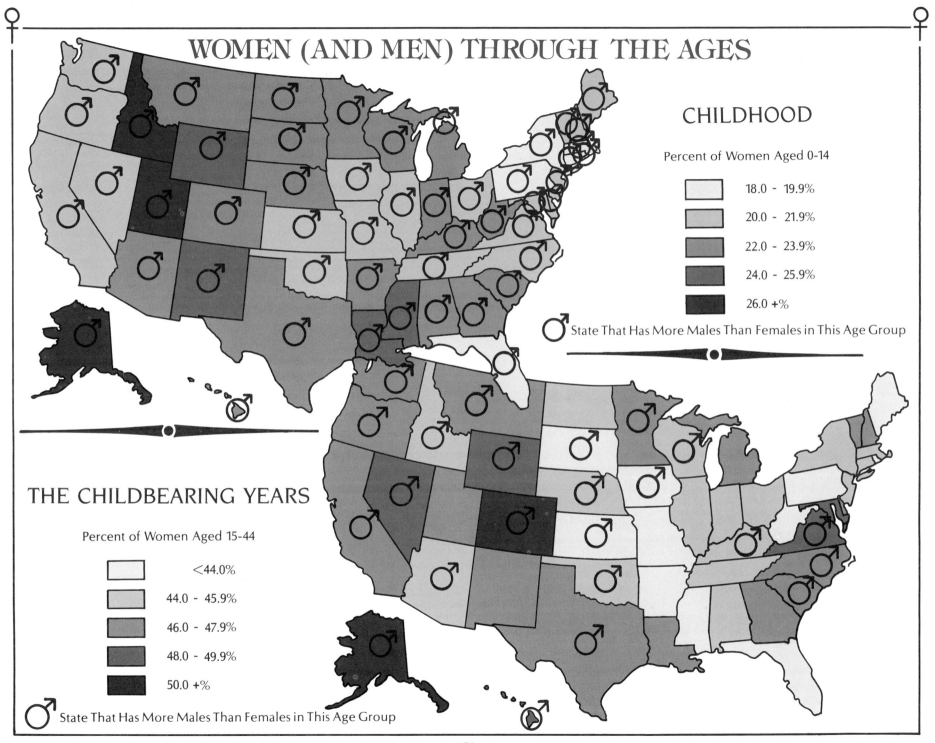

WOMEN (AND MEN) THROUGH THE AGES

CHILDHOOD

Percent of Women Aged 0-14

	18.0 - 19.9%
	20.0 - 21.9%
	22.0 - 23.9%
	24.0 - 25.9%
	26.0 +%

State That Has More Males Than Females in This Age Group

THE CHILDBEARING YEARS

Percent of Women Aged 15-44

	<44.0%
	44.0 - 45.9%
	46.0 - 47.9%
	48.0 - 49.9%
	50.0 +%

State That Has More Males Than Females in This Age Group

By the time we reach the Middle Years men aged 45–64 outnumbered women in only three Far West states: Alaska, Wyoming and Nevada. In all other states, women were in the majority. This age group had the narrowest range of percentages from state to state with a difference of only 9.4 percentage points between the highest and lowest values—those of Alaska and Pennsylvania, respectively. A region of low values is particularly apparent in the Rocky Mountain states. In contrast, the Northeast had a particularly high proportion of women in this age group, over one in five. Florida also is beginning to reveal its identity as a mecca for older persons.

The reputation of Florida as a retirement haven becomes particularly apparent in the map of women aged 65+. In Florida, 19% of women were elderly, as contrasted with only 3% in Alaska. Other low values can be found in Hawaii and several Rocky Mountain states. Besides Florida, there are two regions where women in this age group were proportionally high, the Plains states and the Northeast. Only in Hawaii do men in this age group outnumber women. Significantly, Hawaii had for 1969–71 the highest life expectancy for men of any state.

The map of median age can be seen as a summary of the last four maps. The median age is the middle value among all ages of women. Half the women in the state are older than the median age and half are younger. Note that Florida had the highest median age at 36.6, while Utah's was the lowest, 24.5 years. These values should not be too surprising when we remember that Florida was the state with the highest percentage of women over 65 and that Utah had the largest proportion of female children. Southern New England and the Northeast had the highest median ages after Florida, between 32.6 and 33.6 years. Several western states in addition to Utah (Alaska, Wyoming, Idaho and New Mexico) also had a relatively young population. In those places, the median age for women was in the mid- to late 20s.

Compare the median age of men with that of women. Only in Alaska was it higher, and only by six-tenths of a year. In all other states, the median age of women was higher than men, reflecting a woman's greater life expectancy. The difference varied from less than one year, common in several western states, to slightly over three years in states scattered throughout the Northeast and South.

TOWN AND COUNTRY

The U.S. Bureau of the Census defines the urban population as consisting of those persons living in places with 2,500 or more people and those who live in an "urbanized area." An urbanized area is made up of a central city or cities and the adjacent settled territory, the total population of which is 50,000 or more. All persons not defined as urban are considered rural. The "Urban/Rural" map (page 26) showing the percentage of women living in rural versus urban areas has some surprises.

Nevada and Utah had among the highest percentages of women in urban areas, using this definition. With their very low population densities, four and nine women per square mile, respectively, one would assume these states had a high proportion of rural dwellers. Instead, the figures indicate that most people are clustered in urban areas instead of spreading throughout the whole available land area. The proportions of urban women were highest in Hawaii, the Southwest and the Northeast. Rural women represented significantly more than half the female population in only two states: West Virginia and Vermont. Here, about two out of every three women lived

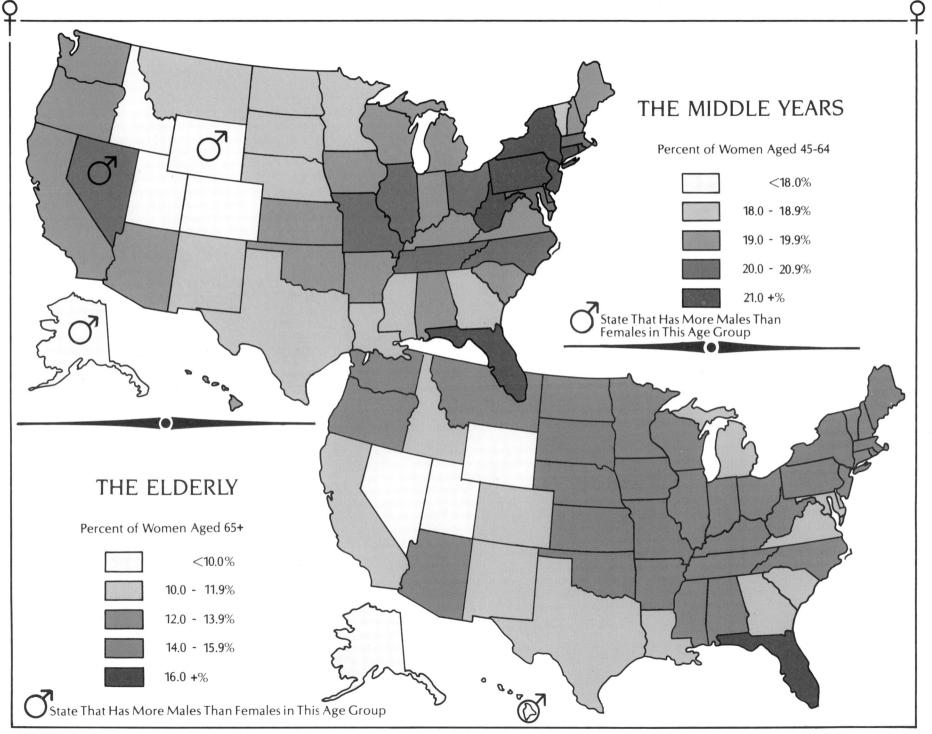

THE MIDDLE YEARS

Percent of Women Aged 45-64

<18.0%

18.0 - 18.9%

19.0 - 19.9%

20.0 - 20.9%

21.0 +%

State That Has More Males Than Females in This Age Group

THE ELDERLY

Percent of Women Aged 65+

<10.0%

10.0 - 11.9%

12.0 - 13.9%

14.0 - 15.9%

16.0 +%

State That Has More Males Than Females in This Age Group

MEDIAN AGE

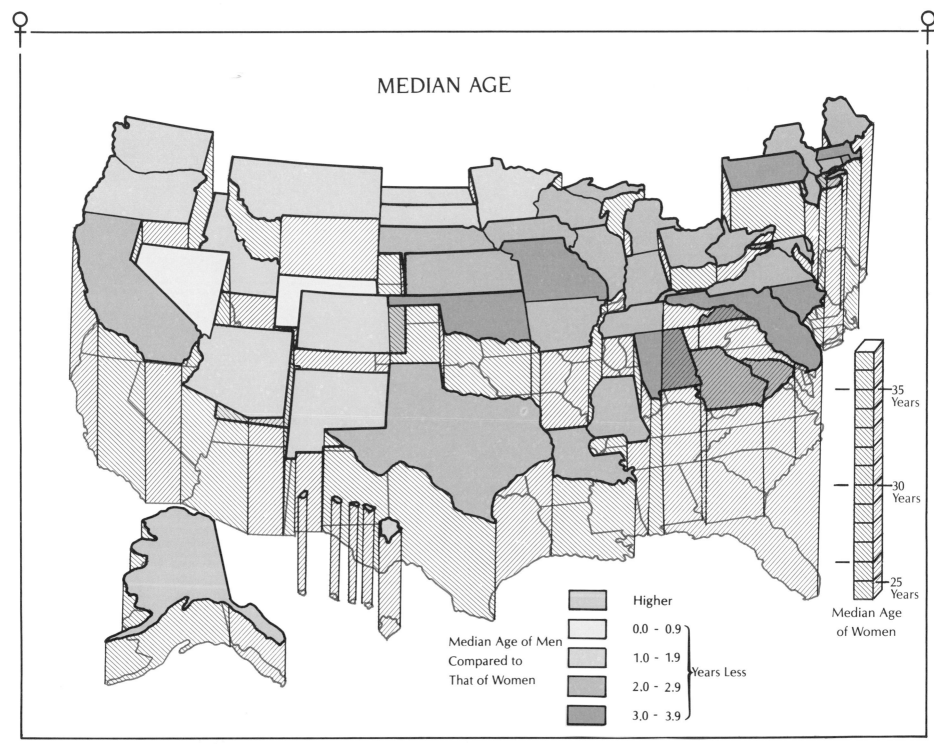

Median Age of Men
Compared to
That of Women

Higher

0.0 - 0.9
1.0 - 1.9 } Years Less
2.0 - 2.9
3.0 - 3.9

35 Years
30 Years
25 Years

Median Age
of Women

in rural areas. The next category, including about 10 states, highlights areas where the rural-urban split was about 50-50. The remainder of northern New England, the Dakotas, Montana and several southeastern states came under this classification.

Now that a basic demographic picture of women in the United States has been presented, we are ready to explore some of the more detailed issues dealing with the geography of women.

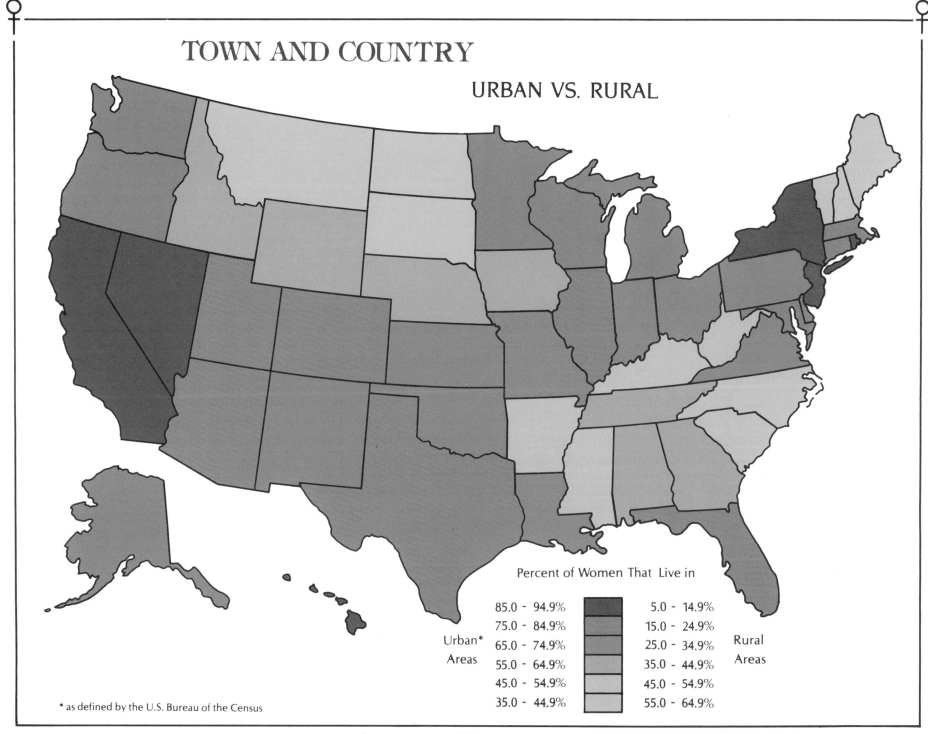

TOWN AND COUNTRY

URBAN VS. RURAL

Percent of Women That Live in

Urban* Areas		Rural Areas	
85.0 - 94.9%		5.0 - 14.9%	
75.0 - 84.9%		15.0 - 24.9%	
65.0 - 74.9%		25.0 - 34.9%	
55.0 - 64.9%		35.0 - 44.9%	
45.0 - 54.9%		45.0 - 54.9%	
35.0 - 44.9%		55.0 - 64.9%	

* as defined by the U.S. Bureau of the Census

EDUCATION

"What are we educating women for? To raise this question is to face the whole problem of women's role in society. We are uncertain about the end of women's education precisely because the status of women in our society is fraught with contradictions and confusion." [1]

—Mirra Komarovsky

Until recently, education and access to knowledge have been the privilege of a limited few. Many individuals and groups, ranging from the witch doctor to the modern corporation, have realized the need to restrict access to information in order to maintain their own power. Ever since Eve's encounter with the Tree of Knowledge, the educated woman has been considered by many as a threat to the social order.

Not surprisingly, oppressed and disadvantaged people have looked to education as a means of liberation, realizing that knowledge allows them to exercise control over their own lives and to protect their rights. Immigrants to the United States traditionally have valued the importance of education in achieving political power and economic security. Education provides the intellectual tools with which to understand and even challenge those in authority.

Women's access to education has not been completely closed in the past. There have been men, such as Roger Ascham, tutor to Queen Elizabeth I of England, who considered an intelligent woman a joy and delight. The *hetairae* of ancient Greece, women trained as professional companions to the male elite, were meticulously educated and expected to converse intelligently on many topics. However, education for the wives of these men was considered unnecessary and, until recently, has been viewed as superfluous for all women who will function primarily as wives and mothers.

The educated woman, or "bluestocking," was once regarded as a figure of fun. Not only was such a woman viewed as bizarre, she was also considered unfeminine. Knowledge and matters of the intellect were considered essentially masculine concerns and the woman that pursued an education was thought to have compromised her femininity. She might be female in the physical sense, but in mind she was considered male. The educated woman was made to feel unattractive to men. Such a perspective forced women to make an impossible choice between their sexual identity and their intellects.

The controversy regarding the place of education in women's lives was very much alive in 19th-century America. Since colonial days, some education, specifically in the form of reading, had been considered extremely important for women and men. The Protestant denominations promoted literacy so that church members of both sexes could read the word of God for themselves, rather than rely solely upon the interpretations of others. But beyond this very basic level, equality of access to education did not always fare as well.

Until the establishment of public high schools in the 19th century, formal higher education was available only to those who could afford it, regardless of sex. However, educational segregation based on gender was pronounced. Secondary education for boys could include preparatory work for college. Girls, however, were not considered for a college education and were not offered the same curriculum as boys. Academies were established for women's higher education, but the curriculum placed emphasis on such areas as music, drawing, needlework and French. Instruction in more intellectual disciplines was considered unsuitable to the girls' future roles as wives and mothers. A few fortunate women had the opportunity to continue their studies on their own in a home setting, but there was little practical outlet for their knowledge.

At the beginning of the 19th century the problems hindering women's full educational participation were threefold. First, there were few or no opportunities for college preparatory training; second, colleges did not admit women as students; and third, there was no opportunity for advanced or professional training. Even if a woman was able to overcome these obstacles, she met even tougher ones in attempting to practice in the professions.

During the mid-nineteenth century, changes began to take place. As more women sought educational opportunities, female seminaries were established, offering more intellectually rigorous curricula. Very gradually, a few colleges, notably Oberlin and Antioch, both in Ohio, began to open their doors to women. In addition, another movement was underway, one that sought to establish and endow women's colleges comparable in rigor to those for men.

The last educational barriers to fall were at the graduate and professional levels. The second half of the 19th century witnessed the entrance of women into graduate and professional schools, notably in the fields of medicine and law. During this time, the first law school for women only was established in Boston, and several medical schools for women were also founded in northeastern and midwestern urban centers.

In the campaign to make higher education available to women, two basic questions were widely debated. The first concerned the issue of whether college was appropriate for women at all. Many opponents (women as well as men) argued that the rigors of education would damage the delicate female constitution in all aspects: mental, emotional and physical. In addition, such an advanced level of education was seen as both irrelevant and actively detrimental to woman's natural roles as wife

and mother. Indeed, too much education might actually cause women to become discontent with these roles. The excitement of intellectual pursuits would tempt them, not only to mere neglect of these duties, but to actual refusal to assume them in the first place. The survival of the species might be jeopardized. In addition, by venturing outside the home sphere, the educated women could provide a powerful source of competition in the workplace. Clearly, education for women might lead to the disruption of the economic, political and social status quo as it then existed.

The second question about higher education concerned the relative merits of a coeducational versus a single sex institution. There were those arguing economic practicality, who favored the education of men and women side by side. It was cheaper to admit women to men's colleges than to duplicate new and separate facilities for women. Others viewed the co-mingling of sexes in an educational setting as a logical extension of the interaction between women and men that took place naturally in society. Some felt that the presence of women in the classroom would exercise a civilizing effect on the male students.

Opponents of the coed colleges argued that there was a lack of decorum in allowing young women and men to associate so freely with each other. Concern was expressed that the moral character and virtue of the women students would be in jeopardy and that natural feminine delicacy would not survive such rough male contact. Such arguments were considered to be particularly relevant to coeducation in medical school, where the impropriety of allowing coed instruction in a clinical setting was keenly felt.

The debate concerning coed colleges is still alive today. Slightly more than 100 women's colleges are in existence, although the past few decades have seen most men's and many women's colleges go "coed." Often in

an attempt to improve their financial standing, women's colleges admitted men as visiting students or permitted them to enroll in graduate, evening or part-time programs. Other colleges admit women only, but classes, faculty and dormitory facilities are shared to varying degrees with a nearby men's college; Radcliffe and Harvard or Columbia and Barnard are good examples.

Today, women are freely admitted to coed institutions at the undergraduate level, often outnumbering their male colleagues. And many women's (and men's) colleges have reevaluated the merits of their single sex enrollment policies. Studies have been undertaken to evaluate the advantages of each type of institution, in fact. Some educators feel that, in a coed setting, women tend to defer to men, looking to them for leadership in academic and social activities and taking less initiative in classroom discussion. It is suggested that in a women's college, women feel free to assume leadership and to exercise their intellects. Fear that men will find them less attractive because of their intellectual abilities is somewhat defused in an all-female environment. The absence of the opposite sex makes it easier to focus attention on intellectual pursuits.

There is also the opinion that the faculty of a women's college are more likely to be sensitive to women's academic and emotional needs, and more likely to view women as serious students. Some have suggested that the result of education in such a setting is a group of women who will be prepared to seek challenges and be motivated to take active and leading roles in all aspects of society.

The desire to establish an educational setting specifically designed to foster women's personal and intellectual growth is directly related to important issues raised by the growth of women's studies programs. The feminist Adrienne Rich, pointing out that most colleges and universities are dominated by men at both the instruc-

tional and administrative levels, has stated flatly that, "The university is a transmitter of social values and class interests hostile to women."[2] The point is not that the male perspective is wrong (it is only natural that men should teach from a male perspective), but that it is often the *only* perspective taught. Rich points out the danger of women and men automatically accepting the idea of a university as being neutral, genderless, impartial and objective when, in fact, institutions are only as objective as those who run them.

Male bias in the educational setting has manifested itself in several ways. For example, much of the foundation work in many of the so called "people-oriented" disciplines of sociology, history, psychology and anthropology was laid initially by men. Personal stereotypes about the place of women in society and sexual roles have permeated the research efforts of many scholars. History provides a good example. Until fairly recently, historians directed their research efforts toward the study of war and politics, enterprises from which women traditionally have been excluded. Little effort was directed toward understanding the activities in which women participated and contributed. The result of such a perspective would suggest that only men shaped civilization and that women were merely passive bystanders.

Women's studies is increasingly recognized as a valid intellectual discipline. Its purpose—to establish an equal place for women's experiences, values and perspectives in the academic world and to foster an understanding of the relationship between women and men in society—has largely been achieved. Many universities and colleges now offer graduate and undergraduate degrees specifically in women's studies. Other academic departments may offer a specialization in women's issues within particular disciplines. Numerous professional journals focusing on women's studies have been established to serve as forums for these new perspectives and interpretations.

The issue of male bias in the university can be extended to encompass the educational system as a whole. It is of vital importance that women participate as educators at both the instructional and administrative levels to insure that female values and perspectives are given equal priority. While women now make up a sizeable percentage of teachers, men are disproportionately represented at the administrative level where the majority of educational policy is determined. Even when most of the instructional staff is female, the principal is often male. The higher one looks in the administrative hierarchy, the fewer women one sees. Even among the teaching staff, women predominate only at the preschool and elementary levels of education. By high school, the balance has begun to tip in favor of men and at the college level men clearly dominate.

Women have not penetrated to a greater degree in the more advanced levels of teaching and administration perhaps because of the need to take primary responsibility for family and childcare. In consequence, women have not focused their attentions and energies exclusively on their teaching careers. Even at the university level, women may prefer to accept part-time faculty positions in order to accommodate family responsibilities. They remain in positions that require relatively less training and experience than their male collegues.

Part-time study programs are particularly useful to women with family responsibilities or for those who must work in paid employment full-time. They also allow women who have been out of an educational setting for a number of years to reenter gradually.

The maps in this section illustrate a number of aspects concerning women and education.

THE EDUCATED WOMAN

High School Basics

The percentage of persons completing high school is one indicator of a community's attitude toward education. Is education a priority? Is opportunity for education available to all? An examination of persons with high school diplomas can serve as a good overall measure of the level of education in that region.

The first four maps ("High School Ages 25+," "High School 18–24," "Female High School Graduates" and "Male High School Graduates") in this section depict information about male and female high school graduates in two different age groups as of 1980. The colors on the "High School Ages 25+" and "High School Ages 18–24" maps (page 32) compare the percentages and distribution of women high school graduates aged 18–24 and 25+. The 25+ age group includes graduates who completed high school before about 1973, while the percentages for the 18–24 year group represent a more contemporary experience. By comparing these two groups we can get a feeling for changes that have occurred over time.

One immediate observation is that the overall percentage of women graduates has increased over the years: The ranges varied between 52% and 83% for the older group versus 72% and 87% for younger women. The decrease in the range of values (from a 31- to 15-point spread) indicates that the level of educational attainment throughout the U.S. has become more consistent from state to state.

In both maps, the lowest values are concentrated in the South. On the other hand, the distribution of high-value states changed somewhat over time. For older women, the highest percentages were clearly concentrated in the northwestern part of the country: Alaska, Utah, Wyoming, Colorado, Washington, Oregon and Montana topped the list. For the younger age group, the distribution was more scattered. This time, North Dakota, Vermont, Hawaii, Minnesota, Massachusetts, Nebraska and Pennsylvania were out in front. The distribution for the over-25 age group reflects the high priority education for women was given in the western states. The map of female graduates on the facing page points out the states where the greatest relative improvement has taken place. Clearly, the southern and Appalachian states have made great strides. Only Alaska had a negative change in the percentage of women graduates.

It is also interesting to compare differences between men and women. In the older age group, the percentage of men with high school diplomas was usually the same or greater than that for women. Only in some of the northern states (especially the Dakotas) was the situation reversed. The map (page 32) for ages 18–24 shows how times have changed. In every state for that age group, the percentage of women graduates was the same or higher than that for men. Women surpassed men most strongly east of the Mississippi. The male high school graduates map (page 33) shows relative rates of change between men aged 25+ and their younger counterparts. Greatest improvement occurred in the Dakotas and in an area centering roughly on Appalachia while a number of Far West states lost ground. This pattern is somewhat similar to that for female graduates.

The College Experience

At one time, a high school diploma was all that was necessary to get a good job, and education beyond the

THE EDUCATED WOMEN: I. High School Basics

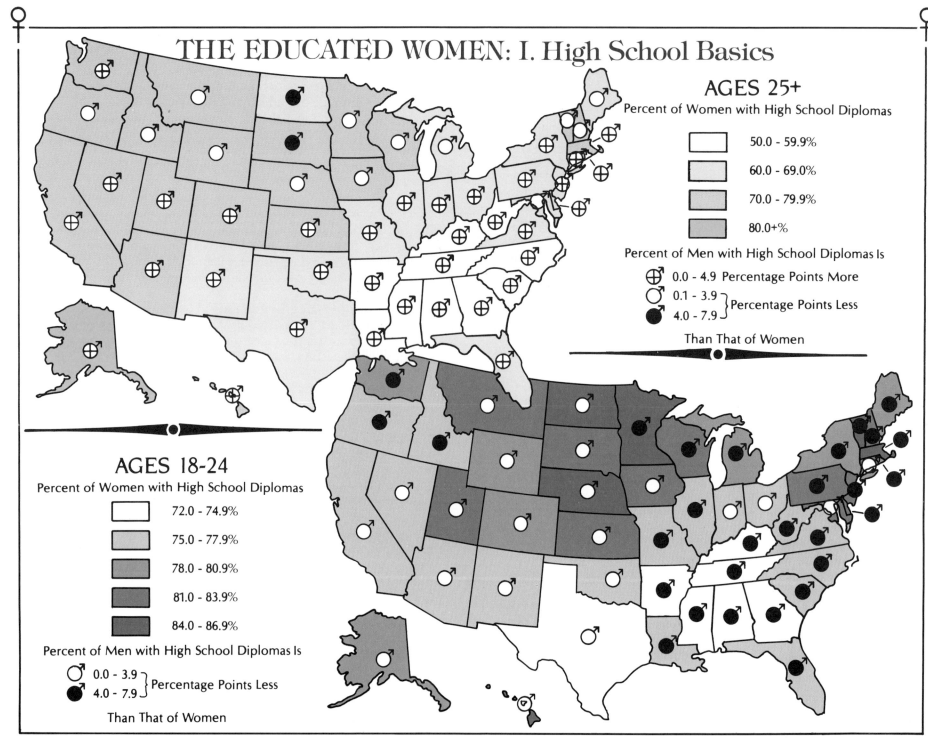

AGES 25+

Percent of Women with High School Diplomas

- 50.0 - 59.9%
- 60.0 - 69.0%
- 70.0 - 79.9%
- 80.0+%

Percent of Men with High School Diplomas Is

- ⊕ 0.0 - 4.9 Percentage Points More
- ◯ 0.1 - 3.9 ⎤ Percentage Points Less
- ● 4.0 - 7.9 ⎦

Than That of Women

AGES 18-24

Percent of Women with High School Diplomas

- 72.0 - 74.9%
- 75.0 - 77.9%
- 78.0 - 80.9%
- 81.0 - 83.9%
- 84.0 - 86.9%

Percent of Men with High School Diplomas Is

- ◯ 0.0 - 3.9 ⎤ Percentage Points Less
- ● 4.0 - 7.9 ⎦

Than That of Women

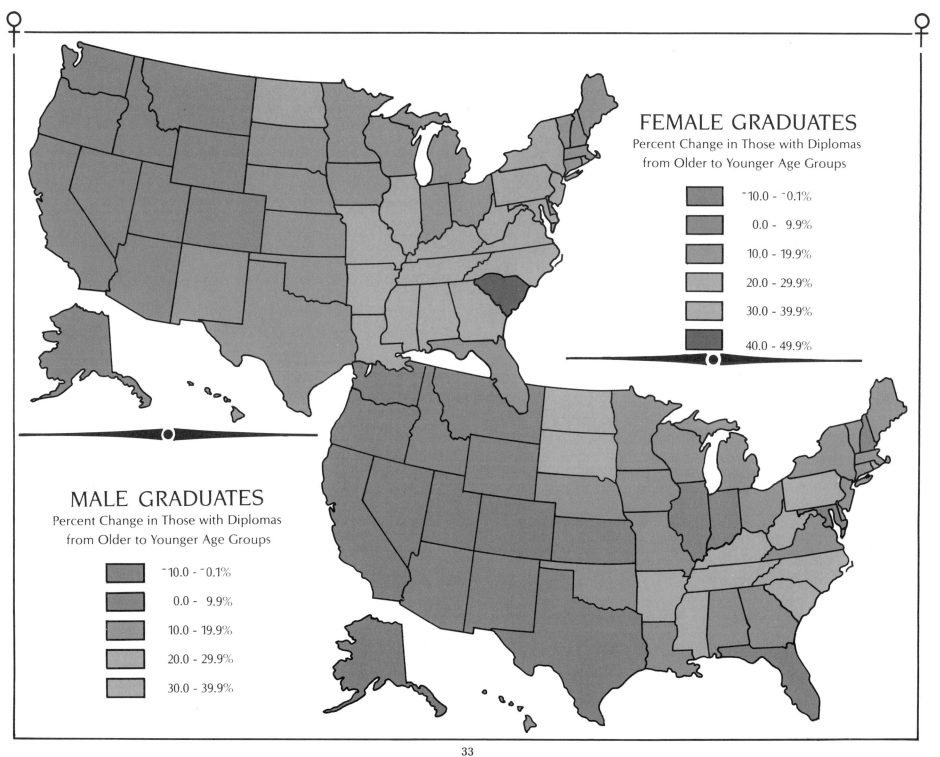

FEMALE GRADUATES
Percent Change in Those with Diplomas
from Older to Younger Age Groups

‾10.0 - ‾0.1%
0.0 - 9.9%
10.0 - 19.9%
20.0 - 29.9%
30.0 - 39.9%
40.0 - 49.9%

MALE GRADUATES
Percent Change in Those with Diplomas
from Older to Younger Age Groups

‾10.0 - ‾0.1%
0.0 - 9.9%
10.0 - 19.9%
20.0 - 29.9%
30.0 - 39.9%

high school level was largely a male preserve. Times have changed. Now it is common for women to have a bachelor's degree, and in many states women students outnumber their male colleagues at this level. This phenomenon was particularly apparent in the Middle Atlantic, northeastern and Far West states in 1980. Only in a few scattered places, Utah, North Dakota, Iowa and Indiana, did male students outnumber female. In about half the states, the split was roughly fifty-fifty.

The distribution of women students in public and private institutions reflects the balance between public and private schools around the country. For example, a relatively large proportion of colleges and universities in the Northeast are privately funded, and it is here that women students are about as likely to be enrolled in private as in public institutions. On the other hand, publicly supported colleges and universities are particularly important in the West, while private institutions are less common. A correspondingly high number of female students (between 90 and 100%) enroll there in the publicly supported colleges because more spaces are available.

As we mentioned earlier, more and more part-time programs are becoming available as both sexes seek to juggle educational needs with family and work commitments. Alaska, California, Nevada and Arizona appear to be the only areas where part-time women students clearly predominated. Some areas, such as that centering on Oklahoma, and a band of states extending diagonally from Michigan to Virginia, seemed to have a roughly equal split between full-time and part-time female students. The Southeast and Northeast are areas where full-time programs were favored. Curiously, many states with a high percentage of full-time female students often had a relatively low ratio of female to male students. Utah, North Dakota, Indiana and Iowa are examples.

The percentages of women with four or more and five or more years of college are presented on the next two maps ("4+ Years of College" and "5+ Years of College"). The second map, "5+ Years of College" is a subset of the first and corresponds very roughly with persons having some sort of graduate education beyond the bachelor's degree. The proportion of women aged 25+ with four or more years of college varied in 1980 from about 9% in Arkansas to a high of 19% in Alaska. (You will recall that Alaska also topped the list for the percentage of women with high school diplomas in that age group.) The range for women with five or more years narrows to between 3% and 8%; however, Arkansas is still the lowest, while Alaska is edged out by Maryland/District of Columbia. On both maps, the high values predominate in the far western and northeastern states. Six states from these two regions, Alaska, Colorado, Hawaii, Connecticut, Massachusetts and Maryland/District of Columbia, appear among the top ten states on both maps. The Appalachian region seems to be a focus for low values, with Tennessee, Ohio, West Virginia and Arkansas appearing among the ten states with the lowest values on both maps.

Included on each map are graduated figures representing the percentage of men with this level of education relative to women. The bigger the symbol, the larger the difference. On both maps, the states with greatest percentage-point difference between the sexes are located in the West and Northeast while states with the smallest differences are concentrated in the South. Superimposing these symbols on the colors gives us an indication of whether there is a correlation between the data for women and the data for men. Indeed, there does seem to be a relationship. The greatest percentage-point difference between men and women occurred in areas where the percentage of women with college educations was the highest. Alaska appears to

II. The College Experience

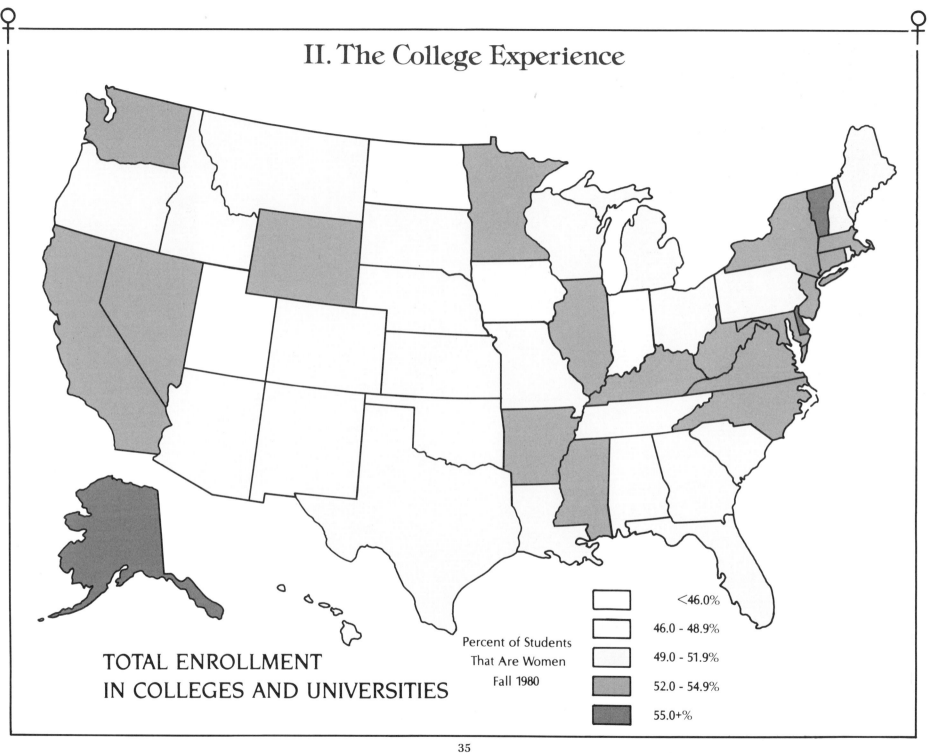

TOTAL ENROLLMENT
IN COLLEGES AND UNIVERSITIES

Percent of Students
That Are Women
Fall 1980

	<46.0%
	46.0 - 48.9%
	49.0 - 51.9%
	52.0 - 54.9%
	55.0+%

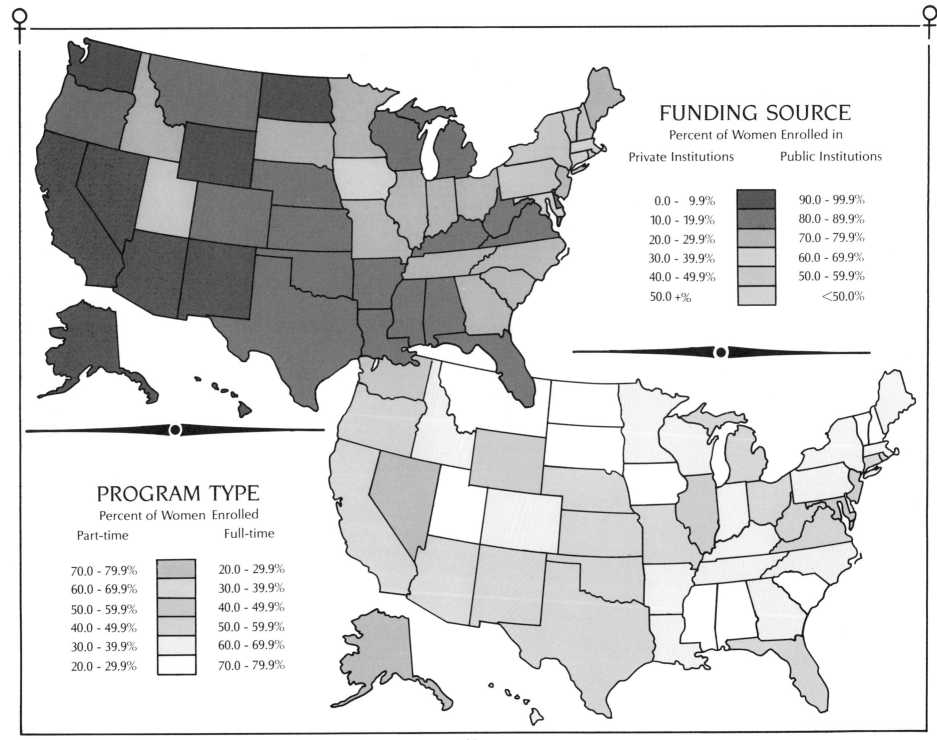

FUNDING SOURCE
Percent of Women Enrolled in

Private Institutions Public Institutions

0.0 - 9.9%	90.0 - 99.9%
10.0 - 19.9%	80.0 - 89.9%
20.0 - 29.9%	70.0 - 79.9%
30.0 - 39.9%	60.0 - 69.9%
40.0 - 49.9%	50.0 - 59.9%
50.0 +%	<50.0%

PROGRAM TYPE
Percent of Women Enrolled

Part-time Full-time

70.0 - 79.9%	20.0 - 29.9%
60.0 - 69.9%	30.0 - 39.9%
50.0 - 59.9%	40.0 - 49.9%
40.0 - 49.9%	50.0 - 59.9%
30.0 - 39.9%	60.0 - 69.9%
20.0 - 29.9%	70.0 - 79.9%

4+ YEARS OF COLLEGE

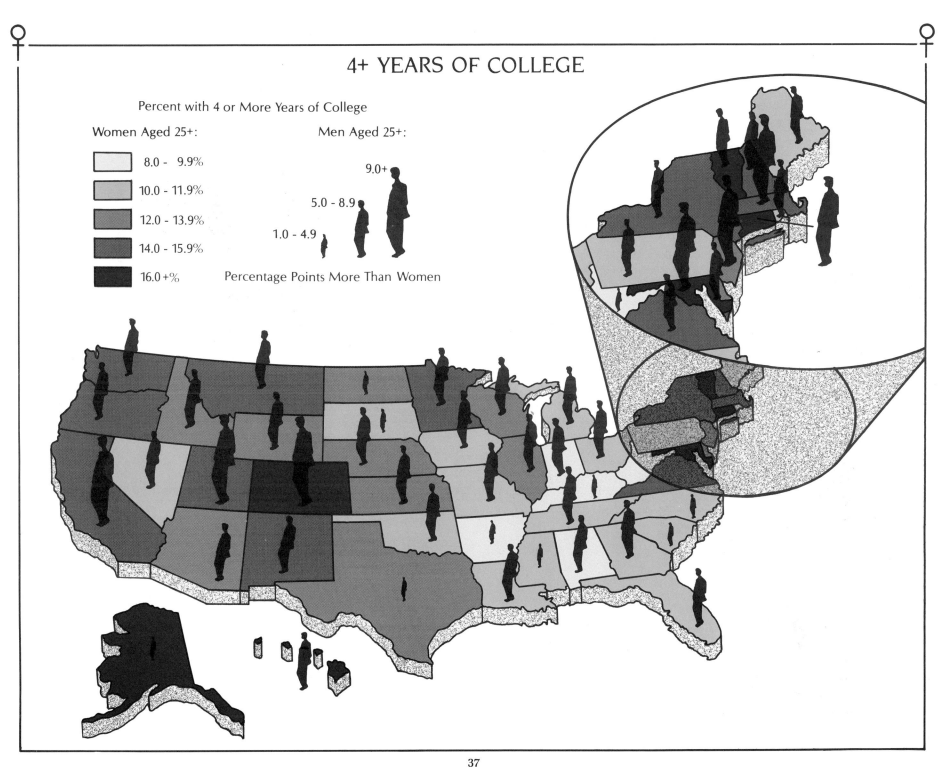

Percent with 4 or More Years of College

Women Aged 25+:

- 8.0 - 9.9%
- 10.0 - 11.9%
- 12.0 - 13.9%
- 14.0 - 15.9%
- 16.0 +%

Men Aged 25+:

9.0+

5.0 - 8.9

1.0 - 4.9

Percentage Points More Than Women

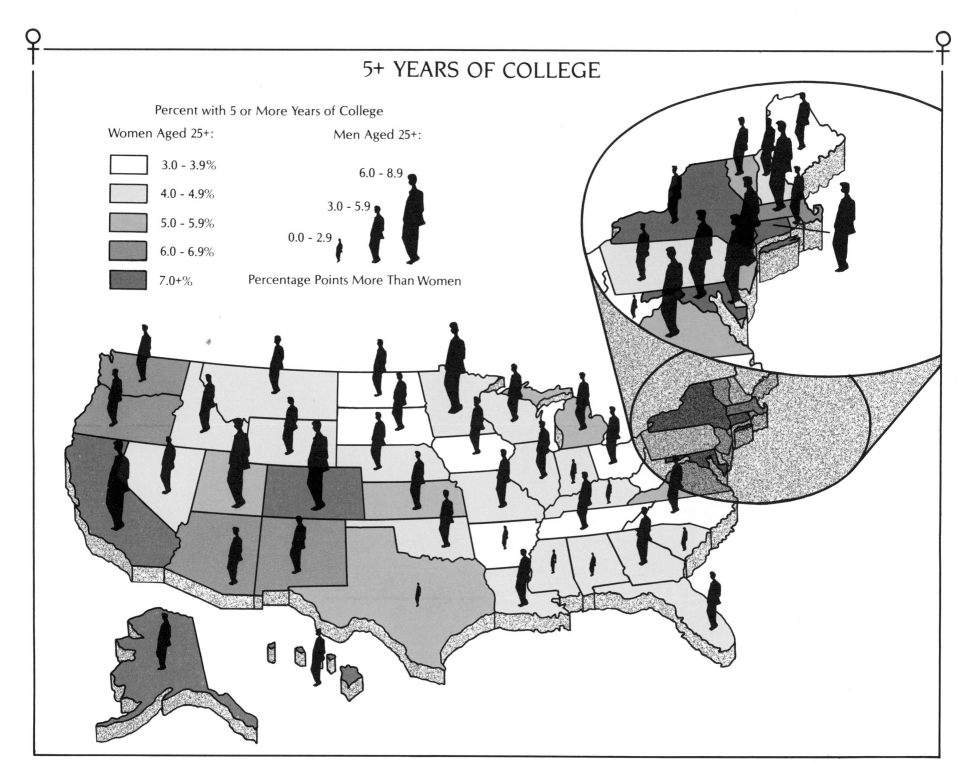

5+ YEARS OF COLLEGE

Percent with 5 or More Years of College

Women Aged 25+:

☐	3.0 - 3.9%
☐	4.0 - 4.9%
☐	5.0 - 5.9%
☐	6.0 - 6.9%
■	7.0+%

Men Aged 25+:

6.0 - 8.9

3.0 - 5.9

0.0 - 2.9

Percentage Points More Than Women

have been an exception. Areas with lower values for women often had a smaller difference in the educational levels of men and women.

Rising to the Top

More specific indicators of the depth of women's educational involvement can be found by examining women's participation in advanced degree and professional programs. The chart on the "Doctoral Studies" map shows that as of 1980–81, women still concentrated their efforts in the fields of education, social sciences and the humanities. However, it is encouraging to see that over 20% of women's doctorates were earned in the traditional male fields of engineering, physical and life sciences. The actual state-by-state distribution showing the ratio of female to male doctoral recipients must be regarded with caution when drawing any conclusions about larger regional patterns. The total number of doctoral recipients, both male and female, is relatively small, ranging from a low of two in Alaska to a high of 3,800 in California. Only in states with a fairly high total is the sample size large enough to be a useful predictor of trends in that state. Alaska had no female doctoral recipients that year, but if just one of the two had been a woman, it would have held the all-state high with 50%! It's also important to remember that these statistics indicate the number of students actually receiving their degrees during that period, not the total number currently enrolled in doctoral programs.

While keeping these cautions in mind, it is still possible to form some tentative generalizations. The highest ratios of female to male doctoral recipients were concentrated east of the Mississippi, and included only a few states (Tennessee, Alabama, North Carolina and Ohio), which fell at the low end of the scale in regard to women with 4+ and 5+ years of college. With the exception of New York, the five states handing out the largest total number of doctoral degrees (California, New York, Massachusetts, Illinois and Texas) all had women receiving slightly less than one-third of all degrees.

The maps of "Medical School Enrollment" and "Law School Enrollment" focus on 1980–81 enrollment in top professional fields traditionally dominated by men. For medical school, the highest ratios of female to male students were concentrated in the Northeast and Southwest while women were poorly represented in the Dakotas and the Deep South. On average, women made up a larger percentage of students enrolled in law school. Three states (Colorado, New Mexico and Maine) topped the list with over 40% of those students enrolled being female. On both maps, Utah, Alabama, Mississippi, Arkansas, North and South Dakota were among the eight states with the lowest female to male ratios. Utah ranked lowest in both cases.

A Rising Consciousness

In 1984 there were slightly over 100 women's colleges in the United States, approximately three-quarters of which offered four-year degrees. The number of these institutions has been declining during past years as more women's colleges have become coed. The 'Women's Colleges" map shows the location of each college, classifying it in accordance with its enrollment size and type of program (two-year or four-year). Women's colleges clearly predominated in states along the eastern seaboard and also in the Midwest. The majority of states west of the Mississippi have no women's colleges at all. With the exception of two colleges, one in Texas and the other in Minnesota, the largest women's institutions (measured according to 1980–81 enrollment) were

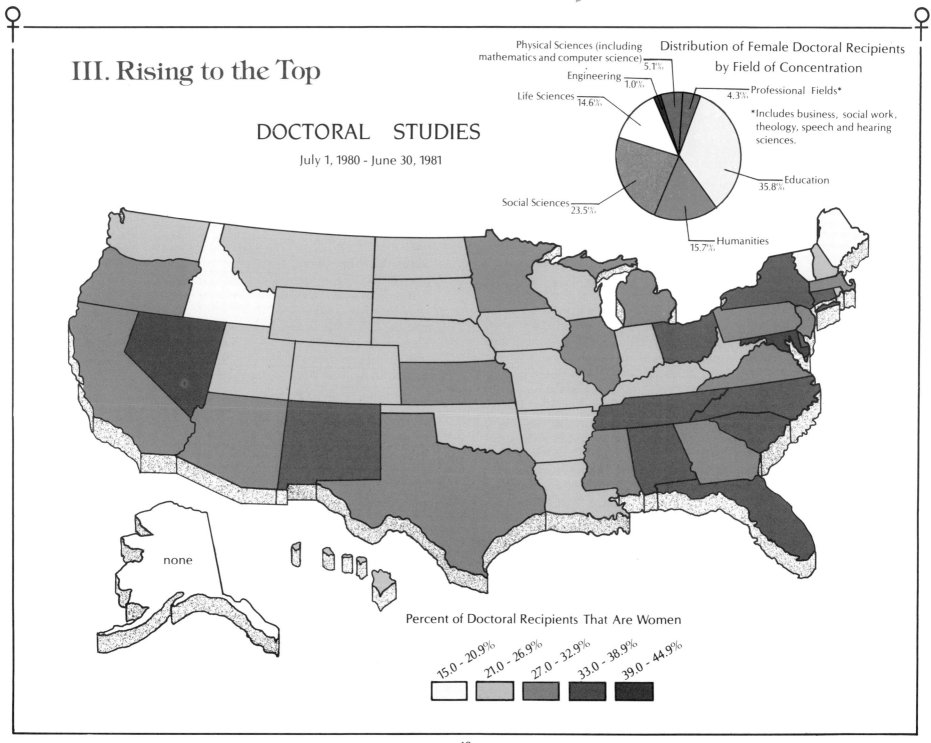

III. Rising to the Top

DOCTORAL STUDIES

July 1, 1980 - June 30, 1981

Distribution of Female Doctoral Recipients by Field of Concentration

Physical Sciences (including mathematics and computer science) 5.1%

Engineering 1.0%

Life Sciences 14.6%

Professional Fields* 4.3%

*Includes business, social work, theology, speech and hearing sciences.

Education 35.8%

Social Sciences 23.5%

Humanities 15.7%

Percent of Doctoral Recipients That Are Women

15.0 - 20.9% 21.0 - 26.9% 27.0 - 32.9% 33.0 - 38.9% 39.0 - 44.9%

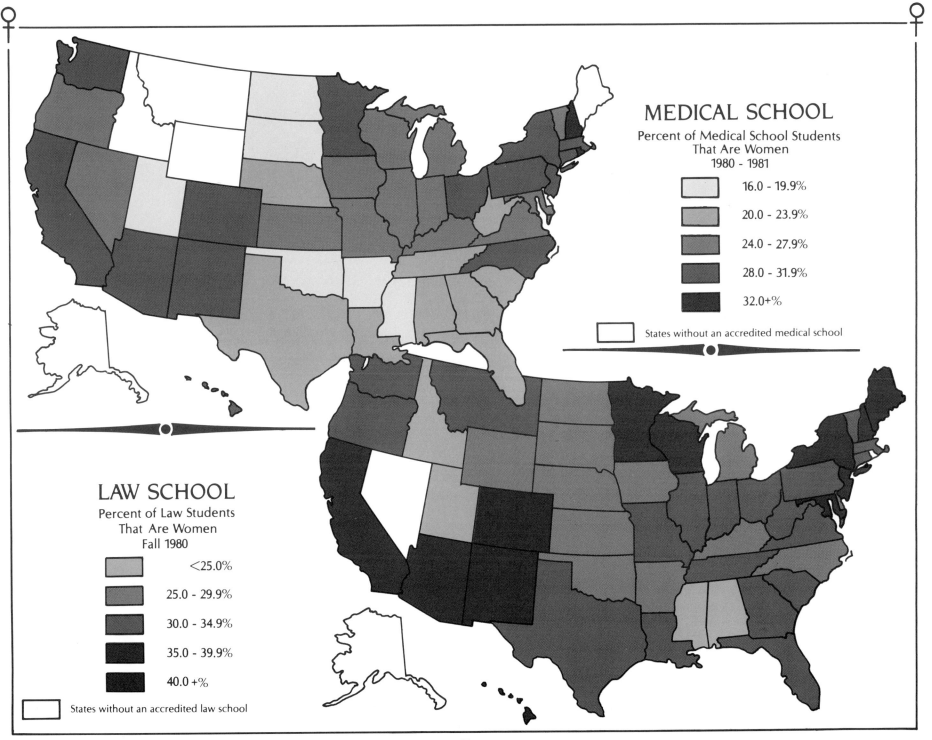

MEDICAL SCHOOL

Percent of Medical School Students
That Are Women
1980 - 1981

16.0 - 19.9%

20.0 - 23.9%

24.0 - 27.9%

28.0 - 31.9%

32.0+%

States without an accredited medical school

LAW SCHOOL

Percent of Law Students
That Are Women
Fall 1980

<25.0%

25.0 - 29.9%

30.0 - 34.9%

35.0 - 39.9%

40.0 +%

States without an accredited law school

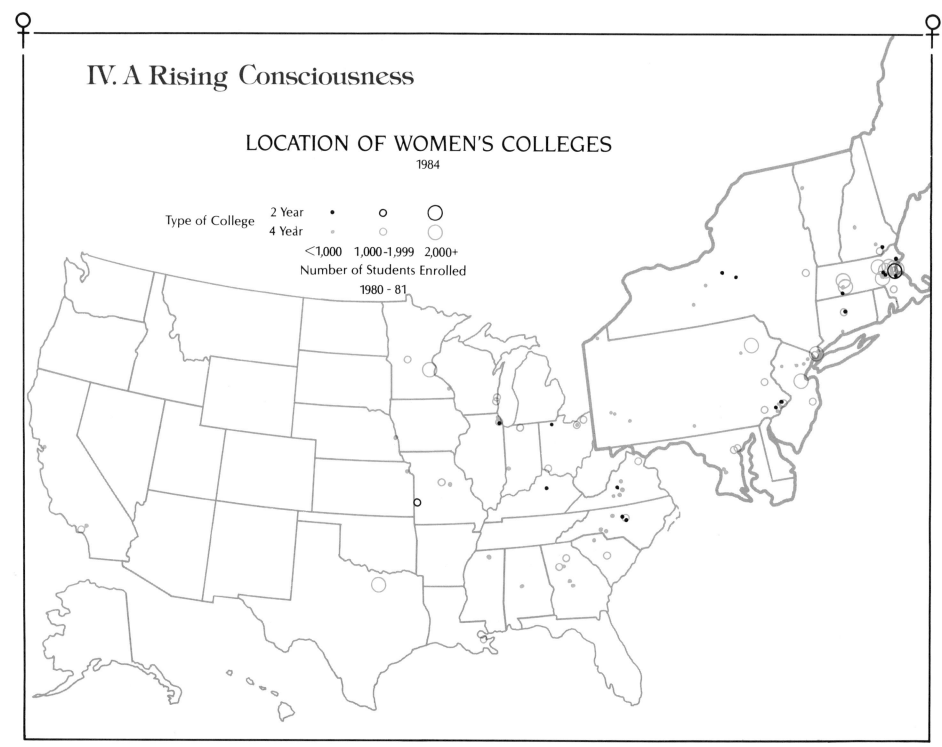

IV. A Rising Consciousness

LOCATION OF WOMEN'S COLLEGES
1984

Type of College 2 Year • ○ ◯

4 Year

<1,000 1,000-1,999 2,000+

Number of Students Enrolled

1980 - 81

found in four northeastern states: Pennsylvania, New York, New Jersey and Massachusetts.

Over 200 colleges and universities now offer a bachelor's or graduate degree in some aspect of women's studies. (Our "Women's Studies Programs" map does not include all the institutions that offer certificate programs, associate's degrees or minors in women's studies.) Most of the schools are in the Northeast, Midwest and California. Such programs appear especially popular in urban areas: Los Angeles and San Francisco in the West, Chicago in the Midwest, and Boston, New York and Philadelphia in the Northeast. Several states do not appear to offer any programs at all at this level.

THE EDUCATING WOMAN

Role Models in the Classroom

It is important not only to look at women as students, but also as educators. We conclude with several maps ("Elementary School Teachers," "Secondary School Teachers," "Post-Secondary Faculty," "School Principals" and "Women Presidents of Colleges and Universities") showing women in teaching and administrative positions.

Teaching was one of the first professions open to women. It is not surprising therefore to find that, in 1980, women were well represented as teachers at the elementary and secondary levels. Some very strong regional patterns emerge for this data. Most noticeable is the high ratio of female to male teachers in the Deep South and Appalachia. In fact, there is a very high correlation between the percentage of women elementary and secondary school teachers in 1980. The most noticeable difference between the two sets of data is the

difference in their ranges. Between 71% and 95% of elementary school teachers were women as opposed to 33% and 64% for secondary school.

Continuing to look at women faculty at the college level, one notices the range of values has decreased further. Clearly, as the age of the student body rises and the required depth of subject knowledge increases, the ratio of female to male instructional staff declines. The South and Middle-Atlantic states continued to lead the way with Mississippi being the only state where more than one-third of the college faculty was female in 1981. The Rocky Mountain and northern Plains states had the lowest percentages of female faculty. Almost 90% of women professors were White. The small graph accompanying the map of post-secondary education shows how the remaining female faculty were distributed among several racial minorities.

Leaders in Administration

Remember being sent to the principal when you were in grade or high school? How often was the person occupying that office a woman? In 1980 for the country as a whole, there was a one out of six chance that the principal would be female. Those odds increased to about one out of three in Maryland, while in Utah it was a mere one out of 16. In fact it would be rare indeed if your principal was a woman in Maine, Pennsylvania, Indiana, Minnesota, North Dakota, Utah, Iowa and Kansas. In those states the ratio of female to male principals was less than one in 10. The southern states no longer ranked consistently high as they had with women teachers.

Almost 250 colleges and universities in the United States had a woman president in 1983, constituting less than 10% of all presidents. About 60% were heads of

four-year schools. Although most of these institutions had enrollment sizes of less than 2,000 students, several major colleges and universities with more than 10,000 students had a woman as president. As with women's colleges and women's studies programs, women presidents were concentrated in the Northeast, Midwest and California.

The past years have shown women to be gaining parity in their pursuit of education. Great strides have also been made for women as faculty and educational administrators. As women's level of education increases, so does their visibility in the work force. That increased level of participation will be the subject of the next section.

WOMEN'S STUDIES PROGRAMS

1984

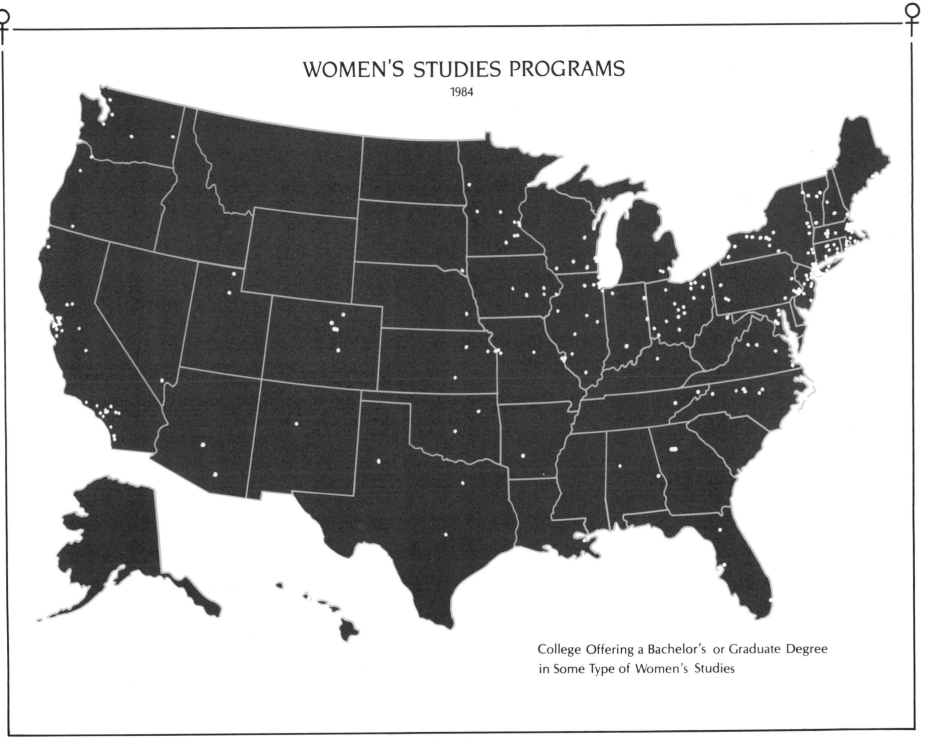

College Offering a Bachelor's or Graduate Degree
in Some Type of Women's Studies

THE EDUCATING WOMAN: I. Role Models in the Classroom

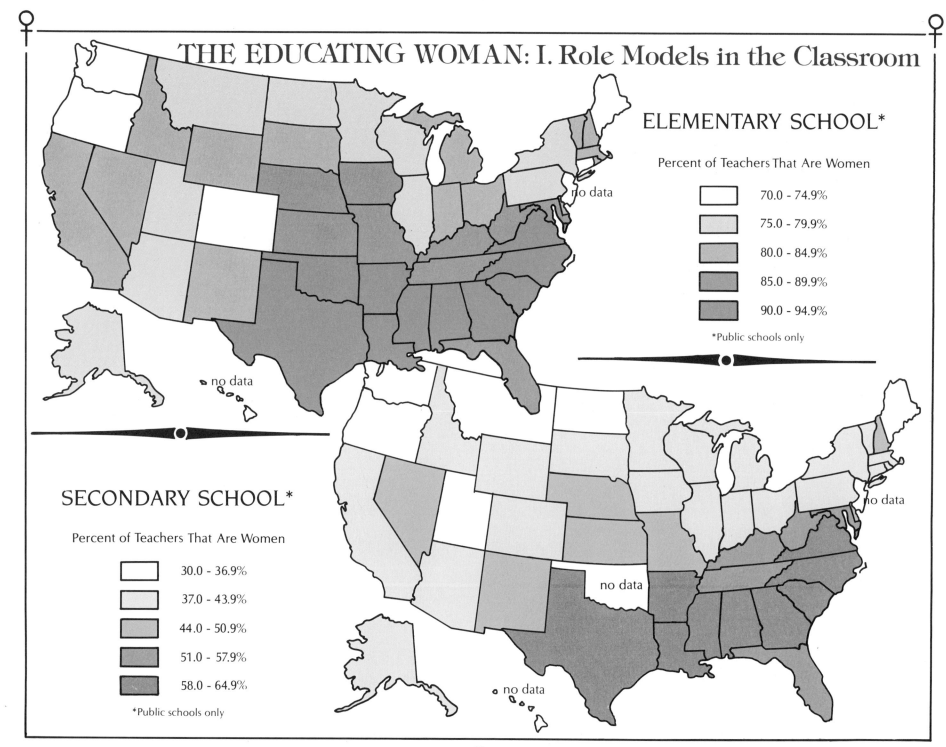

ELEMENTARY SCHOOL*

Percent of Teachers That Are Women

- 70.0 - 74.9%
- 75.0 - 79.9%
- 80.0 - 84.9%
- 85.0 - 89.9%
- 90.0 - 94.9%

*Public schools only

no data

SECONDARY SCHOOL*

Percent of Teachers That Are Women

- 30.0 - 36.9%
- 37.0 - 43.9%
- 44.0 - 50.9%
- 51.0 - 57.9%
- 58.0 - 64.9%

*Public schools only

no data

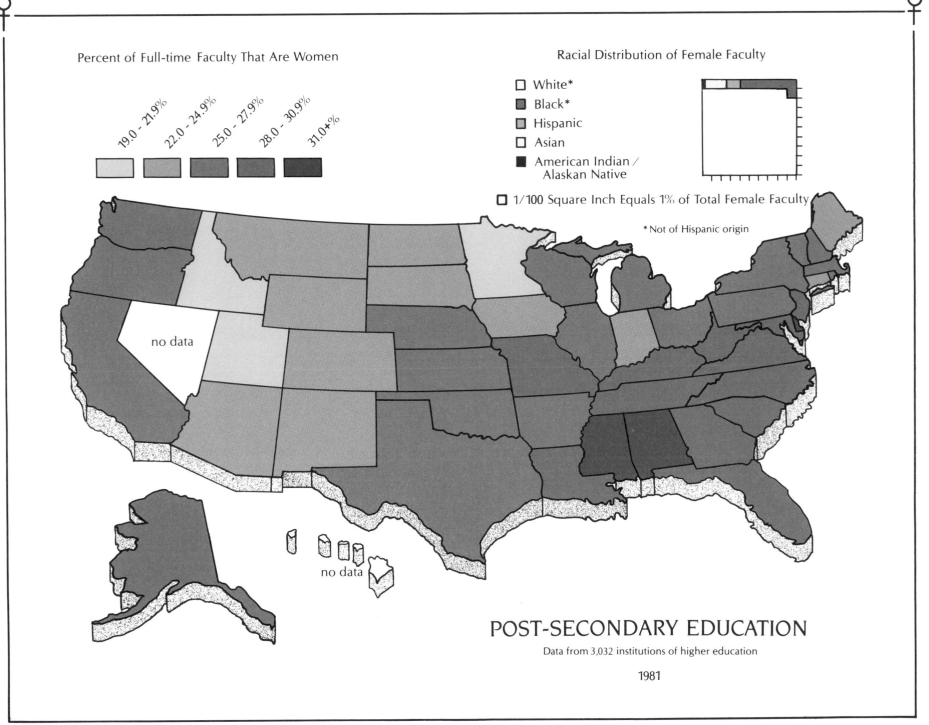

Percent of Full-time Faculty That Are Women

19.0 - 21.9% 22.0 - 24.9% 25.0 - 27.9% 28.0 - 30.9% 31.0+%

Racial Distribution of Female Faculty

☐ White*
◼ Black*
◼ Hispanic
☐ Asian
◼ American Indian / Alaskan Native

☐ 1/100 Square Inch Equals 1% of Total Female Faculty

* Not of Hispanic origin

no data

no data

POST-SECONDARY EDUCATION

Data from 3,032 institutions of higher education

1981

II. Leaders in Administration

SCHOOL PRINCIPALS*

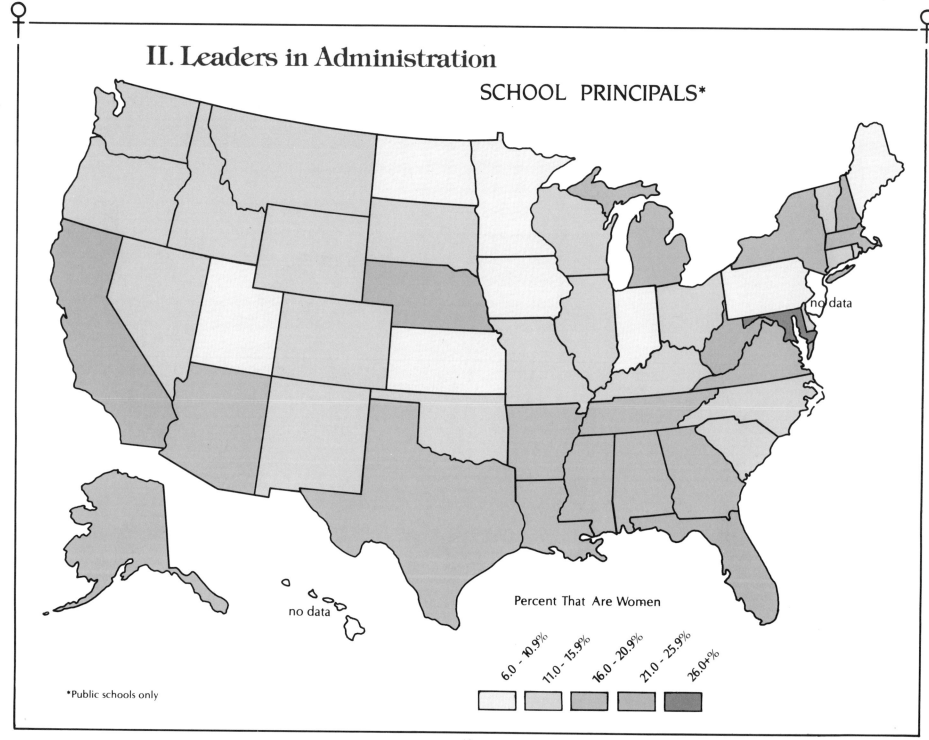

no data

no data

Percent That Are Women

6.0 - 10.9% 11.0 - 15.9% 16.0 - 20.9% 21.0 - 25.9% 26.0+%

*Public schools only

WOMEN PRESIDENTS OF COLLEGES AND UNIVERSITIES

December 31, 1983

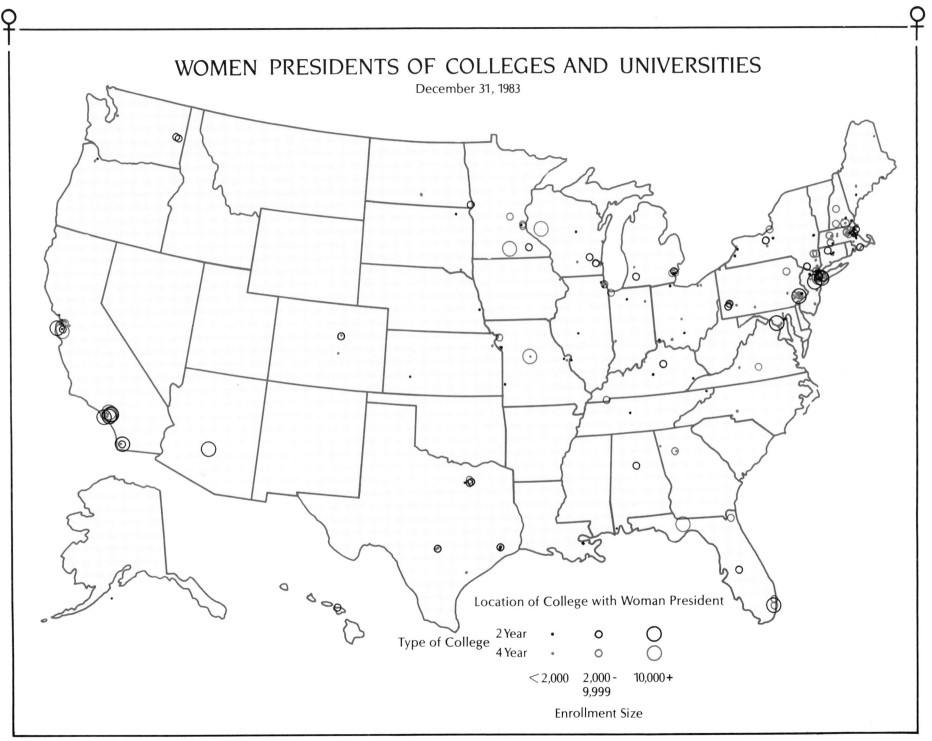

Location of College with Woman President

Type of College 2 Year • ○ ○
 4 Year · ○ ○

<2,000 2,000 - 10,000+
 9,999

Enrollment Size

EMPLOYMENT

"But what's more important. Building a bridge or taking care of a baby?" [1]

—June Jordan

"There is men's work and there is women's work."
"The women's task is to raise children and manage the home, while the men provide economic support."
"Men produce, women reproduce."
"Women do not have to learn a skill because someone else will support them."
"Women work outside the home because they want to, not because they have to."
"Homemaking and childcare are not really work."
"In past times, women rarely worked outside the home."

These are some of the stereotypes about women and work which scholars are now reexamining. Such stereotypes can be misleading for a variety of reasons, mostly because they create inaccurate pictures of the contributions of women and men and of what has been the norm for social roles and behavior. Stereotypes can also be used as a rationale for paying women less, for skimping on their educational training, and for discriminating against them in the workplace.

It is incorrect to believe that, in the past, women's activities have always been confined to keeping house and supervising children. Prior to the industrial revolution, agricultural production provided the main source of employment: women in Western society participated actively in agricultural and local craft economies. Bringing their children with them or leaving them with kin, women worked in the fields and small family gardens. They tended livestock and worked with male relatives in small, family-owned businesses and shops. In a time when most people lived on the edge of subsistence, every hand was needed to produce enough to feed, clothe and shelter the family.

In the home itself, women prepared and preserved food, did the cleaning and laundry, made clothing, served

as nurse and supervised the children. Even now, in some depressed regions of "modern" Western countries, women still provide agricultural labor. And in Third World countries, which contain three-quarters of the world's population, some sources estimate that rural women produce more than half the food.[2] Somewhere between one-quarter and one-third of the world's families are supported by women.[3]

In the pre-industrial West and in many contemporary pre-literate societies, women's active participation in the economic life of the community was possible—and necessary—for several reasons. First and foremost, the home and worksite existed in close proximity, allowing women to supervise children and participate in economic tasks at the same time. Second, much of what the family needed to survive was produced by the family rather than purchased from an outside supplier. For any member of the family not to assist in production-related activity was a luxury most could not afford. Third, in a non-specialized, non-technological society, the skill levels of many tasks were such that long periods of training were not required. A rigid distinction was not drawn between family and economic life; rather, the two spheres were integrated.

The industrial revolution, with its emphasis on specialization and the production of consumer goods for mass markets, changed the nature of work and the way it was portioned out. With the establishment of factories as centers of production outside the family home, the location of the home and worksite were no longer the same. The woman's role as a mother became alienated from her role as a provider. As labor moved from the home and local village to the factory, it was no longer possible for women to participate in economic activity and supervise children, unless mothers were able to find some kind of paid work that could be done at home.

Whenever economically feasible, women stayed home to tend the children while men went to the worksite. As the 19th and 20th centuries progressed, the productive (as opposed to reproductive) role of women was eroded. The new factories became the centers for many of the once home-based production activities. Where once women had provided important goods to their families, husbands now purchased these goods "ready-made."

Women then had to choose between supervising their children and contributing to the economic support of their families. Society decreed that their primary responsibility was the former. Unfortunately, for a large number of women, that choice was unrealistic. Wages were so low and times so hard that, even in the relatively prosperous United States, many mothers were forced to find paid employment.

Large numbers of single women and widows, contrary to another popular Victorian myth, could not count on having fathers, brothers or sons to provide for them, and husbands of many married women simply were not able to earn enough to cover expenses. The 1850 Census estimated that over 250,000 women worked in factories alone, with the figure approaching one-third of a million 20 years later.[4] By 1900, about 20% of women 14 and older were in the paid labor force.[5]

Women's work was hardly frivolous. It is difficult to imagine anyone choosing to spend 10 to 12 hours per day, six days a week, in a noisy, poorly ventilated factory or shop. Many, if not most, of these women might well have traded these poor working conditions for full-time homemaking if they had had the economic means to do so. And yet there are indications that at least some of these women savored, if not the work itself, at least the sense of self-sufficiency it brought. Many of the women who worked in the Lowell, Massachusetts mills in the 19th century felt a new sense of pride in their

independence and ability to send money to their families.

With the emergence of a healthy middle class, some women gained freedom from economic want and were expected to remain in the home to devote their full energies to the care of children, spouse and other family members. Many women found the continuous, unrelieved round of housekeeping and childrearing unsatisfying, yet the stigma against women working in paid employment—something only poor women did—eliminated employment as an alternative to develop other talents and abilities. Instead, these women looked beyond their front doors and saw a host of social problems needing the attention of concerned people. Some women volunteered their time to charitable work and various reform causes. Abolition and temperance were especially popular in the mid-19th century. A few of the more daring worked for women's suffrage. Many devoted themselves to these goals on an almost full-time basis, although they did not receive any financial remuneration and therefore weren't really "working." Other women attempted to move into professional fields, meeting with various degrees of resistance and success.

By the 1950s, new labor-saving devices had completely redefined the tasks—and status—of homemakers. No longer were women expected to preserve food, weave cloth and make clothes. They were now consumers, not producers. Mandatory public education relieved mothers of childcare responsibilities for at least part of each day. And middle class wives suffered from, in Betty Friedan's words, the "problem that had no name."

Women today are entering the paid workforce in record numbers. What is new since World War II is not so much that single and poor women are working, but that married, middle class women are in the labor force.[6] In 1950, about 34% of all women ages 16 to 64 were in the labor force. By 1980, that figure had risen to 52%,[7] constituting about 42% of the total labor force.[8] Even more dramatic are the figures for women with children. In 1950, only 12% of women with children under six were in the labor force; by 1982, the figure was 50%.[9] Married women with husbands present have also shown a significant increase in labor force participation, from 24% in 1950 to 51% 30 years later.[10]

Despite the influx of women into the paid labor force, women have tended to work in traditionally female occupations. In the 19th century, many women worked in factories, as seamstresses and as domestic servants. In the late 19th and early 20th centuries, teaching and clerical occupations became female domains. By 1981, 66% of employed women were engaged in white collar jobs, including 17% as professional and technical workers, 7% as managers and administrators and 7% and 35% in sales and clerical positions, respectively. Fourteen percent of working women found blue collar jobs, but only 2% in skilled trades specifically and 10% as operatives. Service work accounted for the jobs of 20% of working women. By contrast, far fewer men were engaged in lower-paying service and clerical work (only 6% and 9%, respectively) concentrating instead in the higher-paying skilled blue collar trades (21%). Fifteen percent of male workers were managers and administrators, twice the figure for women.[11]

These statistics show that more than half of female workers were employed in clerical and service work. These were the only major occupational categories where the number of women employed exceeded that of men. The ten jobs employing the highest numbers of women in 1981 were secretary, bookkeeper, sales clerk (retail), cashier, waitress, registered nurse, elementary school teacher, private household worker, typist and nursing aide.[12] Some professional areas where women have made substantial inroads include accounting, pharmacology,

computer science, banking and financial management. All these areas are no longer considered non-traditional for women since more than 25% of those employed in each field are now female. Women are also a presence now in law, medicine and engineering, although they still, at less than 20%, constitute a distinct minority. Women are increasingly owning their own businesses. The 1977 Census of Women-Owned Businesses counted over 700,000 businesses owned by women, 7% of all businesses.[13] Many women have chosen to start home-based businesses that allow them to work at home while supervising their children.

For a number of reasons, female workers still earn considerably less than their male counterparts. Equal pay for equal work was an issue over 100 years ago, when women started joining trade unions in an attempt to achieve more equitable working conditions. Today, family responsibilities mean that women are much more likely to work part time than men. Women's employment history is more intermittent as they leave the workforce periodically to bear and raise children. These obligations mean that it takes women longer to put in the time and experience necessary to qualify for higher-paying positions.

It was estimated that in 1981, 29% of men but only 17% of women had 10 or more years of work experience.[14] The Census Bureau estimated that in 1980, about one-third of employed women worked less than 35 hours per week.[15] But even comparing the earnings of men and women who worked full time, year round, women were still found to earn only about 60% of men. The median earnings for men employed full time, year round in 1979 was over $18,000, while that for women was only about $11,000.[16]

The wage gap has been fairly constant over the past 30 years. Even recently, many women still feel less of a need to pursue job training seriously, especially if they plan to marry. This attitude, combined with family commitments, means that women stay in low-paying clerical and service occupations. These types of employment are more suited to part-time schedules and are easier to return to after a period of several years out of the paid workforce. Studies suggest that even after equalizing for differences in training, experience, age, etc., there still exists a gap between men's and women's earnings that can only be attributed to discrimination in the workplace.[17]

Women of all ages in 1980 were much more likely to live in poverty than were men: 27% versus 17%.[18] Of persons 15 and older, women made up almost two-thirds of those living in poverty, with a rate of 14% for women contrasting with 10% for men.[19] A number of factors have combined in recent years to produce the phenomenon now referred to as the "feminization of poverty." The disparities in pay and employment history mentioned above put women at a financial disadvantage. Not only do many traditional women's jobs pay poorly, but they are also much less likely to offer important fringe benefits such as health insurance and pension plans.

Women today are increasingly likely to be totally responsible for their own financial support. Two types of women are especially vulnerable. The first are those with children but no husband present, accounting for almost half of all families in poverty.[20] In 1981, about one-third of such women and their families lived in poverty, as compared with only 11% of male-headed families, no wife present, and 6% of married couple families.[21]

The increase in out-of-wedlock births and in the divorce rate means that many more women are responsible for the sole support of their children than before. Young teenage women with babies have not completed the training and education necessary to get a good job. Divorced women who have been full-time homemakers must try to enter the job market in middle age with few

translatable skills. Even with training and experience, the lack of affordable and readily available childcare means that many mothers are forced to rely on public assistance for all or part of their income. The 1985 monthly AFDC grants for a woman with two children ranged from a low of $96 in Mississippi to a high of $719 in Alaska (a figure far in excess of that of most other states due to Alaska's high cost of living).[22] Nor can women count on receiving child support even if they are eligible for it.

The other group of women particularly likely to be living in poverty are those over 65. In 1981, a full 72% of poor persons 65 and over were women. The rate for all women 65+ was 19%, eight percentage points higher than the rate for men.[23] For retired persons, two important sources of income are pensions and social security. Fifty percent of women working in 1980 were in jobs without pension plans.[24] Even when pension plans are available, a woman's greater tendency to leave and reenter the workforce periodically makes her less likely to meet age and tenure requirements. The result is that about 90% of women retire without a pension from their jobs.[25]

Married women cannot always rely on their husbands' pensions being transferred to them upon the husbands' deaths. And social security benefits—calculated against tenure in the workforce and average earnings—are less for women than men, since women tend to work in the paid labor force for shorter periods of time and at lower salaries. As of 1983, if a woman was divorced before she had been married 10 years, she was not entitled to any benefit from her ex-husband's social security. If she did not have a paid job during that time, she had not built any equity in the retirement system. When a homemaker and her husband retire (for those relying on social security), she qualifies for a benefit of one-half her spouse's until he dies.

The recognition that sex-based discrimination has contributed to women's lower earning rate has resulted in legislation at both the federal and state levels prohibiting sex discrimination in both employment and pay. Types of employees covered vary from state to state. The 1963 Equal Pay Act (with later amendments extending its coverage) was the first federal law to prohibit discrimination in pay on the basis of sex. Some states have enacted their own equal pay laws (Michigan and Montana were the first in 1919) or included equal pay provisions in minimum wage laws. Other states prohibit sex-based discrimination in pay through the use of broader fair employment practices and civil rights laws.[26] Title VII of the 1964 Civil Rights Act prohibits discrimination in employment based on sex and is applicable to public and private companies with 15 or more employees. A number of states have enacted their own laws, lessening the number of employees in private establishments required for coverage.

WORKING WOMEN

Leading off this section are two maps showing the participation of women in the labor force in 1980. The Census Bureau has defined the labor force to include those persons aged 16 or older who are currently employed or actively looking for work. Armed forces personnel are included, but students, housewives and househusbands are not. The first map displays the percentage of the total labor force that was female in each state in 1980. While the range of values is narrow, from a low of 37% in West Virginia to a high of 45% in Maryland/District of Columbia, the distribution is marked. The female to male ratio is highest in the states along the eastern seaboard from Florida to New Hampshire. Low

WORKING WOMEN
LABOR FORCE* PARTICIPATION

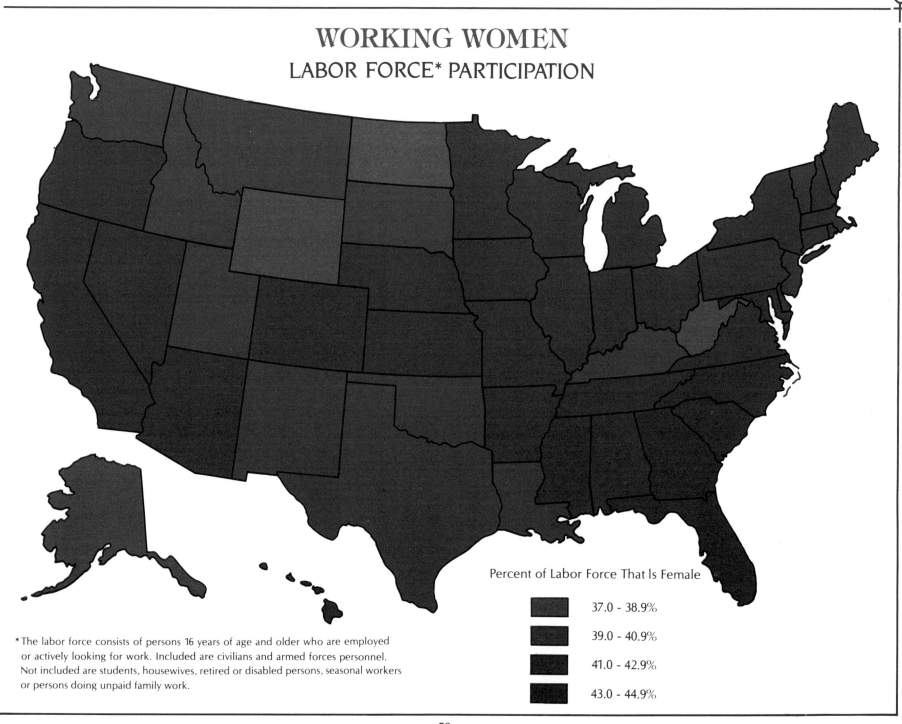

Percent of Labor Force That Is Female

	37.0 - 38.9%
	39.0 - 40.9%
	41.0 - 42.9%
	43.0 - 44.9%

*The labor force consists of persons 16 years of age and older who are employed or actively looking for work. Included are civilians and armed forces personnel. Not included are students, housewives, retired or disabled persons, seasonal workers or persons doing unpaid family work.

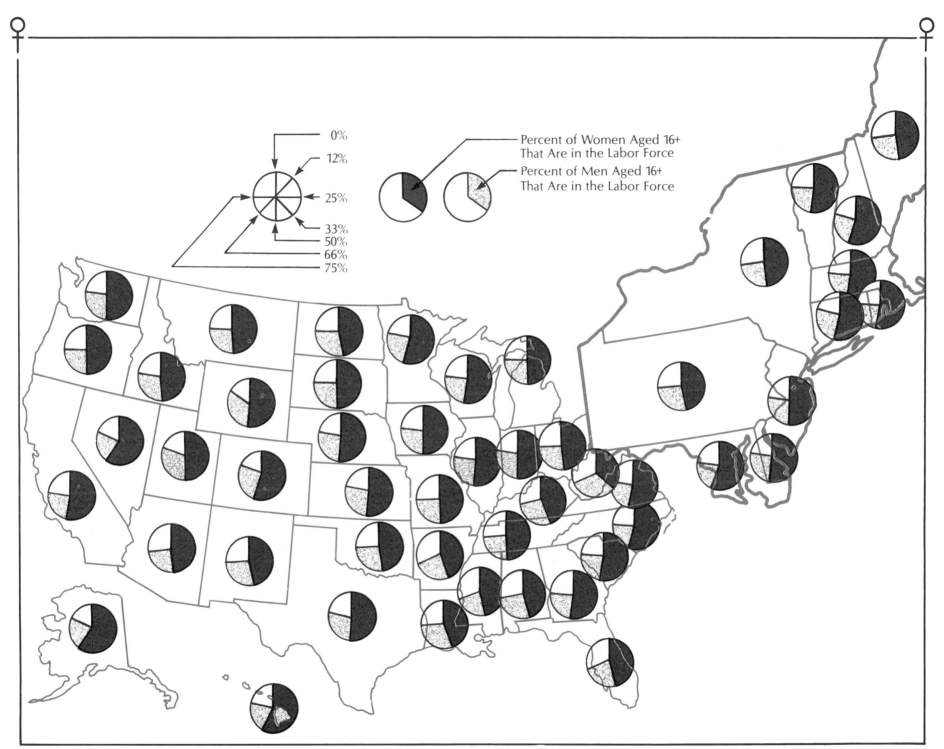

0%
12%
25%
33%
50%
66%
75%

Percent of Women Aged 16+
That Are in the Labor Force

Percent of Men Aged 16+
That Are in the Labor Force

ratios are concentrated in Alaska, Appalachia and the northern Plains/Rocky Mountain region. It appears that this may simply reflect the ratio of women to men in each state as a whole. For example, out of the 12 states in which women make up the smallest percentage of the labor force, nine are states with among the lowest female to male ratios in the total population.

The map on the facing page makes possible two types of comparisons. The "pie" can be used to represent either the total number of men *or* women 16 years of age and older. The pattern represents the percentage of all men 16+ who are in the labor force, while the red tint presents that information for women. Thus, one can examine labor force participation for men or for women. In addition, one can compare the difference in participation rates between the sexes. The map shows clearly that participation rates for men exceeded those for women. Between 67% and 83% of all men 16+ were in the labor force, while for women the range fell to between 36% and 61%. It does seem that states with high participation rates for one sex often had a high percentage of the other sex in the labor force. Note that Florida had a low rate of labor force participation for both men and women. This may be due in part to the large number of retirees in that state.

How does the percentage of women who work compare with that of men? The gender gap appears narrowest in several widely scattered states. In Hawaii, Nevada, Florida, Maryland/District of Columbia and North Carolina the difference between men and women is only about 20 percentage points. The gap appears widest in several Rocky Mountain (Idaho, Utah, Wyoming, North Dakota) and Appalachian states (West Virginia, Kentucky, Ohio) and Louisiana.

Women in the home have two types of responsibilities: as homemakers, and, for those with children, as mothers. As the need for two incomes increases and as more women seek careers in the marketplace, the percentage of wives and mothers entering the workforce has also increased. Two maps are presented, "Working Mothers" and "Working Wives," the first displaying information about mothers (married or unmarried) working inside and outside the home, while the second provides similar information for all married women, whether or not they have children.

The map of working mothers focuses specifically on women with children under 6 years of age. The highest percentages of such women working outside the home (values of 52% or more) are clearly clustered in the Deep South. This region, along with South Dakota, was the only one where this percentage exceeds the percentage of *all* women 16+ who work. In other words, in those states, it was more likely for a mother with children under six to be working outside the home than it was for women as a whole. There are several areas, the Plains states, around Maryland, several southern states, and New Hampshire/Vermont, where the division between mothers in the home and in the paid labor force was close to fifty-fifty. Mothers of young children are least likely to participate in the paid labor force in Utah and several northeastern states. In the case of Utah it is likely a result of the strong priority placed on home and family life by the Mormon religion.

This map provides interesting food for thought. Why do several northeastern states with large urban areas (Philadelphia, New York and Boston) that serve as meccas for career women actually have among the lowest percentages of mothers who work? Could it be that relatively high total family incomes allow middle and upper class women to take a sabbatical from work until the children reach school age? Or, on the other hand, could it be that these urban areas are centers for large numbers of unwed mothers on welfare, untrained and unable to find employment? Many southern states,

WORKING MOTHERS

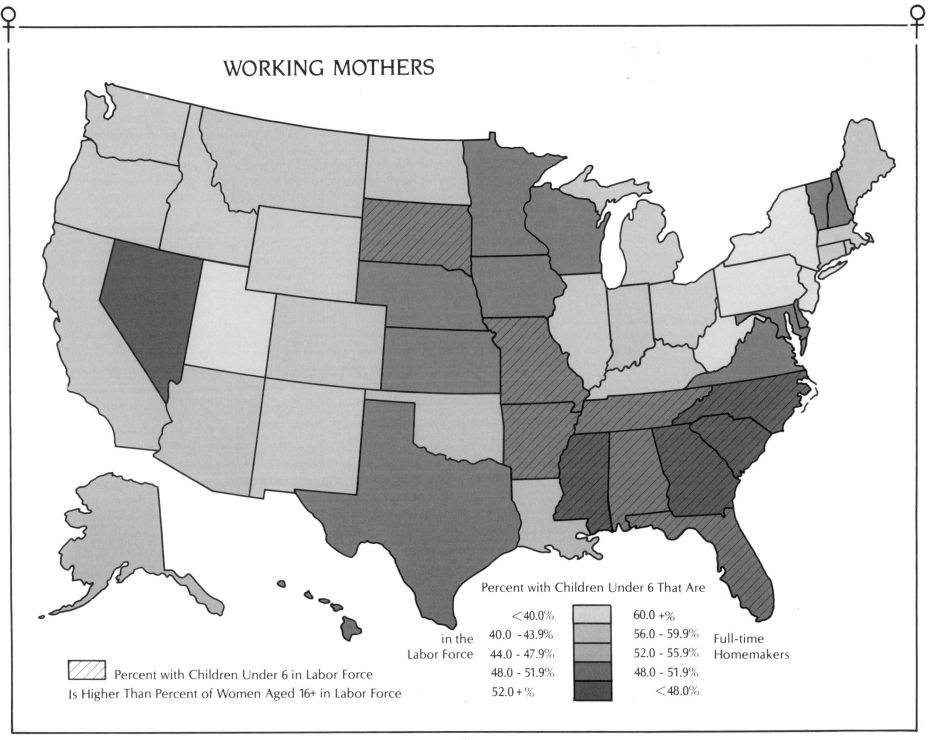

Percent with Children Under 6 That Are

in the
Labor Force

<40.0%
40.0 - 43.9%
44.0 - 47.9%
48.0 - 51.9%
52.0 +%

60.0 +%
56.0 - 59.9%
52.0 - 55.9%
48.0 - 51.9%
<48.0%

Full-time
Homemakers

Percent with Children Under 6 in Labor Force
Is Higher Than Percent of Women Aged 16+ in Labor Force

however, also have large numbers of mothers below the poverty level, yet here a large percentage of such women are in the labor force.

The range of values for working wives in 1980 was similar to that for working mothers although the distribution was somewhat different. While several southern states are still included, the range of high values travels up the eastern seaboard, breaks around Maryland and then resumes in New England. Several other scattered states, Alaska, Nevada, Colorado, Minnesota and Wisconsin, also had a high percentage of married women working outside the home. Between Indiana and Wyoming one finds a fairly homogeneous region where the split between married women in the labor force and full-time homemakers was about even. Six states, West Virginia, Kentucky, Pennsylvania, Ohio, Michigan and Utah, were found among the 10 states with the lowest percentages of both mothers and wives working outside the home.

The opportunity to engage in part-time employment (defined as less than 35 hours per week) outside the home is particularly important for married women and mothers. We have presented two maps ("Civilian Employment Schedule: Women", "Civilian Employment Schedule: Men") showing the relative proportion of full-time versus part-time employment for men and women in 1980. Immediately noticeable is the difference in range of values for the two sexes. While only between 10% and 17% of working men were employed in a part-time capacity, the figures rose to between 23% and 40% for women. The lowest value for women (that of Nevada) was still higher than the highest percentage for men (Hawaii). In 18 states, more than one-third of employed women work on a part-time basis.

A strong regional distribution is evident. Southern women who worked outside the home were much more likely to work on a full-time basis than their northern sisters. For men, the states with the highest percentage of part-time employment appear west of the Mississippi while the lowest values are to be found in the Northeast and three scattered western states. For both sexes, Utah, North Dakota and Minnesota had among the largest percentages employed part time.

The making of war and the provision of defense have been, at least in Western society, almost exclusively male activities. The presence of women in the military has only slowly gained acceptance. In recent times, women associated with the military worked in clerical, administrative or medical capacities and served as WAVES or WACS. Now women have a somewhat greater opportunity to participate as officers or enlisted personnel in more varied capacities. Their percentage of total enlistment is still small, from 4% in Connecticut to 15% in Iowa as of 1980. The highest participation rates appeared in the Midwest and several Gulf Coast states. If you are familiar with the locations of the major military bases in the U.S. you might be able to discover which branch of the military is more apt to hire women. For example, Colorado is the home of NORAD as well as several other prominent Air Force bases. Colorado also exhibits a higher percentage of women in the military. Would this suggest that the Air Force is especially receptive to female personnel? One would need to compare these statistics with the locations of Army, Air Force, Navy and Marine installations to answer that question.

MONEY MATTERS

Presented next are six maps ("Median Income"; "Median Earnings"; "Elementary School Teachers: Median Earnings"; "Registered Nurses: Median Earnings"; "Sec-

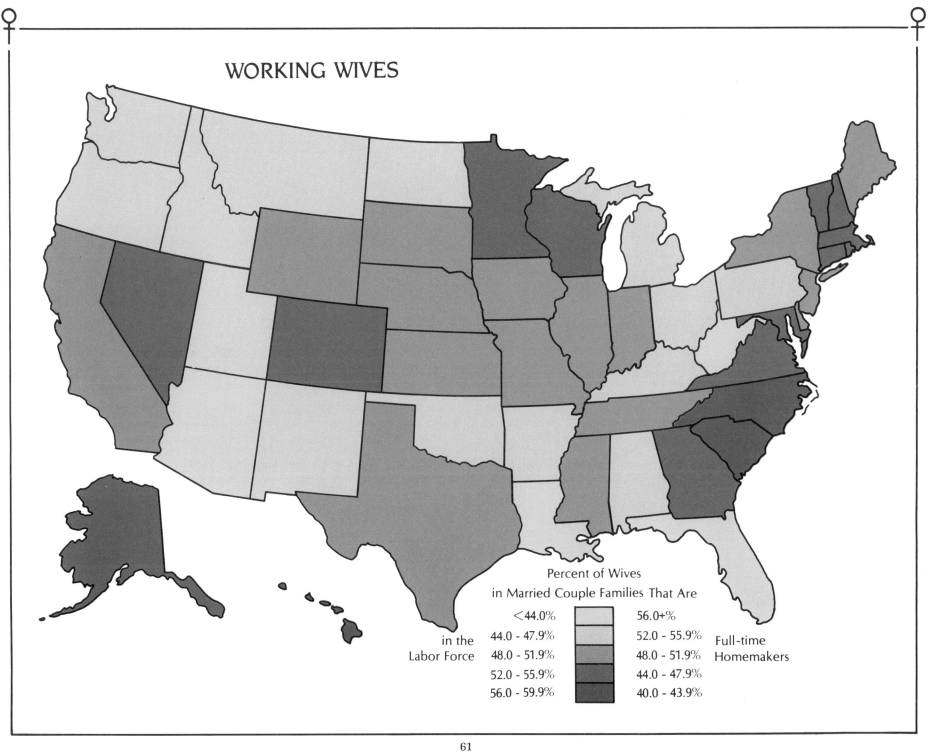

WORKING WIVES

Percent of Wives
in Married Couple Families That Are

in the
Labor Force

<44.0%
44.0 - 47.9%
48.0 - 51.9%
52.0 - 55.9%
56.0 - 59.9%

56.0+%
52.0 - 55.9%
48.0 - 51.9%
44.0 - 47.9%
40.0 - 43.9%

Full-time
Homemakers

CIVILIAN EMPLOYMENT SCHEDULE

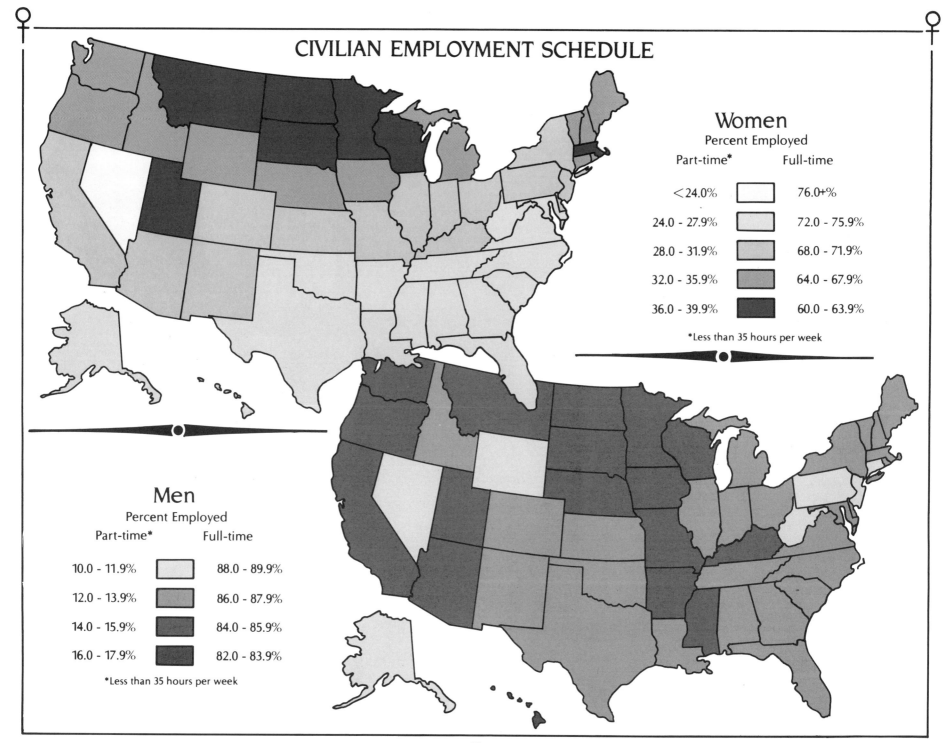

Women
Percent Employed

Part-time*		Full-time
<24.0%		76.0+%
24.0 - 27.9%		72.0 - 75.9%
28.0 - 31.9%		68.0 - 71.9%
32.0 - 35.9%		64.0 - 67.9%
36.0 - 39.9%		60.0 - 63.9%

*Less than 35 hours per week

Men
Percent Employed

Part-time*		Full-time
10.0 - 11.9%		88.0 - 89.9%
12.0 - 13.9%		86.0 - 87.9%
14.0 - 15.9%		84.0 - 85.9%
16.0 - 17.9%		82.0 - 83.9%

*Less than 35 hours per week

ARMED FORCES EMPLOYMENT

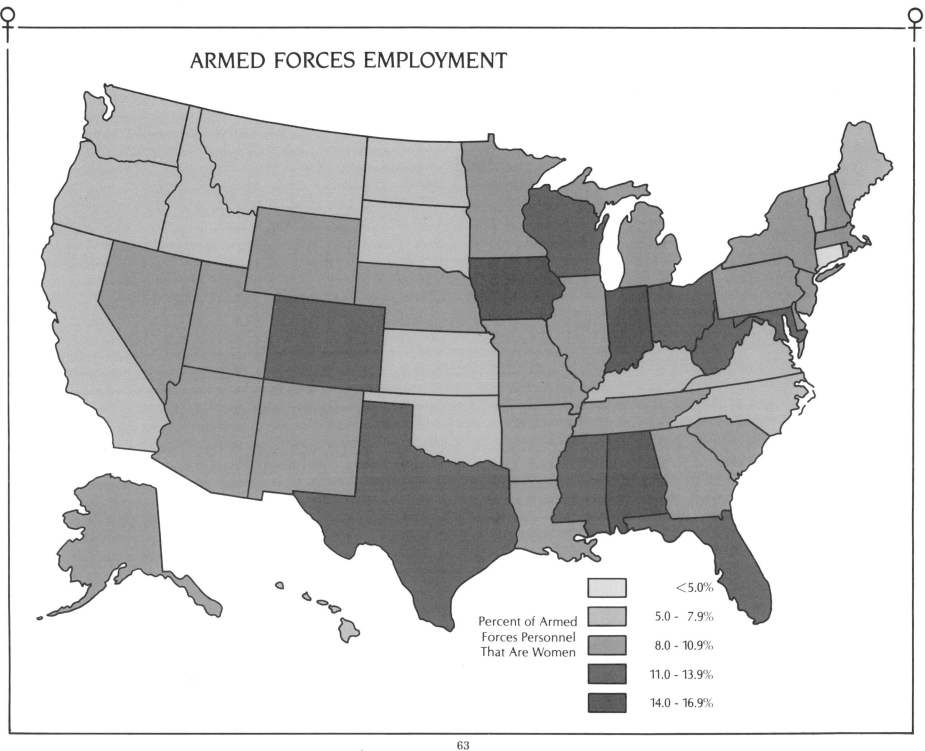

Percent of Armed
Forces Personnel
That Are Women

	<5.0%
	5.0 - 7.9%
	8.0 - 10.9%
	11.0 - 13.9%
	14.0 - 16.9%

retaries: Median Earnings"; "Private Household Workers: Median Earnings") focusing on women's median incomes in 1979 as compiled by the U.S. Census Bureau in 1980. We include data on total median income (for women 15+ with income) from all sources, including wages, public assistance, social security, disability, etc., as well as data on median earnings of women employed full time, year round in 1979. Also incorporated into the first two maps are comparisons between women's and men's incomes. Four maps are used to show the median earnings state by state for women employed in several traditionally female occupations: secretarial work, private household work, teaching and nursing.

With the maps of median income/earnings, it is important to observe both the relative height of the state (the actual median income/earnings) as well as the color indicating women's median income/earnings as a percentage of men's. The five states with the highest median incomes (all more than $6,000) for women were Alaska, Nevada, Hawaii, Maryland and California. In half the states, the median income was between only $4,000 and $5,000. Women in South Dakota, Mississippi, Arkansas, North Dakota and Idaho were the least fortunate financially. The difference between the incomes of men and women was the most pronounced in the Midwest and Rocky Mountain states while the wage gap was relatively small in Alaska, Hawaii, Nevada and several southeastern states. In Wyoming, women's income was less than one-third of men's. Nowhere was it greater than 60%.

Median earnings for women who had worked full time, year round began where median incomes left off. The state with the highest median *income* for women was Alaska at $7,965. The state with the lowest median *earnings*, Mississippi, had a figure of $8,024. As with median income, Alaska topped the list of median earnings at $16,057, $4,000 higher than the figure for second-place California.

Women also had relatively high earnings in Michigan, Washington, Maryland and New York. However, in the first two states, the gap in earning between men and women was relatively small, where in the second two states it was much wider. The greatest gap in the earning levels of women and men occurred in states on the East Coast.

It is interesting to compare the map of median earnings with those maps of earnings for specific occupations. Not surprisingly, the salaries of private household workers were well below the median earnings averaged across all occupations. On the other hand, the median earnings for nurses and secretaries was higher. The range of earnings for elementary school teachers most closely approximated the range of earnings for all occupations. Six states consistently ranked among the top 10 as having the highest earnings in each occupation: Alaska, California, Hawaii, New York, Nevada and Michigan. We have not presented information on men's earnings in these jobs. However, it is interesting to note that, although these are female-dominated occupations, men employed in these capacities consistently had higher median earnings than their female colleagues.

THE FEMINIZATION OF POVERTY

The information presented here on "Women Below the Poverty Level" also comes from the 1980 Census and refers specifically to female householders with no husband present. The map showing women below the poverty level is further restricted to family households in which the female householder lives with one or more relatives (but again, no spouse). The feminization of

MONEY MATTERS

MEDIAN INCOME
1979

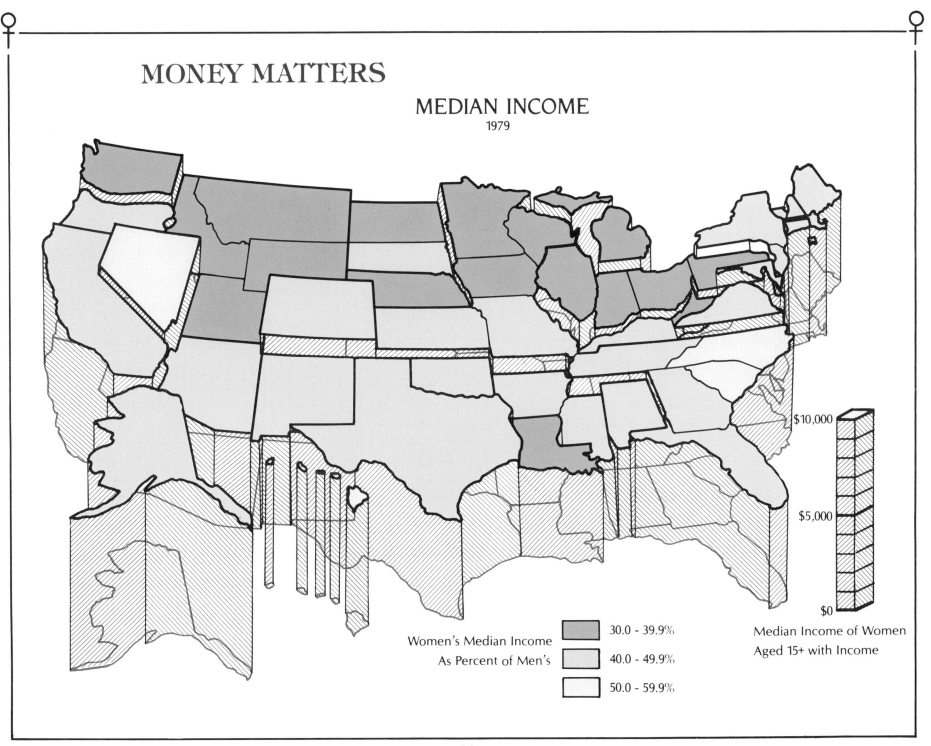

Women's Median Income
As Percent of Men's

30.0 - 39.9%

40.0 - 49.9%

50.0 - 59.9%

$10,000

$5,000

$0

Median Income of Women
Aged 15+ with Income

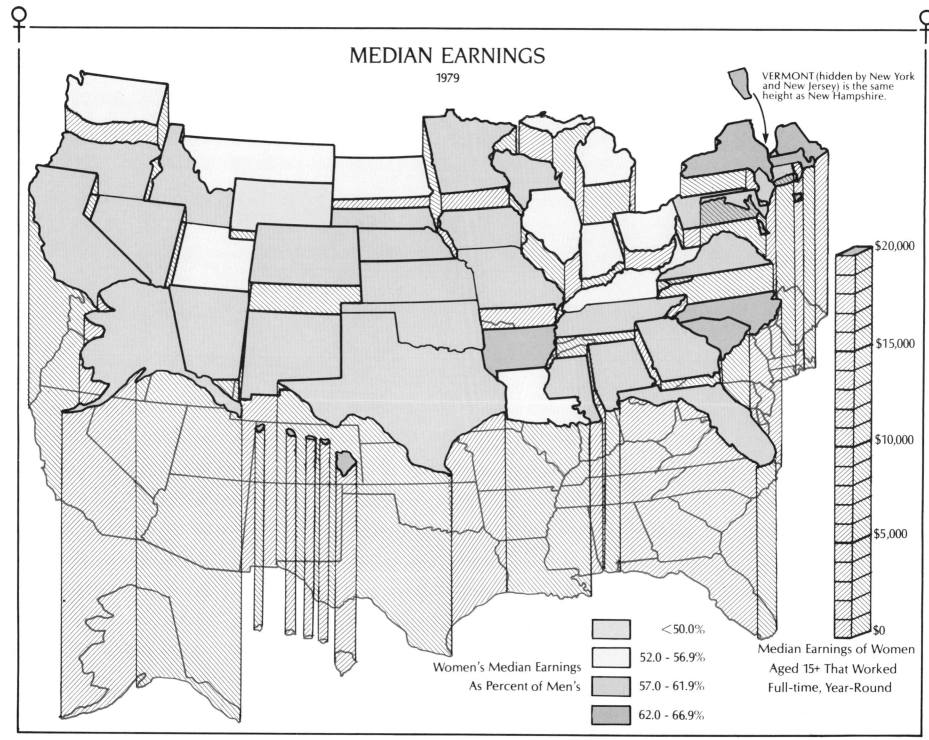

MEDIAN EARNINGS

1979

VERMONT (hidden by New York and New Jersey) is the same height as New Hampshire.

Women's Median Earnings As Percent of Men's

< 50.0%

52.0 - 56.9%

57.0 - 61.9%

62.0 - 66.9%

Median Earnings of Women Aged 15+ That Worked Full-time, Year-Round

$20,000

$15,000

$10,000

$5,000

$0

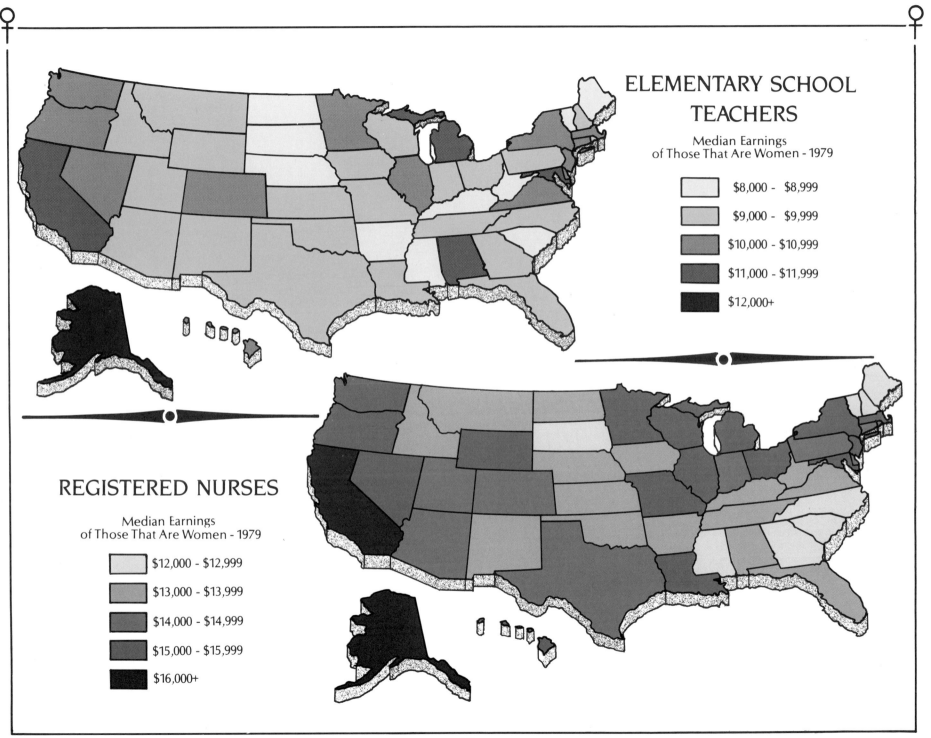

ELEMENTARY SCHOOL
TEACHERS

Median Earnings
of Those That Are Women - 1979

$8,000 - $8,999
$9,000 - $9,999
$10,000 - $10,999
$11,000 - $11,999
$12,000+

REGISTERED NURSES

Median Earnings
of Those That Are Women - 1979

$12,000 - $12,999
$13,000 - $13,999
$14,000 - $14,999
$15,000 - $15,999
$16,000+

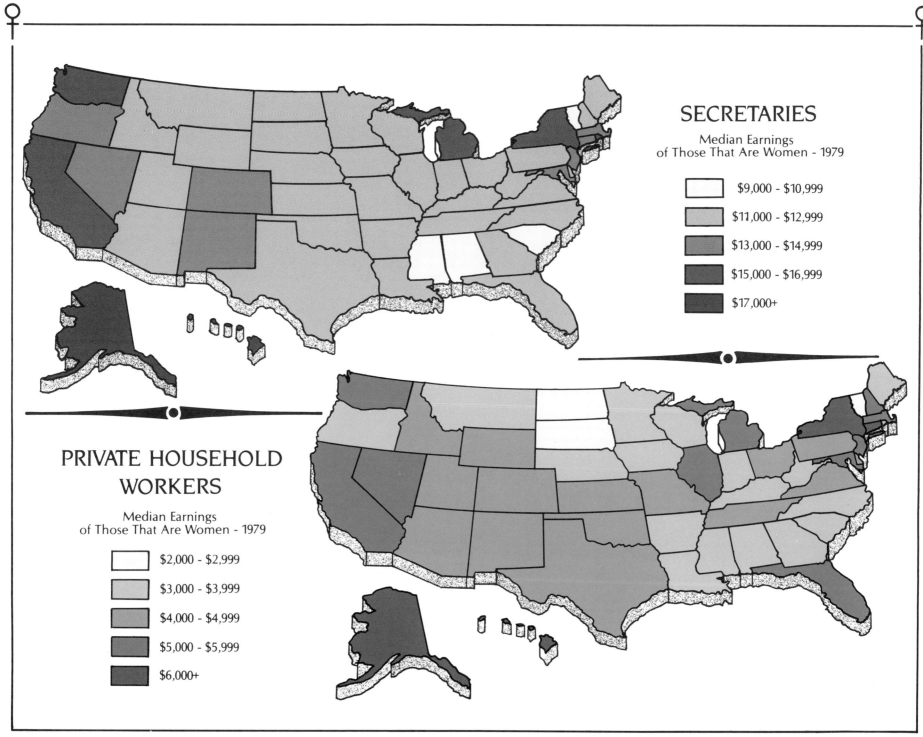

SECRETARIES

Median Earnings
of Those That Are Women - 1979

$9,000 - $10,999

$11,000 - $12,999

$13,000 - $14,999

$15,000 - $16,999

$17,000+

PRIVATE HOUSEHOLD
WORKERS

Median Earnings
of Those That Are Women - 1979

$2,000 - $2,999

$3,000 - $3,999

$4,000 - $4,999

$5,000 - $5,999

$6,000+

THE FEMINIZATION OF POVERTY

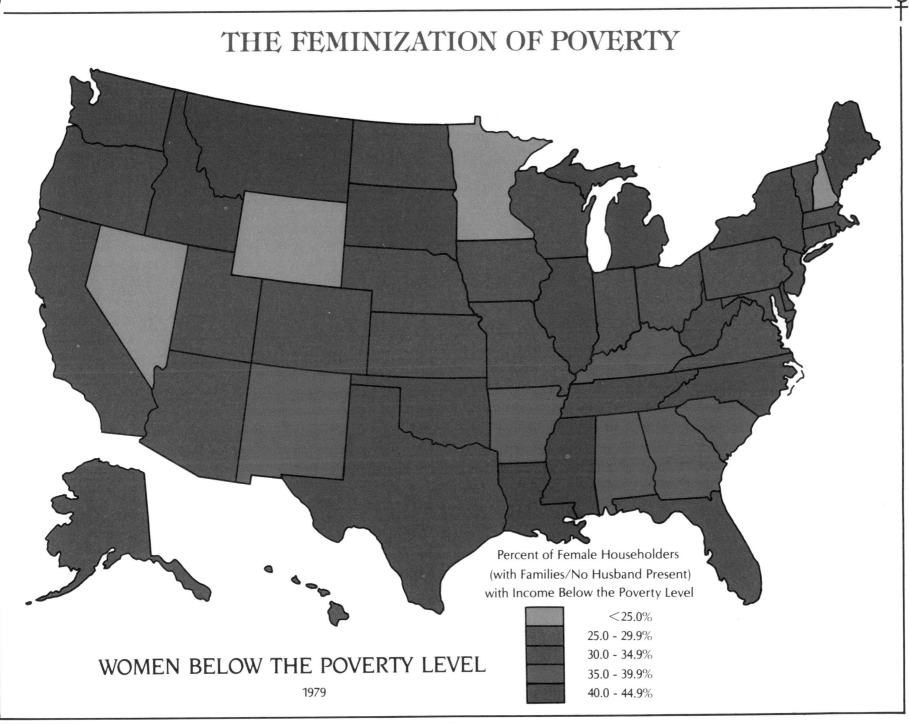

Percent of Female Householders
(with Families/No Husband Present)
with Income Below the Poverty Level

< 25.0%

25.0 - 29.9%

30.0 - 34.9%

35.0 - 39.9%

40.0 - 44.9%

WOMEN BELOW THE POVERTY LEVEL

1979

poverty appears most keenly felt in New Mexico, Kentucky and the Deep South. In these states, more than one-third of the female householders and their families were living below the poverty level. The Deep South appears to be an area where a high level of working mothers corresponded with a high poverty rate. Only four states, Nevada, Minnesota, Wyoming and New Hampshire, had fewer than one-quarter of such families below the poverty level.

To cope with the problems of poverty, public assistance and social security are provided by the government. Public assistance includes aid to families with dependent children, general assistance and disability income, while social security was designed to provide supplemental income during one's retirement years. We have presented information on the percentage of these female family and non-family householders with no husband present, receiving public assistance, social security and public assistance only (no other income).

With public assistance and social security, it is important to realize that these women may have additional sources of income, especially those on social security. However, for some women, social security is their sole support. Many did not fall below the poverty level until they had retired or their husbands had died. Note that we have separated out the number of women relying solely on public assistance. Their proportions are generally low in the West and higher in the East. While in most states the figure was below 6%, in New York it approached 10%. The proportion of all female householders as described above receiving public assistance (possibly in addition to other income) was especially high in the Southeast, New York, Massachusetts and Michigan. The pattern is somewhat different for women receiving social security. There are three states, West Virginia, Iowa and South Dakota, where more than half of these householders receive social security. The low-est percentages occurred in the western states, including Alaska and Hawaii. The range of female householders receiving some type of government benefits was lowest in several western states, and highest in five southeastern states, varying from 27% in Alaska to 73% in Mississippi.

PROTECTION UNDER THE LAW

Discrimination against women in the workforce has in the past been evident in unequal pay structures, hiring practices and opportunities for advancement. As of January 1, 1982, eight states (Texas, Louisiana, Arkansas, Mississippi, Alabama, Georgia, North Carolina and Virginia) did not have broad-based laws specifically prohibiting discrimination on the basis of sex in private employment. Other states had enacted anti-discrimination laws that applied to private businesses with more than a minimum number of employees. In many states, if a woman worked for a small company she might not have had legal protection against discrimination.

The distribution of "Unequal Opportunity" is interesting. Four states (Texas, South Carolina, Florida and Maryland) that required the highest minimum number of employees before anti-discrimination laws applied are next to states without those laws at all. States offering the greatest protection (a low minimum number) were usually in the North.

Most states relied on either of two types of laws to prohibit wage discrimination on the basis of sex (see "(Un)Equal Pay"). They might have had statutes specifically forbidding this type of discrimination or they might have utilized general civil rights, or fair employment practices legislation to deal with the problem. One can-

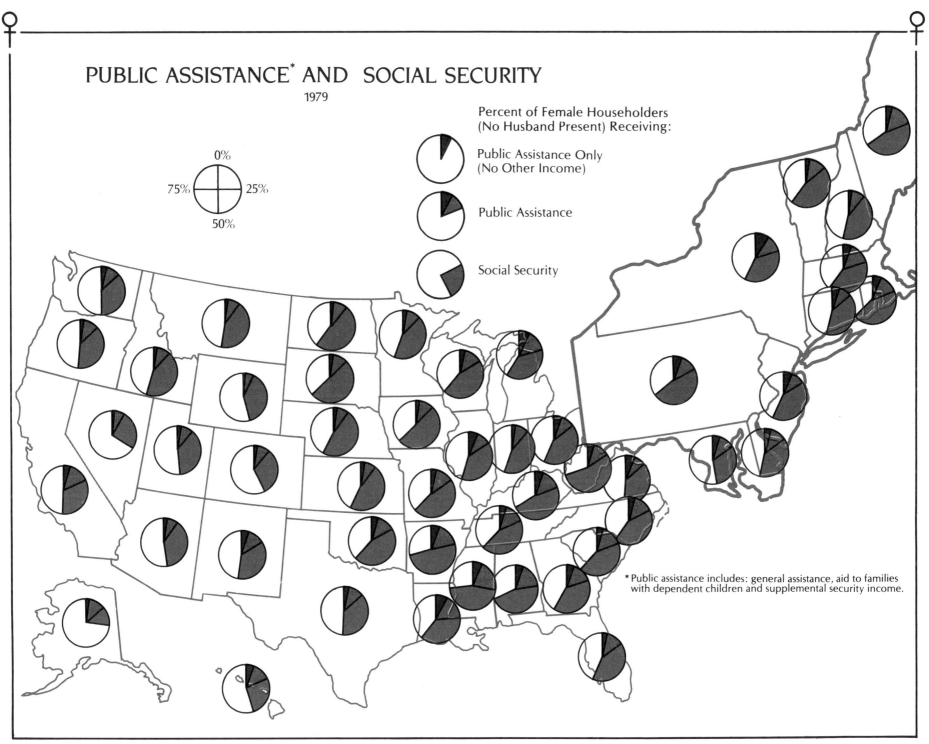

PUBLIC ASSISTANCE* AND SOCIAL SECURITY
1979

Percent of Female Householders
(No Husband Present) Receiving:

Public Assistance Only
(No Other Income)

Public Assistance

Social Security

0%
75% — 25%
50%

*Public assistance includes: general assistance, aid to families
with dependent children and supplemental security income.

PROTECTION UNDER THE LAW

(UN)EQUAL OPPORTUNITY

January 1, 1982

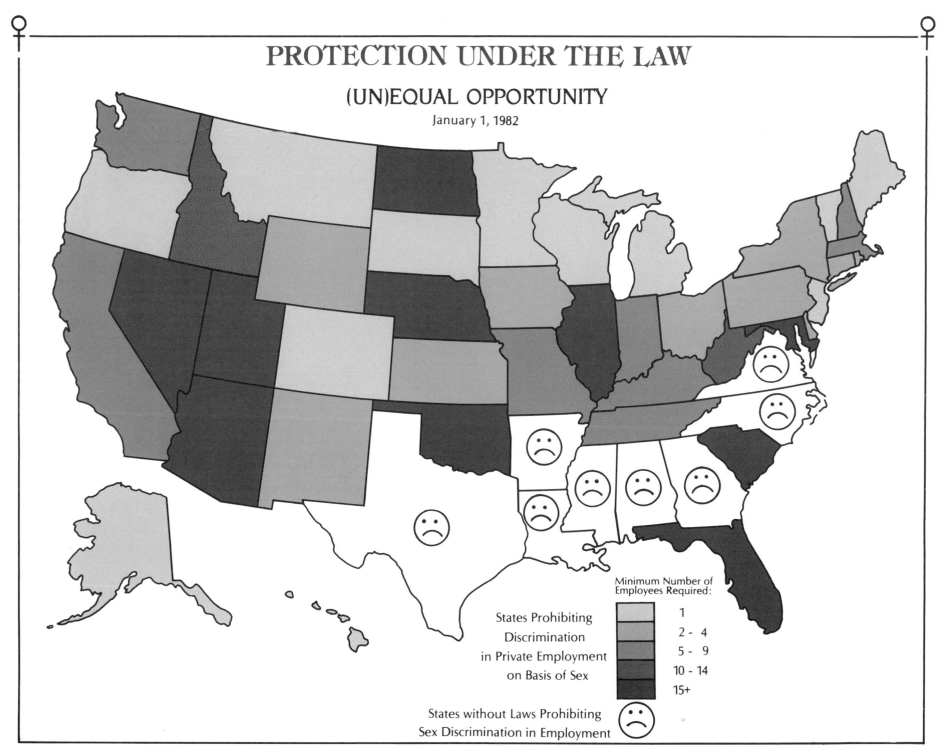

Minimum Number of
Employees Required:

States Prohibiting
Discrimination
in Private Employment
on Basis of Sex

1
2 - 4
5 - 9
10 - 14
15+

States without Laws Prohibiting
Sex Discrimination in Employment

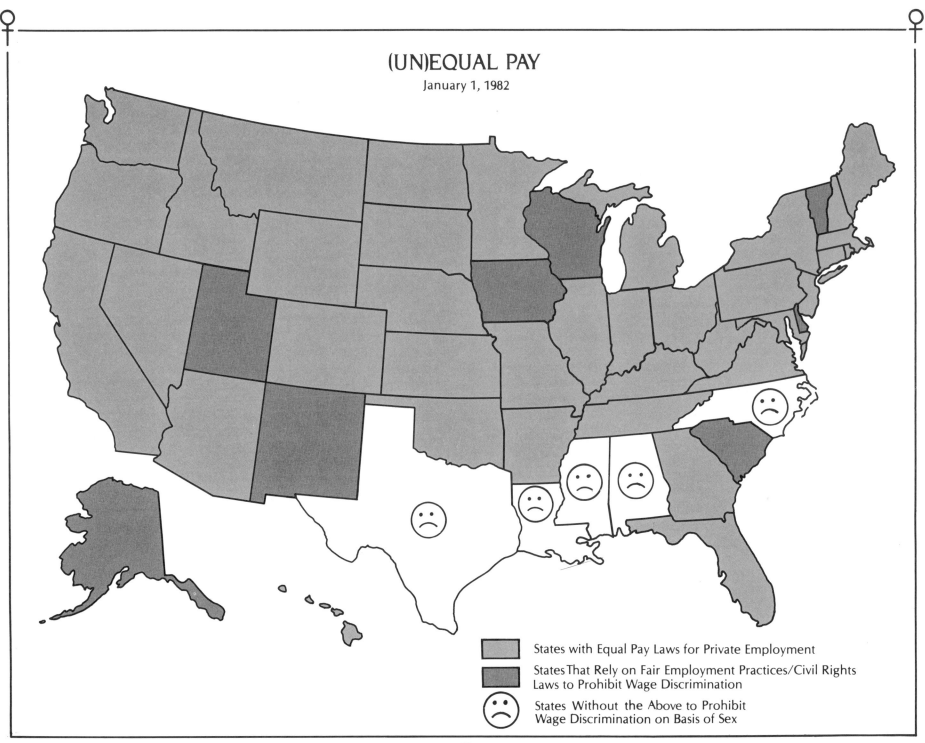

(UN)EQUAL PAY

January 1, 1982

States with Equal Pay Laws for Private Employment

States That Rely on Fair Employment Practices/Civil Rights Laws to Prohibit Wage Discrimination

States Without the Above to Prohibit Wage Discrimination on Basis of Sex

not help but notice similarities between the distribution on this and the previous map.

WOMEN'S WORK

The next 28 maps present a picture of women's work as we enter the 80s. Many occupations have been stereotyped as being specifically for men or women. Secretaries are assumed to be female while welders are male. The following maps allow you to test your stereotypes about different jobs. How true are those images of men's and women's work? Are there regional patterns of female versus male dominance that emerge within an occupation?

The information upon which we based these maps was collected by the U.S. Bureau of the Census as a part of the 1980 Census of population. This is not complete count data. It is based on a sample of each state's population. (See our discussion on data types in the Introduction.) The data refers to the experienced civilian labor force, consisting of persons employed at the time of the Census and those who were unemployed but had had work experience within the previous five years.

The Census grouped all such persons into six major occupational categories, with many subcategories listed under each. From among these we have selected ten broad occupational groups to map, in addition to two specific jobs for each. While the Bureau of Labor Statistics uses the 25% mark as the criterion to distinguish traditional from non-traditional female occupations, we have chosen 50% as a breakpoint when making the maps. We have used the yellow end of the spectrum to indicate states where men dominate a particular occupation (the percentage of women is less than 50%) while shades of blue highlight states where the job is performed mainly by women. Those regions where the split is about even are indicated in green (a mixture of blue and yellow). Some occupations have yellow in every state, while others will be mostly blue. The color scheme allows you to see at a glance occupations dominated by men or women and whether this trend holds true at the national as well as state level.

Before looking at the individual maps, take time to study the graph "Charting Their Progress." For each occupation mapped, the graph shows the range of state values for the percentage of persons that are women in each occupation. The dot represents the average for the U.S. as a whole. Those occupations with high percentages are typically female-dominated, while those with low percentages are usually filled by men. The length of each line associated with an occupation gives an indication of the variation in the ratio of women to men in that occupation from state to state. Short lines indicate that the percentage of women in that field was relatively uniform throughout the country while longer lines suggest a greater variation in the proportion of women employed. Major categories are shown in black, while blue is used to indicate more specific jobs.

Rather than discuss each map separately, we will point out several important trends to watch for. Some jobs exhibit a very wide range in the ratio of female to male employees. The maps "Accountants/Auditors" and "Bus Drivers" are good examples. The percentage of women employed as accountants and auditors ranged from a low of 24% in Rhode Island to a high of 56% in Alaska. Because the range (32 percentage points) is so large, we should look at its distribution. The map reveals that there are two areas where women constituted more than 42% of auditors and accountants, the West and the Deep South. In a few states, Nevada, Alaska and Georgia, about 50% of all such employees were estimated to be women. The lowest percentages are clearly concentrated in the

WOMEN'S WORK

CHARTING THEIR PROGRESS

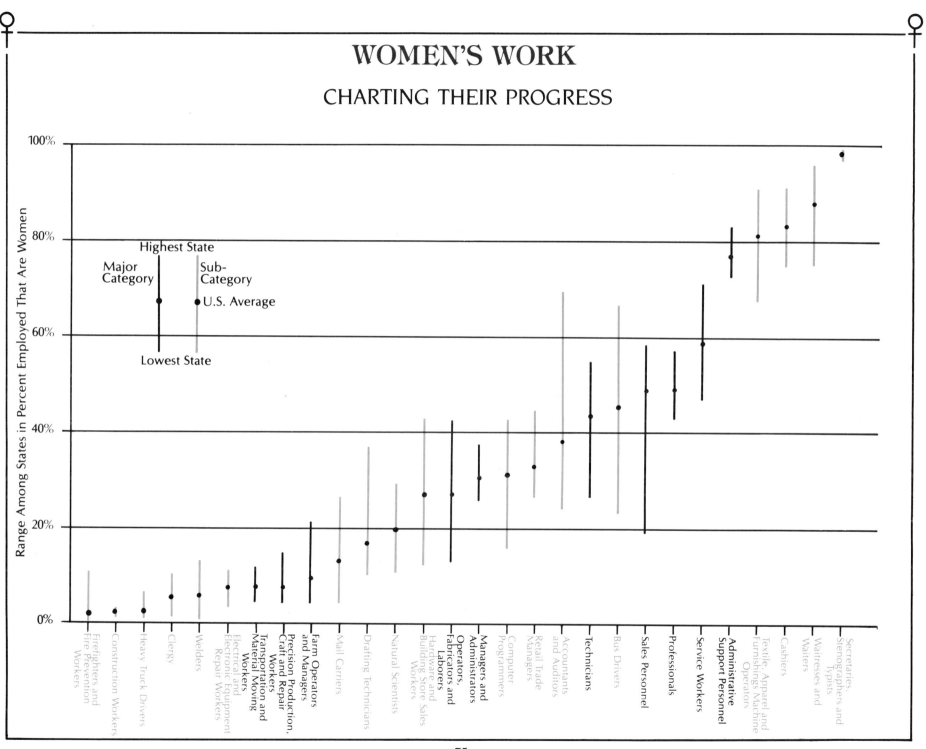

MANAGERS AND ADMINISTRATORS

Percent
That Are Women

24.0 - 26.9%

27.0 - 29.9%

30.0 - 32.9%

33.0 - 35.9%

36.0 - 38.9%

Accountants and Auditors

Percent That Are Women

- 24.0 - 29.9%
- 30.0 - 35.9%
- 36.0 - 41.9%
- 42.0 - 47.9%
- 48.0+%

Retail Trade Managers

Percent That Are Women

- 26.0 - 29.9%
- 30.0 - 33.9%
- 34.0 - 37.9%
- 38.0 - 41.9%
- 42.0 - 45.9%

PROFESSIONALS

Percent
That Are Women

40.0 - 43.9%

44.0 - 47.9%

48.0 - 51.9%

52.0 - 55.9%

56.0 - 59.9%

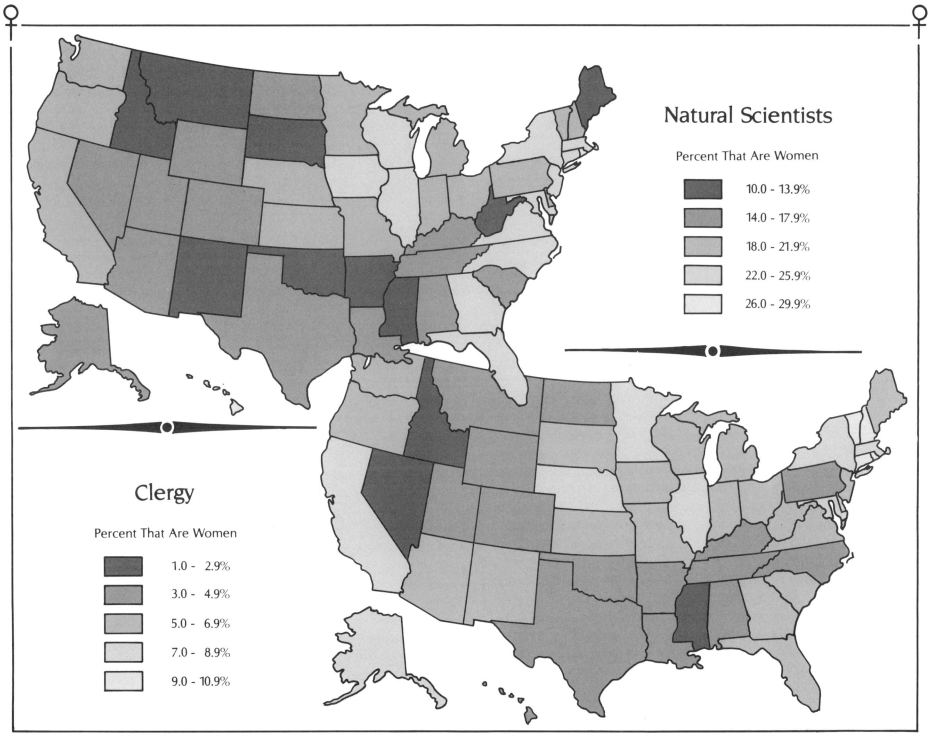

Natural Scientists

Percent That Are Women

- 10.0 - 13.9%
- 14.0 - 17.9%
- 18.0 - 21.9%
- 22.0 - 25.9%
- 26.0 - 29.9%

Clergy

Percent That Are Women

- 1.0 - 2.9%
- 3.0 - 4.9%
- 5.0 - 6.9%
- 7.0 - 8.9%
- 9.0 - 10.9%

TECHNICIANS

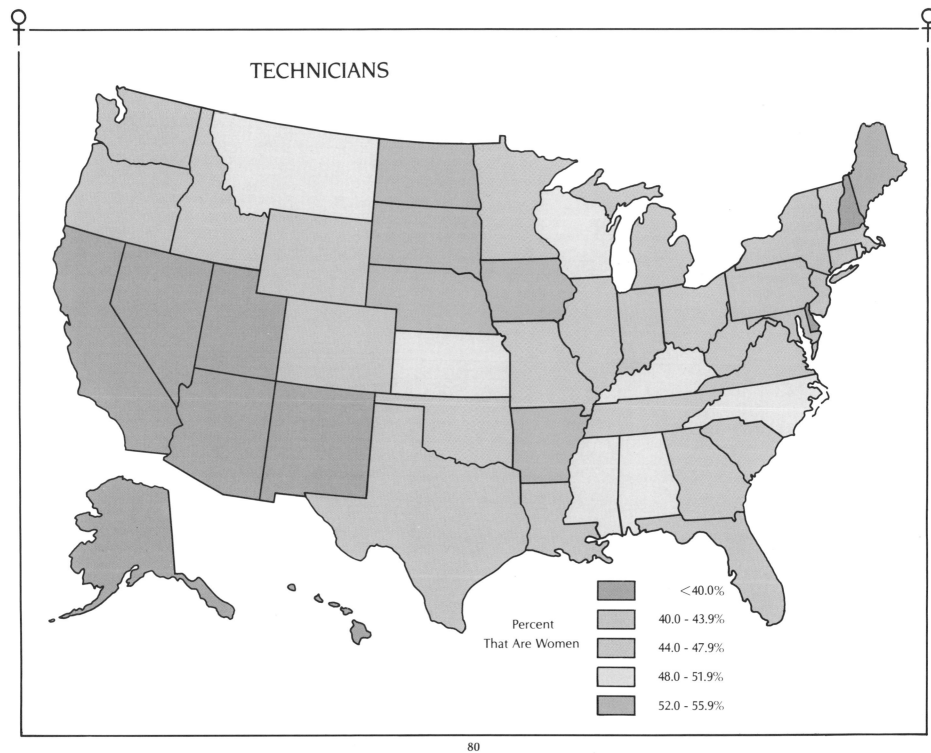

Percent That Are Women

	<40.0%
	40.0 - 43.9%
	44.0 - 47.9%
	48.0 - 51.9%
	52.0 - 55.9%

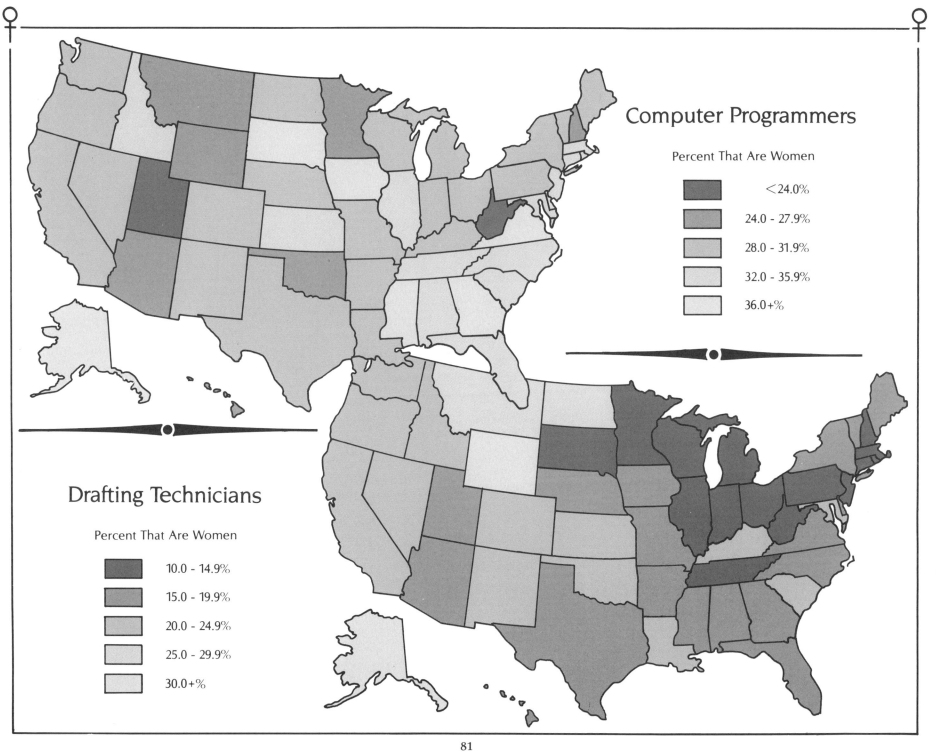

Computer Programmers

Percent That Are Women

- <24.0%
- 24.0 - 27.9%
- 28.0 - 31.9%
- 32.0 - 35.9%
- 36.0+%

Drafting Technicians

Percent That Are Women

- 10.0 - 14.9%
- 15.0 - 19.9%
- 20.0 - 24.9%
- 25.0 - 29.9%
- 30.0+%

SALES PERSONNEL

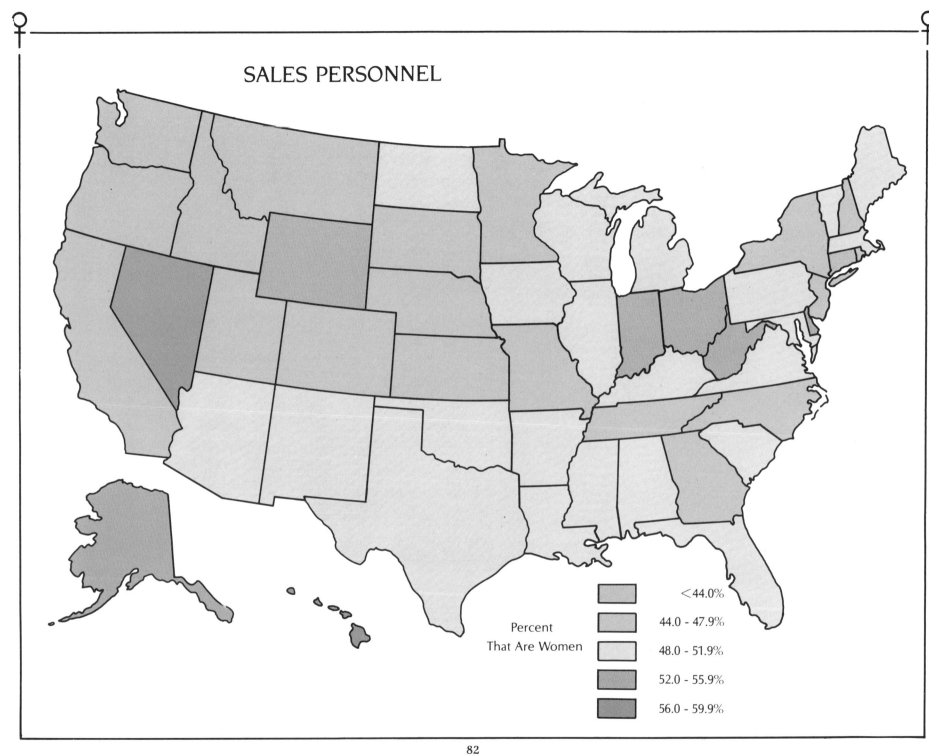

Percent
That Are Women

<44.0%

44.0 - 47.9%

48.0 - 51.9%

52.0 - 55.9%

56.0 - 59.9%

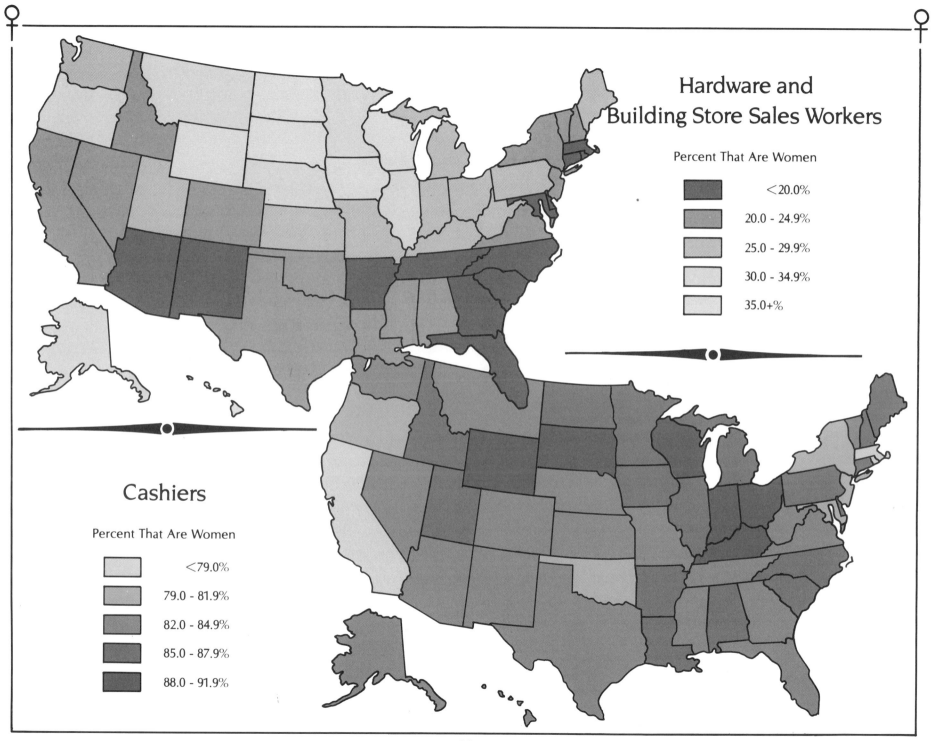

Hardware and Building Store Sales Workers

Percent That Are Women

- <20.0%
- 20.0 - 24.9%
- 25.0 - 29.9%
- 30.0 - 34.9%
- 35.0+%

Cashiers

Percent That Are Women

- <79.0%
- 79.0 - 81.9%
- 82.0 - 84.9%
- 85.0 - 87.9%
- 88.0 - 91.9%

ADMINISTRATIVE SUPPORT PERSONNEL

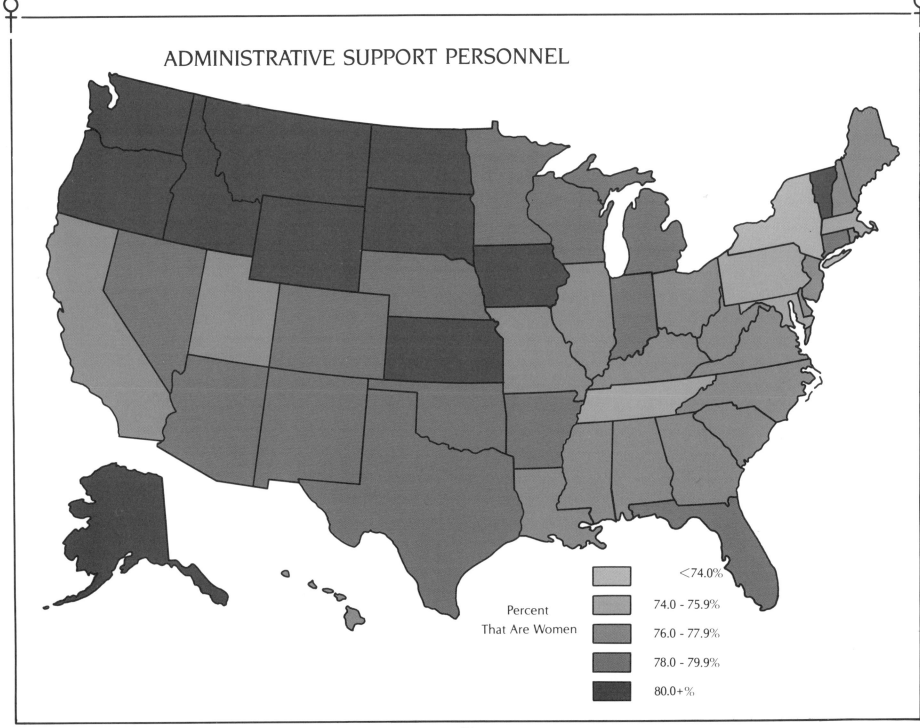

Percent
That Are Women

<74.0%

74.0 - 75.9%

76.0 - 77.9%

78.0 - 79.9%

80.0+%

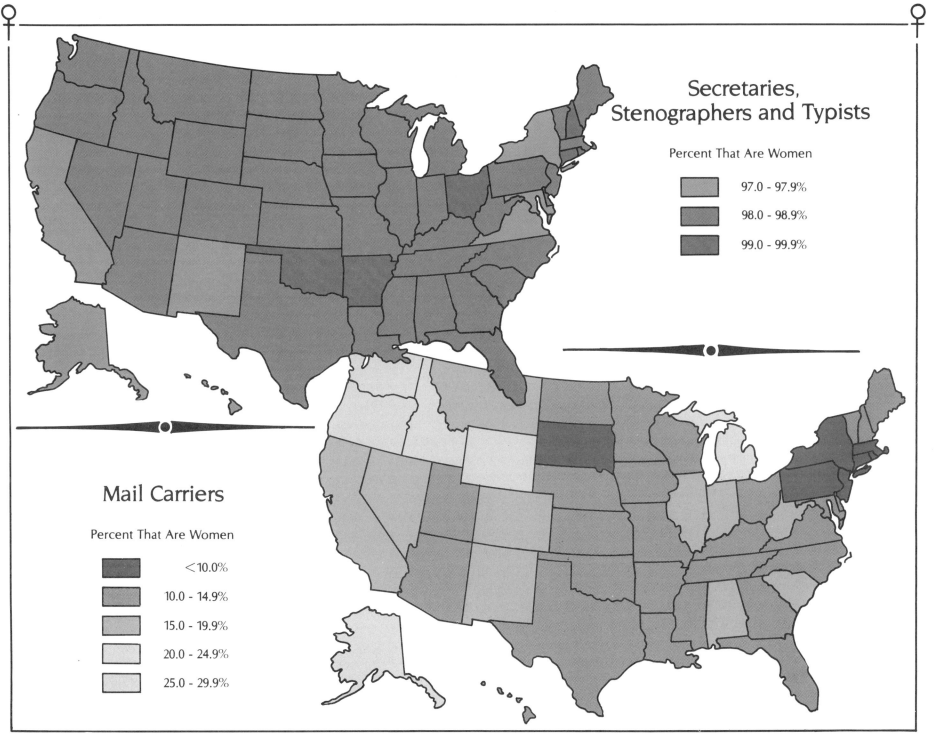

Secretaries, Stenographers and Typists

Percent That Are Women

97.0 - 97.9%

98.0 - 98.9%

99.0 - 99.9%

Mail Carriers

Percent That Are Women

< 10.0%

10.0 - 14.9%

15.0 - 19.9%

20.0 - 24.9%

25.0 - 29.9%

SERVICE WORKERS

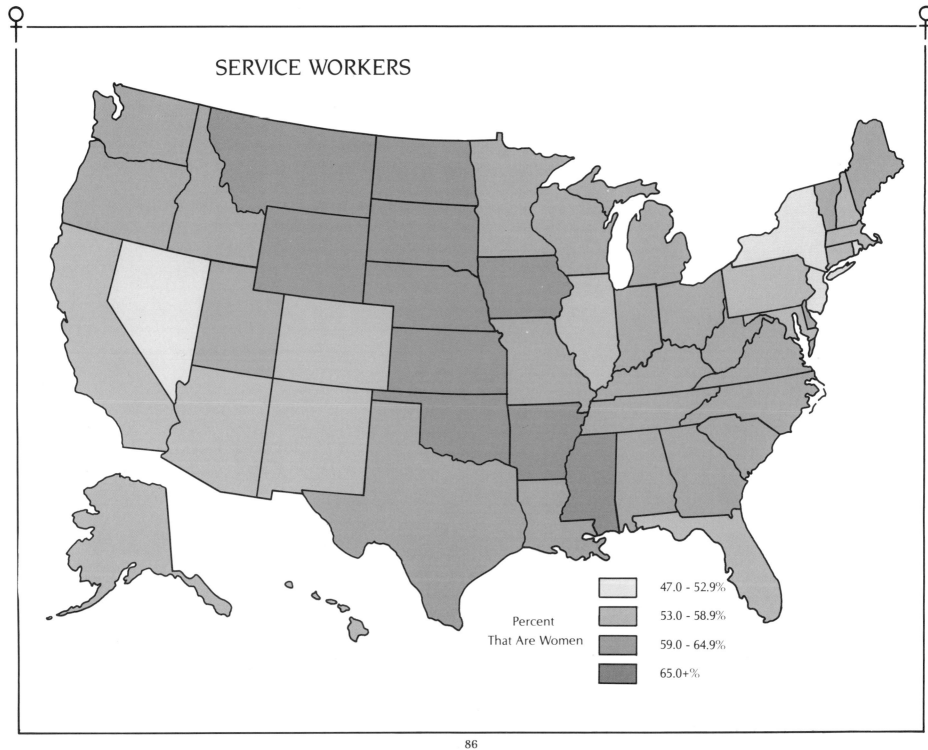

Percent That Are Women

47.0 - 52.9%

53.0 - 58.9%

59.0 - 64.9%

65.0+%

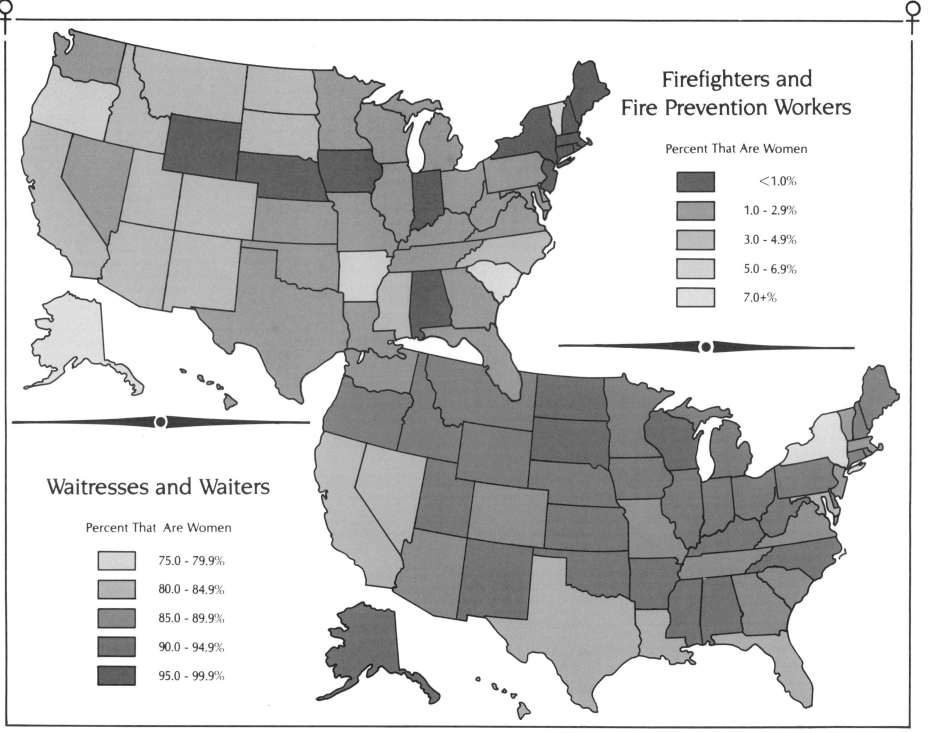

Firefighters and
Fire Prevention Workers

Percent That Are Women

<1.0%

1.0 - 2.9%

3.0 - 4.9%

5.0 - 6.9%

7.0+%

Waitresses and Waiters

Percent That Are Women

75.0 - 79.9%

80.0 - 84.9%

85.0 - 89.9%

90.0 - 94.9%

95.0 - 99.9%

PRECISION PRODUCTION, CRAFT AND REPAIR WORKERS

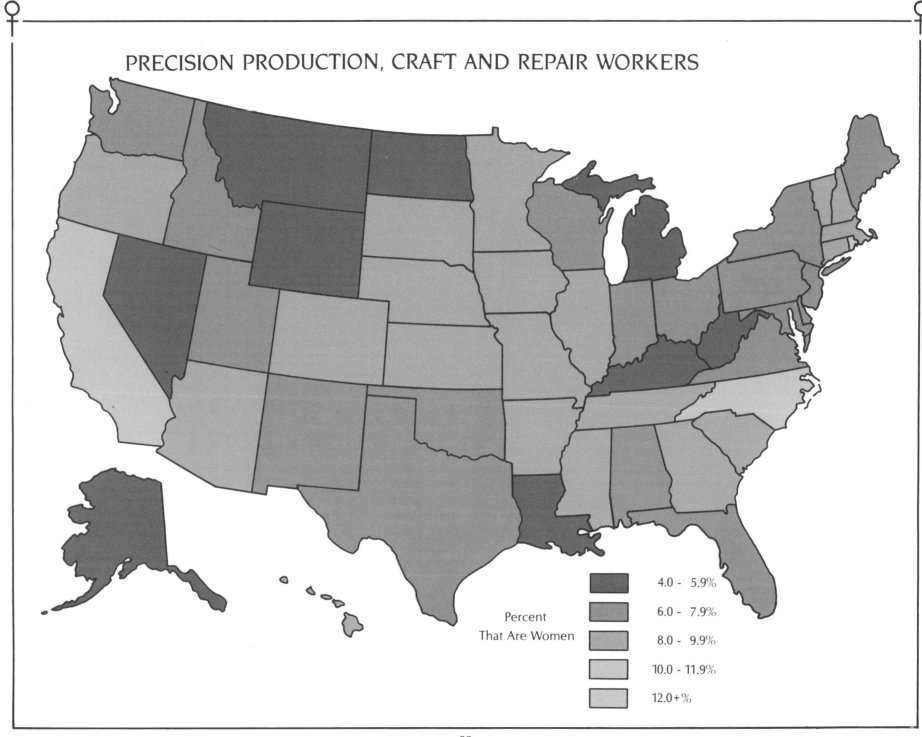

Percent That Are Women

- 4.0 - 5.9%
- 6.0 - 7.9%
- 8.0 - 9.9%
- 10.0 - 11.9%
- 12.0+%

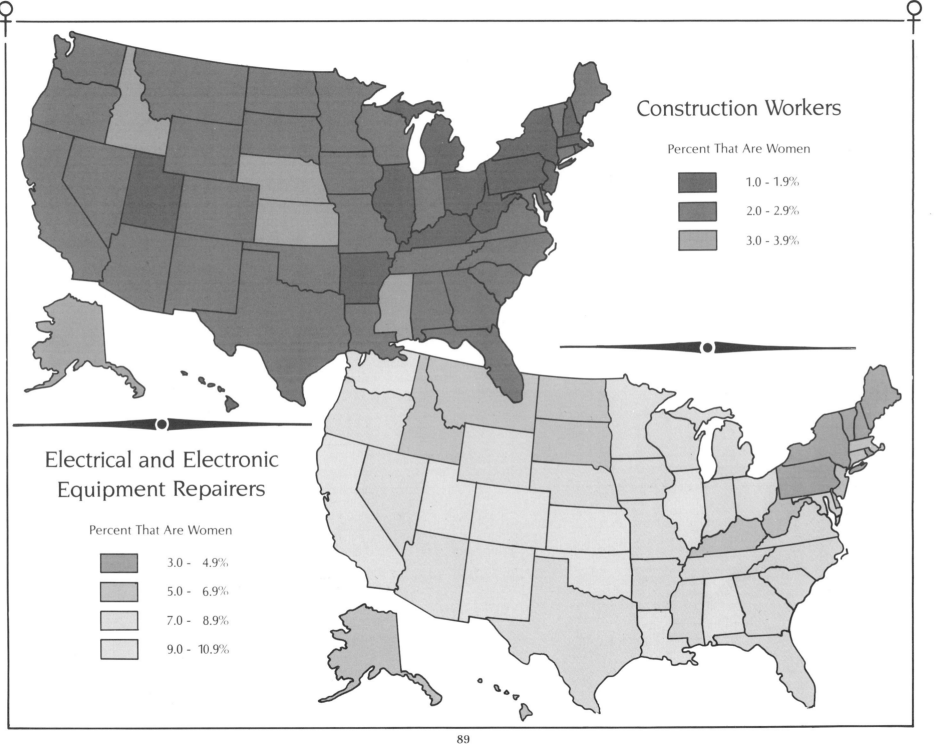

Construction Workers

Percent That Are Women

1.0 - 1.9%

2.0 - 2.9%

3.0 - 3.9%

Electrical and Electronic
Equipment Repairers

Percent That Are Women

3.0 - 4.9%

5.0 - 6.9%

7.0 - 8.9%

9.0 - 10.9%

OPERATORS, FABRICATORS AND LABORERS

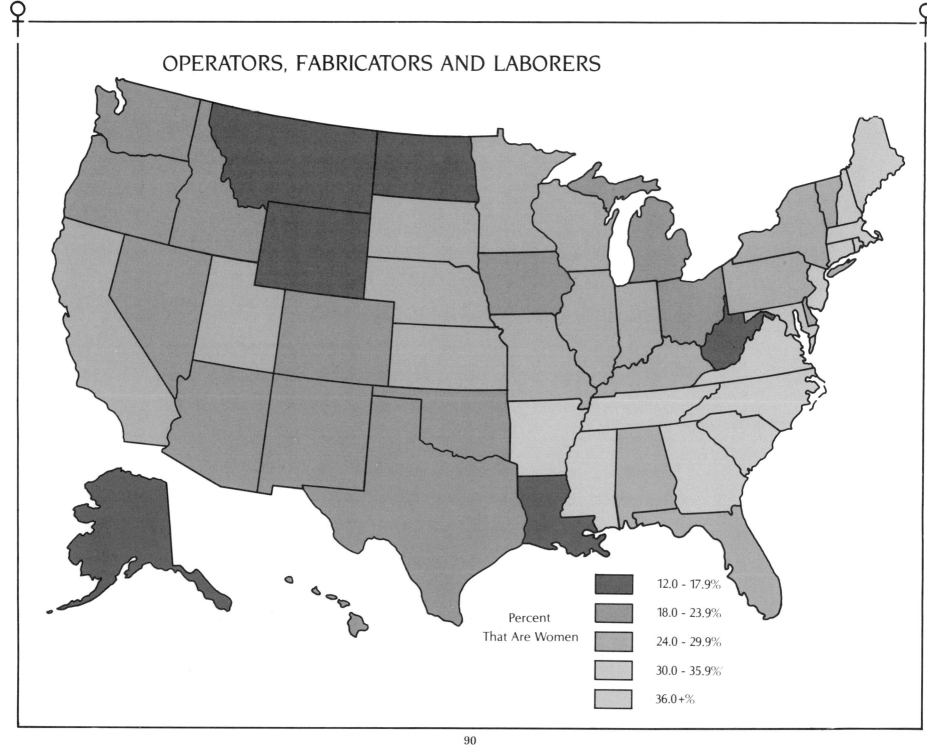

Percent
That Are Women

12.0 - 17.9%

18.0 - 23.9%

24.0 - 29.9%

30.0 - 35.9%

36.0 +%

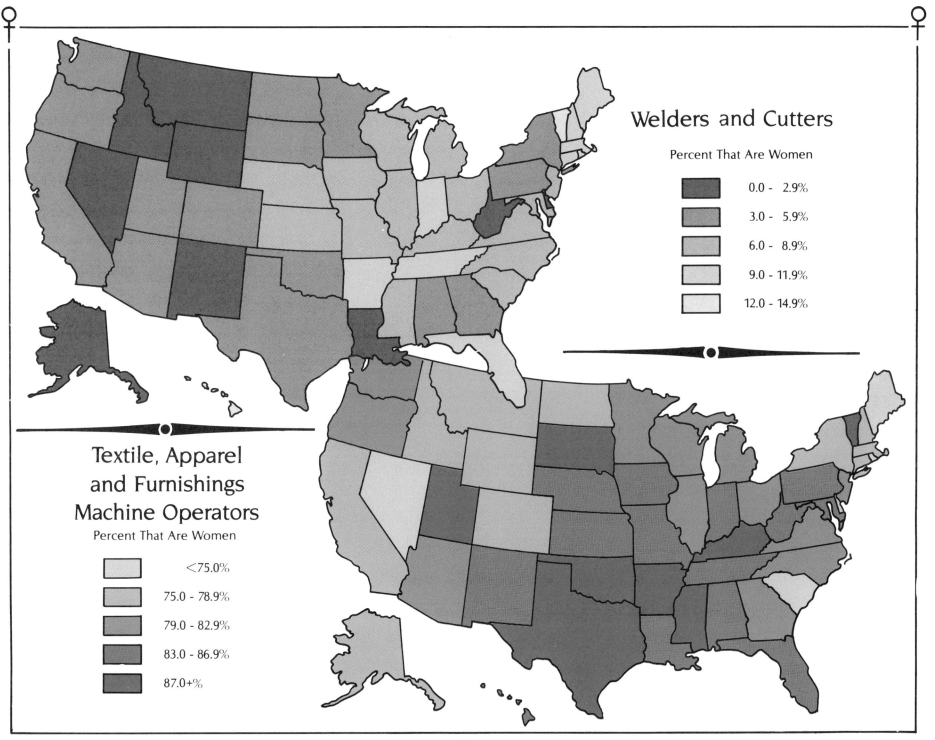

Welders and Cutters

Percent That Are Women

- 0.0 - 2.9%
- 3.0 - 5.9%
- 6.0 - 8.9%
- 9.0 - 11.9%
- 12.0 - 14.9%

Textile, Apparel and Furnishings Machine Operators

Percent That Are Women

- <75.0%
- 75.0 - 78.9%
- 79.0 - 82.9%
- 83.0 - 86.9%
- 87.0+%

TRANSPORTATION AND MATERIAL MOVING WORKERS

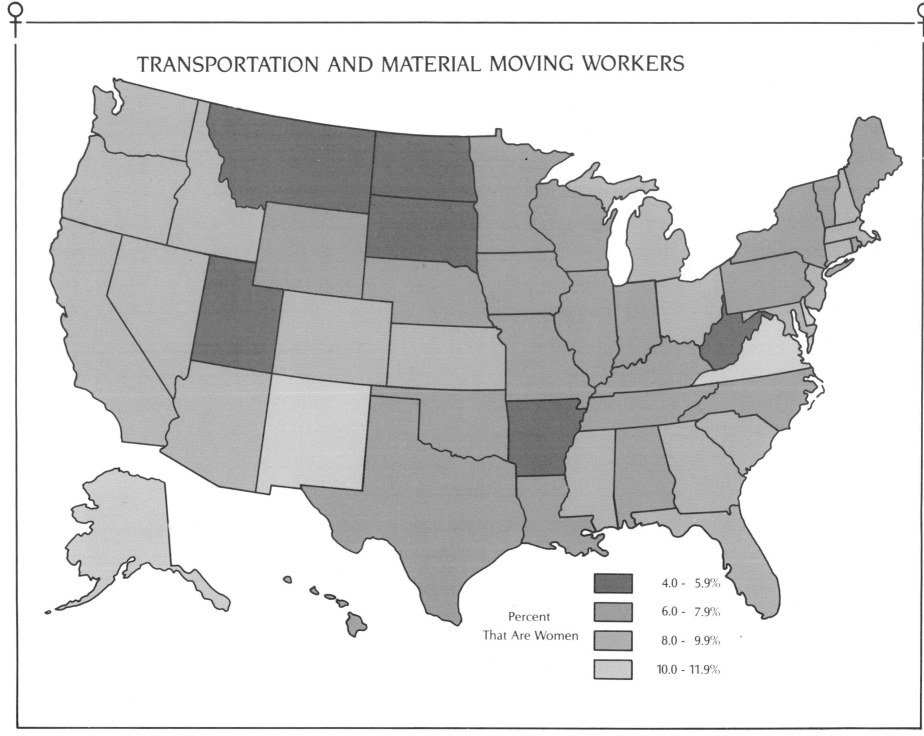

Percent That Are Women

- 4.0 - 5.9%
- 6.0 - 7.9%
- 8.0 - 9.9%
- 10.0 - 11.9%

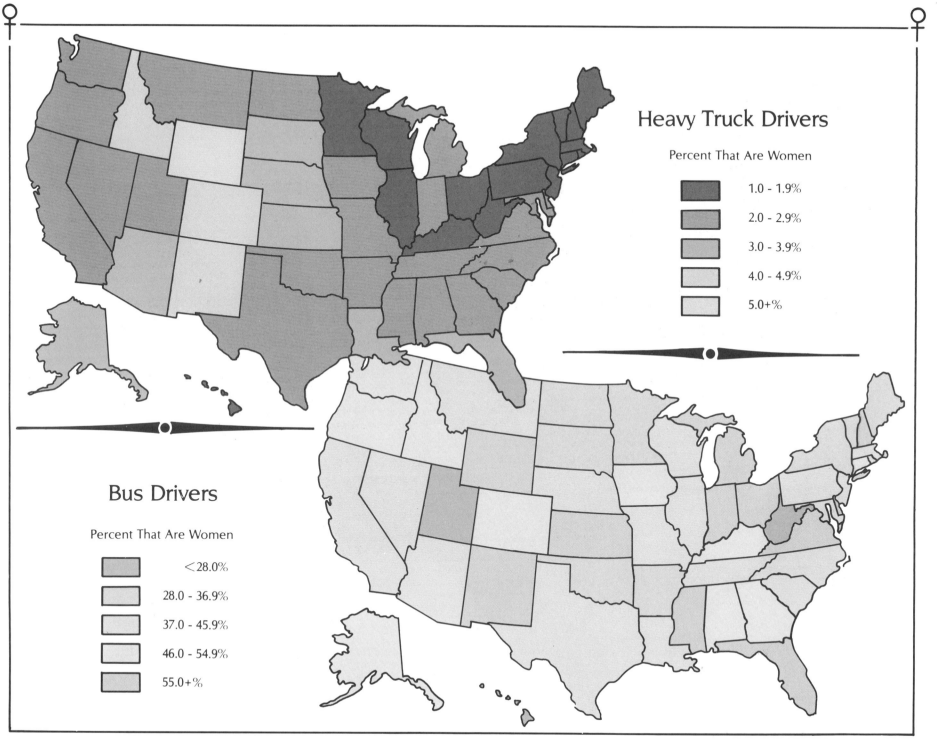

Heavy Truck Drivers

Percent That Are Women

- 1.0 - 1.9%
- 2.0 - 2.9%
- 3.0 - 3.9%
- 4.0 - 4.9%
- 5.0+%

Bus Drivers

Percent That Are Women

- <28.0%
- 28.0 - 36.9%
- 37.0 - 45.9%
- 46.0 - 54.9%
- 55.0+%

FARM OPERATORS AND MANAGERS

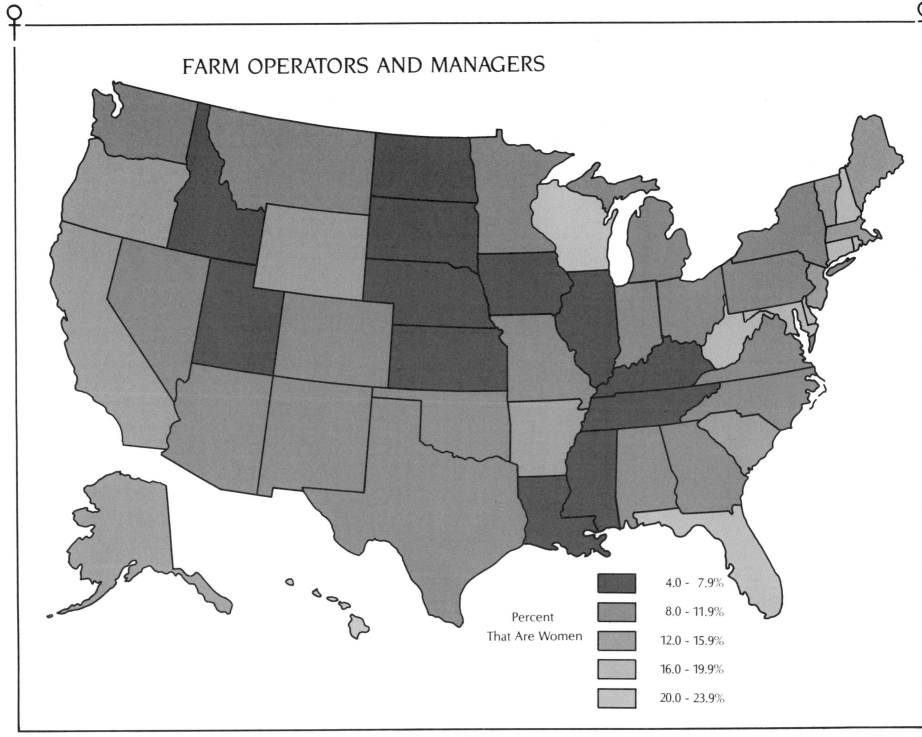

Percent
That Are Women

4.0 - 7.9%

8.0 - 11.9%

12.0 - 15.9%

16.0 - 19.9%

20.0 - 23.9%

TAKING CARE OF BUSINESS

WOMEN-OWNED FIRMS*

Number in 1977
Per 1,000 Women Aged 21+**
(Ranked Low to High)

1st (lowest)
2nd
3rd
4th
5th (highest)

$86,000+
$66,000 - $85,000
$46,000 - $65,000
<$46,000

Average Gross Receipts Per Firm, 1977

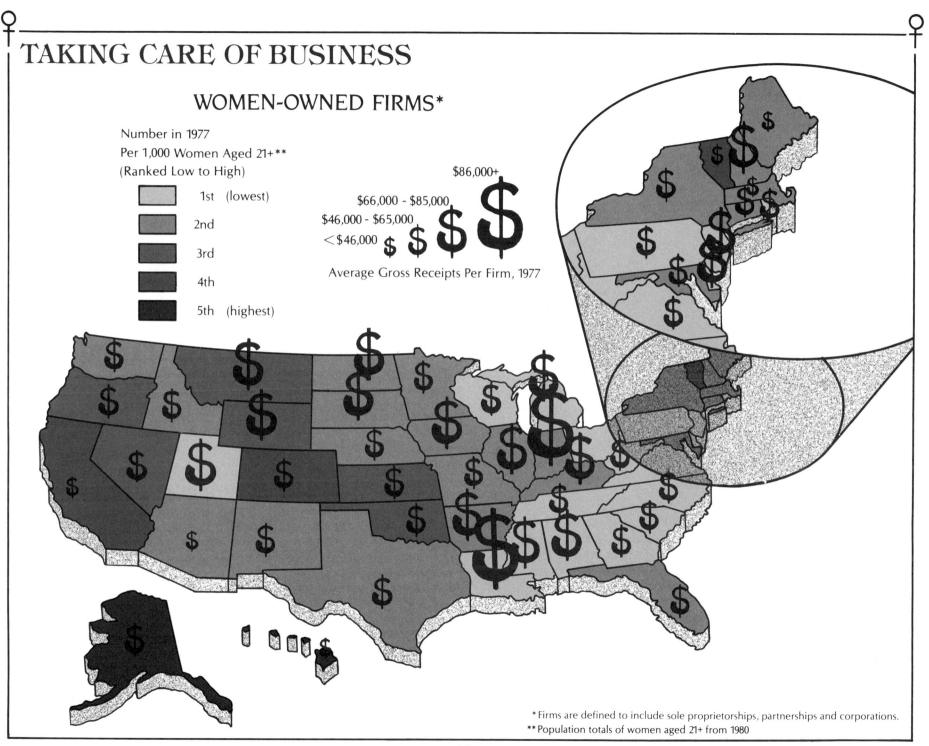

* Firms are defined to include sole proprietorships, partnerships and corporations.

** Population totals of women aged 21+ from 1980

Northeast. Bus driving is a blue collar occupation that also exhibits a wide range (47 points) of values. Bus drivers can work full time for large bus companies, or can be employed on a part-time basis as is the case with many school bus drivers. Centers of high and low values are scattered. There are clusters of states within which exist similar percentages of female employees. Examples are the Dakotas, the Midwest and the Pacific Northwest. Women are least well represented in Utah, West Virginia and Hawaii. It is difficult to establish any broad regional patterns.

Next, look for maps that reveal occupations that are highly polarized; that is, strongly dominated by one sex. In very polarized jobs, the range of values is often quite narrow. The maps "Secretaries" and "Construction Workers" provide good examples. Secretarial work is considered "women's work." By mapping the percentage of secretaries that are women, we find that this stereotype is confirmed. In all states, the percentage of male secretaries is estimated to be less than 3% of the total. It is important to realize that with such a narrow range of values, differences between states may not be statistically significant. Nevertheless, it is interesting to note that the stereotype is slightly less true in several Northwest and Far West states, and especially accurate in New England, Oklahoma and Arkansas.

At the opposite end of the spectrum, we encounter women who are construction workers, a distinct minority of all such employees. Despite the relative influx of women into blue collar trades in recent years, this is a male-dominated occupation in which women accounted for only about 2% of all employees. Construction workers were slightly more likely to be female in the Southwest and Plains states.

Other examples of polarized occupations include clergy, truck drivers, welders and firefighters, all of whom tended to be male. Those waiting on tables, cashiers,

and textile workers are more likely to be female. Among major occupational categories, rarely are women more than 20% of transportation and material-moving workers, precision production, craft and repair employees or farm operators and managers. However, *major* occupational categories often have a wide range of female to male ratios because they include many varied types of specific jobs. For example, women comprise between 47% and 72% of all service workers, depending on the state. Yet specific service jobs, such as firefighters and persons waiting on table can be strongly dominated by one or the other sex.

Finally, notice data breakpoints on the maps, specifically those around 25% (used to define traditional versus non-traditional employment for women) and the 50% mark around which we centered our color scheme. Note states where women exceed these levels of participation for any given job, and occupations for which the ranges fall below the 25% line, above the 50% mark, or in between. There are several occupations, such as technicians and retail trade managers, that are no longer non-traditional for women, but where women still constitute less than half of those employed. By comparing regional patterns on different maps, you should be able to isolate geographical areas where occupations are, on the whole, more likely to follow male-female stereotypes as opposed to areas where jobs are less sex typed. It is these regions of the country where men and women will have the most opportunity to work in the job that suits them best as individuals.

TAKING CARE OF BUSINESS

We conclude this section with the maps "Women-Owned Firms' and "Women's Banks." If women's sphere has

has traditionally been the home, the world of business and finance has been the domain of men. But where once being an entrepreneur was synonymous with being male, more and more businesses are now run by women. Women-owned businesses vary from small home-based enterprises to firms with gross receipts well in excess of $100,000. The information for our map comes from the 1977 Census.

The Census definition of a firm includes sole proprietorships, partnerships and corporations. The business in question may have one or more locations or may have no fixed location, as in the case of a self-employed repairwoman. The Census provides information on the number of women-owned firms per state, and the total gross receipts of all such firms. In an attempt to standardize the data for comparison purposes, we have calculated the number of firms as a rate per 1,000 women aged 21 or over in 1980. These women would have been 18 years or older in 1977 at the time of the Census of Women-Owned Businesses. We also figured the gross receipts as an average of dollars received per firm. For example, if a state had 20 firms, with gross receipts totaling one million dollars, that would average out to $50,000 per firm.

It is interesting to note that many larger firms (as measured by gross receipts) were located in a north-south band stretching from Michigan to Louisiana, with Indiana topping the list at an average of $100,000 per firm. Several New England and Far West states had firms averaging the smallest gross receipts. The larger firms are not always located in states with the higher rates of ownership. The highest rates of firm ownership are found in states with some of the smallest gross receipts. Hawaii, California and Vermont are good examples. It is interesting to speculate if these states are characterized by large numbers of women operating small or part-time businesses out of their home while supporting children or supplementing the family income. The West in general seems to have a higher rate of women owning their own businesses.

In the past, women who wanted to start their own businesses often had difficulty receiving start-up loans from banks. Women's banks have been established with one goal being to provide financial assistance to women entrepreneurs. As of 1984, women's banks were operating in seven cities. All had been established between 1975 and 1979. An eighth bank (not mapped), the Western Women's Bank, had been founded in San Francisco in 1976, but as of 1980 it was no longer a women's bank. Five out of the seven banks existing in 1984 were in the eastern half of the U.S., and all were in or near major urban areas. As of 1983, their assets ranged between about 16 and 35 million dollars, the high figure belonging to the first such bank established, the First Women's Bank in New York City.

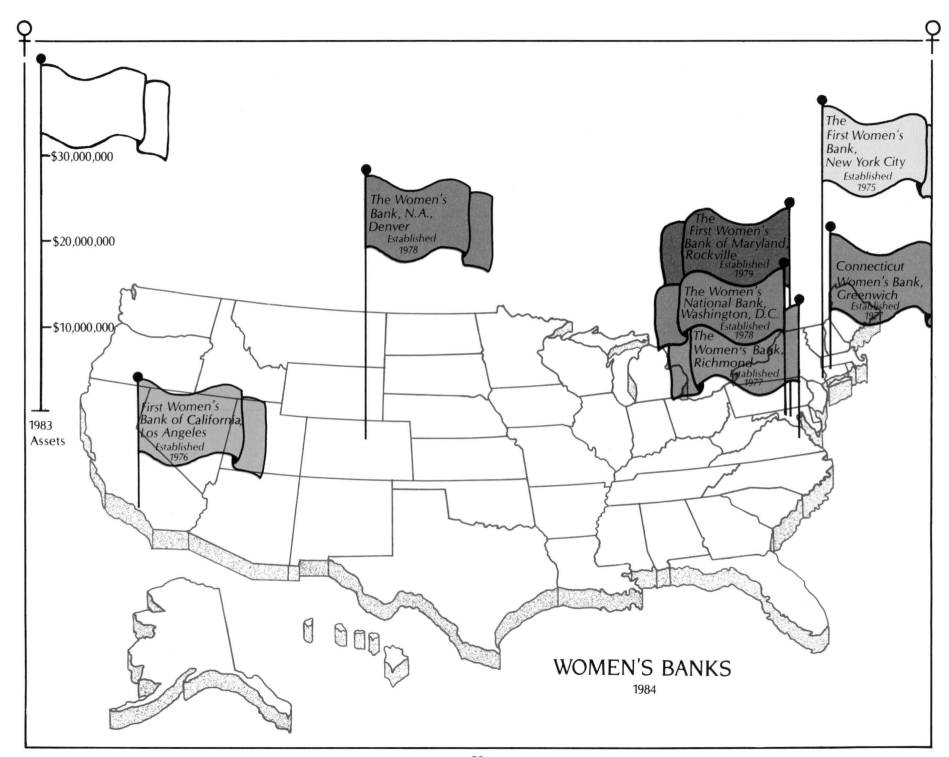

$30,000,000

$20,000,000

$10,000,000

1983 Assets

First Women's Bank of California, Los Angeles *Established 1976*

The Women's Bank, N.A., Denver *Established 1978*

The First Women's Bank of Maryland, Rockville *Established 1979*

The Women's National Bank, Washington, D.C. *Established 1978*

The Women's Bank, Richmond *Established 1977*

The First Women's Bank, New York City *Established 1975*

Connecticut Women's Bank, Greenwich *Established 1977*

WOMEN'S BANKS

1984

FAMILY

"Above the titles of wife and mother, which, although dear, are transitory and accidental, there is the title human being, which precedes and outranks every other." [1]

—Mary Livermore

While the family has been extolled as a woman's greatest source of fulfillment, it has been condemned more recently as her enslaver. We are all familiar with the philosophy that a woman's place is in the home. As the setting in which children are nurtured, the home and family provide a link with immortality. Since she alone is able to bear children, a woman's primary purpose has been defined as nurturing and caring for those children. While to many the appellations of wife and mother are dear, to paraphrase Ms. Livermore, many women have felt the need to establish other identities.

Our Victorian forebears promoted the view that home and family were a woman's proper, and only legitimate, spheres of activity. For a woman to concern herself with anything other than the welfare of her family and household was to invite the label of being "unfeminine." In her roles as daughter, wife and mother, the woman was idealized as creating a place of peace and serenity in the home. This haven contrasted sharply with the aggressively "masculine" business world.

Men's traditional role in the family has meant that women first were provided for by their fathers and then their husbands. There was little place for a woman who did not marry and have children. Social and cultural attitudes strictly defining a woman's place were reinforced by legal restrictions on her right to work, marry, own property and control her finances. A woman's first duty was to produce children, preferably sons. In some societies, women had little freedom or power, even within the family circle, until they had produced children *and* outlived their childbearing years.

In Western society during the late 19th century, women began to seek equality with men. Women de-

manded that they no longer be solely thought of as human beings who can only produce children. The bid for freedom brought with it increased responsibility as women pursued work outside the home setting. The redefinition of traditional male and female roles produced tension, confusion and, some would maintain, the disintegration of the family.

The redefinition process continues today. One of the issues at the heart of this transition is that of childcare. If women are to be allowed opportunities for personal growth and economic autonomy, someone else must assume partial responsibility for childcare. No longer can it be assumed (if indeed it ever could) that a father or husband will provide economic support so that a mother can remain home. All too often, mothers must work outside the home to support their children. For these reasons, acceptable alternative childcare must be available.

The childcare problem is not new to our century. Wealthy families have always been able to hire help. The 18th and 19th centuries in Europe witnessed the utilization of "baby farms" where women forced to work could send their infants. Baby farms were notorious for abysmally inadequate care. Today we are experimenting with a variety of childcare arrangements. Perhaps the husband will assume more responsibility for direct supervision. Perhaps a live-in nanny will be hired to provide care within the home setting or the child might be placed in a daycare center. State and federal funding has been made available to support some childcare facilities, most noticeably for low-income women so they can return to work. Unfortunately, these programs have suffered cutbacks in recent years and not enough spaces are available to meet the demand. Some employers have attempted to assist with childcare provision, either by providing on-site daycare, by setting up referral services to connect families with childcare programs, or by making the service available through a voucher system. Despite these alternatives, the problem has yet to be adequately addressed.

These societal changes have resulted in changes in household structure. While we are part of a family, we live in households consisting of those persons with whom we share living space on a daily basis. The Census Bureau divides households into two types, family and non-family. A family household is made up of two or more persons living together who are related by birth, marriage or adoption. Examples include a married couple with or without children, a child with an elderly parent or a brother and sister. The number of family households declined from 80% of all households in 1970 to 73% in 1980.[2] The number of married couple households as a percentage of all households also declined steadily from 1950 when the figure was 78%, to 69% in 1970 and 60% in 1980.[3] The traditional family household composed of two parents and children is giving way to more diverse and individually tailored living arrangements.

For many people, a household shared with non-family members has come to fulfill many of the functions of a family, specifically, those of companionship and shared economic responsibility. A non-family household consists of a person living alone or with unrelated roommates. In 1970, it was estimated that non-family households comprised 20% of all households, a figure that had risen to 27% in 1980.[4] One contributing factor to this rise has been the increased number of men and women who choose to live together out of wedlock. Such couples are counted as non-family households. While cohabitation is still technically illegal in a number of states, action is rarely taken against the participants. Women were estimated as more likely to live alone than men, a difference of 10% versus 6%.[5]

Not only has the composition of households altered,

but so has the structure of power and authority within. Traditionally in Western society, a male (husband, brother or eldest son) has been designated as head of the household and was responsible for making major decisions and providing economic support. His wife and female relatives were expected to follow where he chose to lead. The recently edited diaries and letters of 19th century frontier women made it clear that they often followed their menfolk with great reluctance.

Nowadays, changing attitudes and household composition have resulted in more women assuming the position of household head. While 35 years ago only 15% of adult women headed their own households, by 1980 the proportion had risen to 25%.[6] Women headed 28% of all households in 1980 compared with 21% in 1970. They also headed more than half of non-family households (57%), 17% of family households (up from 11% in 1970) and 4% of married couple households.[7] It is clear that in married couple households the male partner still assumes the role of head, but at least the 1980 Census allowed a choice. The 1970 Census only allowed for male heads in married couple households.

One of the most striking phenomena has been the rise in the percentage of families headed by women with no husband present. Eighty-two percent of women heading families in 1980 had no spouse in the household, a situation characteristic of one in six family households. Fifty-eight percent of these women had children under 18, a slight increase (3%) from ten years before.[8] More and more children are now living in single parent households.

There are many factors contributing to these changes in household structure. Women on the average are marrying later or not at all. In 1950 the age at first marriage for women was 20.3 while by 1981 it had risen to 22.3.[9] Women who once would have remained in their parents' home until they married are now setting up housekeeping by themselves or with friends.

While the marriage rate for 1980 (10.6 marriages per 1,000 persons)[10] was very close to that 30 years earlier, the divorce rate has doubled. If the divorce rate is calculated per every 1,000 married women 15 and older, the figures are even more startling: from 10.3 divorces in 1950 to 22.6 in 1980.[11] In a sampling of 30 states, the average length of a marriage prior to divorce was only 6.8 years.[12] More than one-third of all divorces happened in the first four years of marriage.[13]

A larger proportion of female-headed families has occurred also because of the increase in out of wedlock births. In the early 1950s about 16 out of every 1,000 single women of childbearing age gave birth, in contrast with 29 per 1,000 in 1980.[14] Despite this trend, however, fertility and the birth rate have in general declined. Women averaged about two children in 1980 versus three in 1950.[15] Some have chosen not to have children at all. The birthrate dropped from 24.1 births per 1,000 in 1950 to 15.7 per 1,000 in 1981, a decrease of 35%.[16]

At the other end of the age span, women outlive men, and so many elderly women live alone. In 1981, 50% of women over 65 were widowed.[17] In just ten years, between 1970 and 1980, the proportion of widows living alone increased 23%.[18]

SINGLE BLISS(?)

The first map of this section, "Single Women" shows the percentage of women 15 years and older who were single in 1980. The percentages varied from a low of 17% in Oklahoma to 29% (almost one-third) in Massachusetts. In ten states at least one in four women were single. Single women were concentrated clearly in the Northeast and Midwest. States with large urban areas

SINGLE BLISS (?)

SINGLE WOMEN

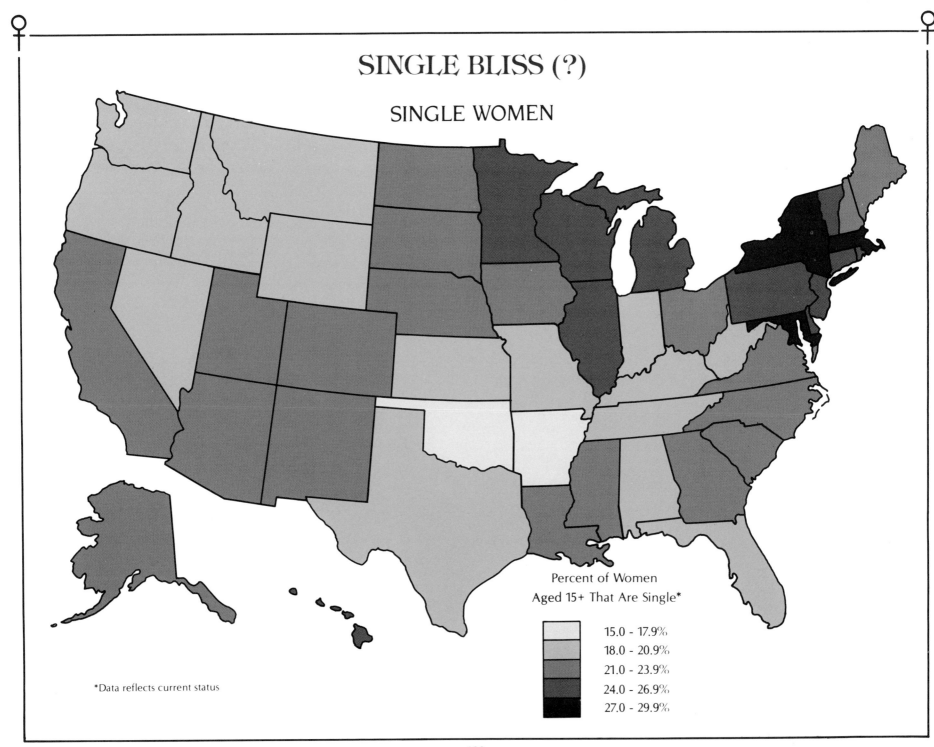

Percent of Women
Aged 15+ That Are Single*

	15.0 - 17.9%
	18.0 - 20.9%
	21.0 - 23.9%
	24.0 - 26.9%
	27.0 - 29.9%

*Data reflects current status

and larger populations tended to have large proportions of single women. For women who choose not to be homemakers, urban areas offer the widest selection of career opportunities.

The "Single Men Vs Single Women" map allows a comparison between single men and single women, presented as the number of single men for every 1,000 single women in that age group. We might expect that there would be a higher number of single men in those states that also have a high number of single women. But as the "Women Vs. Men" map shows, the opposite is true! States that had a high percentage of single women also had a lower ratio of single men to women. The Northeast is a good example. Here, the numbers of single men and women were about equal, a region contrasting sharply with many of the western states where there were between 300 and 680 more single men for every 1,000 single women. These latter were states with among the lowest percentages of single women. Remember that single people tend to be younger on average than the total adult population and that it is in the younger age groups that men are most likely to outnumber women. States where women have very high median ages (such as those in the Northeast) were states where the numbers of single men and women were much closer.

If you are a single person and want to increase your opportunities to meet singles of the opposite sex, it might be of interest to explore the distribution of singles in large cities across the country. Urban areas in general tend to have more singles, varying between 30% and 70% of the population, than the surrounding areas. We have presented two maps depicting the percentages of single women and men in cities with populations greater than 250,000.

It is important to note that these maps show the percentage of all women (or all men) 15 + that are single,

not the ratio of single men to single women. It is possible for a city to have a higher percentage of men who are single than women, and yet to have those women actually outnumber the men. Boston and Washington, D.C. had the highest percentages of women who are single, while Boston also topped the list for men. The cities where 50% to 59% of women are single far outnumber the cities in that category for men. Cities with percentages over 50% tend to be located in the East. Western cities are more likely to have between 20% and 40% of the population being single for both men and women. Only one city has less than 30% of the female population as single, while there are ten such cities for men.

MAKING IT LEGAL(LY)

Since the 1960s, it has been more acceptable and increasingly popular for men and women to live together without benefit of a formal marriage ceremony. The lack of such a ceremony does not always mean that the couple is not legally married. So-called common law marriage, in which the couple jointly agrees to live as husband and wife (as distinguished from simple cohabitation), has been recognized in many states. States which allow common law marriage may prohibit cohabitation. This method of contracting a marriage was particularly useful on the frontier when it was not always possible to have a civil or religious official available to solemnize the couple's decision.

We have mapped the status of common law marriage in the U.S. as of year end 1981. Some states, although they no longer recognize common law marriages contracted in their *own* jurisdiction, will recognize such a marriage if it has been legally contracted in *another* state.

WOMEN VS. MEN
Aged 15+

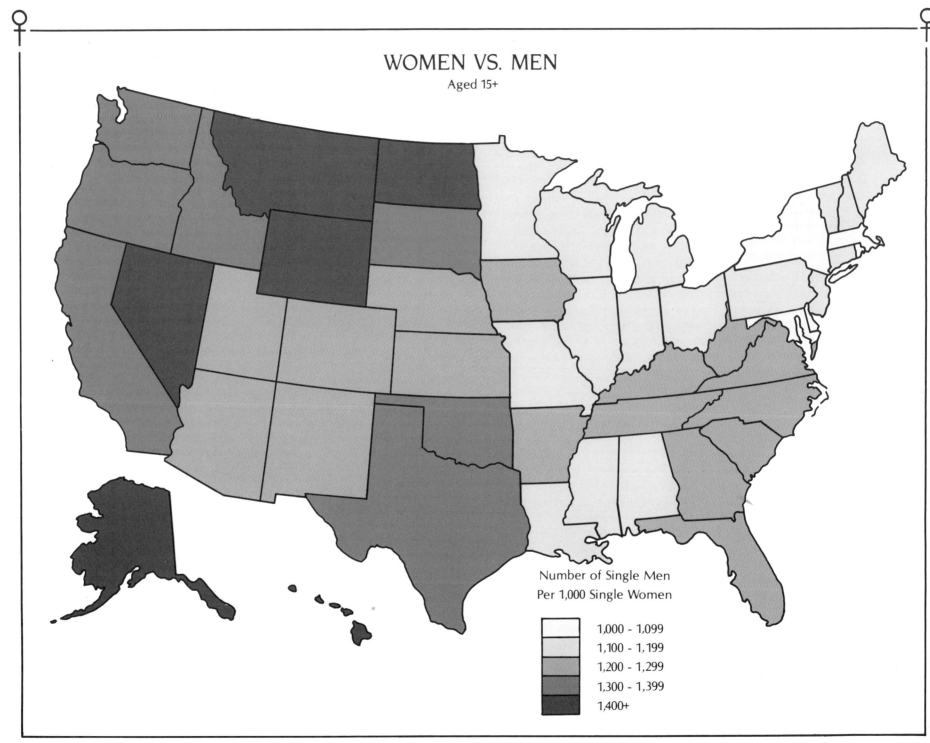

Number of Single Men
Per 1,000 Single Women

1,000 - 1,099
1,100 - 1,199
1,200 - 1,299
1,300 - 1,399
1,400+

SINGLE WOMEN
In Major Cities (>250,000)

Percent of Women That Are Single
Aged 15+

30.0 - 39.9%

40.0 - 49.9%

50.0 - 59.9%

60.0 - 69.0%

SINGLE MEN
In Major Cities (>250,000)

Percent of Men That Are Single
Aged 15+

30.0 - 39.9%

40.0 - 49.9%

50.0 - 59.9%

60.0 - 69.9%

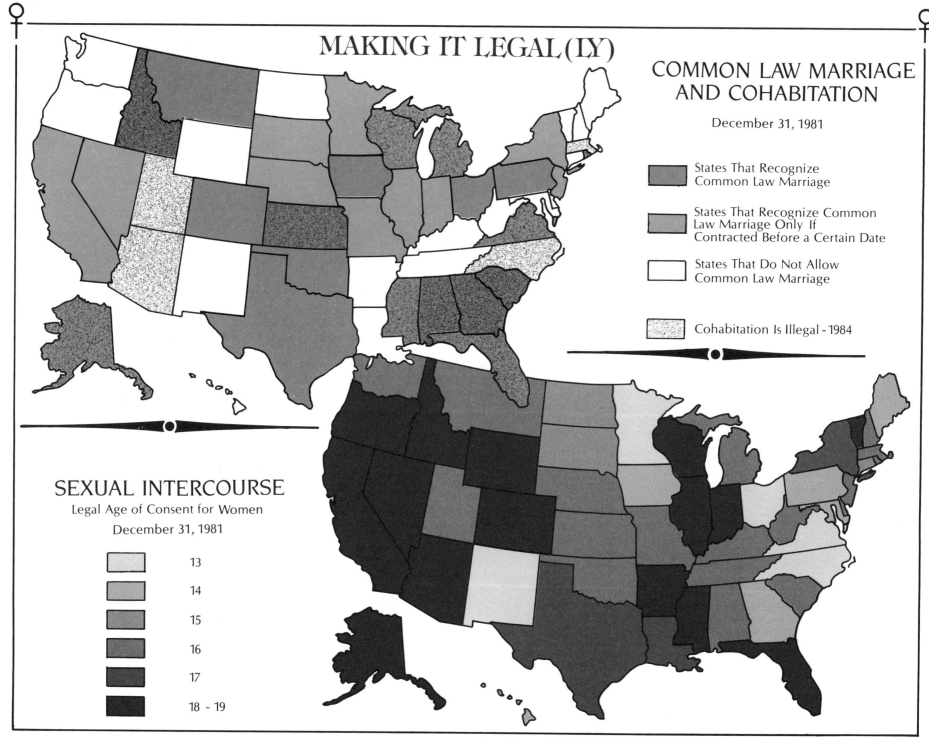

MAKING IT LEGAL (LY)

COMMON LAW MARRIAGE AND COHABITATION

December 31, 1981

States That Recognize Common Law Marriage

States That Recognize Common Law Marriage Only If Contracted Before a Certain Date

States That Do Not Allow Common Law Marriage

Cohabitation Is Illegal - 1984

SEXUAL INTERCOURSE

Legal Age of Consent for Women

December 31, 1981

13
14
15
16
17
18 - 19

The "Common Law Marriage and Cohabitation" map shows only those 13 states where it was legal to contract a common law marriage within that jurisdiction. The map does not indicate which states will recognize such a marriage if legally contracted elsewhere. Sixteen states recognized common law marriage contracted in their own jurisdiction only if entered into before a specified date, varying between 1631 in Virginia and 1968 in Florida.

There is quite a difference in the minimum ages at which sexual intercourse is legal for women. While five states set the minimum at 13, Wyoming decided that 19 was more appropriate.

As of 1983, persons 18 or older were free to marry in all states except Mississippi and Wyoming, where the ages were 21 and 19, respectively. Younger persons wishing to marry had to obtain the consent of a parent or guardian. At the youngest ages, court consent was also required. The "Marriage Laws" map shows the youngest statutory age at which a woman could marry receiving parental consent only. If court permission was obtained, it was often possible to marry at a younger age than specified on the map. Occasionally, parental consent was not required if the woman was pregnant or had had a child by her fiancé. Four states, Alabama, South Carolina, Texas and Utah had set the minimum age of consent with parental permission at 14, while another seven states designated 18 as being appropriate. Sixteen appeared to be the age favored by most states.

THE TIE THAT BINDS

We would expect that the distribution of married women (those *currently* wedded, including separated) would be related to that for single women. Not surprisingly, areas such as the Northeast that had a high percentage of women who were single also had a relatively low percentage of women aged 15 or older who were married. In no state was the percentage of married women less than 50%. In a few states, about two out of every three women were married. Areas with the highest proportions of married women included Utah, Wyoming, Idaho and Alaska. It is not surprising that Utah ranked high since the Mormon population is especially supportive of marriage and large families.

While the average age at first marriage is higher now than it was 30 years ago, a significant portion of women still marry when they are teenagers. In recent years, the phenomenon of teenage marriage has become a cause for concern in this country. Women who marry young often are not able to complete their education and compete successfully in the job market. The 1980 Census estimated that in three states, Oklahoma, Wyoming and Kentucky, one out of 10 women between the ages of 15 and 18 was married. There appeared to be a relationship between the proportion of all women who were married and the frequency of teenage marriage. New England, the Northeast and the Great Lakes states were all areas with a low proportion of teenage marriage. States with a higher rate extended in a band from West Virginia to Texas, coinciding with one we saw for married women. However, Alaska had a high percentage of married women but a relatively low rate of teenagers entering wedlock.

A comparison of marriage and divorce rates is the subject of the "Marriage Rate," "Divorce Rate" and "Marriage Vs. Divorce" maps. The marriage rate is expressed as the number of marriages contracted in a given year per 1,000 persons. The divorce rate is computed in a similar fashion. Marriage rates in 1980 varied from a low of 7.5 per 1,000 in Delaware to a high of 142.8 in Nevada, while other high rates were experienced in South

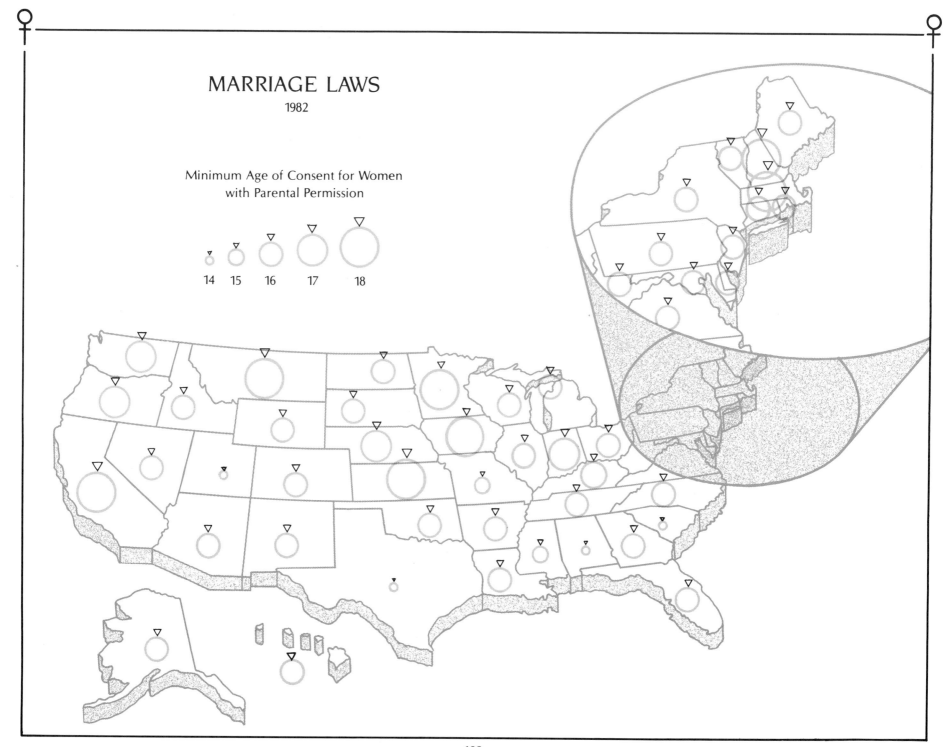

MARRIAGE LAWS
1982

Minimum Age of Consent for Women
with Parental Permission

14 15 16 17 18

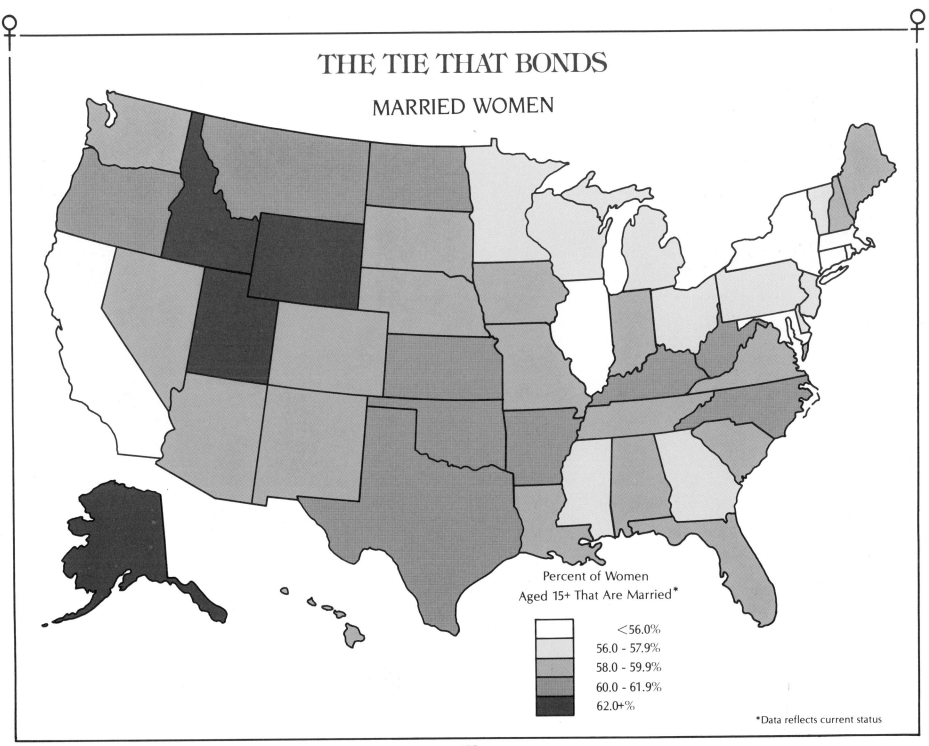

THE TIE THAT BONDS

MARRIED WOMEN

Percent of Women
Aged 15+ That Are Married*

<56.0%
56.0 - 57.9%
58.0 - 59.9%
60.0 - 61.9%
62.0+%

*Data reflects current status

TEENAGE MARRIAGE

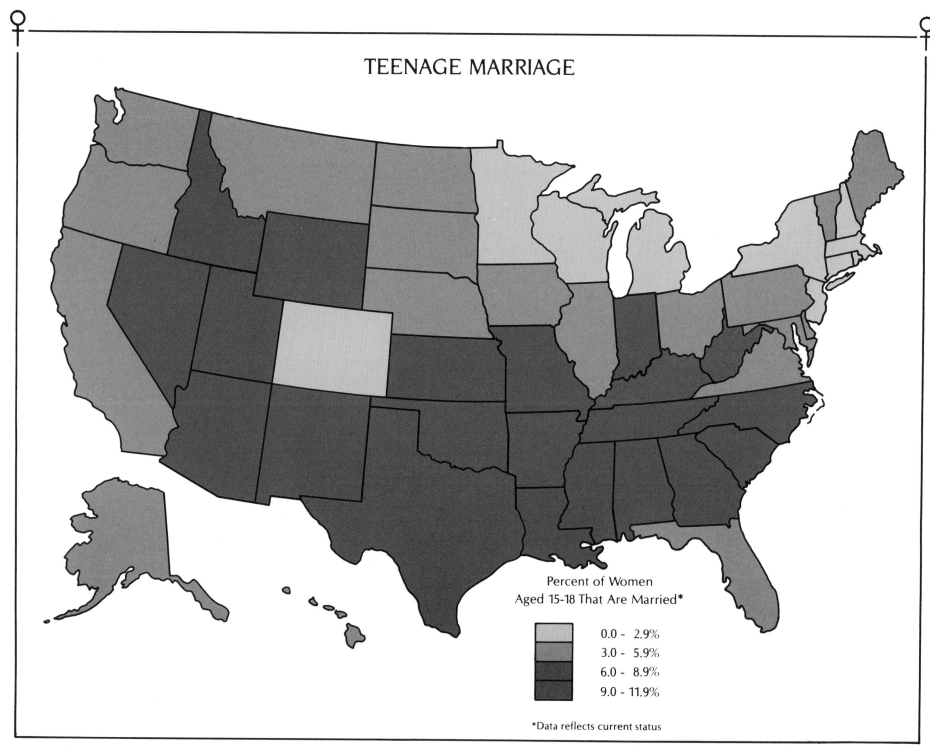

Percent of Women
Aged 15-18 That Are Married*

0.0 - 2.9%
3.0 - 5.9%
6.0 - 8.9%
9.0 - 11.9%

*Data reflects current status

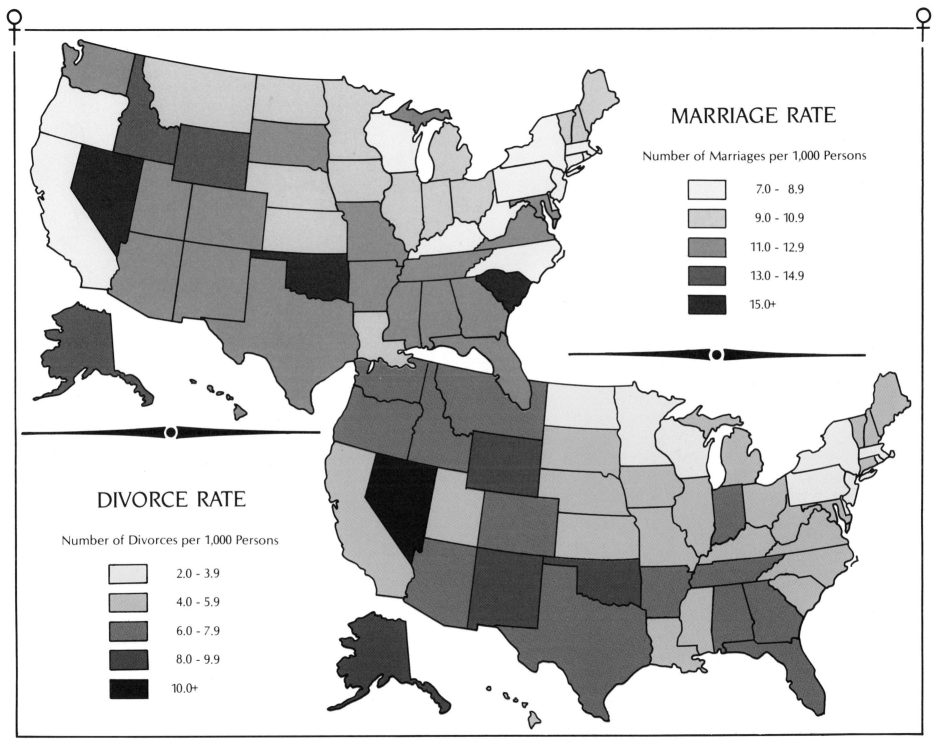

MARRIAGE RATE

Number of Marriages per 1,000 Persons

- 7.0 - 8.9
- 9.0 - 10.9
- 11.0 - 12.9
- 13.0 - 14.9
- 15.0+

DIVORCE RATE

Number of Divorces per 1,000 Persons

- 2.0 - 3.9
- 4.0 - 5.9
- 6.0 - 7.9
- 8.0 - 9.9
- 10.0+

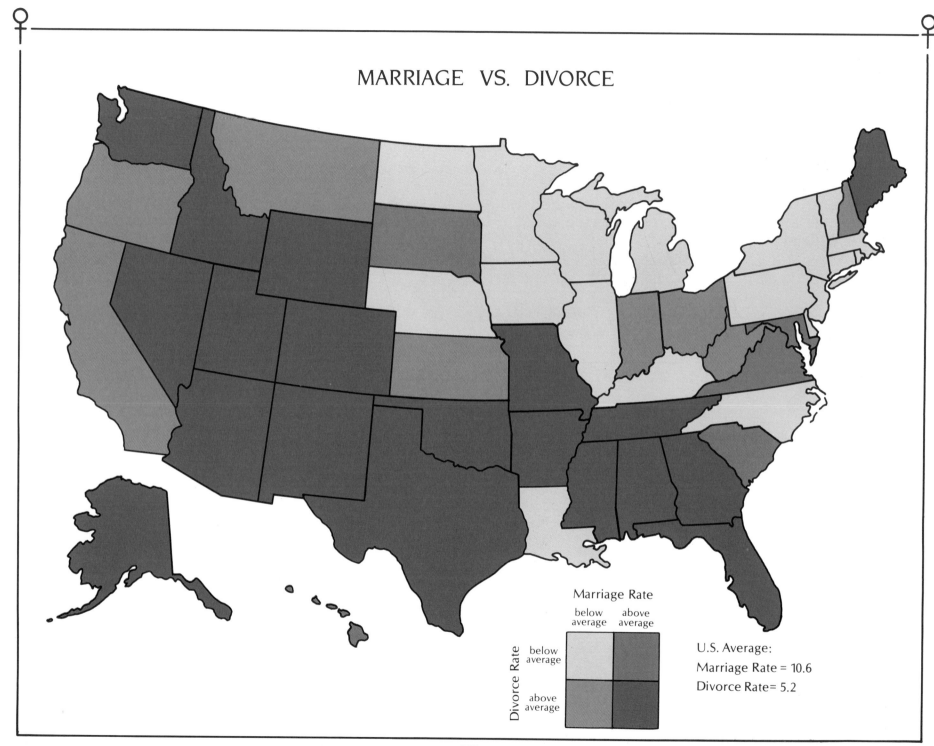

MARRIAGE VS. DIVORCE

Marriage Rate

below average above average

Divorce Rate

below average

above average

U.S. Average:

Marriage Rate = 10.6

Divorce Rate = 5.2

Carolina and Oklahoma. In general, rates in the South and West (excepting California and Oregon) were higher than those in the North and East. The range of divorce rates was narrower than that for marriage, starting with a low of 2.9 divorces per 1,000 persons in Pennsylvania and ranging to a high of 17.3 exhibited by Nevada. The lowest values were concentrated in the Northeast and the region around Minnesota while the highest values predominated in the South and Far West, especially Alaska, Wyoming, New Mexico and Oklahoma, in addition to already mentioned Nevada.

Note that Nevada had both the highest marriage and divorce rates in the country, considerably ahead of the second place contenders, South Carolina and Alaska, respectively. These figures reflect the liberal marriage and divorce laws in this state. The marriage rate in Nevada was eight times that of South Carolina and 14 times that of the national average while its divorce rate was twice that of Alaska!

It is not always easy to compare distributions on two separate maps. In an attempt to overcome this problem, we have used a two-variable choropleth map entitled "Marriage Vs. Divorce" to combine information about marriage and divorce rates. Each state's marriage and divorce rates are classified as being either above or below the national average. This technique allows us to classify the states into four categories: those with both marriage and divorce rates higher than average; those with both rates lower than average; states with high marriage rates but low divorce rates; and states with low rates of marriage combined with a high incidence of divorce. Two groups of states, centered roughly on Mississippi and Utah, fall into the first category. Perhaps these are regions where people are quick to marry and relatively quick to divorce. Another explanation might be that since these states have a high percentage of married women, there is a larger pool of potential di-

vorces. The Northeast and northern Midwest present the opposite situation. Here people were slow to marry and slow to divorce. Or perhaps a better explanation is that it's hard to have a high divorce rate when a large percentage of the population is not married! A comparison with the map of married women might yield some clues. Some states, such as Hawaii, South Dakota, South Carolina, Virginia and Maryland, had above-average marriage rates, combined with a below-average incidence of divorce. A final few states were characterized by the reverse situation.

Breaking Up Is Hard To Do

The next four maps may help provide clues to the patterns on that of "Marriage Vs. Divorce." The first map, "Divorced Women" shows the percentage of women who were currently divorced in 1980. (Women who had been divorced but then remarried would be included under married women.) States with the highest proportions of divorced women were predominantly located (with the exception of Florida) in the Southwest, extending up the West Coast. In Nevada, over 10% of the women aged 15+ were divorced and not currently remarried. By contrast, in Louisiana and several northern Plains and eastern seaboard states, less than 6% of women were divorced.

The "Median Duration of Marriage" map presents information on median duration of marriage prior to divorce in 30 states. The taller the state, the longer the marriage. Many of the states with above-average durations are the same states that had below-average marriage and divorce rates. This pattern suggests that while people in these regions were slower to marry, they also waited longer before getting a divorce. The short dura-

BREAKING UP IS HARD TO DO
DIVORCED WOMEN

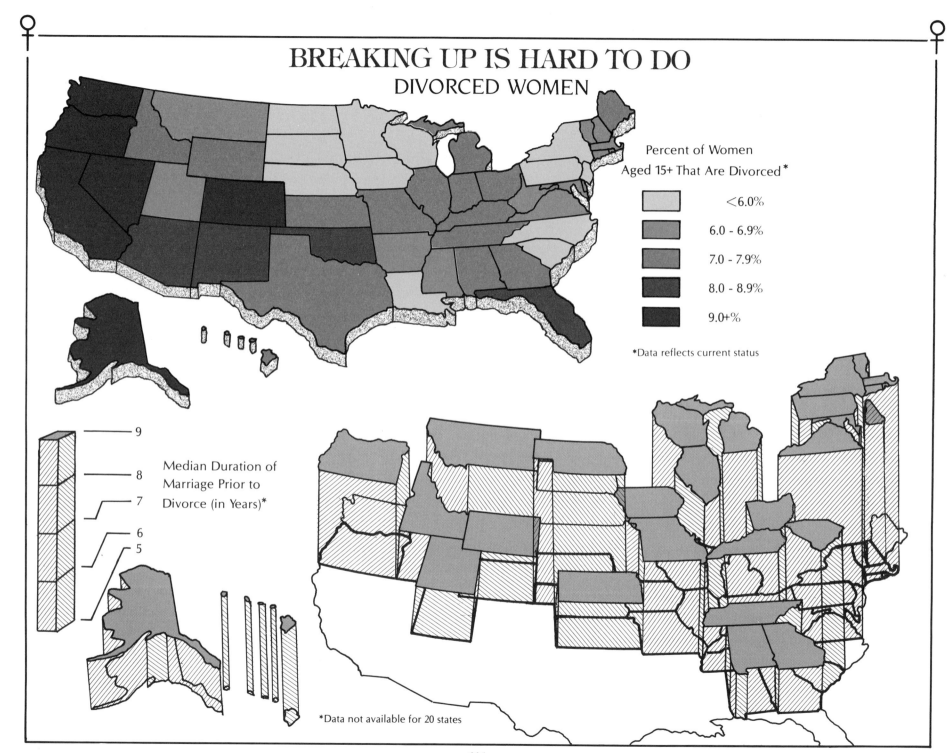

Percent of Women
Aged 15+ That Are Divorced*

	<6.0%
	6.0 - 6.9%
	7.0 - 7.9%
	8.0 - 8.9%
	9.0+%

*Data reflects current status

Median Duration of
Marriage Prior to
Divorce (in Years)*

9
8
7
6
5

*Data not available for 20 states

tion of marriage in several southeastern states that had above-average marriage and divorce rates suggests that here people were quick to marry but just as quick to divorce!

A trial separation is often the first step towards divorce. If this is true, we would expect that the distribution of separated women might match the distribution of divorced women. The "Separated Women" map reveals both similarities and differences. The northern Plains states had a low percentage of both separated and divorced women. The region centered on Appalachia had middle range values on both maps. However, many northeastern and several southern states had high proportions of women who were separated but low proportions of divorced women. North Dakota had the lowest percentage of separated women while Maryland/District of Columbia had the highest, at 1% and 9%, respectively.

Widows accounted for between 10% and 15% of all women 15+ in 42 states. They were a smaller proportion of the female population in the western states. Alaska ranked last at only 4%. Higher values are concentrated in the South and Northeast.

KID STUFF

The fertility ratio is a measure of the number of children under 5 per 1,000 women of childbearing age. The mapped distribution of the fertility ratio in 1980 shows well defined pockets of high and low values. Not surprisingly, these "pockets" often coincide with regions we have seen defined on earlier maps of marital status. The Northeast was an area in which very low fertility ratios coincided with a low percentage of women who were married. In Montana, Utah, Idaho, Wyoming and

Alaska, the reverse was true. North Dakota had a very low fertility ratio, despite the high proportion of married women.

Closely related to the fertility ratio is the birth rate. While the birth rate for the United States is relatively low in the international context, there was wide variation among the states, from a low in Connecticut of 12.5 births per 1,000 persons in 1980 to a high of 28.6 in Utah. Alaska too had a high birth rate, in part because it was the only state in which over half the women were of childbearing age. The high values start in Mississippi, move into the Southwest and spread up into the Rockies. Births were considerably less frequent in the Northeast and Midwest.

It has become much more common in recent years for women and men to have children out of wedlock. As more young women become sexually active, the rate of unintended pregnancy has increased. Such pregnancies are more common among low income and some minority groups. Occasionally, financially secure older women now deliberately choose, even though they are not married, to have children. Depending on the state, between 6% and 28% of all births in 1980 were out of wedlock. In the District of Columbia and Mississippi, one out of every four births was to an unmarried woman. With the exception of Illinois, the highest rates were in states lining the Gulf Coast and eastern seaboard. Many of these states had relatively large numbers of rural women in poverty (the Deep South) or major cities with a large number of urban poor (New York, New Jersey, Illinois and the District of Columbia). In only four states, Utah, Wyoming, Idaho and North Dakota, were out of wedlock births less than one in 10.

Some statistics focused specifically on births to teenage women in 1982. It is alarming to note that in many states nearly half of these births were out of wedlock, with the percentages being much higher for teenagers

SEPARATED WOMEN

Percent of Married Women Aged 15+
That Are Separated*

1.0 - 1.9%

2.0 - 2.9%

3.0 - 4.9%

5.0 - 6.9%

7.0 - 9.9%

*Data reflects current status

WIDOWS

Percent of Women Aged 15+
That Are Widowed*

<7.0%

7.0 - 8.9%

9.0 - 10.9%

11.0 - 12.9%

13.0 - 14.9%

*Data reflects current status

KID STUFF

FERTILITY RATIO

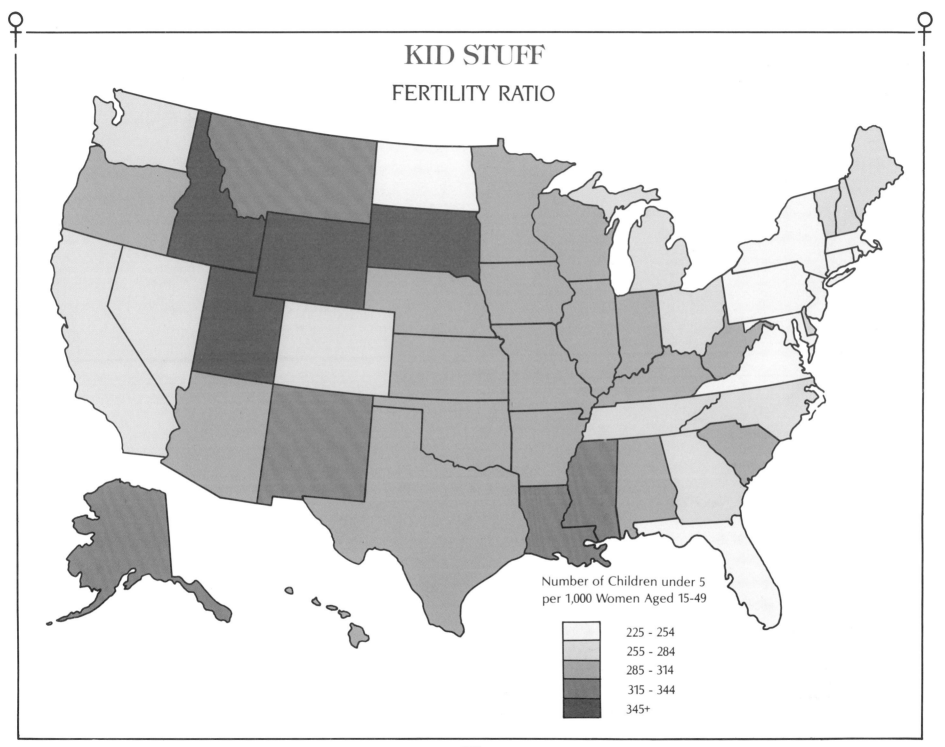

Number of Children under 5
per 1,000 Women Aged 15-49

225 - 254
255 - 284
285 - 314
315 - 344
345+

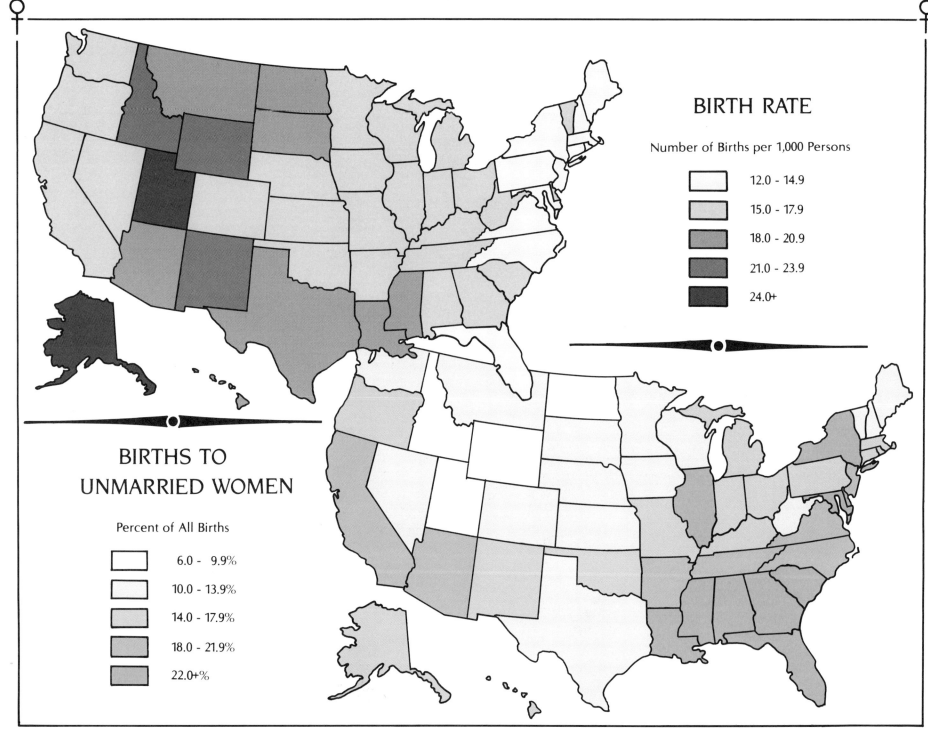

BIRTH RATE

Number of Births per 1,000 Persons

12.0 - 14.9

15.0 - 17.9

18.0 - 20.9

21.0 - 23.9

24.0+

BIRTHS TO
UNMARRIED WOMEN

Percent of All Births

6.0 - 9.9%

10.0 - 13.9%

14.0 - 17.9%

18.0 - 21.9%

22.0+%

than women in general. Looking at the map we can see a definite east-west division. Teenage mothers in the West were somewhat more likely to be married than in the East, although the Appalachian region was a notable exception. In eight states, located mostly in the Northeast, six out of 10 births to teens were out of wedlock. However, in two of these states, Massachusetts and Connecticut, teen births as a percentage of all births were relatively very low. In contrast, Mississippi and South Carolina not only had a high proportion of teenagers having babies out of wedlock, but teenage births were a large proportion of all births. The Pacific Coast, Rocky Mountain and northern Plains states joined the Northeast as areas with low ratios of teen births to all births.

Cuts in publicly funded childcare have a particularly strong impact on single and low income mothers. Childcare budget cuts can be felt in several ways, including a decline in the number of children served, relaxation of program standards and reduction in staff and opportunities for staff training. Unfortunately, the distribution of funding cuts shows that many of the states that had instituted cuts between 1981–83 could least afford to do so. As a result of cutbacks in federal Title XX funds between 1981–83, more than two-thirds of the states experienced reduction in the amount of federal money available for childcare. In nine states, these cuts had a negative effect in all of the categories listed above.

ALTERNATIVE HOUSEHOLDS

With the relative number of married couple families on the decline, more "alternative households" are being formed. These include divorced women with and without children, never-married women with children and women who live alone or with unrelated roommates.

The remainder of this section focuses on women in these various types of household arrangements.

The Census estimated that in 1980, women living alone accounted for between 5% and 12% of the female population, depending on the state. Such women can be of any adult age, never married, divorced or widowed. The highest proportions of such women were concentrated in three areas: the Pacific Coast, the High Plains and the Northeast. Alaska and Hawaii had the lowest rates, with only five out of every 100 women living alone. The solitary woman was also relatively rare in South Carolina and the Rocky Mountain states. (Remember that the Rocky Mountain states had high proportions of married women.) Florida also had a high percentage of women living alone, possible reflecting large numbers of elderly widows.

Married couple families, consisting of husband, wife and any related family, make up what we think of as the "traditional" household. Yet in several states, notably New York, Maryland/District of Columbia, California, Nevada and Massachusetts, married couple families were barely 50% of all households. These "traditional" families were more prevalent in the Rocky Mountain and Plains states, and a group of states centering on Appalachia. In Idaho and Utah such families accounted for two-thirds of all households. Very few married couple families were headed by women, between only 1% and 7%. Women were most likely to assume this role in several northeastern states and least likely to be family heads in the Rocky Mountain and Plains states.

The next six maps ("Female-Headed Households," "Family Households," "Non-Family Households," "Female-Headed Households, No Husband Present," "Female-Headed Households, No Father Present [2 maps]") focus on households headed by women in 1980. Female-headed households (family and non-family inclusive) made up between 19% and 39% of all households.

BIRTHS TO TEENAGE WOMEN

1982

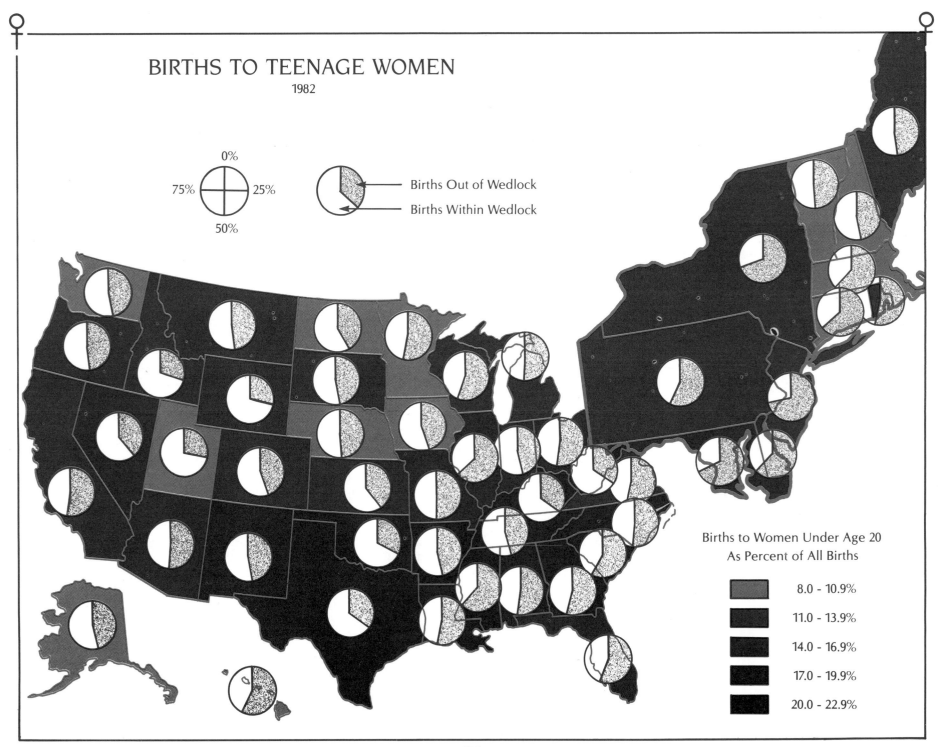

0%

75% 25%

50%

Births Out of Wedlock

Births Within Wedlock

Births to Women Under Age 20
As Percent of All Births

8.0 - 10.9%

11.0 - 13.9%

14.0 - 16.9%

17.0 - 19.9%

20.0 - 22.9%

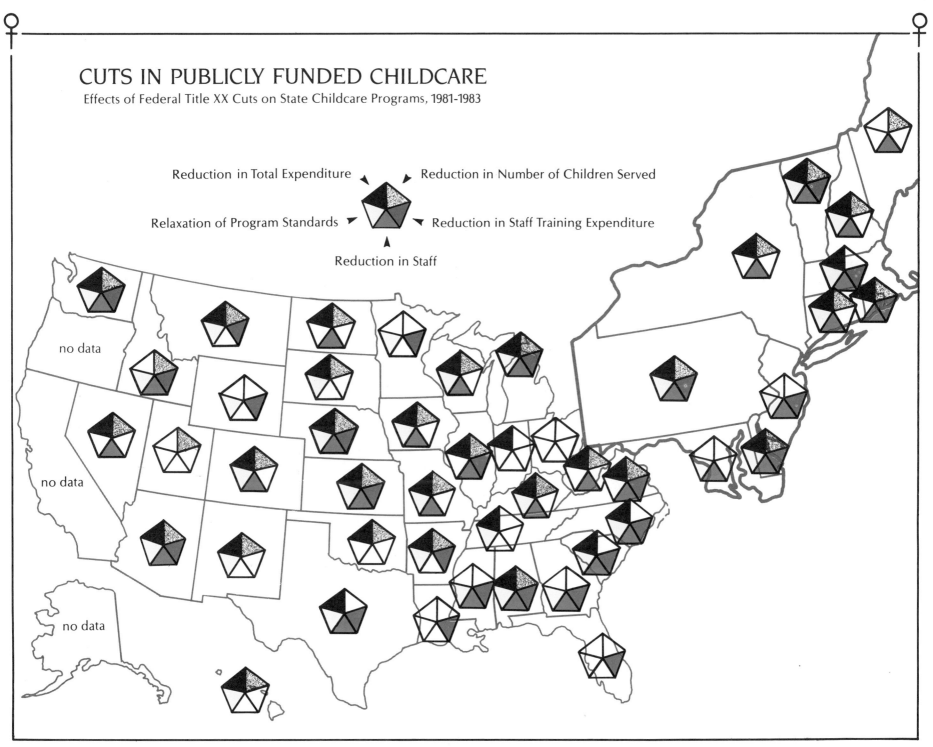

CUTS IN PUBLICLY FUNDED CHILDCARE

Effects of Federal Title XX Cuts on State Childcare Programs, 1981-1983

Reduction in Total Expenditure

Reduction in Number of Children Served

Relaxation of Program Standards

Reduction in Staff Training Expenditure

Reduction in Staff

no data

no data

no data

ALTERNATIVE HOUSEHOLDS

WOMEN LIVING ALONE

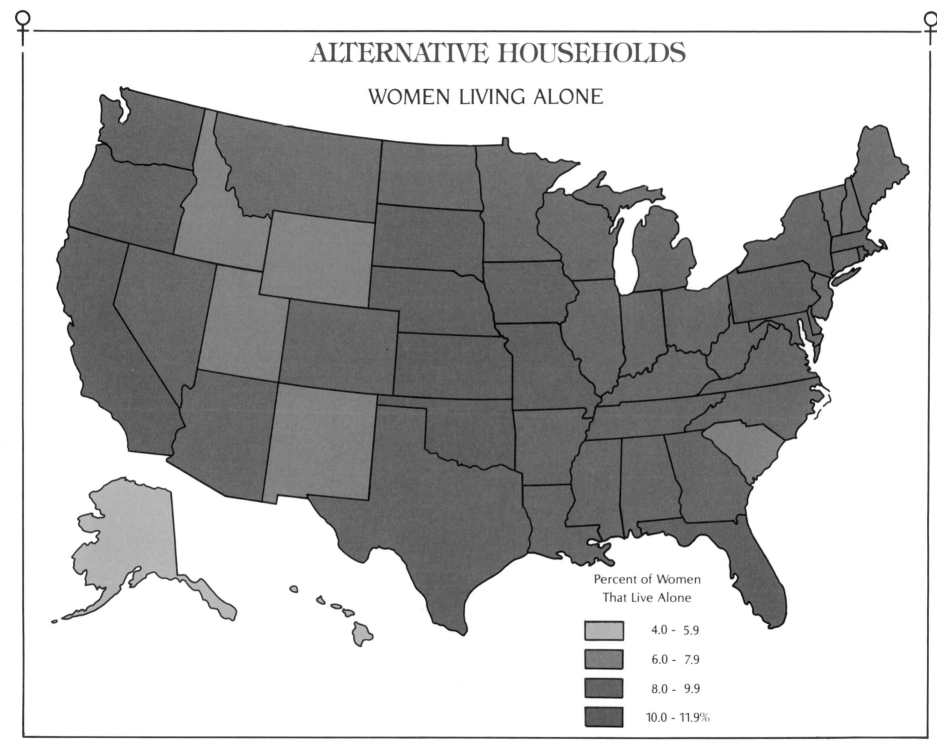

Percent of Women
That Live Alone

4.0 - 5.9

6.0 - 7.9

8.0 - 9.9

10.0 - 11.9%

MARRIED COUPLE FAMILIES

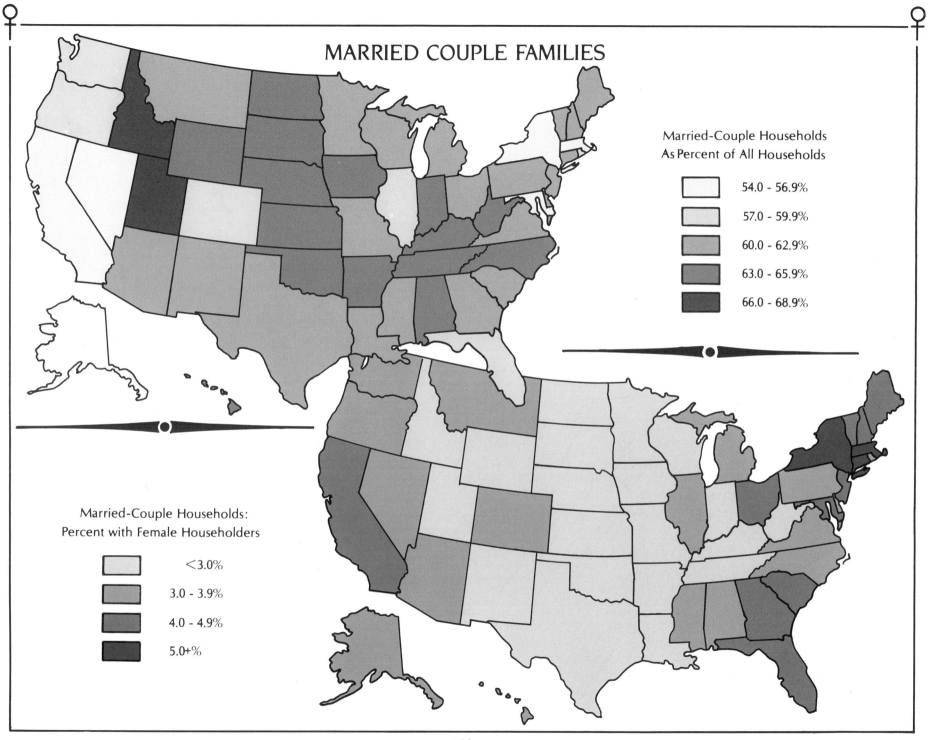

Married-Couple Households
As Percent of All Households

- 54.0 - 56.9%
- 57.0 - 59.9%
- 60.0 - 62.9%
- 63.0 - 65.9%
- 66.0 - 68.9%

Married-Couple Households:
Percent with Female Householders

- <3.0%
- 3.0 - 3.9%
- 4.0 - 4.9%
- 5.0+%

FEMALE-HEADED HOUSEHOLDS

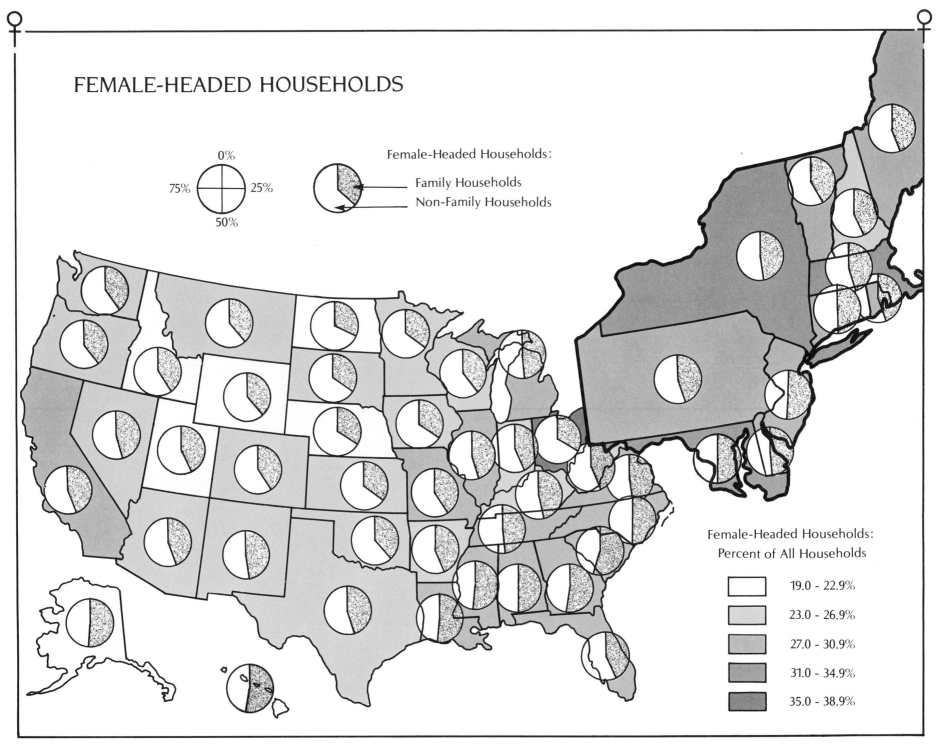

0%
75% 25%
50%

Female-Headed Households:

Family Households
Non-Family Households

Female-Headed Households:
Percent of All Households

19.0 - 22.9%

23.0 - 26.9%

27.0 - 30.9%

31.0 - 34.9%

35.0 - 38.9%

In five states, Rhode Island, Massachusetts, Maryland/District of Columbia, New York and Ohio, women headed over 30% of all households. Female-headed households are more prevalent in states with large numbers of unmarried mothers, single, divorced and elderly women. In many Rocky Mountain and Plains states, as well as Alaska and Hawaii, households were headed up by women in only one out of four or five cases. These states often had relatively high proportions of married couple families, which, as we have seen, are usually headed by men.

The pie charts give an indication of the breakdown of households headed by women into family or non-family types. Family households accounted for between 32% and 55% of all female-headed households. In the West, women were slightly more likely to head non-family households, while in the Northeast and Southeast, the split between the two types was fairly even. Many of these states, particularly those in the Southeast, also had a high incidence of out-of-wedlock births, suggesting that many of these female-headed households consisted of unmarried mothers with young children.

The two maps, "Family Households" and "Non-Family Households," look at first family and then non-family households in terms of the percentage headed by women. The first map reveals that in most states women headed fewer than one out of every five family households. (Remember, other types of families in addition to those with married couples are included in this group, and married couples can designate a woman as head.) New York, with the highest percentage, had just under 23% of its families headed by women. North Dakota ranked 50th at just 10%. With the exception of California, the East Coast, Gulf and Midwestern states had the greatest percentage of female-headed family households.

A non-family household with a woman as head was far more common. The range extended from a low of 35% (Alaska) to a high of 64% (West Virginia). There was a noticeable concentration of high values in the central and eastern half of the country with the very highest percentages clustering around the Appalachian region. Only four states (Alaska, Nevada, Wyoming and Hawaii) had fewer than half of non-family households headed by women! In most states, the majority of non-family households were headed by women.

In the next few maps we look specifically at *family* households headed by women where no husband was present. The "Female-Headed Households, No Husband Present" map shows that in every state, at least three-quarters of the families headed by women were of this type. Most female householders were responsible for their family's economic support. This phenomenon was especially apparent in the central portion of the U.S. from the Gulf Coast states north to Michigan. States in the New England region and Northwest were slightly more likely to have a husband present when there is a female family householder.

In the "Female-Headed Households, No Father Present: with Children less than 18" map, we see that between half and three-quarters of these female householders had their own children under 18 living with them. The values ranged from a low of 49% in West Virginia to a high of 78% in Alaska. Female family householders without spouses in the Northwest were especially likely to have children under 18 while states with lower percentages were concentrated in Appalachia and along the eastern seaboard to southern New England.

In the next map, "Female-Headed Households, No Father Present: Percentage of Children less than 18 in this type of household" focusing on female family householders, we show the percentage of children under 18 in each state who were living with their mother

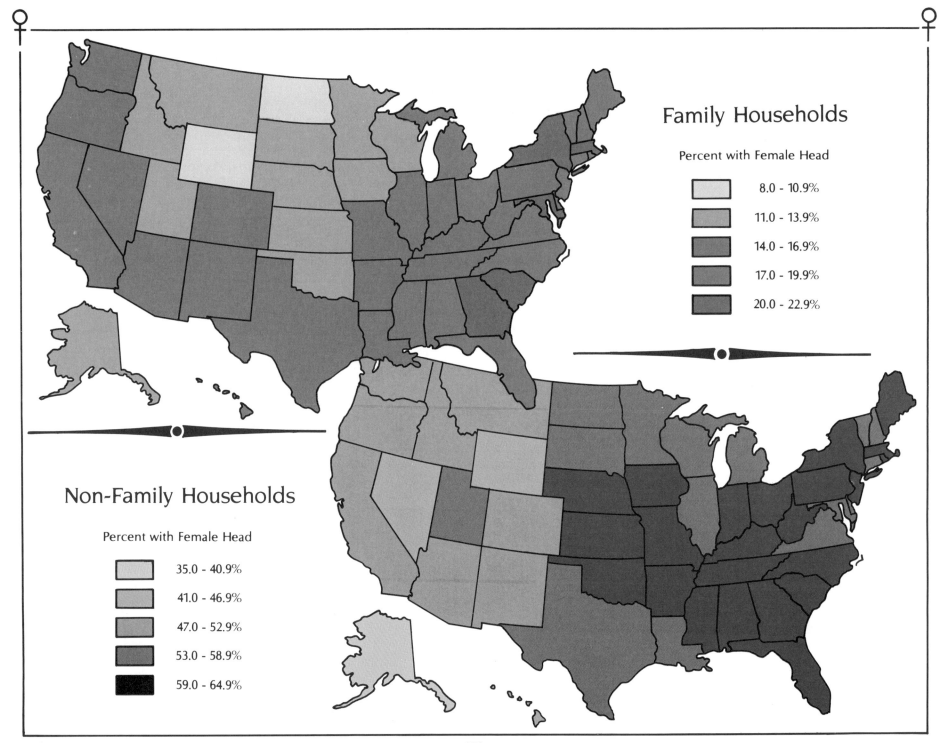

Family Households

Percent with Female Head

8.0 - 10.9%

11.0 - 13.9%

14.0 - 16.9%

17.0 - 19.9%

20.0 - 22.9%

Non-Family Households

Percent with Female Head

35.0 - 40.9%

41.0 - 46.9%

47.0 - 52.9%

53.0 - 58.9%

59.0 - 64.9%

A HOUSE DIVIDED

Non-Family
Male Head of Household

Non-Family
Female Head of Household

Family
Male Head of Household

Family
Female Head of Household

26.8% Non-Family Total

73.2% Family Total

FEMALE-HEADED FAMILY HOUSEHOLDS

No Husband Present

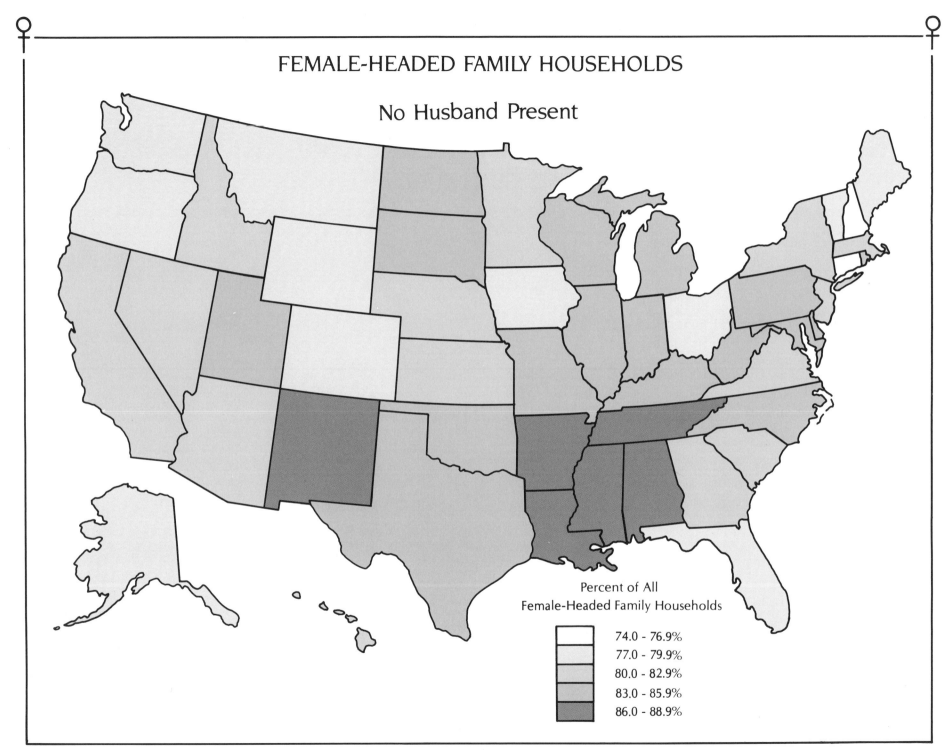

Percent of All
Female-Headed Family Households

- 74.0 - 76.9%
- 77.0 - 79.9%
- 80.0 - 82.9%
- 83.0 - 85.9%
- 86.0 - 88.9%

No Father Present

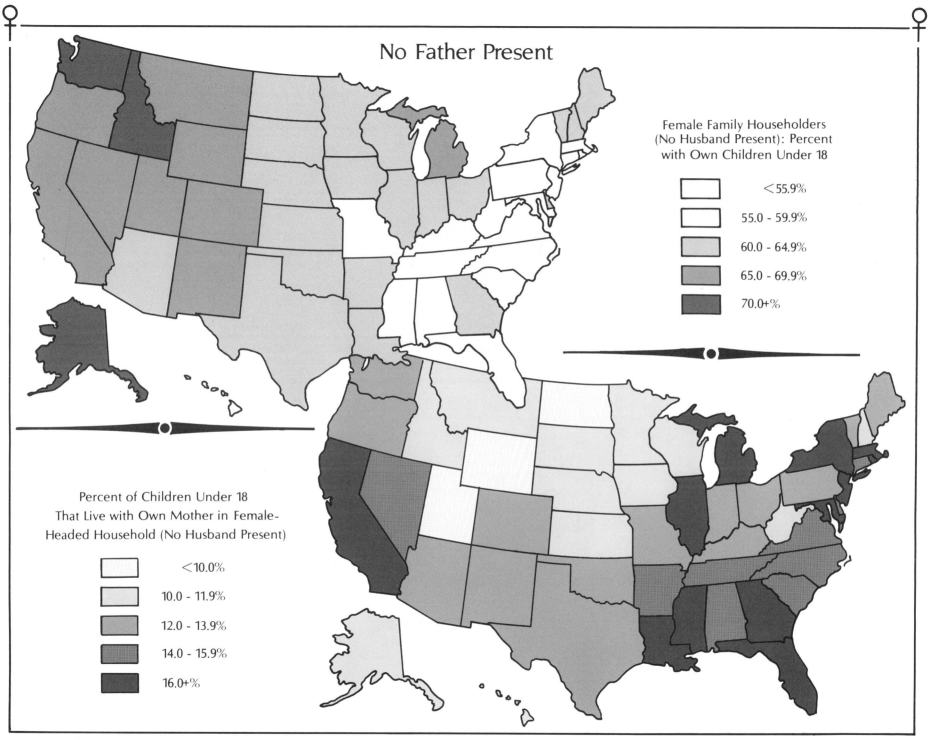

Female Family Householders
(No Husband Present): Percent
with Own Children Under 18

	<55.9%
	55.0 - 59.9%
	60.0 - 64.9%
	65.0 - 69.9%
	70.0+%

Percent of Children Under 18
That Live with Own Mother in Female-
Headed Household (No Husband Present)

	<10.0%
	10.0 - 11.9%
	12.0 - 13.9%
	14.0 - 15.9%
	16.0+%

WOMEN IN HOMES FOR THE ELDERLY

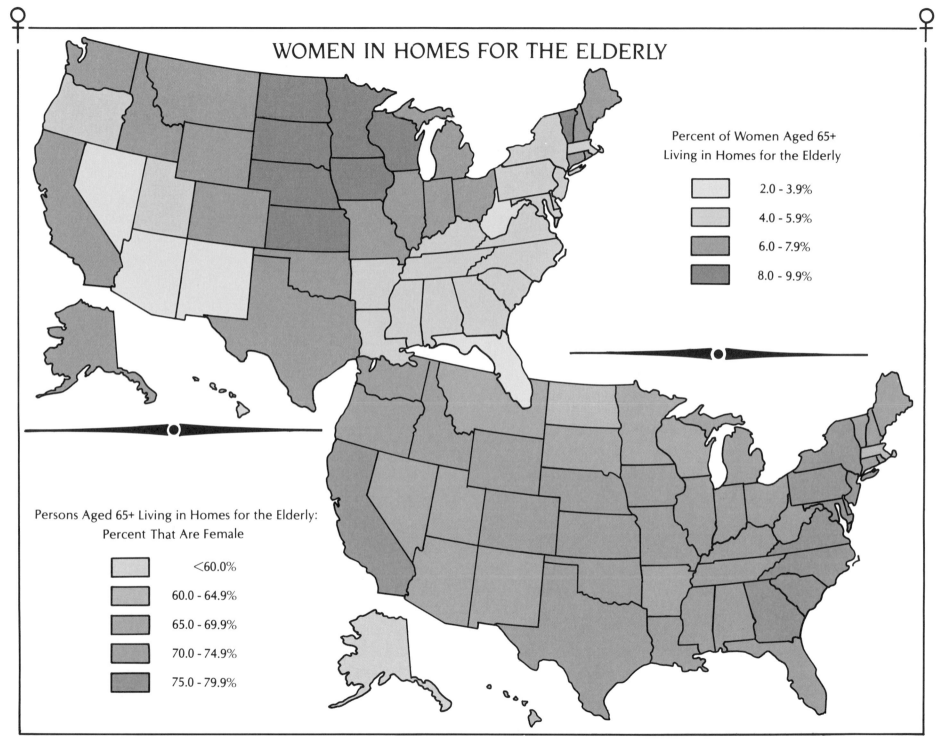

Percent of Women Aged 65+
Living in Homes for the Elderly

- 2.0 - 3.9%
- 4.0 - 5.9%
- 6.0 - 7.9%
- 8.0 - 9.9%

Persons Aged 65+ Living in Homes for the Elderly:
Percent That Are Female

- <60.0%
- 60.0 - 64.9%
- 65.0 - 69.9%
- 70.0 - 74.9%
- 75.0 - 79.9%

but had no father present. In New York, approximately one out of every five children lived in this type of household. In contrast, the proportions for Alaska, Hawaii, and the northern Rockies and Plains states were much lower, less than 12%. Notice that in western states where female householders without spouses were more likely to have children, those children represented a proportionately *smaller* number of all children than in the East, where female householders were slightly less likely to have children.

Finally, we look at women living in homes for the el-derly in 1980. As women on average continue to outlive men, they predominate in homes for the elderly. The northern High Plains (and northern states generally) had the greatest percentage of women over 65 in homes for the elderly. In all states, women made up more than half of the persons living in homes for the elderly, in many places outnumbering male residents two and sometimes three to one. Alaska was the only state where the split between men and women was about even. Women were a clear majority of residents in the East Coast states.

HEALTH

"Dear me, how much cruel bondage of mind and suffering of body poor woman will escape when she takes the liberty of being her own physician of body and soul!" [1]

—Elizabeth Cady Stanton

Health care professionals play a major role in our physical, psychological and reproductive lives, not only through direct treatment of illness, but also in the direction and design of health care research. However, health care professionals, no matter how dedicated, are fallible human beings capable of error and misjudgment. Consequently, members of both sexes need to assume personal responsibility for health by engaging in preventive care and education. We must realize that good health is a complex state not always easily defined or understood. Health maintenance involves more than just feeling good. It requires *judgment* about what is normal and abnormal on physical, psychological and reproductive levels.

Health care professionals have devoted vast amounts of money, time and research to defining what states of mind and body are normal (healthy). They attempt to understand the interplay between psychological and physiological processes, and to determine which areas of health research receive priority. For example, what level of cholesterol or Vitamin B is appropriate? Is it the same for women as for men? Are the problems of alcoholism, obesity and premenstrual syndrome physiologically or psychologically based? Which contraceptive method shall receive more attention, a pill for men or for women?

It is difficult in any judgment situation to screen out the personal biases and values of those making the decisions. Such biases are problematic for all persons receiving health care, but particularly so for women because it is the male health care providers who predominate at the research and major decision-making levels.

In modern Western society, women's health care has

been in the hands of men. At the end of 1979, it was estimated that only about 11% of all physicians, about 12% of obstetricians/gynecologists, and approximately 16% of psychiatrists were women.[2] Research studies used to determine physical and psychological norms for persons of both sexes have used men as test subjects. Such results have been assumed to be equally relevant to women and at times women have been considered neurotic or abnormal because they did not conform to a theory based on male behavior. Even the determination of what is healthy psychological, sexual and reproductive behavior in women has been defined by men who have only indirect experience with how those processes manifest themselves in women.

To illustrate how bias can interfere with health care it is useful to contrast past and present images of what is healthy for women. The 19th-century Victorian attitude toward femininity contributed to the undermining of the mental and physical health of women. The feminine woman was one who was fragile and delicate, both physically and emotionally. The prevailing fashion of voluminous and constrictive clothing reinforced attitudes discouraging physical exercises. Corsets designed to emphasize the "womanly" figure often broke ribs and contorted internal organs. Some women went so far as to ingest small amounts of arsenic in an attempt to achieve a fashionably translucent complexion. It was fashionable to have an oversensitive and high strung disposition, even to incline to invalidism. Behavior patterns for the feminine woman included submission, obedience, deference and dependency. In addition, it was considered normal for a woman to have no sexual desire or pleasure in sex aside from the purely altruistic one of pleasing her husband.

One hundred years ago, medicine was in its infancy and female physiology, particularly those aspects and processes linked to reproduction, was not well under-

stood. With few exceptions, doctors were men who tended to regard male physiology as the norm from which women deviated. Even when that deviation was not considered abnormal in a negative sense, it was still a subject of mystery and misinformation. Ignorance and prejudice resulted in the imposition of indignities upon the female patient. "Female complaints" were treated with pills and potions of questionable efficacy. Clitoridectomies were performed to eradicate supposedly nonexistent sexual desires. Chloroform was occasionally withheld from women in labor on the justification that God had ordained women to bring forth children in suffering.

Even today women are inclined to suffer in an attempt to conform with "feminine" stereotypes. The philosophy of female health and beauty is defined in terms of sexual attractiveness, currently equated with minimal poundage and a dark tan. The negative side of such an image is the not uncommon occurrence of anorexia nervosa and skin cancer. Among other modern absurdities are stiletto heels, tight jeans, hair dying and excessive cosmetics use.

The 20th-century male physician has not been free from prejudice. Modern medical textbooks have been exposed for containing derogatory and paternalistic statements in reference to female patients. Premenstrual symptoms and menstrual cramps have been regarded by some as psychosomatic manifestations of women's maladjustment to their sexuality. Others believe that the predominantly male medical establishment has been too quick to prescribe radical mastectomies, unnecessary Caesarean sections (the U.S. has the highest rate in the world),[3] hysterectomies and sterilizations for low-income women.

Similarly, male psychologists and psychiatrists have not hesitated to define female psychological and sexual development in terms of the male experience. It would

seem sensible to regard such theories with healthy skepticism when Freud, after a lifetime working with female patients, had to ask "What do women want?" Carol Gilligan's book, *In a Different Voice*,[4] eloquently illustrates the ways in which male psychologists have tried to fit women into developmental patterns based on male subjects. Their response has not been to alter the theory to encompass women's experiences, but to contort female behavior to fit the theory and to regard women's development as deviant or stunted.

Such criticisms are not meant to deny the fact that women have benefited almost beyond measure from the modern techniques in health care. No woman would want to return to a time when the infection and trauma often sustained in childbirth resulted in high mortality rates for mothers and infants. These death rates in the United States are now among the lowest in the world. The maternal mortality rate declined from 83 per 100,000 live births in 1950 to nine per 100,000 in 1980, while infant mortality also dropped from 29 to 13 per 1,000 live births in the same period.[5] Nor would many women want to return to a time when breast or cervical cancer was untreatable. Few women would want to relinquish the ability to plan pregnancies that modern research has made possible.

While life expectancy has increased for both sexes over the past century, women do outlive men. For the period 1969–71, the average life span of women and men who died in those years was 74.6 and 67.0 years, respectively.[6] By 1982, the average estimated life span had increased to 78.2 and 70.8.[7] A survey in that same year indicated that the incidence of four "behavioral risk factors," obesity, sedentary life-style, smoking and alcohol abuse, was reported more often by men than women.[8] Among the 10 leading causes of death in the United States in 1980, women's death rates were higher than men's in only three categories. While the two top-rank-

ing causes of death for both sexes were heart disease and cancer, accounting for about 60% of all deaths, the rates for women were only 83% and 80% of men's, respectively.[9]

In 1980, men also led women where substance abuse was concerned. About 37% of men sampled reported the use of cigarettes versus 29% for women.[10] For alcohol, the sample rate for use in 1982 was 69% of men versus only 46% of women and for marijuana 10% and 3% respectively.[11]

The 1980 Census estimated that only 39% of the residents in mental institutions were female.[12] It is also interesting to note that while more women than men aged 15+ were admitted to hospitals for neurotic disorders, their actual average length of stay was shorter than men's.[13] Men's suicide rate in 1980 was more than three times that of women (19 per 100,000 and six per 100,000), representing a slight increase for men and a slight decrease for women over the previous decade.[14]

Women have begun to realize the benefits of taking greater responsibility for their health and of exercising a greater voice in the health care system. The percentage of medical degrees awarded to women between 1960 and 1980 has increased from about 6% to about 23%.[15] There is a move to recognize and allow increased responsibility for nurse-midwives and nurse-practitioners, the majority of whom are female. Women's health centers and clinics have emerged in cities around the country while health manuals such as *Our Bodies, Ourselves* are being written for women, by women.

The ability to control their reproductive lives is perhaps the single most important gain for women from medical research. The availability of safe and effective family planning methods such as contraception, sterilization and abortion has provided women with control over their reproductive systems. Not only has the impact been felt on the physical and emotional lives of

individual women, but also on the whole concept of women's place and role in society. The toll that the fear of unwanted pregnancy takes on the emotional, sexual and physical lives of women *and* men cannot be over-estimated. The ability to plan a pregnancy allows women the freedom to be less economically dependent on men and to participate more fully in other aspects of life besides that of the family.

By 1983, state laws governing abortion, contraception and sterilization were of a largely regulatory, rather than prohibitive nature. These laws focused on such things as utilization by minors, use of public funding, notification of spouse or parent, etc. The three mentioned methods of reproductive control have not been accepted as appropriate by everyone. Sterilization (for both men and women) is now the most widely used method of family planning in this country![16] Clearly, however, such an irreversible solution is only acceptable for those who don't want children or who have already completed their families. Opinion about birth control varies, although it is approved in a broad sense by the majority of women in the U.S. But methods of contraception can range from the almost 100% effectiveness of the pill and IUD, to extremely unreliable methods such as *coitus interruptus* and the "rhythm" technique.

Clearly, the most controversial method of reproductive control is that of abortion. While its legal status is currently favored by a majority of Americans, it continues to serve as a focus of impassioned debate. By 1973, it had been made illegal in most states except when necessary to save the mother's life. (A few states allowed abortions under specific circumstances involving rape, incest, fetal deformity, etc.) In that year, however, the U.S. Supreme Court handed down its landmark decision in the case of *Roe vs. Wade* making it illegal for states to prohibit abortions during the first and second trimesters of pregnancy.

It should be remembered, however, that the absence of a specific prohibition does not mean abortion is equally available to all women in the U.S. For example, a number of states have prohibited the use of public funding for abortions, a restriction that has ironically been felt most keenly by poor women least able to support children in the first place, and far less likely to be knowledgeable about alternative types of birth control. In spite of such hindrances and accompanying controversies, the rate of legal abortions increased 79% between 1973 and 1980. In this latter year it has been estimated that there were 428 abortions for every 1,000 live births in the U.S.[17] A 1982 survey indicated that one-half of unmarried and one-third of married women would consider ending an unplanned pregnancy by means of abortion. This same report estimated that if the then current abortion rate continued, about 40% of all women will have had an abortion by age 45.[18]

It is unfortunate that in this time of increased opportunity for reproductive control, the number of unmarried adolescent women becoming pregnant and bearing children is increasing. For a number of reasons, birth control is less available to and underutilized by adolescent and low-income women. These factors, coupled with an era of sexual permissiveness and declining marriage rates, has resulted in a rise in the number of women and children living in poverty. It is ironic that a time of increased opportunity for reproductive control should coincide with a period of loss of economic control.

LET'S GET PHYSICAL

The average life expectancy for women who died between 1969 and 1971 ranged from a low of 72.3 years in

LET'S GET PHYSICAL

LIFE EXPECTANCY*

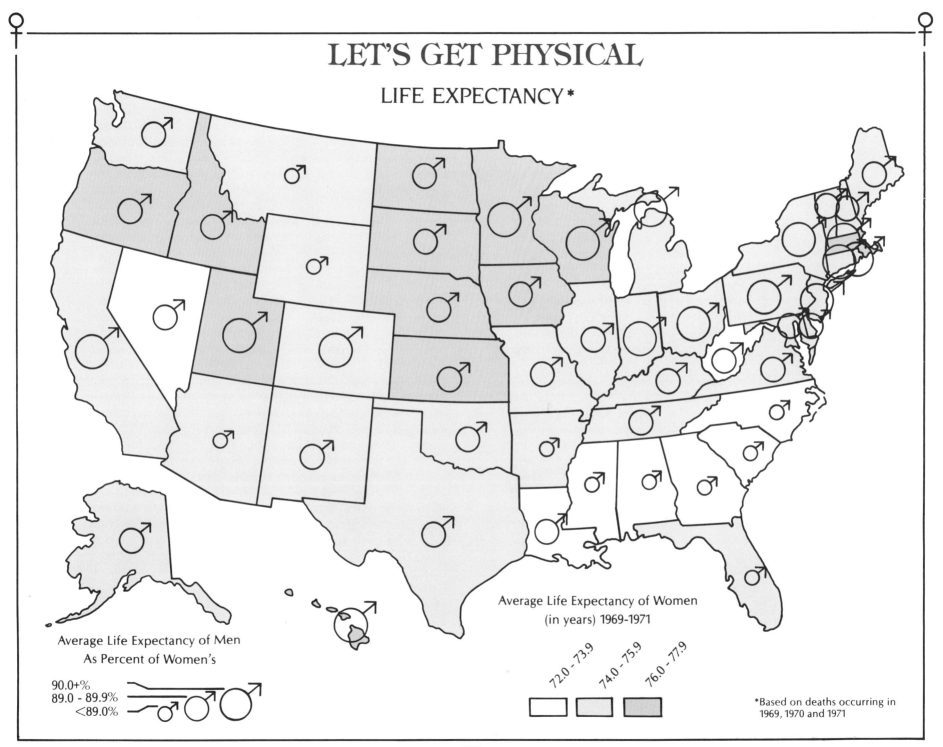

Average Life Expectancy of Men
As Percent of Women's

90.0+%
89.0 - 89.9%
<89.0%

Average Life Expectancy of Women
(in years) 1969-1971

72.0 - 73.9 74.0 - 75.9 76.0 - 77.9

*Based on deaths occurring in
1969, 1970 and 1971

South Carolina to 77.0 years in North Dakota. While the range is small, there is a definite regional trend made clearly visible by the first map in this section, "Life Expectancy." With the exception of Florida, the Deep South had the lowest average life expectancy for women. Moving to the north and west, the average life expectancy increased, with particularly high life spans occurring in states around Minnesota. Nevada stands out as a notable exception to this pattern.

Life expectancy for men during this period, though always lower than women's, exhibited a somewhat wider range, from 63.9 in South Carolina, to 71.0 in Hawaii. When comparing the male life span with that of the female, the Deep South emerged as a homogeneous region in which the difference between the life expectancies of men and women was relatively small. Conversely, the Great Lakes, and the Northeast, including southern New England, appear as a unified area where the difference in the life expectancies of the two sexes is relatively large. The western half of the country displayed a more heterogeneous mix of large and small differences.

A 1982 government telephone survey yielded information about the frequency of sedentary lifestyle and obesity for women in twenty-four selected states. Since only a limited number of states were surveyed, it is difficult to draw conclusions about any regional patterns that may exist. However, in regard to sedentary lifestyle, there appeared to be a very loose east-west distribution, with higher rates in the East than in the West. However, one immediately notes that Illinois and West Virginia did not fit into the pattern.

The pattern for obesity seemed a bit more strongly defined. As with sedentary lifestyle, a higher rate of obesity occurred in the East than in the West. In addition, the map reveals a north-south band of high values stretching from Michigan to Florida.

Heart disease can result from many factors, including those of heredity, stress and diet. It is important to keep these factors in mind when looking at the map "Death from Heart Disease." The lowest rates were found in several western and Pacific states, including Arizona, Utah, Nevada, Alaska and Hawaii. The highest rates were located in the Northeast, Illinois and Missouri. While the East generally appeared to have higher values than the Far West, several Deep South states also had relatively low death rates from these diseases. These variations seem to correlate somewhat with the trends we tentatively observed for sedentary lifestyle and obesity. While men suffered higher rates of heart disease than women, the differences between those rates was greater in those western states where women's rates were generally low. Conversely, in high-rate states, women's rates more closely approximated those of men.

Regional patterns on the map "Death from Cancer" were even more strongly defined. The first map, focusing on death from all types of cancer, shows the Northeast/New England region emerging as a center of high death rates. Florida and Missouri also appeared as "hot spots." The next two maps focus on breast cancer and cancer of the reproductive organs. The distribution pattern for breast cancer was somewhat more localized. Despite the general tendency of high values to be found in the northern Plains and Northeast, two states, Michigan and Vermont, had noticeably lower values than others in their region. Similarly, California and Florida were high in contrast to the generally low rates of surrounding states. The area of low rates in the Deep South expanded north to include more of Appalachia. Rates of cancer of the reproductive organs also followed this loose east-west distribution, which for heart disease and cancer appeared to break along a line extending from Oklahoma to North Dakota.

Motor vehicle accidents are a major cause of death

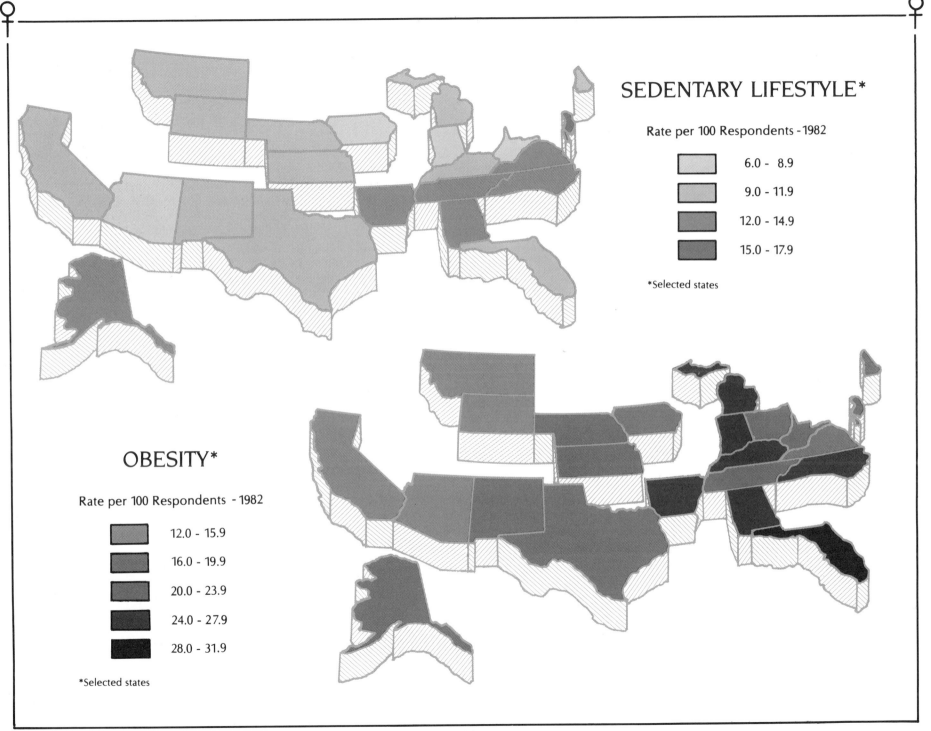

SEDENTARY LIFESTYLE*

Rate per 100 Respondents - 1982

6.0 - 8.9

9.0 - 11.9

12.0 - 14.9

15.0 - 17.9

*Selected states

OBESITY*

Rate per 100 Respondents - 1982

12.0 - 15.9

16.0 - 19.9

20.0 - 23.9

24.0 - 27.9

28.0 - 31.9

*Selected states

DEATH FROM HEART DISEASE

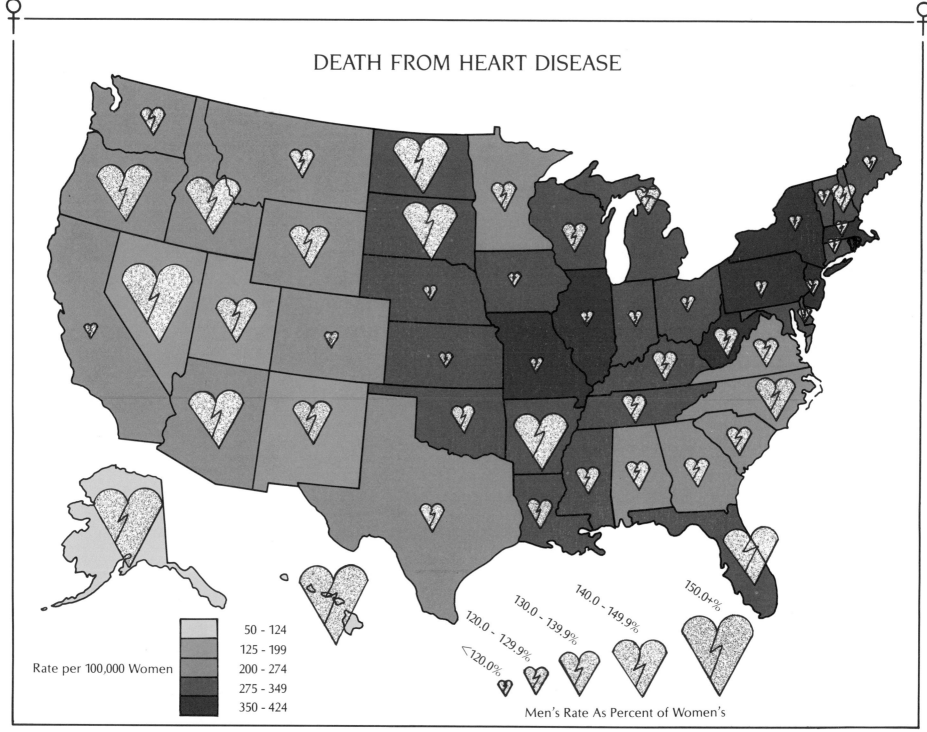

Rate per 100,000 Women

	50 - 124
	125 - 199
	200 - 274
	275 - 349
	350 - 424

<120.0%

120.0 - 129.9%

130.0 - 139.9%

140.0 - 149.9%

150.0+%

Men's Rate As Percent of Women's

DEATH FROM CANCER

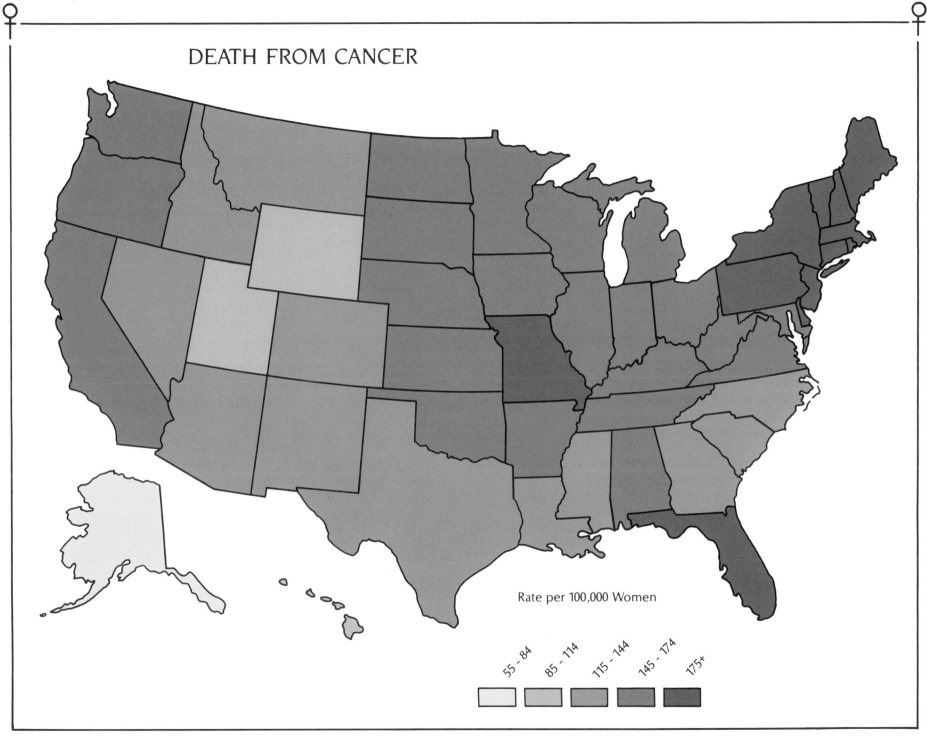

Rate per 100,000 Women

55 - 84 85 - 114 115 - 144 145 - 174 175+

and injury among men and women, especially in the teenage years. The map "Motor Vehicle Deaths" shows an interesting pattern. First, and most obvious, is that the Northeast and New England emerged as areas where the rate for women was lowest. Men's rate as a percentage of women's, however, is quite high as reflected by the presence of larger tombstones. While low death rates for women are associated with large symbols in the Northeast and New England, low values in the area around Wisconsin coincided instead with smaller symbols, indicating that here the difference between men's and women's rates was fairly small. Similarly, varying levels of difference between men and women could be found in areas where women had high fatality rates. The Central Rockies had several high-rate states, while in the northern Plains high rates corresponded with small symbols. Thus, no clear relationship seems to exist between the rates for men and women.

Another aspect of health deals with woman's role as health care provider. While women's contribution has been traditionally limited to the nursing field, more and more women in recent years have become practicing physicians. Two maps are presented showing the distribution of women doctors in the United States, including those working for the federal government. The first map shows the number of women physicians per 100,000 women, a rate which ranged from a low of eight in Idaho to a high of 97 in Maryland/District of Columbia. Clearly, women in the Northeast, especially New York and Massachusetts, had greater access to women physicians than do women in the Deep South, Northern Rockies and Great Plains states where the lowest rates are concentrated.

The Northeast region is also an area where the percentage of physicians that were women was the highest. Michigan also had a high female to male ratio. Even so, fewer than 18% of the physicians there were women,

with male doctors very much in the majority. Not surprisingly, the pattern of the second map is roughly similar to that of the first in its distribution of high and low values.

STATES OF MIND

As society becomes more complex and the role of women undergoes change, the resulting stress takes its toll on people's emotional health. Suicide is just one form of mental illness indicating that a person has exceeded her or his ability to cope. In Nevada, the suicide rate among women surpassed that of all other states with a death rate of 15 per 100,000 women. The region around Nevada was also high in this respect. With the exception of Florida and Oklahoma, the central and eastern portions of the United States showed relatively low suicide rates for women, the lowest being three per 100,000 in New Jersey. For men, the highest and lowest rates were also in Nevada and New Jersey. However, the percentage difference between men's and women's rates was highest in Nebraska, Iowa and South Dakota, where the suicide rate for men was over five times that of women. Compare this area with states like California, Nevada and Utah, where the men's rate was only two to three times that of women.

As part of its population count, the Census Bureau included an estimate of the number of persons residing in mental institutions. While the suicide rate for women in the eastern half of the country is relatively low, the proportion of women residing in mental institutions, particularly in the Northeast, was high. Other than North Dakota (which ranked third), all the states with high values ranged along the eastern seaboard. Note that Nevada and the surrounding states ranked among the

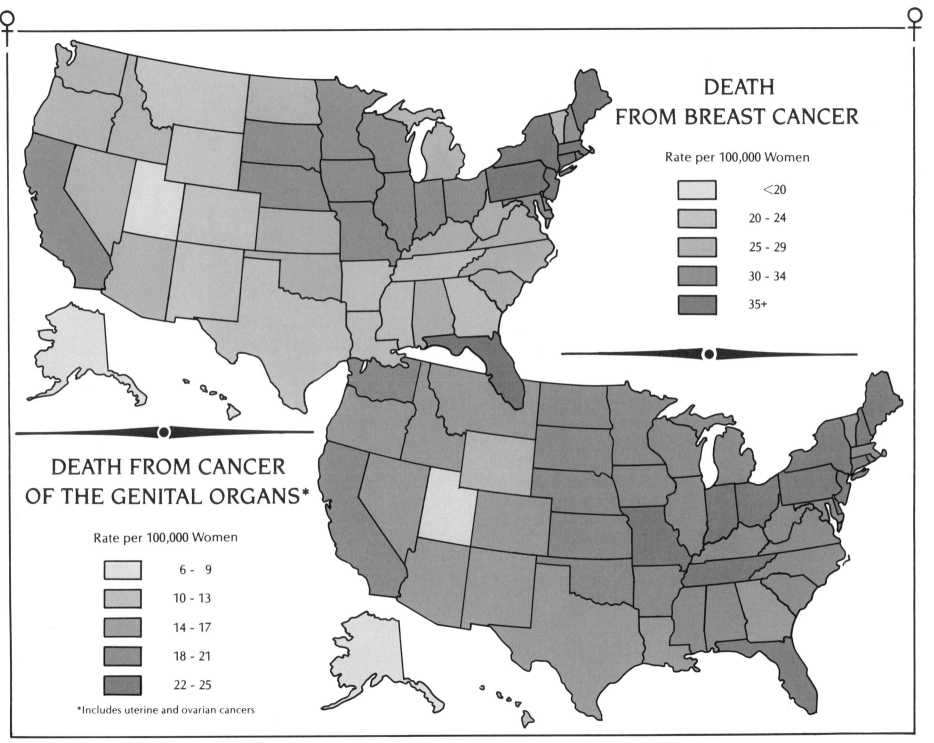

DEATH FROM BREAST CANCER

Rate per 100,000 Women

- <20
- 20 - 24
- 25 - 29
- 30 - 34
- 35+

DEATH FROM CANCER OF THE GENITAL ORGANS*

Rate per 100,000 Women

- 6 - 9
- 10 - 13
- 14 - 17
- 18 - 21
- 22 - 25

*Includes uterine and ovarian cancers

MOTOR VEHICLE DEATHS

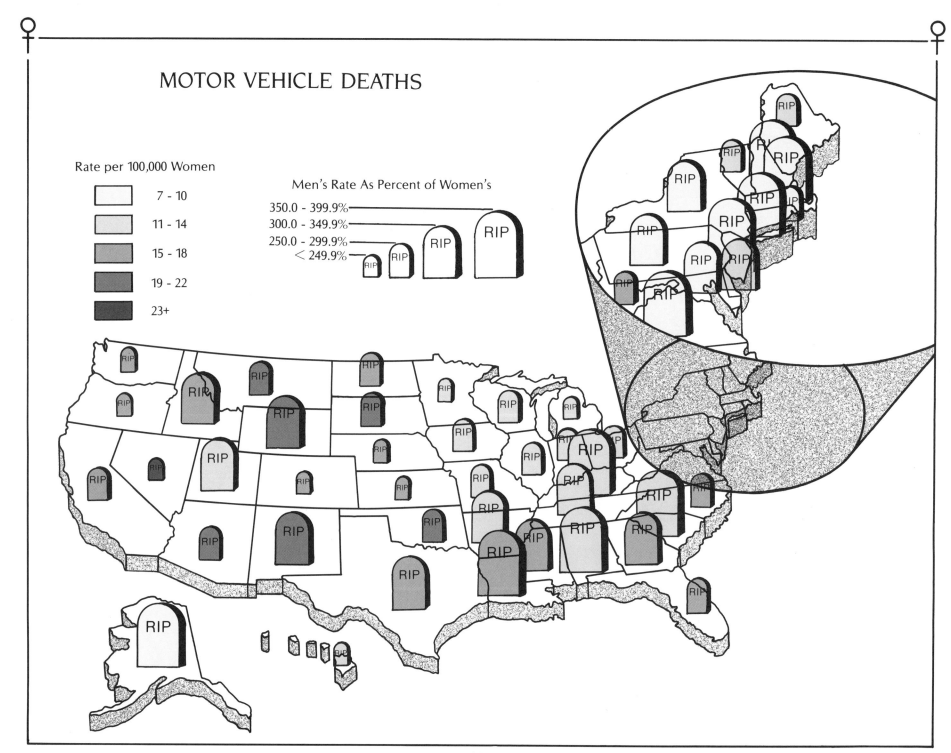

Rate per 100,000 Women

- 7 - 10
- 11 - 14
- 15 - 18
- 19 - 22
- 23+

Men's Rate As Percent of Women's

- 350.0 - 399.9%
- 300.0 - 349.9%
- 250.0 - 299.9%
- < 249.9%

PHYSICIANS
December 31, 1979

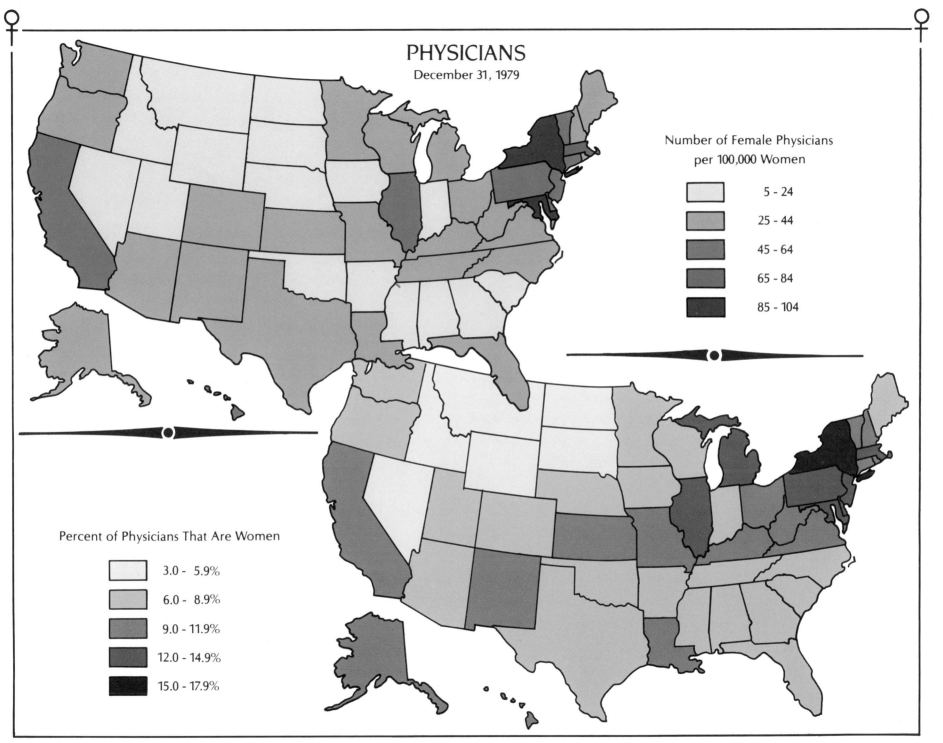

Number of Female Physicians
per 100,000 Women

- 5 - 24
- 25 - 44
- 45 - 64
- 65 - 84
- 85 - 104

Percent of Physicians That Are Women

- 3.0 - 5.9%
- 6.0 - 8.9%
- 9.0 - 11.9%
- 12.0 - 14.9%
- 15.0 - 17.9%

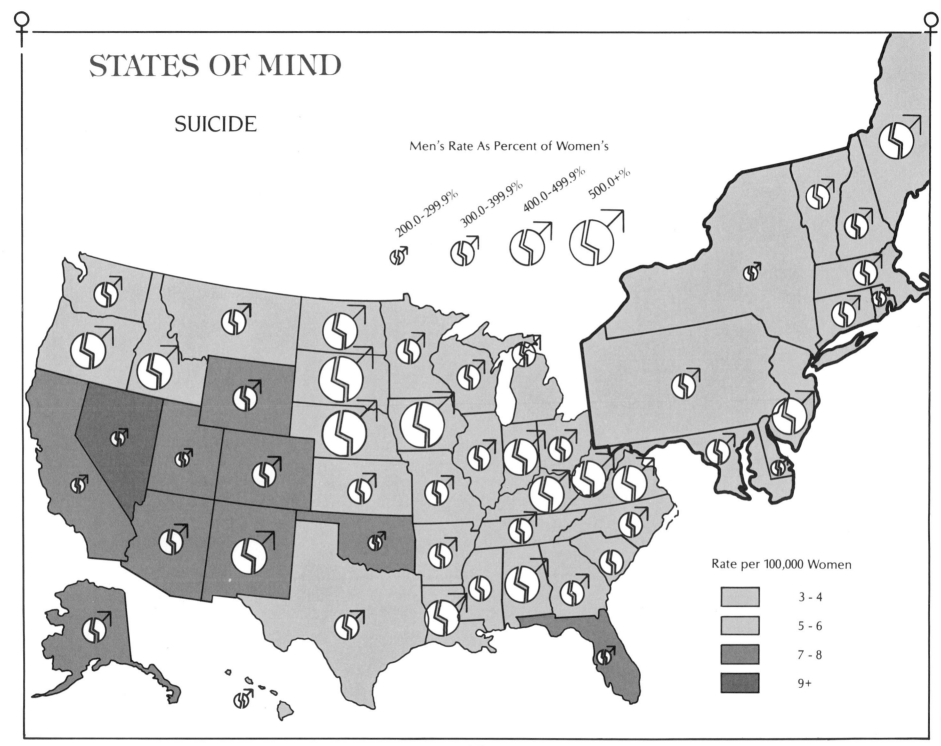

STATES OF MIND

SUICIDE

Men's Rate As Percent of Women's

200.0-299.9% 300.0-399.9% 400.0-499.9% 500.0+%

Rate per 100,000 Women

3 - 4
5 - 6
7 - 8
9+

RESIDENCE IN MENTAL INSTITUTIONS

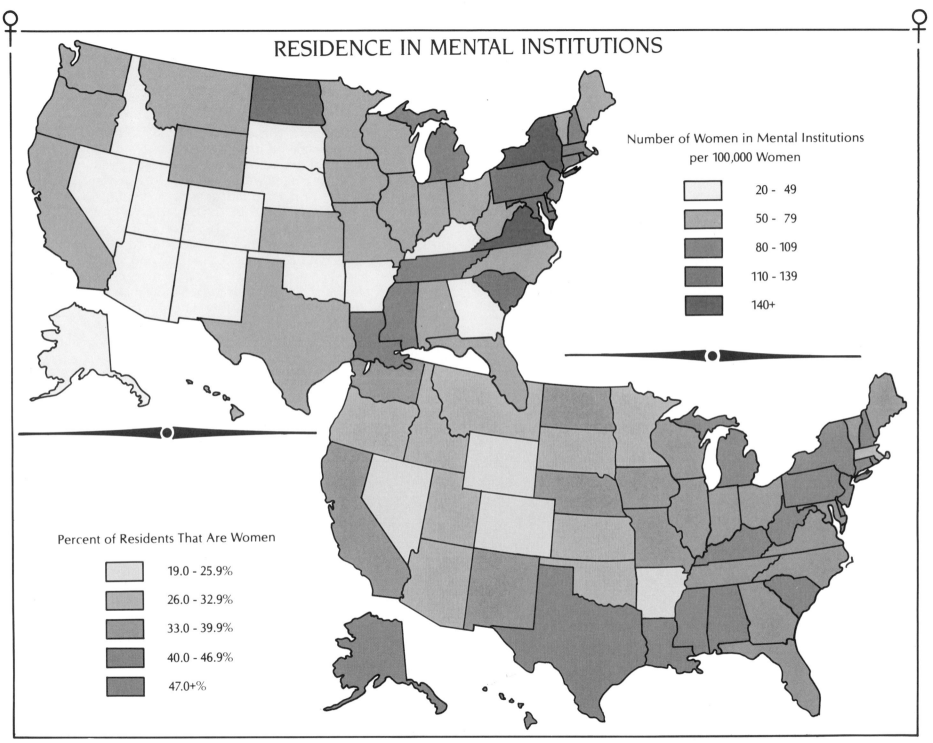

Number of Women in Mental Institutions
per 100,000 Women

- 20 - 49
- 50 - 79
- 80 - 109
- 110 - 139
- 140+

Percent of Residents That Are Women

- 19.0 - 25.9%
- 26.0 - 32.9%
- 33.0 - 39.9%
- 40.0 - 46.9%
- 47.0+%

lowest in the country, together with Alaska, Tennessee and Georgia. It would be interesting to know if low rates were caused by a lack of residential facilities. Perhaps these states simply had fewer places available for the mentally ill.

The states with the highest ratios of female to male residents were also located in the East, notably in Alabama, Delaware and New Hampshire. However, the distribution was more scattered than on the previous map. There were several western states where the percentage of female residents was fairly high (Alaska, Hawaii and Texas). Only in New Hampshire did female residents outnumber their male counterparts.

The number of women pursuing a career in the field of mental health has also increased considerably in recent times. These statistics on psychiatrists were based on a survey conducted by the American Medical Association in 1979 in which doctors were asked to classify themselves according to specialty. The number of female psychiatrists per 100,000 women was highest in four northeastern states, ranging between seven and ten per 100,000 in Maryland/District of Columbia, New York, Massachusetts and Connecticut. This distribution (like that of all physicians) reflects the prominence of the medical profession in those states.

The second map, focusing on the ratio of female to male psychiatrists, presents a more diverse distribution. While the Northeast again led the way with the highest percentage of female practitioners relative to their male colleagues, this zone extended further into the Midwest, Appalachia and some western states, including Oregon, Arizona and Oklahoma. In only one state, Delaware, was more than one-quarter of the psychiatric community reported to be female.

ALTERED STATES

Cigarette smoking and the consumption of alcoholic beverages, once considered male prerogatives, have now become widespread among women. The 1982 government survey that provided information on obesity and sedentary lifestyle also included questions relating to cigarette smoking and drinking. (In this study, a heavy drinker was defined as a person who, upon at least one occasion in the previous month, had consumed five or more drinks.) As with the maps for obesity and sedentary lifestyle, regional patterns on "Cigarette Smoking and Heavy Drinking" are difficult to perceive since data is available for only about half the states. However, it does appear that the northern states sampled were generally higher than those in the South for rates of heavy drinking, with Iowa reporting the highest percentage of heavy drinkers among those women surveyed. The lowest rates occurred in Appalachia, extending into Arkansas, Alabama and North Carolina.

With respect to cigarette smoking, the percentage of respondents who indulged started at a low of 19.5 per 100 in Kansas and increased to 34.4 per 100 in Alaska. No regional pattern was discernible; however, a comparison of these maps with those for heart disease and cancer might prove especially interesting.

The next two maps, "Enrollment in Drug and Alcohol Treatment Programs," focus on the ratio of women to men as participants in alcohol and drug treatment programs. Caution must be exercised when attempting to generalize from this data about the proportions of women in a given state who are actual drug or alcohol abusers. While one state may have a higher percentage of women enrolled as compared to men, this does not necessarily mean that this state had a higher proportion of women dependent on drugs or alcohol. These

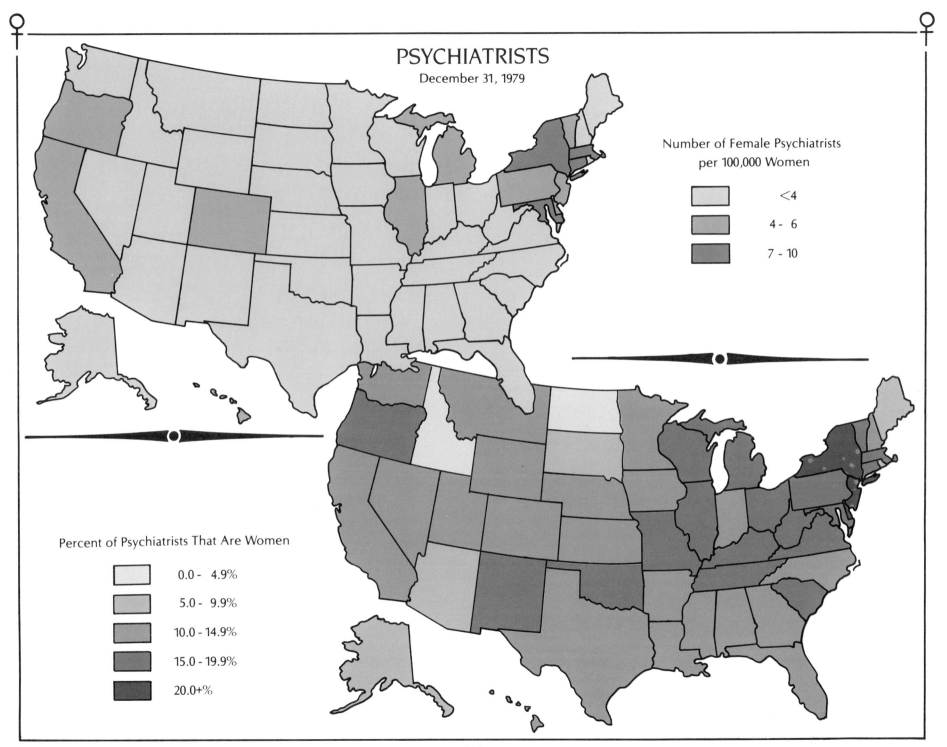

PSYCHIATRISTS

December 31, 1979

Number of Female Psychiatrists
per 100,000 Women

<4

4 - 6

7 - 10

Percent of Psychiatrists That Are Women

0.0 - 4.9%

5.0 - 9.9%

10.0 - 14.9%

15.0 - 19.9%

20.0+%

ALTERED STATES

CIGARETTE SMOKING AND HEAVY DRINKING*

1982

*Selected states

Cigarette Smokers:
Number per Every 100 Respondents

30.0 - 34.9
25.0 - 29.9
20.0 - 24.9
<20.0

Heavy Drinkers:
Number per Every 100 Respondents

15.0 - 19.9
10.0 - 14.9
5.0 - 9.9
0.0 - 4.9

ENROLLMENT IN DRUG AND ALCOHOL TREATMENT PROGRAMS

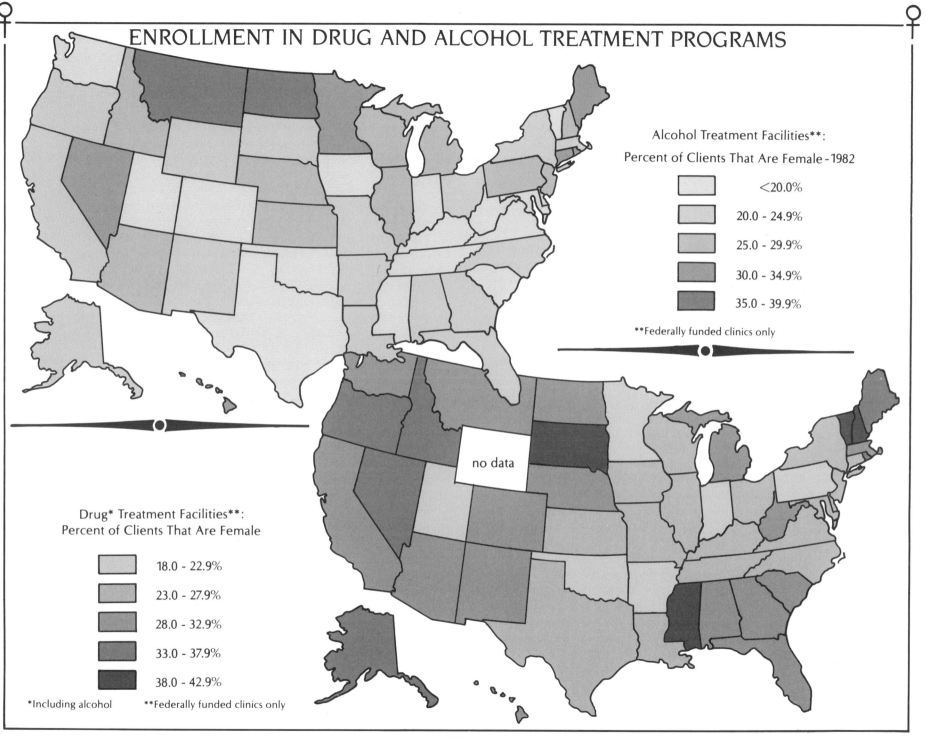

Alcohol Treatment Facilities**:

Percent of Clients That Are Female - 1982

- <20.0%
- 20.0 - 24.9%
- 25.0 - 29.9%
- 30.0 - 34.9%
- 35.0 - 39.9%

**Federally funded clinics only

Drug* Treatment Facilities**:
Percent of Clients That Are Female

- 18.0 - 22.9%
- 23.0 - 27.9%
- 28.0 - 32.9%
- 33.0 - 37.9%
- 38.0 - 42.9%

no data

*Including alcohol **Federally funded clinics only

statistics are only reflective of those persons, men and women, who actually received treatment. Factors such as cultural attitudes toward drug and alcohol dependency and access to treatment may cause the proportions of men and women who actually received help to differ from the total number of those with substance abuse problems. In addition, this data relates only to federally-funded programs. Those programs supported solely by private funds were not included in the survey.

In three states, Maine, North Dakota and Montana, women accounted for one in three of the clients receiving treatment; this proportion dropped to a low of less than one in six for Delaware, Vermont, Iowa, Maryland and Kentucky. A different pattern was displayed on the map focusing on drug treatment (which could include alcohol). Two areas in which women make up one-third or more of the clients included New England and the region defined by Nevada, Oregon and Idaho.

Heavy drinking also contributes significantly to death from liver disease (see "Chronic Liver Disease and Cirrhosis"). The low percentage of women in the Appalachian area reporting heavy drinking coincided with low rates of death from liver disease. However, Iowa, which reported the highest rate (among those 24 states) of heavy drinking among women, had one of the lowest rates of death from liver disease! In three states, Minnesota, Mississippi and South Dakota, the death rates for men and women were almost exactly the same. In a number of states, however, starting in the Northeast and moving in a band south and west, the death rate for men was more than twice that of women. The rate for men in Rhode Island was more than three times that of women. In general, rates of women and men in the Far West and South seemed somewhat more alike.

THE BIRDS AND THE BEES

Since issues surrounding reproductive health are some of the most important for women, we have devoted the remainder of this section to maps dealing with contraception, abortion, sterilization, pregnancy and venereal disease. All our data is based on research done by or for the Alan Guttmacher Institute in New York, a private organization that conducts studies on family planning.

The first map introducing these issues, "Family Life and Sex Education Policy," deals with states' attitudes toward sex education in school. As of 1980, only two states, Maryland and New Jersey, and the District of Columbia, required schools to offer courses in sex education and family life. The remaining states either encouraged such courses, left the decision up to individual school districts or had no specific policy. Some states actively promoted the discussion of birth control and abortion, while in other states it was specifically discouraged. The District of Columbia appeared as the only state-level jurisdiction both requiring sex education and family life courses and encouraging the discussion of abortion and birth control.

The laws and policies pertaining to contraception appear to have been of a largely regulatory nature. Topics of concern included advertising, product distribution and the provision of family planning services to minors. Only two states, Minnesota and Utah, appeared to have policies specifically covering distribution to minors.

The availability of family planning clinics and public funding for such services can be viewed as a partial indicator of statewide attitudes toward reproductive planning and education. For the map "Family Planning Clinics" we have tried to devise a measure of such service availability by determining the number of clinics providing family planning for every 100,000 women be-

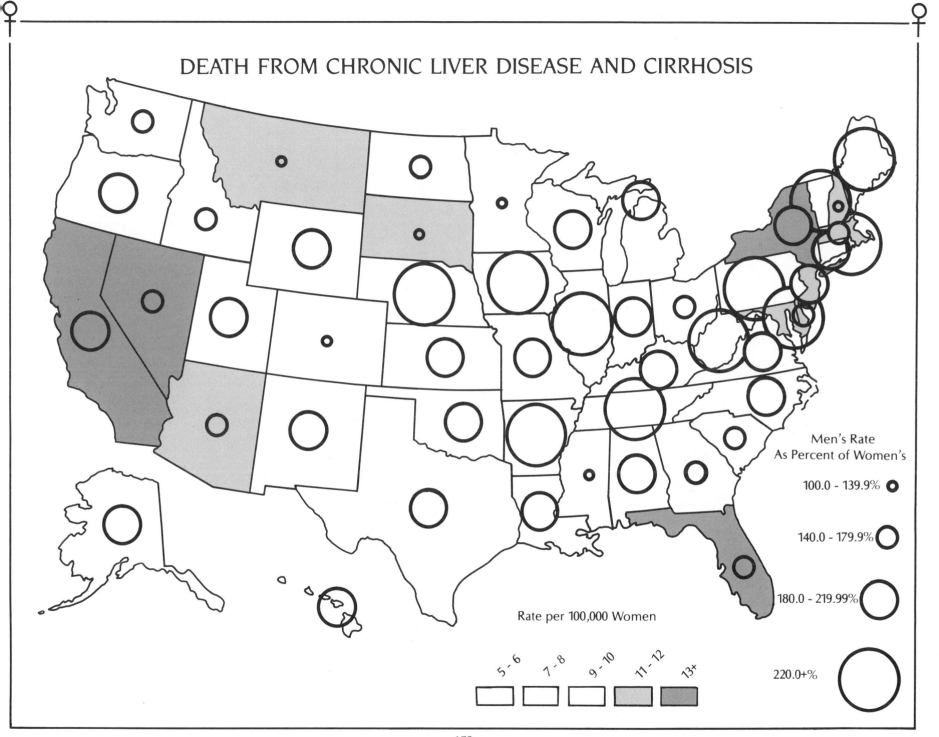

DEATH FROM CHRONIC LIVER DISEASE AND CIRRHOSIS

Men's Rate
As Percent of Women's

100.0 - 139.9%

140.0 - 179.9%

180.0 - 219.99%

220.0+%

Rate per 100,000 Women

5 - 6 7 - 8 9 - 10 11 - 12 13+

153

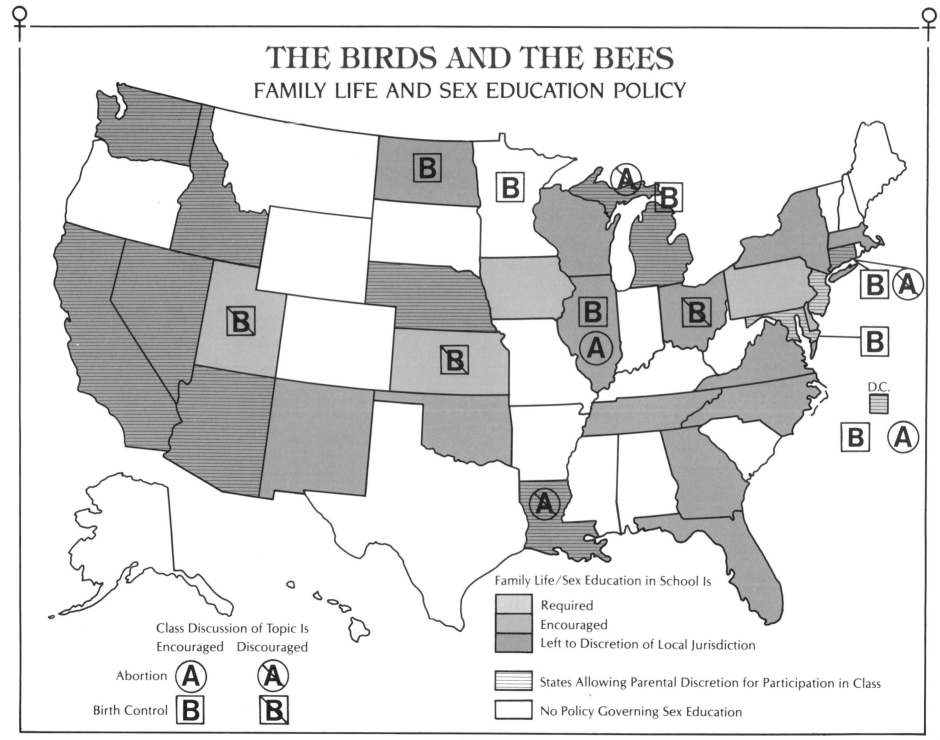

THE BIRDS AND THE BEES
FAMILY LIFE AND SEX EDUCATION POLICY

Family Life/Sex Education in School Is

- Required
- Encouraged
- Left to Discretion of Local Jurisdiction

States Allowing Parental Discretion for Participation in Class

No Policy Governing Sex Education

Class Discussion of Topic Is

	Encouraged	Discouraged
Abortion	Ⓐ	Ⓐ
Birth Control	🅱	🅱

D.C.

LAWS REGULATING CONTRACEPTION

April 30, 1983

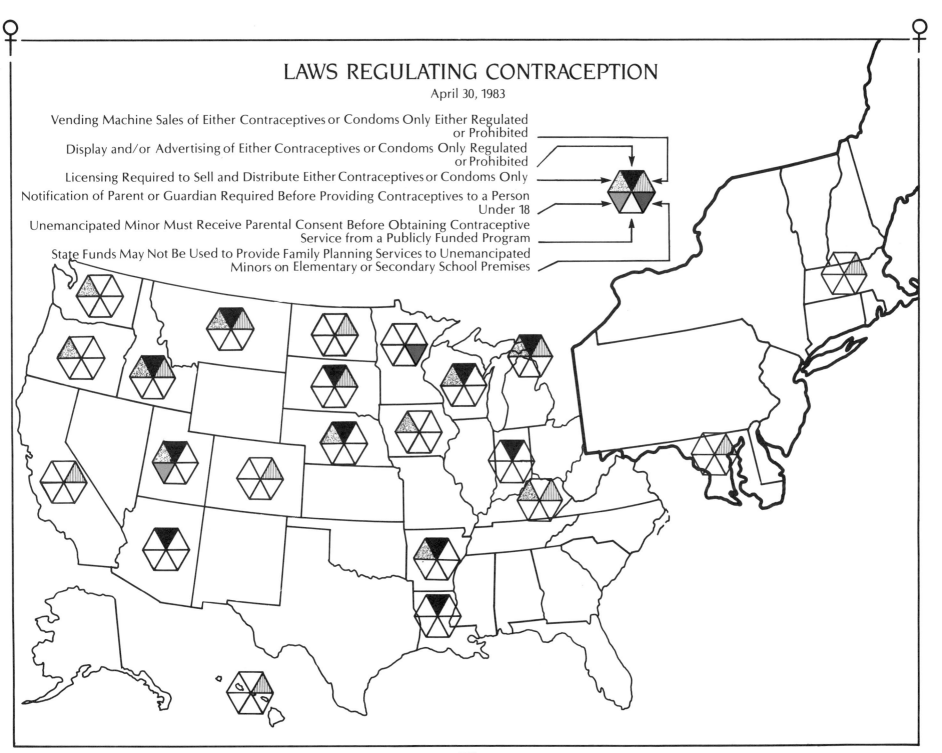

Vending Machine Sales of Either Contraceptives or Condoms Only Either Regulated or Prohibited

Display and/or Advertising of Either Contraceptives or Condoms Only Regulated or Prohibited

Licensing Required to Sell and Distribute Either Contraceptives or Condoms Only

Notification of Parent or Guardian Required Before Providing Contraceptives to a Person Under 18

Unemancipated Minor Must Receive Parental Consent Before Obtaining Contraceptive Service from a Publicly Funded Program

State Funds May Not Be Used to Provide Family Planning Services to Unemancipated Minors on Elementary or Secondary School Premises

tween the ages of 15 and 49. This measure does not include services provided by private physicians. Clinics are especially important sources of information for women who are young and/or low-income. The number of clinics per 100,000 women in this age group was highest in several southern states, while a number of northern states centering on the Midwest had among the lowest rates. Some states, such as Illinois, New Jersey and New York, had a relatively low rate of clinics despite high percentages of births to unwed women.

Funding for family planning services comes from both state and federal appropriations, with the latter source having provided 86% of the total funding in fiscal year 1980.[19] The majority of federal funds were available through Title X of the Public Health Service Act. Other federal programs providing funds were Title V (Maternal and Child Health), Title XIX (Medicaid) and Title XX of the Social Security Act. It is important to remember that women needing family planning services had to meet certain qualifications, low-income status being one of the most important, to receive assistance through many of these programs. Sometimes states were required to provide matching funds in order to receive federal money. This money was included in the federal funds total.

As with family planning clinics, we have made an attempt to standardize the statistics by converting them to the amount of money spent per 100,000 of the target population, roughly defined as women aged 15 to 49. The map "Public Funding" reveals the overwhelming support from federal rather than state funds. Only four states (California, Colorado, Minnesota and Georgia) had more than 25% of their public funding coming from state sources. In fact, many states provided no state money whatsoever, except possibly in regard to state matching funds.

Because family planning services are particularly im-portant for young and low-income women at risk of unintended pregnancy, attempts are made to monitor the number of such women actually served by both clinics and private physicians. It was estimated that in several states, over 80% of such women received family planning assistance in 1981. High rates of service delivery could be found in both northeastern and western states. In contrast, less than 50% of at-risk low-income and teenage women in Utah received assistance. It is interesting to note that two years later, Utah was one state requiring parental consent before a teenager could be provided with contraceptive services. Five other states, Florida, Oklahoma, Louisiana, Alabama and Illinois, were also under the 50% mark with regard to the percentage of at-risk teenage women obtaining help with family planning. Note that data was not available for low-income clients in seven states (Wyoming, Texas, Wisconsin, Kentucky, West Virginia, Tennessee and New York) making it difficult to perceive other regional patterns which might have existed.

Since abortion is one of the most controversial issues in our society, we have included seven maps dealing with this topic. The first, "Laws Regulating Abortion," focuses on selected laws and policies regulating abortion in 1973 and in 1983. 1973 was the time of the Supreme Court's landmark decision in the case of *Roe vs. Wade* which held that states could not make laws prohibiting abortion in the first two trimesters of pregnancy. Prior to this time, the majority of states permitted abortion only when needed to save the mother's life. Only four states (Alaska, Hawaii, Washington and New York) allowed abortion on demand, the only restriction being that it must be performed by a physician.

Ten years later in 1983, laws and policies for abortion, as for contraception, were largely regulatory in nature. Areas of concern included use of public funding, use of

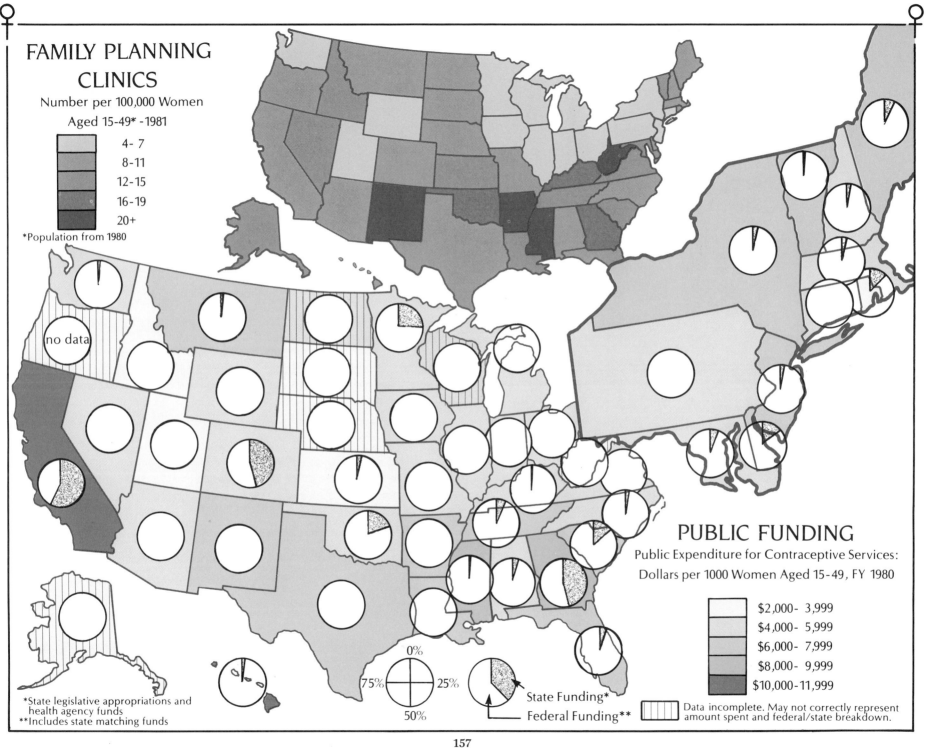

FAMILY PLANNING CLINICS

Number per 100,000 Women

Aged 15-49* -1981

- 4- 7
- 8-11
- 12-15
- 16-19
- 20+

*Population from 1980

no data

PUBLIC FUNDING

Public Expenditure for Contraceptive Services:

Dollars per 1000 Women Aged 15-49, FY 1980

- $2,000- 3,999
- $4,000- 5,999
- $6,000- 7,999
- $8,000- 9,999
- $10,000-11,999

0%

75% 25%

50%

State Funding*

Federal Funding**

*State legislative appropriations and health agency funds
**Includes state matching funds

Data incomplete. May not correctly represent amount spent and federal/state breakdown.

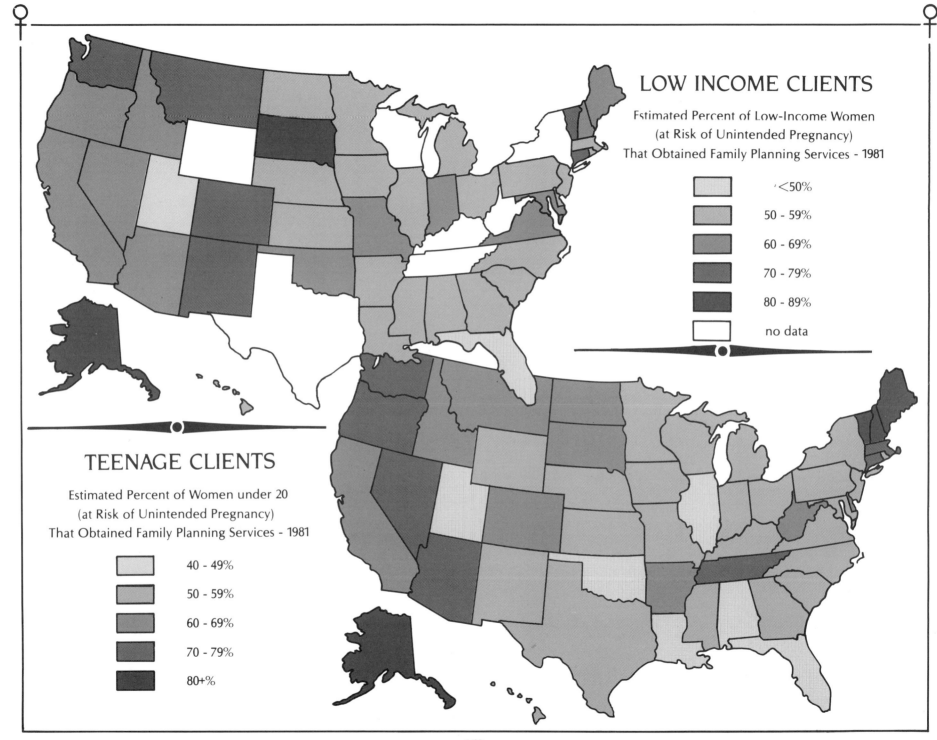

LOW INCOME CLIENTS

Estimated Percent of Low-Income Women
(at Risk of Unintended Pregnancy)
That Obtained Family Planning Services - 1981

- <50%
- 50 - 59%
- 60 - 69%
- 70 - 79%
- 80 - 89%
- no data

TEENAGE CLIENTS

Estimated Percent of Women under 20
(at Risk of Unintended Pregnancy)
That Obtained Family Planning Services - 1981

- 40 - 49%
- 50 - 59%
- 60 - 69%
- 70 - 79%
- 80+%

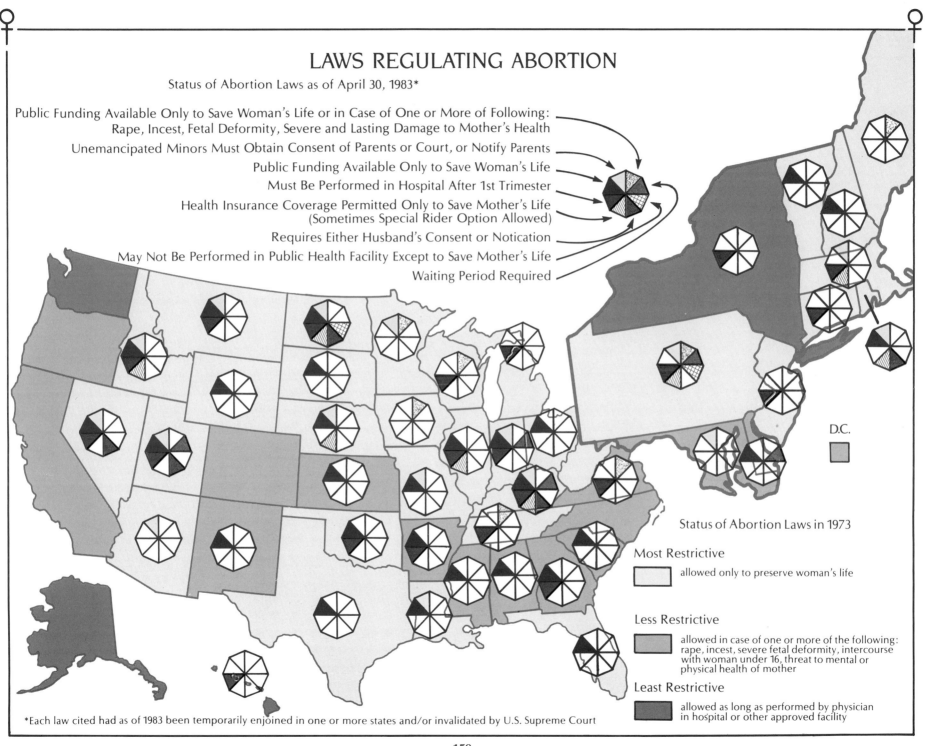

LAWS REGULATING ABORTION

Status of Abortion Laws as of April 30, 1983*

Public Funding Available Only to Save Woman's Life or in Case of One or More of Following:
Rape, Incest, Fetal Deformity, Severe and Lasting Damage to Mother's Health

Unemancipated Minors Must Obtain Consent of Parents or Court, or Notify Parents

Public Funding Available Only to Save Woman's Life

Must Be Performed in Hospital After 1st Trimester

Health Insurance Coverage Permitted Only to Save Mother's Life
(Sometimes Special Rider Option Allowed)

Requires Either Husband's Consent or Notication

May Not Be Performed in Public Health Facility Except to Save Mother's Life

Waiting Period Required

D.C.

Status of Abortion Laws in 1973

Most Restrictive

allowed only to preserve woman's life

Less Restrictive

allowed in case of one or more of the following:
rape, incest, severe fetal deformity, intercourse
with woman under 16, threat to mental or
physical health of mother

Least Restrictive

allowed as long as performed by physician
in hospital or other approved facility

*Each law cited had as of 1983 been temporarily enjoined in one or more states and/or invalidated by U.S. Supreme Court

159

health insurance to cover abortion, provision to minors, waiting periods and spousal notification. All of these policies have been challenged at the state or federal level. The states appearing particularly restrictive as of 1983 included Utah, Kentucky, Pennsylvania and North Dakota. Policies prohibiting the use of public funding for abortion were the most common, followed by those requiring the procedure to be performed in a hospital. Many people disagreed with the 1973 Supreme Court decision, and later laws and policies have been viewed by some as an attempt deliberately to make abortions less easy to obtain.

Not surprisingly, the number of places providing legal abortion services increased after 1973. For women seeking abortions, especially poor women, two major considerations are accessibility to an abortion facility and availability of funding. If a woman cannot get to a clinic or cannot pay for the procedure, the actual legality of abortion is irrelevant. The map "Abortion Clinics" clearly shows that these services were most accessible to women in several northeastern and Pacific coast states. In these places, over 90% of women aged 15–44 lived in counties with abortion facilities. By contrast, the northern High Plains, parts of Appalachia and the south central portions of the country had fewer than 50% of such women living near abortion facilities.

Public funding for abortion is both controversial and fiscally complex where it does exist. Money is provided through state and federal Medicaid programs for low-income women. The Hyde Amendment, in effect for the period of our map, severely restricted the use of federal funding for abortions. Depending on the months involved, criteria for use of federal funding in fiscal year 1980 varied in strictness. Because of these restrictions, only 12% of abortion funding came from federal government sources. While the Hyde Amendment did not effect state laws, 35 states also had their own policies severely restricting the use of state money for abortions. However, in California, Hawaii, West Virginia and the District of Columbia, all funding was provided from state appropriations. California, Michigan and the District of Columbia had the highest rates of funding (federal and state combined where applicable) per 1,000 women of reproductive age. By contrast, four states, North Dakota, Arkansas, Mississippi and Rhode Island, made no public funding available at all.

As was apparent from the map of abortion facilities, the ease of obtaining an abortion varied from place to place. As an additional measure of accessibility, we can study where women choose to have the procedure performed. One would assume that residents of states with stricter laws, fewer clinics and less funding would go elsewhere to have an abortion. In "Place of Abortion Vs. State of Residence," the top map shows the percentage of women going out of state to have an abortion. In South Dakota, West Virginia and Wyoming, over 40% of women requiring abortions obtained them in another state. You will recall that in these three states, less than half the women lived in counties with abortion facilities. Several states with a high level of access to abortion services (such as California, New York and Massachusetts) had fewer than 4% of women seeking services elsewhere. This relationship does not always hold, however. Minnesota, which had low accessibility to facilities, also had less than 4% of its abortions performed out of state.

The lower map shows states which provided a significant proportion of their services to women from other states. The District of Columbia and Kansas stood out in this regard. An odd situation occurred in the Dakotas where the percentages on both maps were high, indicating that while many residents are going out of state, nonresidents were also coming in for the same service!

It would be expected that the 1973 Supreme Court decision would increase the number of legal abortions

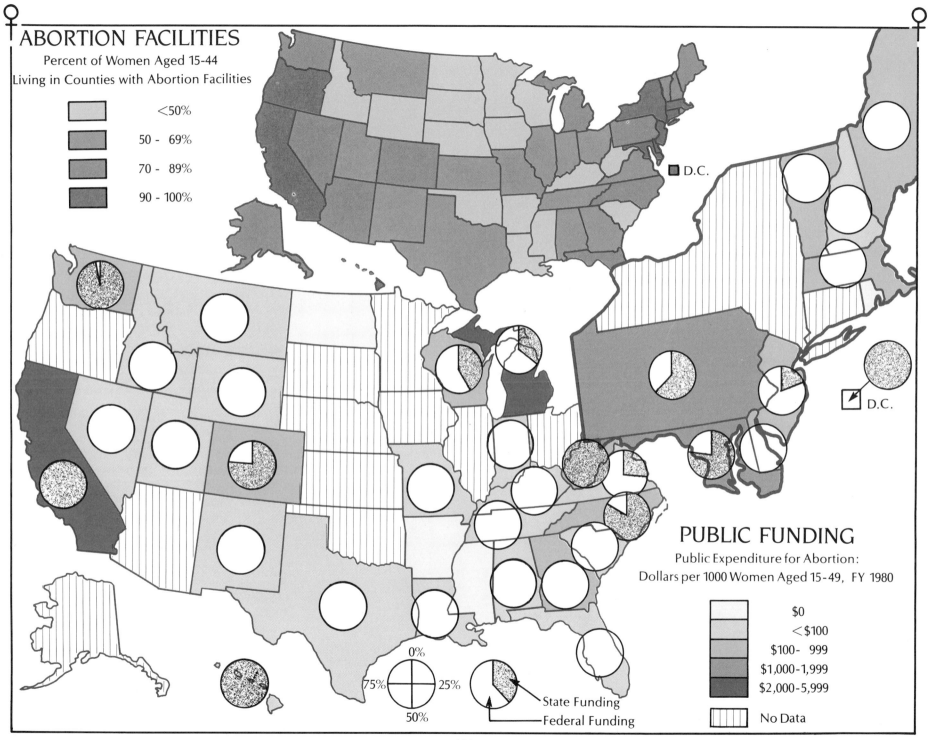

ABORTION FACILITIES

Percent of Women Aged 15-44
Living in Counties with Abortion Facilities

- <50%
- 50 - 69%
- 70 - 89%
- 90 - 100%

■ D.C.

PUBLIC FUNDING

Public Expenditure for Abortion:
Dollars per 1000 Women Aged 15-49, FY 1980

- $0
- <$100
- $100- 999
- $1,000-1,999
- $2,000-5,999

No Data

D.C.

0%

75% ⊕ 25%

50%

State Funding
Federal Funding

PLACE OF ABORTION VS. STATE OF RESIDENCE

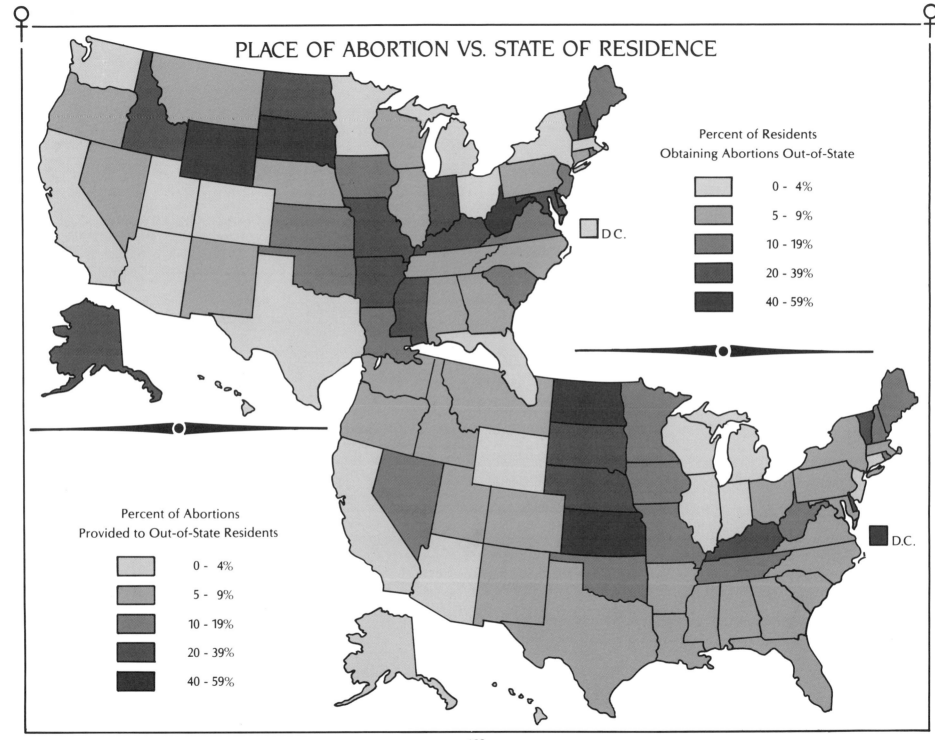

Percent of Residents
Obtaining Abortions Out-of-State

- 0 - 4%
- 5 - 9%
- 10 - 19%
- 20 - 39%
- 40 - 59%

D.C.

Percent of Abortions
Provided to Out-of-State Residents

- 0 - 4%
- 5 - 9%
- 10 - 19%
- 20 - 39%
- 40 - 59%

D.C.

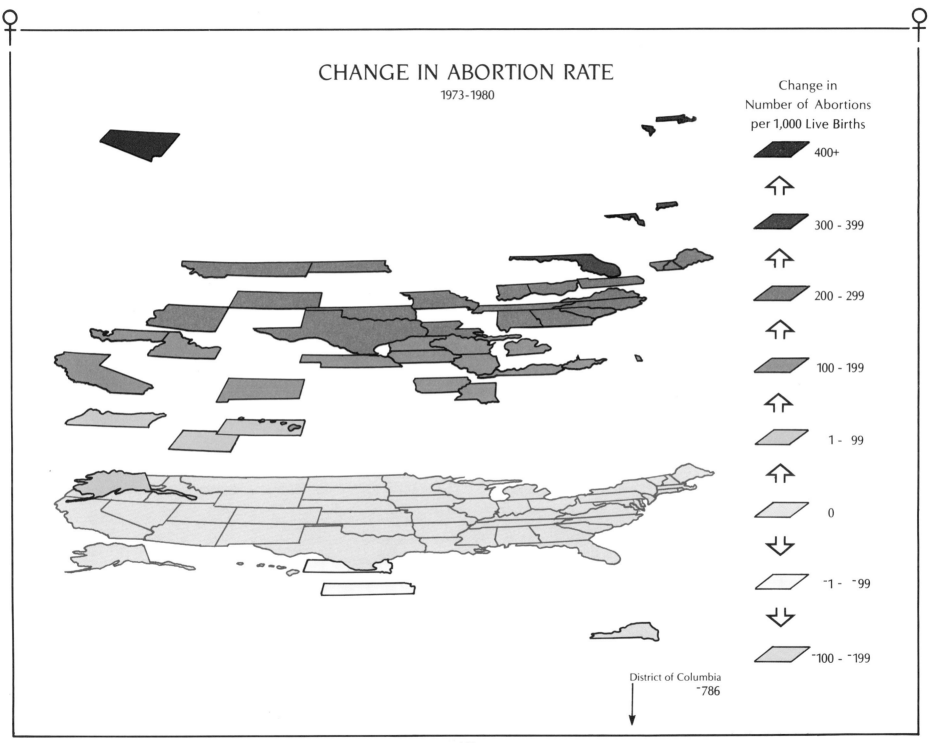

CHANGE IN ABORTION RATE
1973-1980

Change in
Number of Abortions
per 1,000 Live Births

400+

300 - 399

200 - 299

100 - 199

1 - 99

0

¯1 - ¯99

¯100 - ¯199

District of Columbia
¯786

performed throughout the country. However, in three states, New York, Kansas and South Dakota, the rate in 1980 was less than that seven years before. The states that had the greatest increases during that period were Nevada, New Jersey, Massachusetts and Rhode Island. Nevada showed the greatest jump with an increase of 589 abortions per 1,000 live births. With the exception of Nevada, larger increases tended to occur in states on the East Coast. This map, "Change in Abortion Rate," can be compared with that on page 166 showing 1980 abortion rates. The Northeast and West Coast had high abortion rates in 1980 while the south central, northern Rockies and Plains states had low values. The lowest rate was in Utah (97 per 1,000) and the highest in the District of Columbia (1,569 per 1,000), a rate more than double that of the second-place contender, New York with 780 per 1,000 live births. It is important to remember that the abortion rate includes abortions provided to instate *and* out-of-state residents.

While sterilization is now occasionally reversible, it is generally regarded as an operation whose result is permanent. Two types of operations, tubal ligation and hysterectomy, render women incapable of further childbearing. Because a hysterectomy is a major operation resulting in the disruption of a woman's hormonal balance, tubal sterilization is now the method of preference.

Seventeen states had, as of 1983, seen fit to regulate sterilization (see "Laws Regulating Sterilization"). Connecticut actually prohibited the use of hysterectomies for contraceptive purposes. Other restrictions concerned waiting periods, sterilization of minors, second opinions, place of procedure and spousal consent. Not surprisingly, the regulations prohibiting the sterilization of minors seem to have gained the greatest support.

Geographic data on hysterectomies and tubal ligation is available only for large regions. It must be remembered that while all hysterectomies result in the loss of childbearing capability, they are performed for reasons other than contraception. Rates of both sterilization procedures were highest in the South. While hysterectomy rates were lowest in the Northeast, tubal ligation had the lowest frequency of use in the West.

When the decision has been made to have a child, questions dealing with prenatal care arise. The majority of women in the United States receive some type of prenatal care during the first trimester of pregnancy. However, in several southern states and New York, the percentage of women receiving prenatal care was relatively low (between 65% and 70%). With the exception of Virginia, Iowa and Utah, the states with the highest percent of women receiving prenatal care were found in the Midwest.

It might be assumed that those states with a low percentage of women receiving prenatal care would also have a high percentage of babies born with low birthweight. To some extent this appeared to be true. In New York and several Deep South states, a low percentage of women receiving prenatal care corresponded with increased incidence of low birthweight. This inverse relationship tended to be less true in southern New England. These states topped the list for percentage of women receiving prenatal care, yet the percentage of babies born with low birthweight was not as low as we might expect. Note too that those states with a greater percentage of their population below the poverty level also had a high occurrence of babies with low-birthweights. Adequate nutrition is important for the development of a healthy baby.

Income level and the quality of prenatal care are also factors in rates of infant mortality and death from pregnancy. Infant mortality was clearly highest in the Deep South and lowest in the Rocky Mountain, northern Plains

and northern New England states. Death from pregnancy was most frequent in Rhode Island, South Carolina and Oklahoma. It was least common in several New England and northern Pacific states. According to these maps, pregnancy appeared most hazardous for infants and mothers in South Carolina.

Information about obstetricians and gynecologists is from the same survey which earlier provided information on all doctors and psychiatrists. The percentage of these specialists that were women ranged from a low of 2% in Idaho to 22% in Delaware. In about half the states, fewer than one in ten gynecologists and obstetricians were female. The number of female practitioners per 100,000 women aged 15+ was also quite low. Both maps indicated the heaviest concentrations in the Northeast, Michigan and Illinois, similar to the patterns for physicians and psychiatrists as a whole.

Many feminists have advocated the use of a trained nurse-midwife as an alternative to the obstetrician. Nearly half of the states had, as of 1980, some sort of procedure for certifying or regulating the profession of midwife.

The final map of the section shows rates for reported cases of syphilis and gonorrhea. Cases occurring in military personnel were excluded from these statistics. Because of the stigma that is attached to venereal diseases, it is possible that the rates presented underestimated the total number of cases. Maryland and the Deep South, along with Delaware, had high occurrences of these types of venereal disease. Alaska reported the highest rate with 106 cases per 10,000 females and its rate was more than 43% greater than the rate of second-place Maryland.

ABORTION RATE

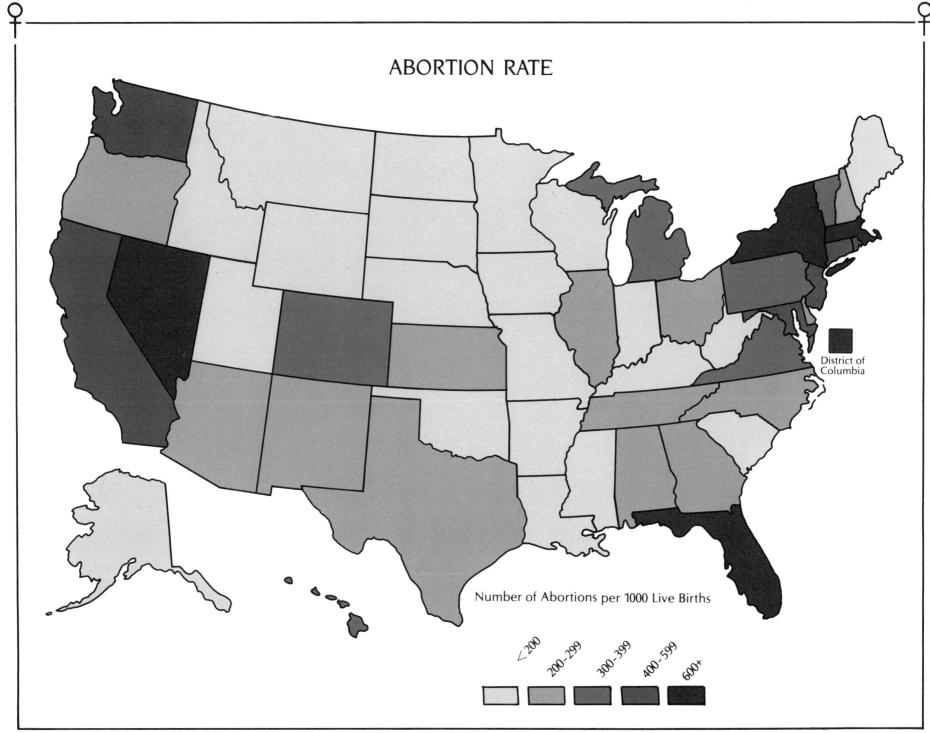

District of Columbia

Number of Abortions per 1000 Live Births

<200 200-299 300-399 400-599 600+

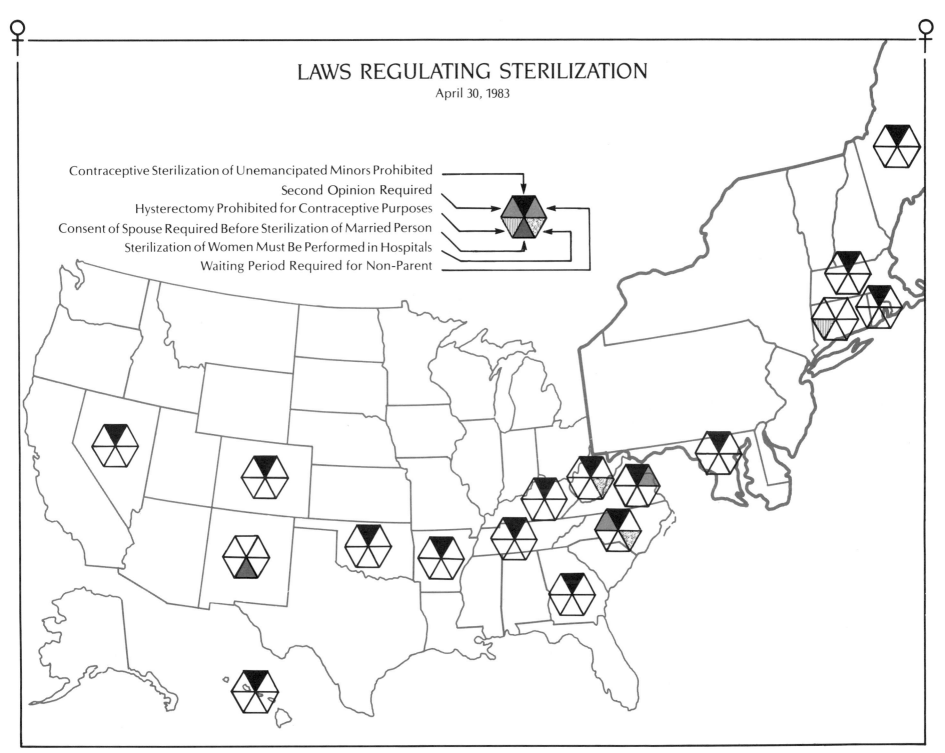

LAWS REGULATING STERILIZATION
April 30, 1983

Contraceptive Sterilization of Unemancipated Minors Prohibited
Second Opinion Required
Hysterectomy Prohibited for Contraceptive Purposes
Consent of Spouse Required Before Sterilization of Married Person
Sterilization of Women Must Be Performed in Hospitals
Waiting Period Required for Non-Parent

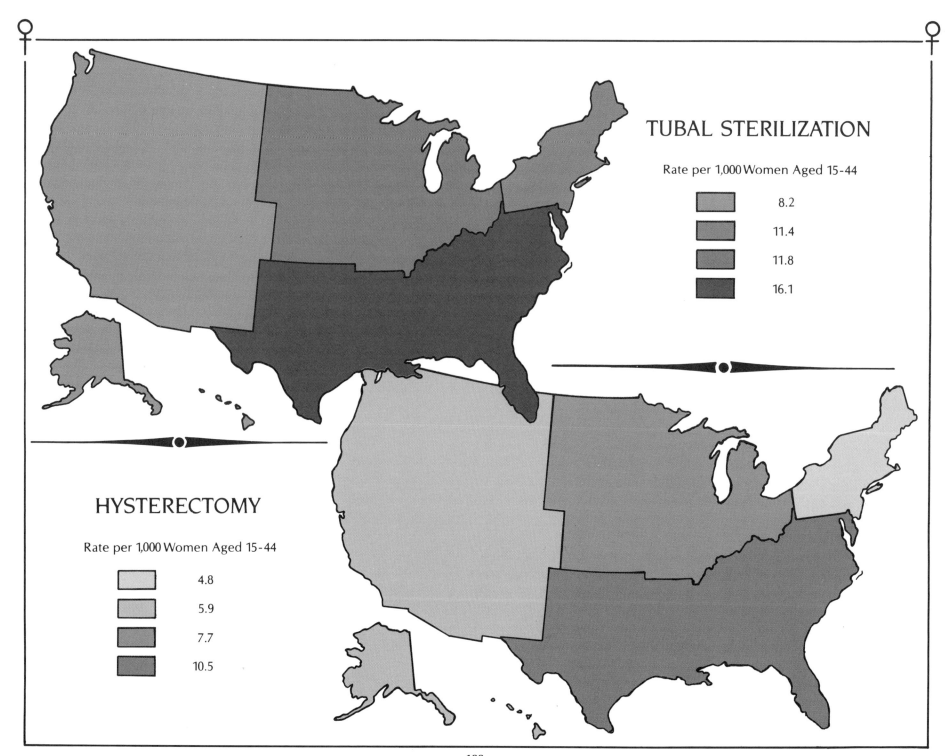

TUBAL STERILIZATION

Rate per 1,000 Women Aged 15-44

8.2

11.4

11.8

16.1

HYSTERECTOMY

Rate per 1,000 Women Aged 15-44

4.8

5.9

7.7

10.5

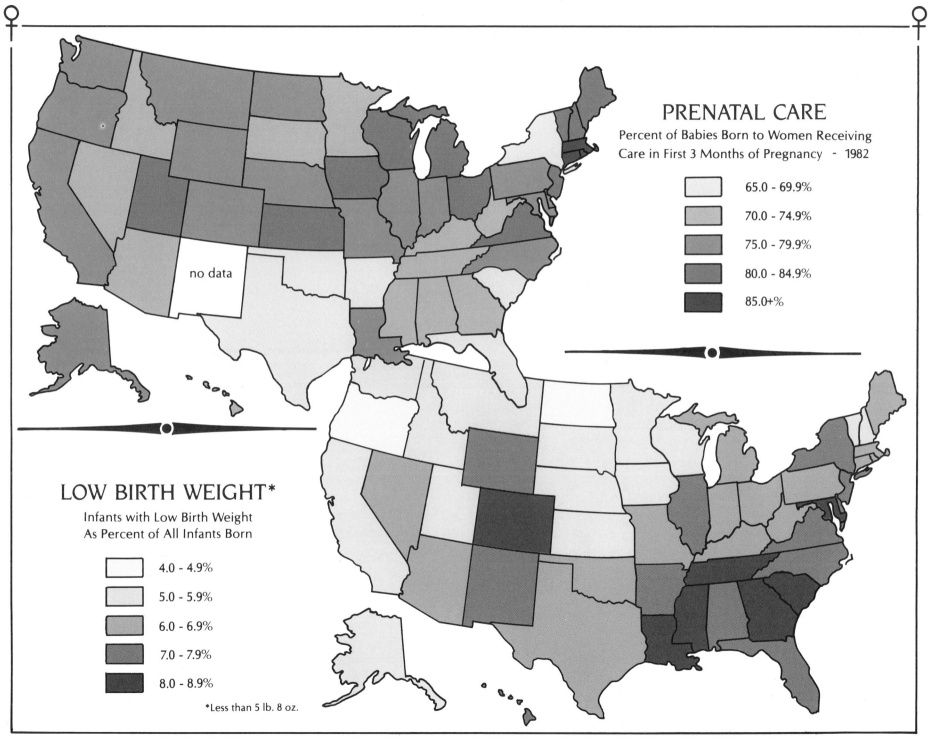

PRENATAL CARE

Percent of Babies Born to Women Receiving Care in First 3 Months of Pregnancy - 1982

- 65.0 - 69.9%
- 70.0 - 74.9%
- 75.0 - 79.9%
- 80.0 - 84.9%
- 85.0+%

no data

LOW BIRTH WEIGHT*

Infants with Low Birth Weight
As Percent of All Infants Born

- 4.0 - 4.9%
- 5.0 - 5.9%
- 6.0 - 6.9%
- 7.0 - 7.9%
- 8.0 - 8.9%

*Less than 5 lb. 8 oz.

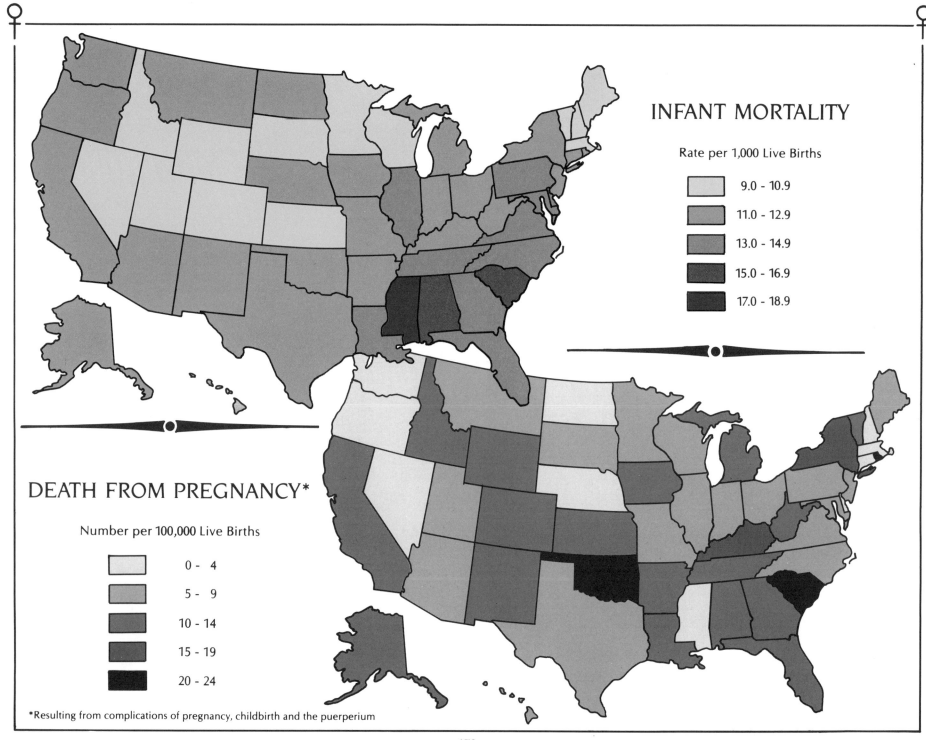

INFANT MORTALITY

Rate per 1,000 Live Births

9.0 - 10.9
11.0 - 12.9
13.0 - 14.9
15.0 - 16.9
17.0 - 18.9

DEATH FROM PREGNANCY*

Number per 100,000 Live Births

0 - 4
5 - 9
10 - 14
15 - 19
20 - 24

*Resulting from complications of pregnancy, childbirth and the puerperium

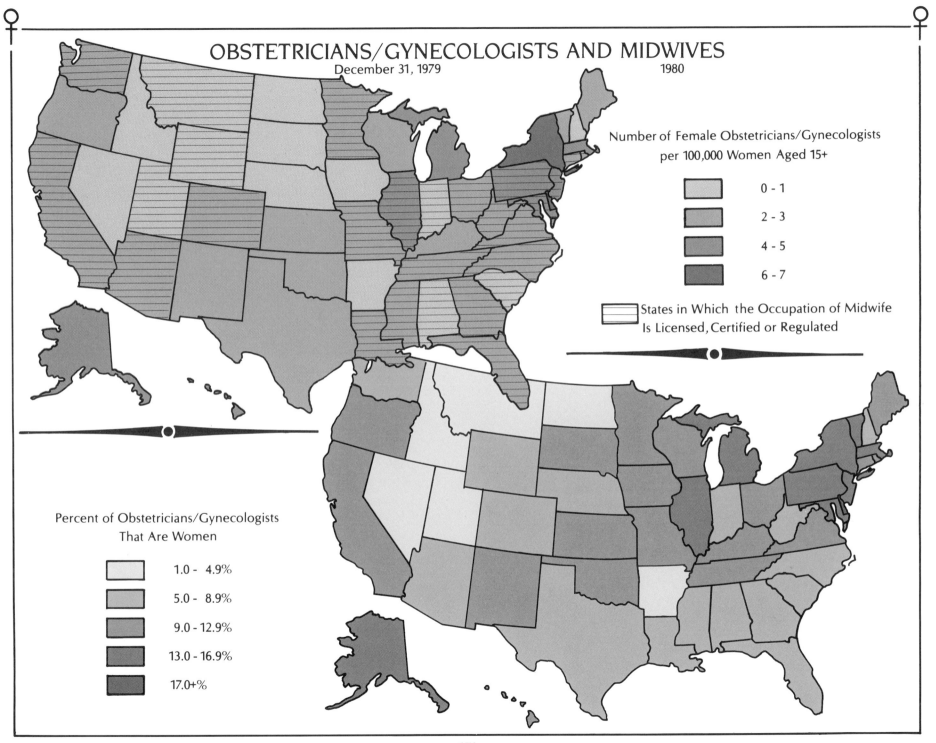

OBSTETRICIANS/GYNECOLOGISTS AND MIDWIVES
December 31, 1979 1980

Number of Female Obstetricians/Gynecologists
per 100,000 Women Aged 15+

- 0 - 1
- 2 - 3
- 4 - 5
- 6 - 7

States in Which the Occupation of Midwife
Is Licensed, Certified or Regulated

Percent of Obstetricians/Gynecologists
That Are Women

- 1.0 - 4.9%
- 5.0 - 8.9%
- 9.0 - 12.9%
- 13.0 - 16.9%
- 17.0+%

SYPHILIS AND GONORRHEA

1979

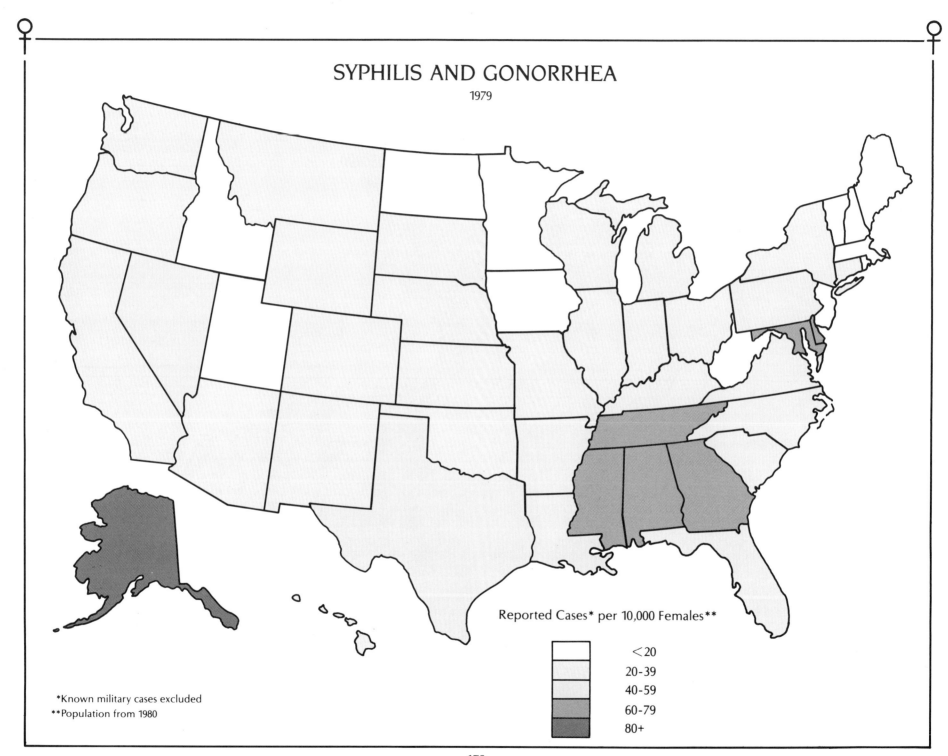

Reported Cases* per 10,000 Females**

	<20
	20-39
	40-59
	60-79
	80+

*Known military cases excluded

**Population from 1980

CRIME

"The phenomenon of female criminality is but one wave in this rising tide of female assertiveness— a wave which has not yet crested and may even be seeking its level uncomfortably close to the high-water mark set by male violence." [1]

—Freda Adler

Over the past few years, television series focusing on crime and violence have become a popular staple of network programming. No type of criminal activity seems exempt from treatment. Special emphasis has been placed on the involvement of women with crime, ranging through their roles as rape victims, abused wives, prostitutes and policewomen. Depictions of violence with sexual overtones seem to draw particularly large audiences, causing some feminists to maintain that the popularity of such programs is indicative of culturally endorsed acceptance of violence against women.

There are three perspectives from which to view the relationship between women and crime: women as perpetrators, women as victims and women as criminal justice professionals. When comparing female and male perpetrators, one notices two significant differences. First, the level of women's criminal involvement is significantly less than men's. Second, female criminals tend to participate in types of criminal activity different from their male counterparts. These discrepancies between the sexes have puzzled criminologists for over 100 years. Explanatory theories have incorporated various biases reflective of the individual criminologist's attitude about women.

Some 19th-century criminologists, in agreement with the prevailing opinion of society, believed that women were morally superior to men. The criminologists carried this double standard of behavior throughout their analysis. They believed that when a woman did become

involved in criminal activity, she became more hardened and incorrigible than her male partner in crime. Unlike her male counterpart, the female criminal was condemned as one who deviated not only from the standards of humanity in general, but more important, from the ladylike behavior considered the norm for her sex. Essentially, the woman who committed a crime unsexed herself. Other criminologists attributed women's lower level of criminal activity to their supposedly more passive and timid natures, rather than to any particular moral superiority.[2] Women were seen simply as having fewer of the innate qualities necessary to become truly superior criminals.

As the early hypotheses involving some form of biological determinism fell from favor, other theories were introduced to explain patterns of criminal activity in women. Early environmental determinists placed the blame on society, and particularly on an economic structure that provided few economic opportunities for women to be financially independent. Out of desperation, they theorized, women turned to petty thievery and prostitution to feed themselves and their families. More recently, radical feminists have placed the blame on racism and sexism.

Still others hypothesized that women were no more or less inclined to criminal activity than men. They merely had less opportunity to commit illegal activities when they were confined to the home as wives and mothers.[3] The idea was also put forth that many women were "hidden" or "closet" criminals. Women were thought to have led men into criminal activity through various forms of temptation while they remained in the background.[4] Another explanation has suggested that police data does not adequately report the level of female criminal activity. This is based on the idea that male victims are unwilling to report victimization by women and that male law enforcement officials are less willing to arrest women out of misplaced chivalry.[5]

Recent FBI Uniform Crime statistics throw the different patterns of male and female criminal activity into sharp focus. However, while these statistics are probably the best indicators of criminal activity available, they should be viewed with caution. The data presents a count of the number of arrests made during a given year, as distinguished from the number of persons arrested. One person might be arrested several times. In addition, note that the data, except in two maps, refers to arrests, not convictions. The person arrested might later be released without being convicted. The statistics also do not give any indication of crimes that have gone unreported. Finally, despite intensive efforts between states to standardize crime-reporting methods, the accuracy of arrest data is still sensitive to variations in local police staffing budgets, departmental priorities and attitudes towards different types of criminal activity.

The FBI collects and maintains statistical information on twenty-nine different categories of crime. These include what are referred to as Part I crimes: those against persons (murder, rape, robbery and aggravated assault) and those against property (burglary, larceny, motor vehicle theft and arson). Part II crimes are those such as fraud, forgery, vandalism and sexual offenses. Also included are so-called "victimless" crimes, of which prostitution, gambling and runaway activity are examples.

In only two categories, prostitution and runaway activity, did the percentage of female arrests exceed that of male, with women making up 70% and 58% of those arrested, respectively, in 1980. Forty-one percent of those arrested for fraud were female, while women as a percentage of those arrested for remaining crimes ranged from a low of 1% for forcible rape to a high of 31% for forgery and counterfeiting.[6]

We have chosen to focus on several of the most serious (Part I) crimes for the maps. Those arrested for this

type of activity are predominantly male. The percentages of female persons arrested in 1980 were:[7]

Murder	13%
Robbery	7%
Aggravated Assault	12%
Burglary	6%
Larceny	29%
Motor Vehicle Theft	9%

The relatively slight increase that has been observed in female crime over the past two to three decades has largely been due to an increase in larceny, primarily shoplifting activity.[8]

We can also examine the predominant types of criminal activity for men and women. Part I crimes actually comprised only 27% of female arrests and a slightly lower figure, 22%, for men. The crimes for which women were most frequently arrested were, in order, larceny (the only Part I crime), miscellaneous offenses, driving under the influence, disorderly conduct and fraud. For men, the miscellaneous category ranked first, followed by driving under the influence, drunkenness, larceny and disorderly conduct. These five categories made up about 60% each of the men and women arrested.[9]

Society has determined that, for its own safety, it is useful to isolate offenders from the population at large. In the United States, a system of municipal and county jails and state and federal correctional institutions has evolved for this purpose. Initially, the goal of these facilities was twofold: to protect society from the offender and to punish criminals in the hope that punishment would serve as a deterrent. Later, efforts were directed towards rehabilitation and reform.

Because men have always comprised the bulk of offenders, prisons were initially established only with regard to the needs of male prisoners. At first, women offenders were housed with their male counterparts. Prisoners of both sexes in the 19th century were forced to live in conditions of unspeakable squalor and brutality. Conditions for men were bad enough, but women suffered the additional degradation of brutality and sexual assault at the hands of both jailers and other male prisoners. The female prisoner was considered even more despicable than the male, and less redeemable. The female criminal was also considered to be sexually evil—a fallen woman in all respects and fair game for any man.

It was not until the end of the last century that separate prisons for women and staffed by women were constructed in the United States. Following the examples of those previously involved in temperance and abolitionist activity, a number of women began to feel that they had a special responsibility to women in prison.[10] These reformers tended to agree with the then-prevalent notion that women were morally superior to men and thus could be redeemed through prayer, kindness and judicious discipline. They recognized the importance of the prisoners learning a trade so they would be able to support themselves when they left prison.

Many early reformers believed that women turned to criminal activity because they were unable to find lucrative employment. While some women's prisons attempted to provide training in skilled trades, most training programs revolved around traditional women's work of a domestic nature. Most women on release from prison were fit to be little else than domestic servants, laundresses or sewing machine operators, all extremely low-paying positions.

The establishment of women's prisons in the late 19th century was, for several reasons, regarded with skepticism by male prison authorities. First, female criminals, as previously mentioned, were considered irredeemable and therefore unworthy of even minimal respect as

human beings. Second, the relative number of women to men offenders was small enough that many did not feel it financially feasible to duplicate separate facilities for women only. Third, the prevailing opinion held that violent women could not be controlled by other women.[11]

Today, the debate concerning the appropriateness of single sex correctional institutions continues and the issues are curiously the same. Most states as of 1981 had only one state correctional facility for women only. For reasons of space, many women offenders have had to be accommodated in predominantly male facilities. However, many contemporary criminologists believe that the introduction of female offenders into male facilities improves the atmosphere of the prison. Homosexual attachments and assaults are considered a serious problem at male facilities. It is felt that the introduction of female inmates will lesson those sorts of tensions and allow the prison to approximate the more normal pattern of the community at large. In addition, the prevailing opinion is that the presence of female inmates tends to make for less violent atmosphere in the prison. Women are viewed as humanizing and gentling influences, by nature less violent and more "civilized."

Similarly, some observers of all-women prisons note the prevalence of homosexual attachments and see integration with male prisoners on a social level as being healthier. The justification is that these women will have to interact with men on the outside upon release, and it is best for them to learn how to cope when in prison.

On the other hand, supporters of single sex prisons, particularly for women, are adamant about the superiority of the single sex institution.[12] Supporters of women's institutions particularly feel that the new trend towards coed institutions is done more in regard to the well-being of the male prisoners. They point out that separate institutions were established for women pre-

cisely because woman were frequent victims of male abuse in early coed facilities.

Many female offenders currently in prison today have been victims of battery, incest or rape. Even on a level of less overt violence, criminologists feel that many female offenders have been unduly dependent on men and maintain that in an all-female environment, such women will learn to establish a more solid sense of self. They would perhaps learn initiative and leadership skills, in essence to gain confidence that they can make it on their own. In support of this goal, it is pointed out that the male/female relationships in a coed institution tend to replicate the traditional, stultifying attitudes toward women found in the lower socioeconomic class in which many offenders originate. Male offenders tend to regard women inmates as sex objects and subordinate to men in general.

Supporters of single sex institutions for women point out that educational and training programs can be geared specifically to the needs of women. Because women there are a minority, coed facilities gear programming primarily to the needs of male inmates. Coed advocates, however, maintain that women inmates are likely to encounter a more diversified range of programming in a coed institution. Women's facilities, it is claimed, tend to be smaller and thus their funding and range of programs is more restricted. Women inmates still tend to be trained in lower-paying jobs rather than learning the higher-paying, skilled blue collar trades.

The flip side of women's involvement in criminal activity focuses on women as victims of crime. Here again the patterns of women's involvement are different from men's. For two out of three crimes against persons, the victimization rate for men was considerably higher than that for women. In 1980 the rates per 100,000 persons 12 and older were as follows:[13]

VICTIMS OF CRIME

	Women	Men
Robbery	409	873
Aggravated Assault	462	1346
Rape	149	23

(Murder victimization was not reported in the National Crime Survey.) Only for rape was the victimization rate higher for women. Women were also more likely to be victims of "personal" larceny (theft) such as purse snatching or pocket picking. Despite what appears to be a large difference in victimization rates for the very serious crimes (rape excepted), women, according to some polls, tend to *fear* being victimized more than do men.[14]

We have focused on women as victims of the two most serious crimes—murder and rape. Statistics are most readily available for these crimes, perhaps because they are the most serious. While only 23% of murder victims in 1980 were women, about 90% of women whose killers were known were murdered by men. (Only 18% of men were killed by women.) The percentage of female murder victims has held fairly constant for the 25 years preceding 1980.[15]

Rape is the most problematic crime affecting women. As an act in which physical assault has been united with sexual intercourse, rape calls forth a confusion of feelings in both sexes. Traditionally, society has focused on the sexual component of rape, maintaining that rape is a crime characterized by uncontrollable sexual desire in men. Its incidence is unfortunate, but after all, the victim is not deprived of life or material possessions. More recently, however, the assessment of the nature of rape has changed. The currently prevailing viewpoint reveals rape as predominantly a crime of violence in which forced sexual intercourse is used to inflict harm and humiliation upon an individual.

The traditional view of rape as a crime of sexual excess has been reinforced by equally traditional attitudes about the nature of sexual behavior and the woman's place in society. A woman's primary role has always been as bearer of children. She has been viewed as the property of the men in the family for she makes possible the continuation of that family. An insult to her chastity was an insult to the family honor. Men have reacted toward rape of a female family member at the hands of an intruding male as an insult to themselves. In a more negative light, cultures regarding a woman's virginity as sacred have ostracized the victim of rape as one who has been defiled. Thus, attitudes toward the victim have been both protectionist and condemnatory.

Because rape involves sexual intercourse, there has been confusion about the nature of men who commit rape and the women who are rape victims. Since sexual intercourse is part of normal heterosexual behavior, the assumption has been that the rapist was merely suffering from frustrated sexual desire, and that the rape victim secretly wanted to be raped. Such assumptions were reinforced when there were no apparent signs of physical abuse on the victim, or when the victim could be suspected of previous sexual indiscretions. The view was that a "good" woman would rather be killed or beaten senseless than be raped.

The attitude toward the rapist was that he was merely reacting to a conscious or unconscious overtures on the woman's part. No man would rape a woman who acted like a lady should. Therefore, he must have been tempted into the act or teased beyond endurance by the victim. Such a representation would invariably elicit sympathy from fellow males. The recognition by psychologists that many women have "rape-like" fantasies has also been used as a rationalization and excuse for rape.

Only recently is our society beginning to acknowledge that the inclusion of sexual intercourse in the rape act is a means by which a rapist can accomplish his chief purpose: the infliction of physical and psychological harm as a way of venting anger and feeling empowered. We are beginning to see rape not as an act of frustrated love/lust, but as an expression of hate. This change in perspective is being felt in the way both rapist and rape victim are regarded by the criminal justice system and society at large.

The treatment given out to the rape victim upon reporting the crime (the physical exam, the questioning and grilling on the witness stand) has caused many rape victims to feel twice victimized, once by the rapist, and again by the criminal justice system. Until recently, the rape victim has at times been treated almost like a criminal herself, being forced to reveal and justify her past sexual behavior and her actions during the rape itself. Perhaps as a result, rape is a highly unreported crime. One Census Bureau survey estimated that in 1980 only 43% of rapes were actually reported.[16] Sentencing practices vary in severity from state to state and many rape victims hesitate to prosecute for fear of reprisal by the rapist.

The criminal justice system and other organizations dealing with rape victims have responded by modifying the way rape victims are treated. A large number of states have passed rape shield laws that limit the degree to which the victim's sexual history can be used as a subject of inquiry in court. Many states have also enacted stiffer penalties for those convicted of rape. Larger police departments have set in place special rape investigation units staffed by personnel trained to be sensitive to the victim's situation. Hospitals and other concerned social agencies have established rape crisis centers to provide victims with counseling and emotional support.

Some of the most encouraging changes reflecting society's new perspective on rape have come in the area of marital rape exemption laws. In English common law (the basis of our own legal system) it was not possible for a husband to be charged with the rape of his wife. The nature of the marital relationship was such that the husband had the right of sexual access to his wife with or without her explicit consent.

A number of states enacted legislation exempting husbands from being charged with spouse rape. However, in response to new views of rape and increased recognition of the importance of mutual consent in sexual activities, many states have modified or abolished the exemption in the past decade. The modifications seem to have essentially followed two approaches. In some states, the exemption has been restricted according to the relationship between the spouses. If the marriage has shown evidence of breakdown in that the couple has initiated legal proceedings for separation or divorce, or is living apart, the exemption may no longer provide a defense to the husband. Other states have modified the exemption according to the nature of the crime itself. Usually in these states, the exemption no longer protects the man in the case of first-degree rape. However, in lesser degrees of sexual assault, the exemption may still apply. A few states, in what appears to be a great leap backward, have actually expanded the exemption to cover persons of the opposite sex living together, whether married or not (cohabitants), and/or "voluntary social companions."

While at the time of our data the FBI still defined rape as carnal knowledge of a female forcibly and against her will, some individual states have redefined rape to be gender neutral, thus permitting the inclusion of male homosexual rape and the rare though possible instances of women raping men. As we saw earlier, the rape victimization rate for women ages 12+ was 149

per 100,000, six times that for men. What is surprising is that the rate for men aged 12+ was as high as 23 per 100,000. Rape is finally being recognized as a crime which affects men as well as women.

One of the most important ways in which the criminal justice system has become more sensitive to women's needs is through the introduction of female personnel. This integration has begun to take place in a number of areas. Three of these, women as lawmakers (legislators) and women as legal interpreters (judges and lawyers) will be discussed more fully in the next section. It seems appropriate here to mention women as law enforcement and correctional officers.

We have already discussed briefly the use of female correctional personnel to supervise female offenders in the mid- and late 19th century. Some female correctional officers are now found even in male correctional institutions. Women did not become police officers, however, until the beginning of this decade, and it was not until 1968 that a woman was employed on patrol.[17] Even by 1980, police and correctional officers were predominantly male, with Census estimates putting the proportions at about 94% and 86% respectively. Female officers have tended to concentrate in administrative roles, or positions working with juveniles and female offenders.

The introduction of women as criminal justice personnel has met with resistance. With so much emphasis in police work controlling violence and aggression, and the perceived need to use physical force to accomplish this end, it is not surprising that police and correctional work has maintained a macho image. Male officers fear that women are not strong enough physically to cope with offenders, and not tough enough emotionally to cope with the tensions of police work. However, some observers feel that female officers are more successful in coping with and diffusing some types of violent confrontation and are better able to maintain a friendly, non-threatening rapport with the local community. In light of conflicting attitudes, it has been difficult for female officers to adopt a tone that allows them to be both female and police officers. One interesting study revealed that some women tend to adopt the macho behavior patterns displayed by male colleagues in an effort to prove they can be as tough and "police-like" as the men while others perpetuated traditional female roles by deferring to the male officers.[18]

WOMEN ON THE FORCE

We begin this section by focusing on women in law enforcement as an indication of the number of women in positions of authority. Census estimates of female officers and detectives showed that even by 1980, the field was still very much male dominated. Women constituted only about 2% of the profession in Delaware, while the high was reached in Alaska at 12%. In fact, Alaska was only one of three states (the others being New Mexico and Colorado) that had more than 10% of their police and detective forces composed of women. The lowest participation rates appeared in the Northeast, Montana and Minnesota. With the exception of Michigan, the highest percentages fell in the South and West.

It is more difficult to make generalizations about the distribution of women as correctional officers in the prison setting, since no data was available for seven states and the District of Columbia. When making comparisons with the previous map, remember that this data is for 1984, not 1980. Perhaps this explains why the range for the percentages of corrections officers who were female was slightly wider, increasing to a full 20% in Alaska. The distribution is similar to that of women police offi-

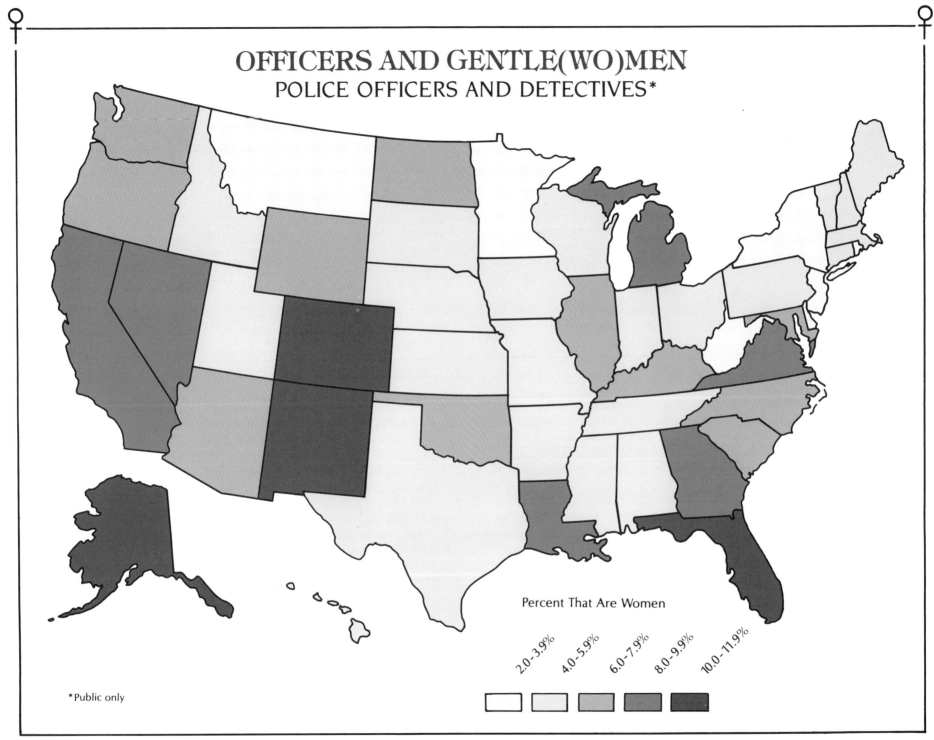

OFFICERS AND GENTLE(WO)MEN
POLICE OFFICERS AND DETECTIVES*

Percent That Are Women

2.0-3.9% 4.0-5.9% 6.0-7.9% 8.0-9.9% 10.0-11.9%

*Public only

CORRECTIONAL OFFICERS IN ADULT SYSTEMS

1984

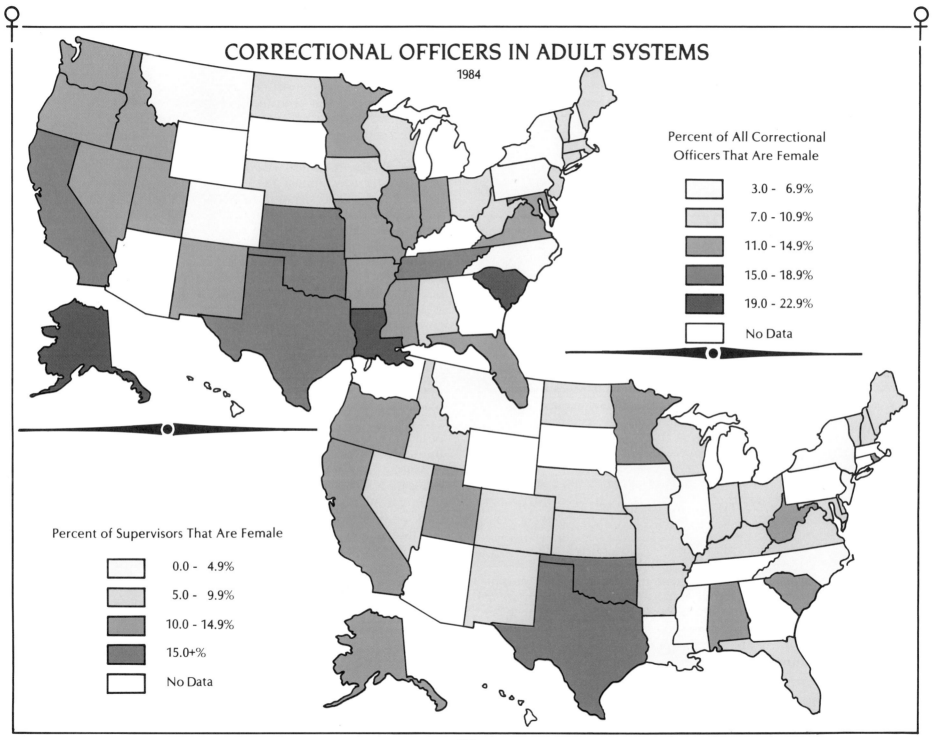

Percent of All Correctional Officers That Are Female

- 3.0 - 6.9%
- 7.0 - 10.9%
- 11.0 - 14.9%
- 15.0 - 18.9%
- 19.0 - 22.9%
- No Data

Percent of Supervisors That Are Female

- 0.0 - 4.9%
- 5.0 - 9.9%
- 10.0 - 14.9%
- 15.0+%
- No Data

cers and detectives in that the highest participation rates were again in the South and West, with the Northeast and Montana appearing at the low end of the scale. However, the states with the higher percentages are different. Louisiana and South Carolina have joined Alaska as the states with the highest percentages of female correctional officers.

Finally it is useful to compare the ratio of female to male personnel in supervisory capacities. In some states, the percentage of women correctional officers seems directly related to the percentage of women in supervisory roles. For example, Texas and Louisiana have high percentages on both maps, while Montana, North Carolina and New York have poor female representation in both instances. However, in other states such as Louisiana, no such relationship is apparent. Montana and New York appear to have the poorest overall percentage rates for women in these professions.

As of 1981, Montana and Pennsylvania did not have any prison facilities for women only, which may be one factor in their low rates of women as correctional officers. It would be interesting to compare these rates of women in corrections with those of women as prisoners to see if there is a correlation.

WOMEN AS VICTIMS

The crime of rape frequently goes unreported, often because of the victim's fear of reprisal. It is difficult to judge whether the apparent increase in rapes over the past years is due to an actual increase in the number of incidents or an increase in the number of rapes actually reported. Whatever the reason, remember that the rates displayed in the map are lower than the actual number of all occurrences.

The rape rate for the United States is high. The majority of states in this country have rates in excess of 30 rapes per every 100,000 women. There appears to be some correlation between a low incidence of rape and the percentage of women living in rural areas. For example, out the 10 states with the lowest rape rates, six have among the highest percentages of rural population. The overall distribution of the rape rates shows the Northeast, Appalachia, the northern High Plains and the Rockies with relatively low rates. With the exception of Michigan, the highest values were found in a few southern states and the Far West.

The rape clearance rate is an indicator of the number of reported rapes for which an arrest has been made. This figure relates *only* to arrests, not final convictions. Some states that had a low incidence of rape (such as Kentucky and West Virginia) also had a high proportion of rapes cleared by arrest. Perhaps with fewer rapes to solve, law enforcement officers are able to give more attention to each case. Conversely, in several states where the rape rate was high the percentage of rapes cleared was low. California, Nevada and Alaska were examples. With the exception of Montana, Vermont and Nebraska, the highest clearance rates in 1980 were concentrated in and around Appalachia.

Legislation dealing with the cause of marital rape is quite complex and has been changing rapidly over the past few years. Some states have statutes that seem to contradict each other. Others will enact a law that seems to limit the marital rape exemption, only to follow it with another law expanding some aspect of the exemption. For example, as of May 1985, the rape statute in Mississippi was silent on the question of marital rape. However, in 1981, that legislature had passed a separate and additional law defining the gender-neutral crime of "sexual battery." It included the proviso that a spouse could not be accused of sexual battery on his or her

WOMEN AS VICTIMS

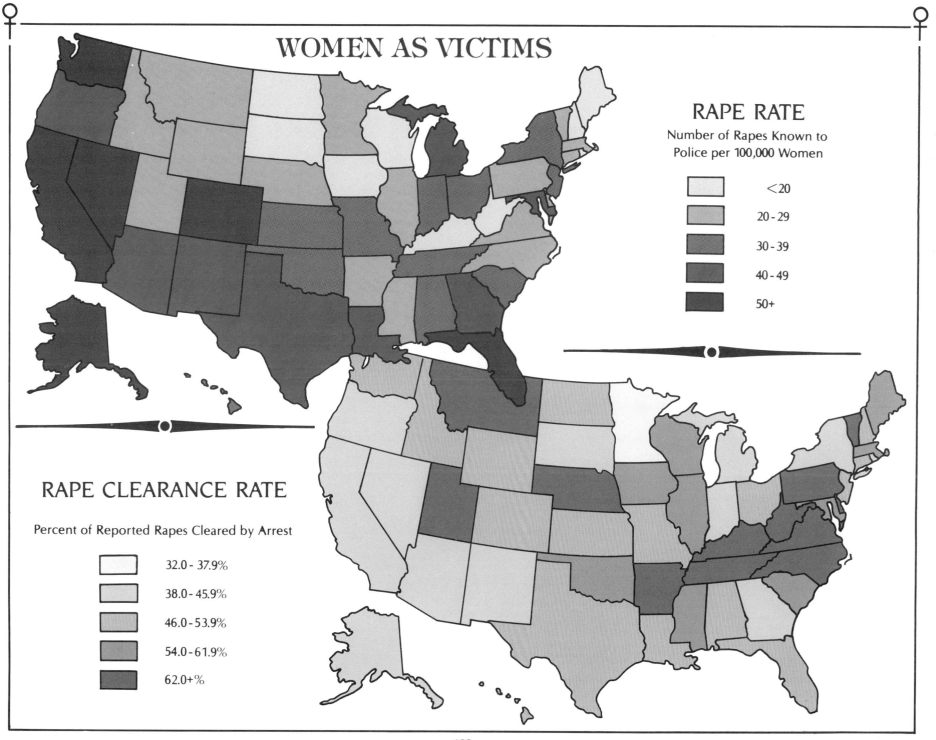

RAPE RATE

Number of Rapes Known to
Police per 100,000 Women

	<20
	20 - 29
	30 - 39
	40 - 49
	50+

RAPE CLEARANCE RATE

Percent of Reported Rapes Cleared by Arrest

	32.0 - 37.9%
	38.0 - 45.9%
	46.0 - 53.9%
	54.0 - 61.9%
	62.0+%

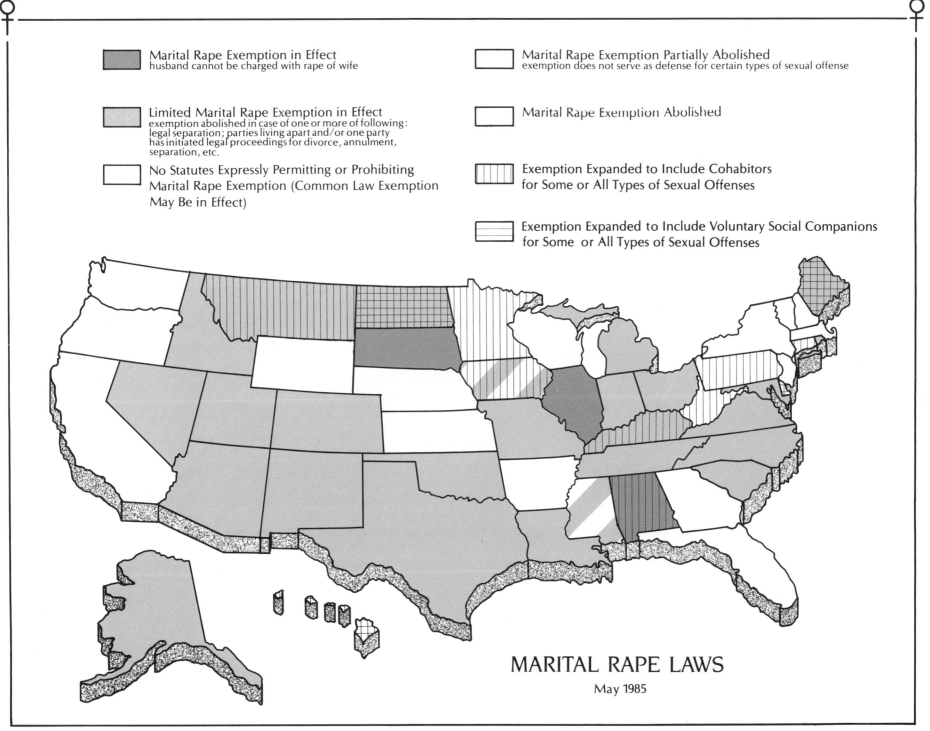

Legend

Marital Rape Exemption in Effect
husband cannot be charged with rape of wife

Marital Rape Exemption Partially Abolished
exemption does not serve as defense for certain types of sexual offense

Limited Marital Rape Exemption in Effect
exemption abolished in case of one or more of following:
legal separation; parties living apart and/or one party
has initiated legal proceedings for divorce, annulment,
separation, etc.

Marital Rape Exemption Abolished

**No Statutes Expressly Permitting or Prohibiting
Marital Rape Exemption (Common Law Exemption
May Be in Effect)**

**Exemption Expanded to Include Cohabitors
for Some or All Types of Sexual Offenses**

**Exemption Expanded to Include Voluntary Social Companions
for Some or All Types of Sexual Offenses**

MARITAL RAPE LAWS

May 1985

partner unless they were living apart at the time. To the layperson, the crime of sexual battery appears identical to that of rape. Whether and how the act was punished might depend on whether it was defined under the rape or the sexual battery statute.

Delaware provides another example of confusing legislation. This state appeared to abolish the spousal exemption in the case of first-degree rape, while at the same time expanding the exemption to cover "voluntary social companions." Therefore, if the wife, as the victim, is defined as a wife, she can prosecute her husband. If the wife is defined as a voluntary social companion, she may *not* be able to prosecute! Three states (Alabama, South Dakota, Illinois) had a marital exemption in effect. On the other hand, nine states (Vermont, New York, Oregon, Nebraska, Kansas, Wisconsin, New Jersey, Florida and Massachusetts) are states where a husband can no longer use his marital status as a defense against a charge of rape by his wife. Because of the complexity of the issue, the classification scheme as it appears on the map is highly generalized. For more specific information, we refer you to our information source as well as the individual state statutes.

Murder rates of women were considerably lower than those of rape and the state–to–state range was much narrower, between one and nine murders per 100,000 women. As with rape, Nevada emerged with the highest murder rate. Other areas of high incidence can be found in the South and West. Women appeared to be safest in several New England states and in a band of states stretching from Wisconsin to Idaho.

Men's rate of death from homicide in 1980 was almost always higher than that of women, in some states as much as five times greater. Maine, Alaska and Oregon are examples of states where the difference was much narrower. The rate for women and men in Maine was, in fact, the same. The largest differences occurred in several widely scattered states (New Mexico, Illinois, West Virginia, New York and Vermont).

WOMEN AS PERPETRATORS

Women are perpetrators of crime as well as its victims. The first two maps in this subsection deal with women convicted of federal crimes. Unlike later maps, these focus on women who have been *convicted* of a crime, not just arrested. The number of women convicted of federal crimes in 1980 was low. Colorado was the only state where the number of women convicted exceeded 10 per 100,000 women. With the exception of Mississippi, the lowest rates appeared in the North, particularly in the Midwest and Northeast. The high end of the data is scattered among five widely separated states.

The bulk of federal crimes appears to have been committed by men. Nowhere did women comprise more than one-third of those convicted. At the most, women only made up 31% (again in Colorado) of the total number of criminals convicted. Other states where the percentage of women was high can be found in the Deep South, the Pacific Northwest and the Midwest.

The next set of maps focuses on women who were arrested for crimes against persons and property in 1980, including murder (and non-negligent manslaughter), robbery, aggravated assault, burglary, larceny and motor vehicle theft. In an attempt to gain a very rough idea of how much women participate in these types of criminal activity, we totaled the number of arrests in these categories and figured them as a rate per 100,000 women.

However, it is important to remember that arrest data is not a perfect indication of criminal participation. One person may be arrested several times in the course of a

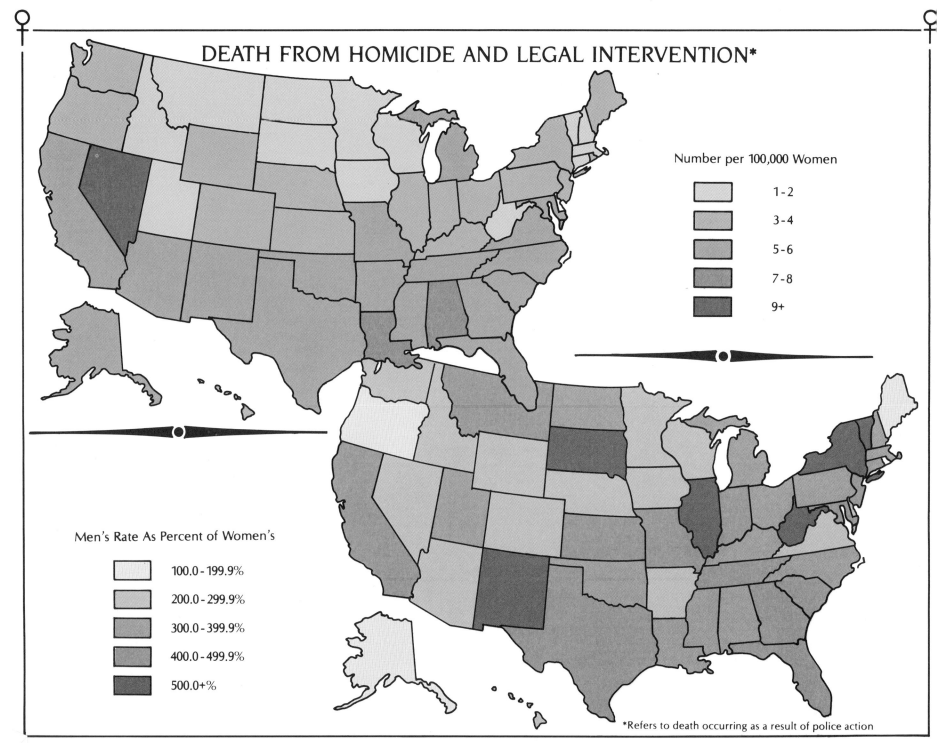

DEATH FROM HOMICIDE AND LEGAL INTERVENTION*

Number per 100,000 Women

1 - 2
3 - 4
5 - 6
7 - 8
9+

Men's Rate As Percent of Women's

100.0 - 199.9%
200.0 - 299.9%
300.0 - 399.9%
400.0 - 499.9%
500.0+%

*Refers to death occurring as a result of police action

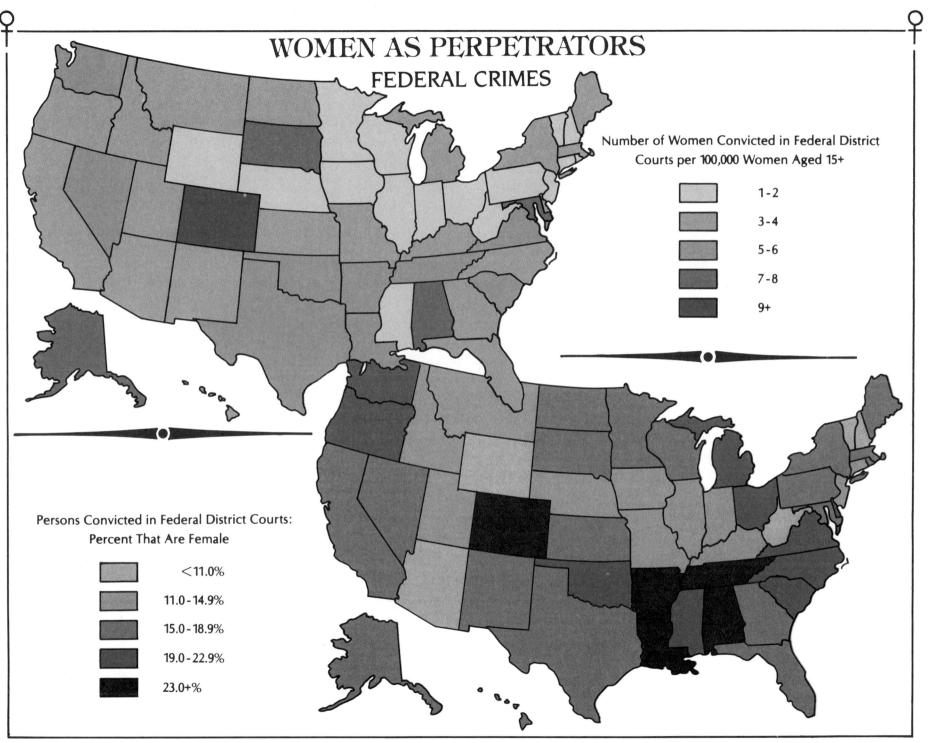

WOMEN AS PERPETRATORS
FEDERAL CRIMES

Number of Women Convicted in Federal District
Courts per 100,000 Women Aged 15+

- 1 - 2
- 3 - 4
- 5 - 6
- 7 - 8
- 9+

Persons Convicted in Federal District Courts:
Percent That Are Female

- <11.0%
- 11.0 - 14.9%
- 15.0 - 18.9%
- 19.0 - 22.9%
- 23.0+%

year. Therefore, this data should not be interpreted as the number of women arrested per 100,000, rather as the number of arrests that were of women per 100,000. Because some crimes tend to be committed primarily by people in a certain age range, it might prove interesting to see if states with a high percentage of women in certain age groups also had high arrest rates for particular crimes.

The number of female arrests per 100,000 women varied widely from a low of 57 in Vermont to a high of 708 in Colorado (again!). Washington, Florida, Maryland and Delaware, along with the remainder of the Southwest, also have high rates of involvement. On the opposite end of the scale, Appalachia, the northern High Plains and northern New England were regions with low arrest rates. Two other notably homogeneous regions with rates in the middle range were the area centered on Iowa and the region along the southeastern seaboard.

The ratio of female to male arrests is the subject of the following six maps focusing on each specific type of criminal activity. Most serious are the crimes against persons: murder, robbery and aggravated assault. Men clearly predominated among those arrested for violent criminal activity. Only in four states (Arkansas, Tennessee, Colorado and Vermont) did arrests of women constitute 20% or more of all arrests. High percentages concentrated particularly in the Deep South while the lowest ratios of female to male arrests all appeared in states west of Minnesota.

Robbery is defined as taking or attempting to take property from a person by violence or threat of violence. The ratio of female to male arrests for robbery was even lower than that for murder. The data range varied between 0% and 11% with Vermont reporting *no* arrests of women for robbery in 1980. The top seven states where the percentages were highest were all west of the Mississippi. The region centering around Mary-

land was characterized by a very low ratio of female to male arrests for robbery.

When looking at aggravated assault, however, the high ratios of female to male arrests were concentrated strongly in the Southeast. With the exception of Vermont and Maine, the lowest percentages were all located west of the Mississippi. To sum up, high and low ratios for murder and aggravated assault seemed to predominate in the southern and western states, respectively. The pattern for robbery appeared more scattered, although the highest values were all in western states.

Burglary, larceny and motor vehicle theft are all crimes against property. Burglary is described as the unlawful entry of a structure with the intent to commit a felony or theft. The range of values for burglary was, in 1980, the narrowest of all six crimes being considered, varying from a low of 3% in Mississippi and Arkansas to a high of only 10% in California. If California is eliminated, the range narrowed to less than five percentage points with Nevada having the second highest value of 8%. The nature of arrest data combined with this narrow range of values makes one especially cautious about drawing any conclusions about distribution patterns. It should be noted that there were low percentage areas in Illinois and southern Appalachia. Eight of the ten states with the highest percentages could be found west of Kansas.

Larceny or theft refers to the stealing of property belonging to someone else. Shoplifting is included in this classification. Of the six types of crime mapped, larceny had the highest ratio of female to male arrests. Female arrests made up 14% of the total in California and soared to 38% in New Mexico. In four states, the ratio of female to male arrests was at least one out of three. The high percentage states were Rhode Island, New Mexico, Mississippi and Hawaii. Only in California (14%) and Vermont (19%) did the values fall below 20%.

WOMEN ARRESTED FOR CRIMES*AGAINST PERSONS AND PROPERTY

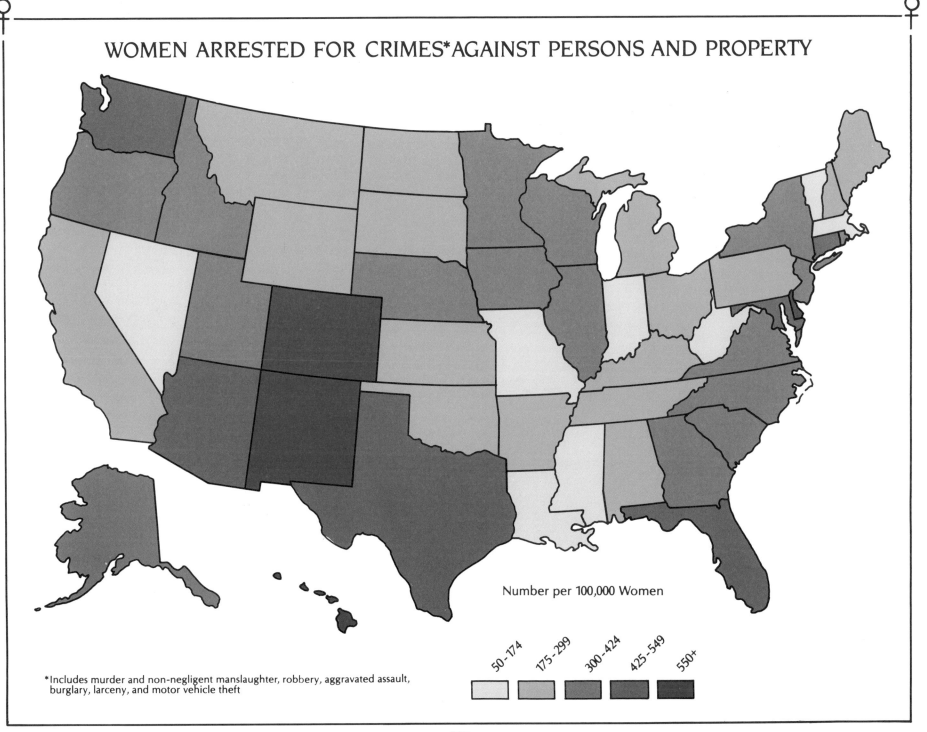

Number per 100,000 Women

50-174 175-299 300-424 425-549 550+

*Includes murder and non-negligent manslaughter, robbery, aggravated assault, burglary, larceny, and motor vehicle theft

CRIMES AGAINST PERSONS

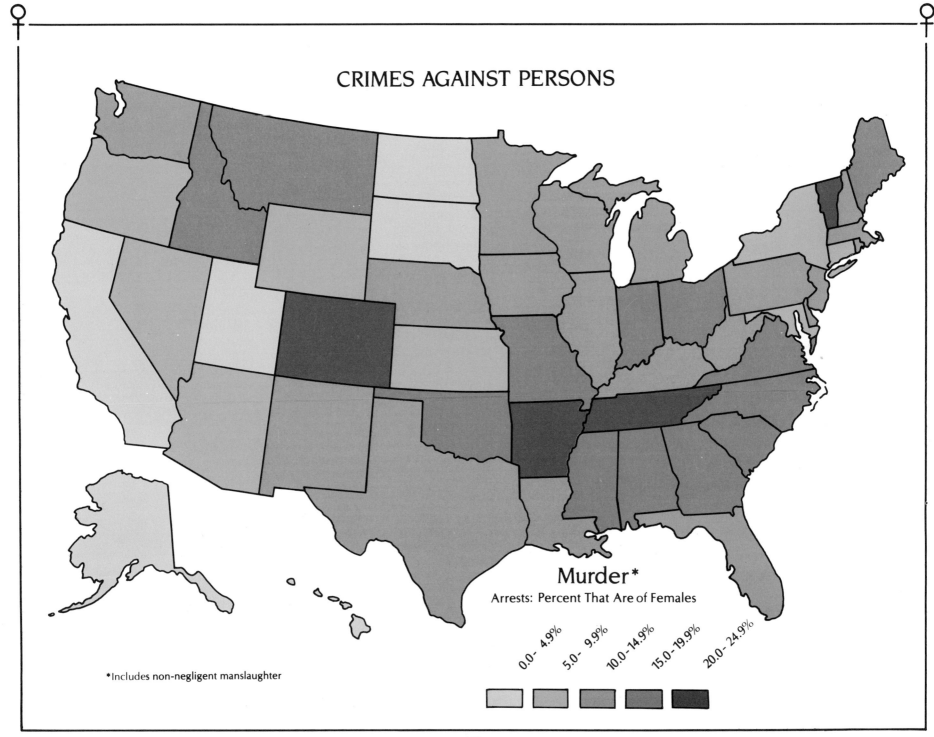

Murder*

Arrests: Percent That Are of Females

0.0- 4.9% 5.0- 9.9% 10.0-14.9% 15.0-19.9% 20.0-24.9%

*Includes non-negligent manslaughter

190

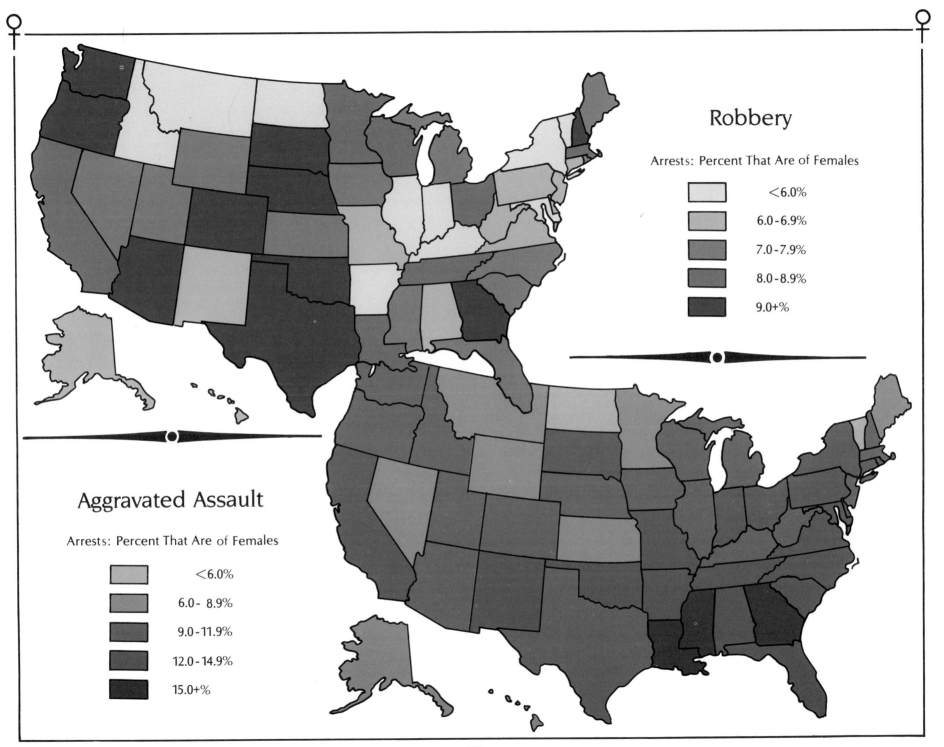

Robbery

Arrests: Percent That Are of Females

<6.0%
6.0-6.9%
7.0-7.9%
8.0-8.9%
9.0+%

Aggravated Assault

Arrests: Percent That Are of Females

<6.0%
6.0- 8.9%
9.0-11.9%
12.0-14.9%
15.0+%

CRIMES AGAINST PROPERTY

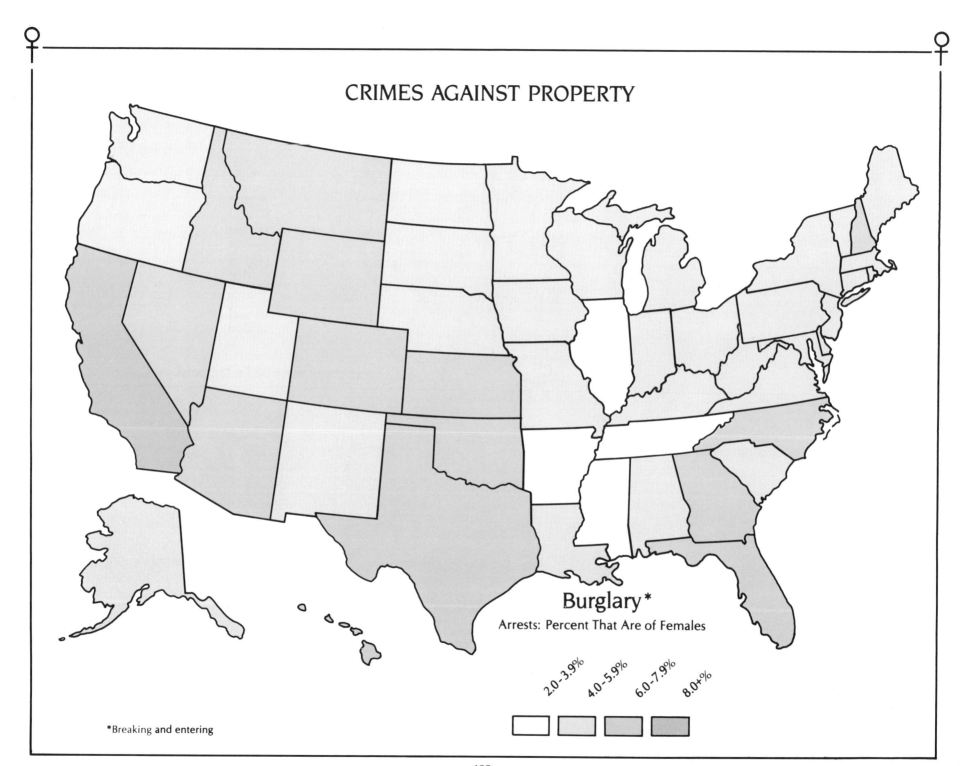

Burglary*

Arrests: Percent That Are of Females

2.0-3.9% 4.0-5.9% 6.0-7.9% 8.0+%

*Breaking and entering

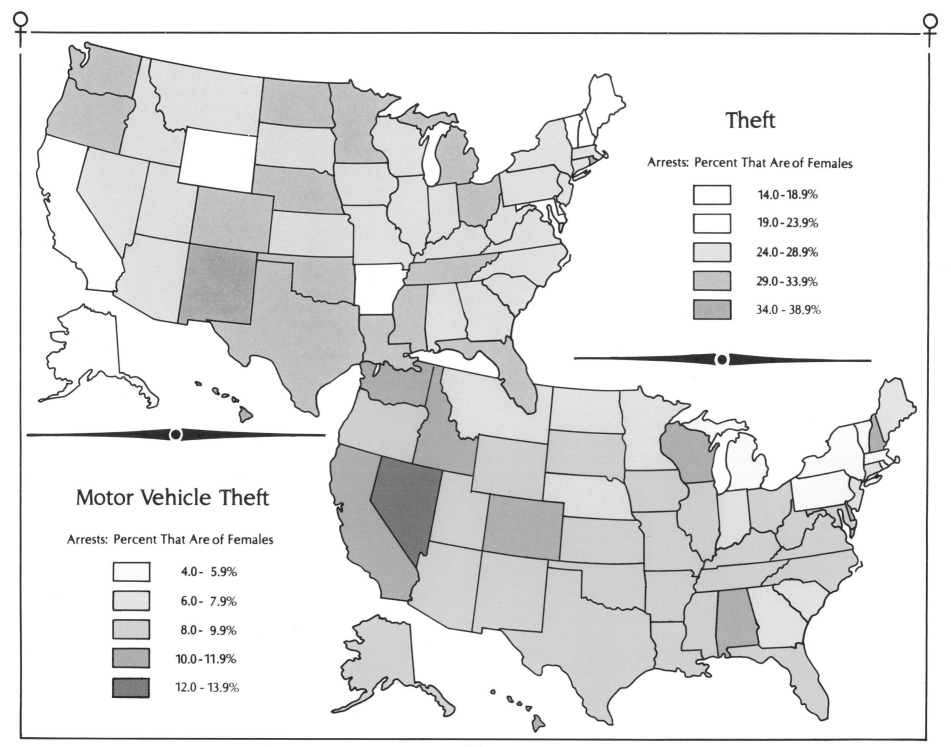

Theft

Arrests: Percent That Are of Females

14.0 - 18.9%

19.0 - 23.9%

24.0 - 28.9%

29.0 - 33.9%

34.0 - 38.9%

Motor Vehicle Theft

Arrests: Percent That Are of Females

4.0 - 5.9%

6.0 - 7.9%

8.0 - 9.9%

10.0 - 11.9%

12.0 - 13.9%

Theft of motor vehicles has been classified as a separate offense. States with low female to male arrests ratios were concentrated in the Northeast while high percentage states were somewhat more scattered. As with burglary, the range of values narrowed considerably when the state with the highest percentage (Nevada at 15%) was set aside. High and low values (for New Hampshire at 11% and Vermont at 4%) then differed only by seven percentage points.

The final maps in this section ("Women's Correctional Institutions," "Women on Death Row," "Security Arrangements" and "Prison Population") focus on the punishment and incarceration of female offenders. In 1981 there was only one federal level all-women correctional institution in existence, the Federal Correction Institution located in Alderson, West Virginia. The remaining prisons for women only were state facilities. At that time there were no such facilities in 14 states distributed through northern New England, the High Plains, the northern Rockies and Hawaii. Only four states (Florida, Texas, New Mexico and Oklahoma) had more than one state facility just for women. With the exception of those in Texas and California, the largest institutions were concentrated in the eastern half of the country. It should be noted that states without separate facilities for women housed their female offenders in coed facilities.

Debates about the appropriateness of capital punishment have been heated in recent years. The location and number of women on death row should naturally be compared only to the distribution of those states that had the death penalty in effect. At the end of 1982, the use of the death penalty was legal in 40 states. However, it seems that the presence of women on death row has been largely a southern phenomena. Ten of the 13 female prisoners on death row at year-end 1982 were incarcerated in southern states. Velma Barfield was, in 1984, the first woman to be executed in 12 years. She had been imprisoned in North Carolina.

Security arrangements for female offenders varied widely from state to state. Women in prison were divided among three types of security arrangements, classified as maximum, medium and minimum. Ideally, the offender, whether female or male, is assigned to the security level most appropriate to her or his type of offense. Criminals constituting the most serious threat are housed in a maximum security facility while those deemed less dangerous might be confined at the medium or minimum levels.

For some states, however, the data and patterns exhibited on the map of security arrangements were more reflective of space available in prisons than the most appropriate assignment. Four states (Connecticut, Pennsylvania, New Jersey and South Carolina), all located in the East, had women only in minimum security prisons as of 1981. At the opposite extreme, another four states (North Dakota, Illinois, Texas and Hawaii) had their women prisoners all housed at the maximum security level. Five states (Colorado, Minnesota, Missouri, Arkansas and Delaware) used only medium security arrangements for female offenders. Note that New Hampshire had no women incarcerated in state facilities at that time.

We conclude this section with two maps "Prison Population: Female" and "Prison Population: Male." The first map depicts the number of women in prison for every 100,000 women in the state. Since women's involvement in criminal activity is less than men's, it is logical that the rate for women in prison is far lower than the rate for men. The highest rate, that of Nevada at 25 per 100,000, was still only one-third of the lowest men's rate (New Hampshire at 73 per 100,000). The three areas with high rates of women in prison included Nevada, Arizona and states along the southeastern sea-

board. While all of the lower rates were located in the northern half of the country, the very lowest were to be found in the Northeast, Minnesota and North Dakota.

The lower map depicts parallel information for men. Keep in mind that the men's rate was, for the U.S. as a whole, 25 times higher than that for women. Even though the two rates were vastly different, the overall distributions were similar.

WOMEN'S CORRECTIONAL INSTITUTIONS*
1981

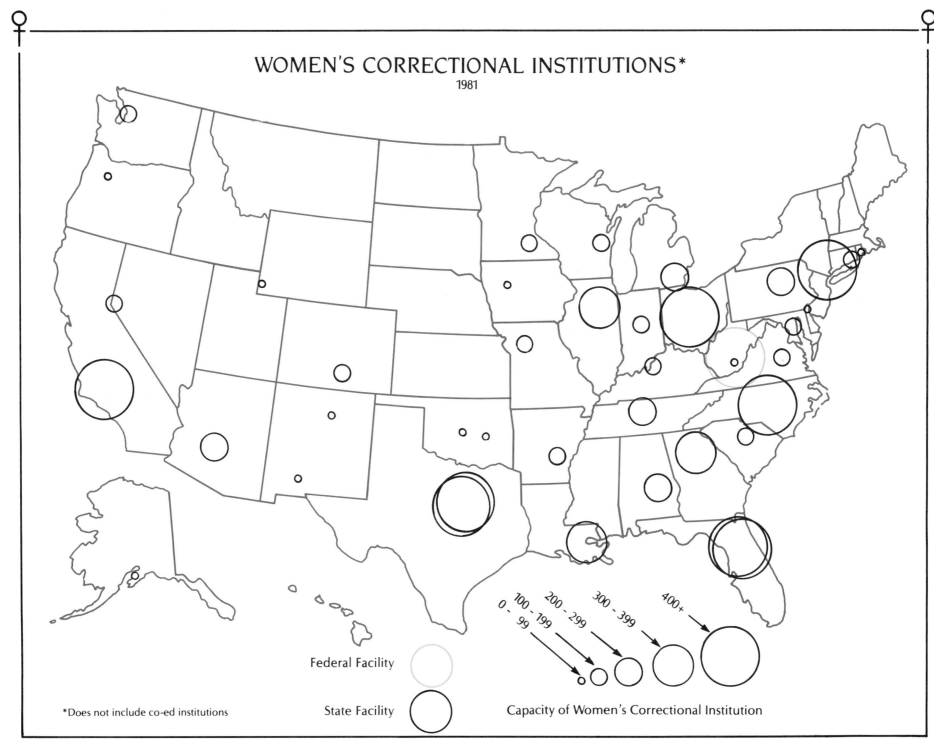

0 - 99
100 - 199
200 - 299
300 - 399
400+

Federal Facility

State Facility

Capacity of Women's Correctional Institution

*Does not include co-ed institutions

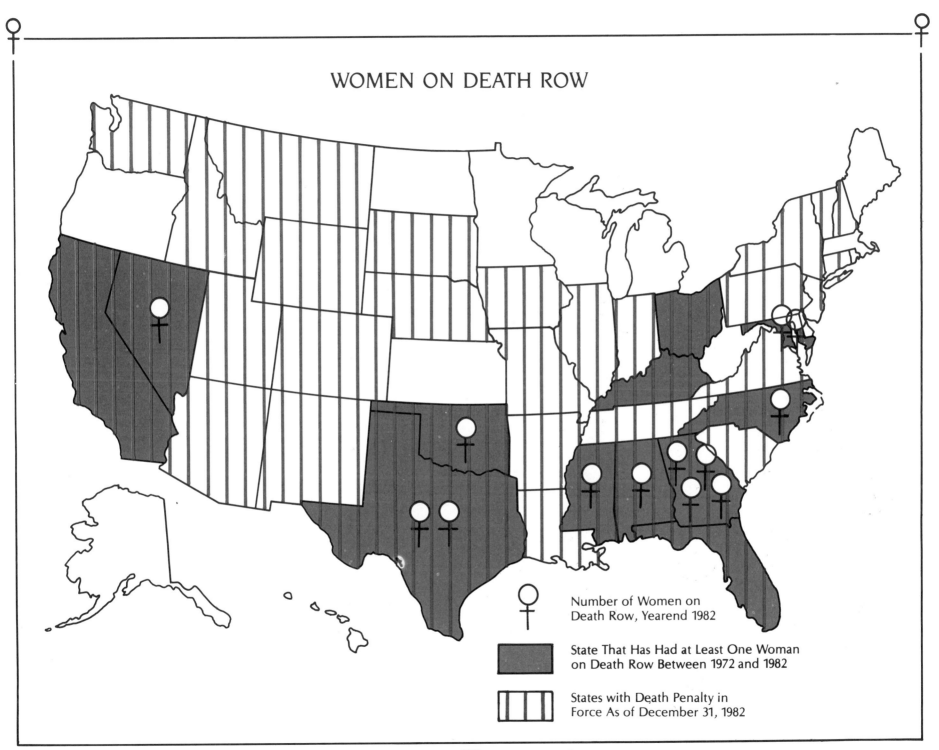

WOMEN ON DEATH ROW

Number of Women on
Death Row, Yearend 1982

State That Has Had at Least One Woman
on Death Row Between 1972 and 1982

States with Death Penalty in
Force As of December 31, 1982

SECURITY ARRANGEMENTS

July 1, 1981

Breakdown of Female Prison Population*
According to Security Arrangement:

Minimum Security
Medium Security
Maximum Security

No Female Prisoners at This Time

no data

*State and federal jurisdiction

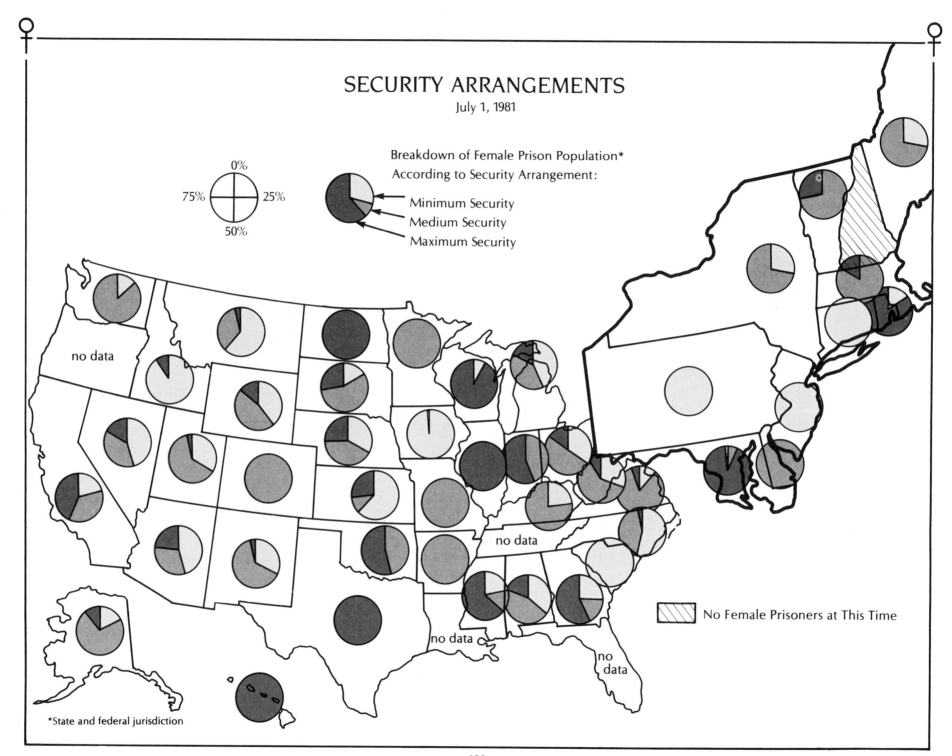

198

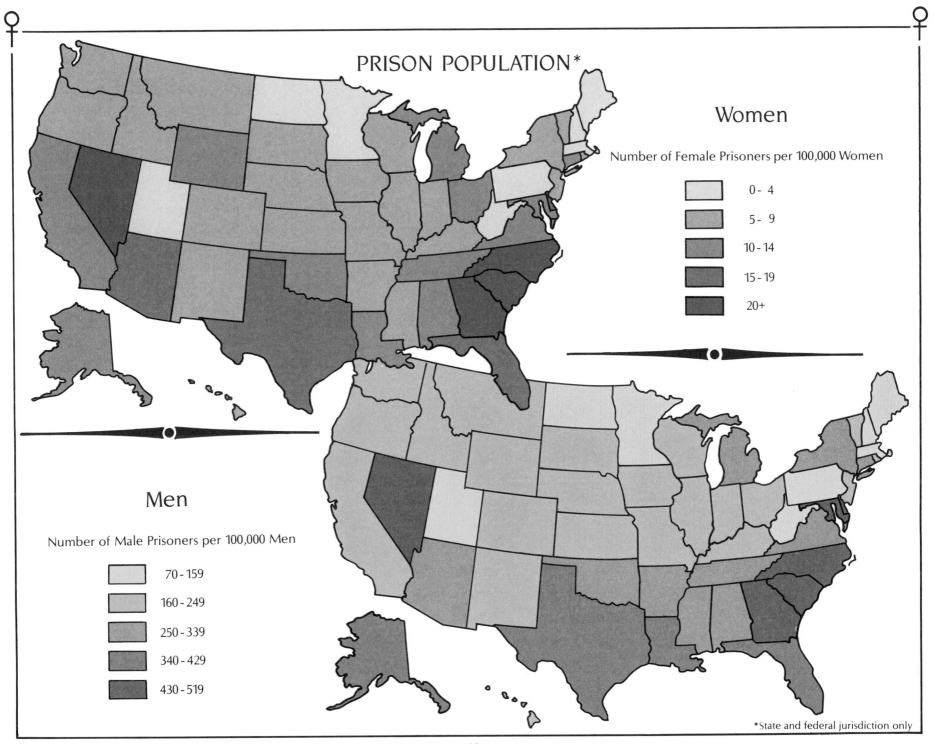

PRISON POPULATION*

Women

Number of Female Prisoners per 100,000 Women

- 0 - 4
- 5 - 9
- 10 - 14
- 15 - 19
- 20+

Men

Number of Male Prisoners per 100,000 Men

- 70 - 159
- 160 - 249
- 250 - 339
- 340 - 429
- 430 - 519

*State and federal jurisdiction only

POLITICS

"If particular care and attention is not paid to the Ladies we are determined to foment a Rebellion, and will not hold ourselves bound by any Laws in which we have no voice, or Representation." [1]

—Abigail Adams in a letter to John Adams

The strength of a democracy lies in its ability to allow all segments of society a chance to participate in the political process, to make laws and to set policy. The democratic system acknowledges that no one person or group should have absolute power to make unilateral decisions affecting the rest of society. The voting process acknowledges that the opinion of every citizen is of value. Decisions are based upon the consensus of the majority, although our system has, to varying degrees, allowed the opinions of minorities to be heard.

Until 65 years ago, however, one-half of the adult population was not allowed to vote. Even now, when women are both able to vote and hold political office at the local, state and national levels, the vast majority of officeholders are still men. National and state policies on programs and issues that primarily affect women are decided for the most part by men. Examples of such programs include social security and services to the elderly, subsidized housing, welfare, low-income legal services, abortion and family planning.

In an effort to insure fairer and more complete representation, groups of citizens sharing common interests (Blacks, Hispanics and women are examples) attempt to elect their own members to legislative positions, assuming that a person like themselves is best able to speak on their behalf. They also lobby actively in the national and state legislatures to make their positions known to other representatives. Essentially, government in the U.S. is a system of competing interests. Each in-

terest group, through the use of compromise, bargaining and persuasion, attempts to insure that laws and policies are to its benefit.

The movement for women's equality appeared at a time when an increasing number of women felt that legislation did not always reflect their best interests. The system was not working for them; it was not allowing them the freedom to conduct their lives in the way they saw fit. Rather, their lives were being ordered to fit the needs and convenience of other social groups. Many women desired a chance to speak and act for themselves.

Two centuries ago, a few months prior to the signing of the Declaration of Independence, Abigail Adams voiced concern to her husband about the social and political inequality existing between men and women. In 1848, Elizabeth Cady Stanton wrote her version of the Declaration of Independence in which she stated that all men *and women* were created equal. From that time on, the movement for women's equality gained momentum in the United States.

The phrase "the women's movement" tends to be ambiguous, meaning different things to different people. We will refer to the movement for women's equality in a broad sense as designating the attempt by women—and men—to realize political, economic and social equality between the sexes, and to allow women full opportunity and participation in all spheres of life. Within this broader context there has been a more specific movement focusing on political equality for women, including the right to vote and the right to make, administer and interpret the law. Those seeking political equality for women see it as a prerequisite to social and economic equality.

Full equality for women is as threatening to many members of both sexes today as it was 100 years ago. In the 19th century, many women did not wish to broaden their activities beyond those of home and family. Others, who may have advocated equality for women in education or employment, stopped short of wanting to expand the franchise to include women. Some women sought outlets for their social consciences and energies by becoming involved in reform causes like temperance and abolitionist movements. Victorian society believed that women had finer moral instincts than men and women's participation in various types of social work was seen as a relatively more natural extension of their role in the family. However, even these activities were frowned upon when they required women to speak and assemble in public; initially only the most radical women demanded the vote. Participation in the political process, with its reputation for shady and unscrupulous dealings, was considered unsuitable for women. It was feared that the finer moral sense for which they were esteemed would become corrupted.

There was a group of women, however, that was not content with a definition of womanhood that restricted their influence to the narrow sphere of home and family. They faced squarely the need for political equality, making its achievement their primary goal. When Elizabeth Cady Stanton called the first women's rights convention in 1848 in Seneca Falls, New York, a resolution was passed calling for women's suffrage. The first national convention was organized in 1850 in Worcester, Massachusetts, to be followed by another nine national meetings over the next ten years.[2] Since that time, the movement for women's political equality has focused on two broad issues: the first, women's suffrage; and the second, the legislative recognition of women's equality as confirmed in an equal rights amendment to the Constitution.

The pursuit of both goals has required supporters to contend with two factors. The first concerned the philosophical question of whether men and women were

in fact equal. In order to provide mass public support for women's political equality, the public had to be convinced that women were worthy of having a voice in the political process and actively desired one. The second factor was of a more pragmatic nature and involved dealing with a political process in which women were regarded and manipulated as one more interest group.

The proponents of women's equality had to become part of a political process of competing interests. There the focus was on how the inclusion of women in the voting population would help or hinder the party in power. In this respect, women were treated like any other interest group. Two specific examples illustrate this point. A few western states allowed women to vote early on when they still held only territorial status. Some have suggested that allowing women the vote provided extra leverage to those groups who favored statehood. Later on, the liquor industry attempted to block women's suffrage for economic reasons, fearing that if women (many of whom were temperance advocates) were allowed to vote, prohibition laws would be enacted. Women were viewed as a threat to the liquor industry. When women's suffrage could be seen to further the interests of a powerful organization, it was promoted; when it threatened the political elite, it was blocked.

Many who favored women's rights had also been active participants in the abolitionist movement. Immediately after the Civil War, disillusionment set in among women's suffrage supporters when blacks were given the franchise while women remained excluded from participation in the political process. In 1869 two women's suffrage organizations were founded: the National Woman Suffrage Association (established by Susan B. Anthony and Elizabeth Cady Stanton) and the American Woman Suffrage Association (a somewhat more moderate organization politically, associated with the efforts of Lucy Stone and Julia Ward Howe). Over the next few decades both organizations, joined in 1913 by the National Women's Party, directed an immense effort toward securing the vote for women, a goal that was achieved in 1920.

Very quickly, however, women realized that suffrage did not automatically bring total equality with men. The National Women's Party, under the leadership of Alice Paul, had played a key role in the attainment of suffrage and turned its agenda to the passage of an equal rights amendment to the Constitution. Such an amendment was introduced into Congress in 1923 and every year for the next 49 years. Between 1944 and 1979, it was supported by both the Republican and Democratic parties. In recent years, under President Reagan, the Republican Party has withdrawn its support while the Democrats have maintained their original favorable position.[3]

After women won the franchise in 1920, however, the movement for women's equality did not really gain national attention again until the early 1960s. At that time, public awareness of women's issues was heightened with the Civil Rights movement and evidenced specifically by the publication of *The Feminine Mystique*, by Betty Friedan, and other feminist books. The National Organization for Women, the largest national feminist organization in the U.S., was founded in 1966. Other organizations such as the National Women's Political Caucus and the Women's Equity Action League, also emerged at this time. *Ms.* magazine, a publication by and for women, was established to promote a moderate feminism to mainstream America.

In the wake of renewed interest in women's equality, the Equal Rights Amendment was again introduced into Congress, this time being passed by the House in 1971 and by the Senate in 1972. In that first year it was ratified by 22 of the 38 states necessary for passage. By 1978, however, the amendment was still three states short of

the number needed, and Congress extended the deadline for its approval until 1982. When by 1982 approval was not forthcoming, the process had to be started from scratch. The amendment was reintroduced in 1983 only to be defeated by a narrow margin.

To insure political equality, it is important for women to participate as judges, legislators and executive officials at all levels of government. In all these roles, it is not surprising that women have made greater inroads at the local and state levels, while remaining most seriously underrepresented at the national level. Local issues, some have suggested, are more closely related to woman's traditional spheres of home and children and it is not unusual for women to participate actively in local school boards and town governments. Involvement in local politics is more easily reconciled with home and family responsibilities, while national and state-level political office require a much greater commitment of time and money. Women candidates, more so than men, are especially likely to be hampered by lack of funds, a particularly important factor considering the cost of political campaigning.

The judiciary is that arm of government responsible for interpreting the laws established by various legislative bodies. It includes municipal courts (for cities large enough to have their own), state courts and federal courts. The state and federal systems have several levels, including trial courts and appeals courts. Most cases are decided at the lowest level of either the state or federal system, depending whether the issue in question is under state or federal jurisdiction. Only if the decision in the case is appealed does it go to a higher-level court.

The U.S. Census estimated that about 17% of judges and 14% of lawyers were female in 1980.[4] In 1984, the proportions in the highest state appeals courts were somewhat lower. At the state level, only about 6% of the judges in the highest-level state courts (state courts of last resort) were female.[5] At the federal court level in that same year, about 7% and 10% of the judges in the U.S. District Courts and Circuit Courts of Appeals, respectively, were women.[6]

Issues of fairness in government are equally applicable to the legislative and executive branches at all levels. Legislators are enormously susceptible to pressures applied by various business and organizational lobbies to pass legislation favorable to those interests. Like judges and lawyers, legislators carry with them the various prejudices and value systems they have developed over the course of a lifetime. For this reason, many social groups, including women, have realized the importance of having their own members participate directly in the lawmaking process.

In recent years, women have made particularly strong inroads in local and state legislatures. As of early 1985, 15% of state lawmakers were female, an impressive increase from just 5% in 1971. However, progress has been less striking at the federal level. In 1971 3% of congressional legislators (senators and representatives combined) were female, while currently the figure stands at about 5%—not much of an increase. There have been only 15 women senators and 105 women representatives in the 200+ years of our country's existence.[7] It is important to remember that many of these women followed their husbands into Congress, taking over their spouses' seats when vacated due to illness or death. One former senator, Rebecca Latimer Fenton (67th Congress), was senator only for one day, having been appointed to that office in an honorary capacity by the state of Georgia.

In the executive branch, women have also been making progress, although again primarily at the local and state levels. At the beginning of 1985, approximately 10% of cities with over 30,000 people had women mayors, a

sizable increase from just 1% 14 years earlier. At the state level, only 4% and 10% of governors and lieutenant governors, respectively, were women. Those percentages increased dramatically in lower-level executive offices. Fully 36% of secretaries of state and 20% of state treasurers were women.[8]

Political scientists and politicians especially want to know whether women, despite their differences, tend to share certain concerns and opinions because they are women, and how the presence or lack of gender specific attitudes affects the political process. This is an important question, because it has bearing on the structure of power in our society. Over the past decade, political scientists and observers have begun to try to understand the place of women in the political process. Researchers are interested in determining whether women voters make up a distinct constituency, with attitudes and values common to them as women that transcend other possible foci of loyalty. Then, if these attitudes are found to exist, how are they different from men's? Can women be counted on to vote as a block on certain issues, as the liquor industry once feared? Is there a gender gap?

Second, scholars of the political process are studying the women who run for and serve in political office. How do these women cope with a political machine that has been dominated historically by men? What sorts of strategies do they use to achieve their goals and are their methods different from those of their male colleagues? Perhaps societal expectations of women hinder their political aspirations. Perhaps women officeholders hold opinions on issues vastly different from their male counterparts. Are these women more likely to be feminists or to be more concerned with social issues than men? Do they feel a special responsibility to represent the women of their constituencies?

Until such time as these questions are answered con-clusively, it would seem to make sense for women to continue to increase their participation in the political process, as in all aspects of life. Elderly women, housewives, black women, women who are poor, married and single, all deserve to have their voices heard. No one man can speak for all men. If, likewise, it turns out that no one woman can speak for all her sisters, then more of those sisters must speak politically for themselves.

THE POLITICAL CLIMATE

We begin this section by focusing on two important constitutional amendments of interest to women, those dealing with women's suffrage and the Equal Rights Amendment. Inspection of these first two maps provides a broad picture of regional attitudes towards women's rights. In 1920, the 19th amendment was ratified granting women the right to vote. Ten states, all of which are located in the southeast section of the country, had failed to ratify this amendment by the time it took effect. Full suffrage had already been granted to women in 15 states prior to the passage of the federal-level amendment, but only two (New York and Michigan) were located east of the Mississippi. The greater tendency for western states to grant women the vote, as mentioned earlier, is clearly evident, especially for the time prior to 1910.

The dates on the map refer to when women had full suffrage in a *state* context. Naturally, this is a function of when a state achieved statehood, as well as when women actually received the vote. For example, while the territory of Wyoming provided for women's suffrage as early as 1869, women were not voting in a state context until 1890, when statehood was achieved. Three other states, in addition to Wyoming, had provided for

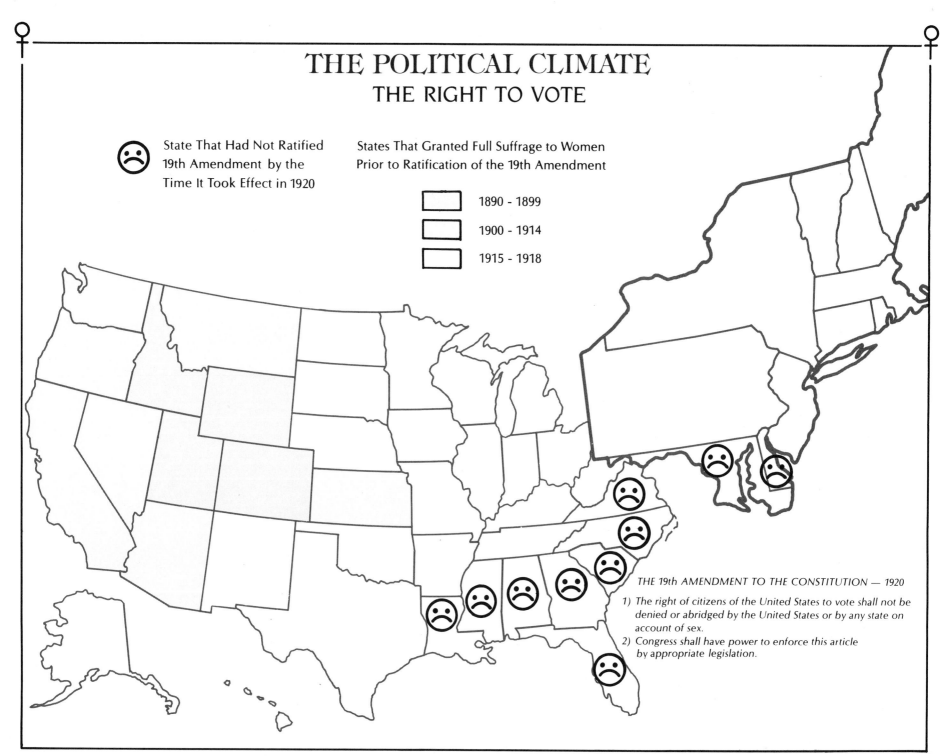

THE POLITICAL CLIMATE
THE RIGHT TO VOTE

State That Had Not Ratified 19th Amendment by the Time It Took Effect in 1920

States That Granted Full Suffrage to Women Prior to Ratification of the 19th Amendment

1890 - 1899

1900 - 1914

1915 - 1918

THE 19th AMENDMENT TO THE CONSTITUTION — 1920

1) The right of citizens of the United States to vote shall not be denied or abridged by the United States or by any state on account of sex.

2) Congress shall have power to enforce this article by appropriate legislation.

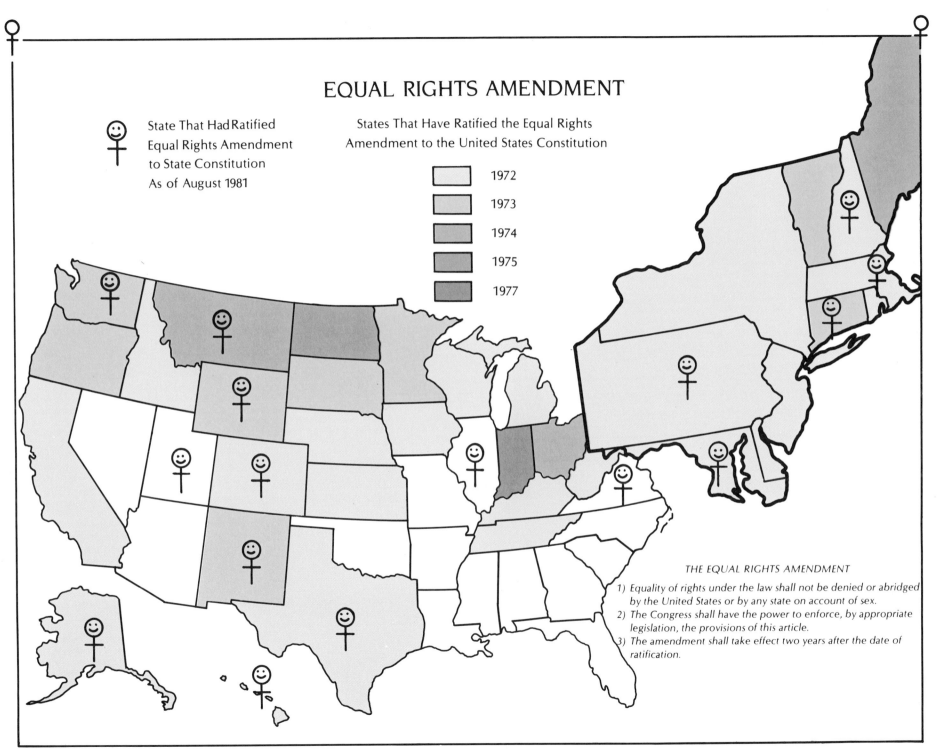

EQUAL RIGHTS AMENDMENT

State That Had Ratified Equal Rights Amendment to State Constitution As of August 1981

States That Have Ratified the Equal Rights Amendment to the United States Constitution

1972
1973
1974
1975
1977

THE EQUAL RIGHTS AMENDMENT

1) *Equality of rights under the law shall not be denied or abridged by the United States or by any state on account of sex.*
2) *The Congress shall have the power to enforce, by appropriate legislation, the provisions of this article.*
3) *The amendment shall take effect two years after the date of ratification.*

women's suffrage when they were still territories: Utah in 1870, Washington in 1883 and Alaska in 1912. In two territories, Utah and Washington, women's suffrage was later overturned, not to be restored until 1896 and 1910, respectively, when both were states.

Thirty-five states ratified the Equal Rights Amendment to the U.S. Constitution, three short of the number needed for passage. All northern states, with the exception of Illinois, supported the amendment. However, unlike the distribution of voting rights support, early support for the ratification of the ERA came from the Northeast and the Midwest. The states failing to ratify are located in the Southeast and Southwest. Idaho and Colorado, two of the first four states to grant women the right to vote, were also among the first states to ratify the ERA. Four states which had women's suffrage before 1920 failed to vote for the Equal Rights Amendment: Utah, Nevada, Arizona and Oklahoma. Five states (Idaho, Nebraska, Tennessee, Kentucky and South Dakota) voted to rescind their earlier ratification of the ERA.[9] In Kentucky that vote was vetoed by the governor.

By 1981, 16 states had added an equal rights clause to their state constitutions. Most of these states are clustered in two areas. The first is centered on the Northeast while the second forms a band running from Texas north to Montana. In Utah and Wyoming, the equal rights provision had been in place at the time they were admitted to the Union in 1896 and 1890, respectively. Of the 15 states to grant women's suffrage before 1920, only five had state ERA provisions by 1981. While Utah, Virginia and Illinois have equal rights clauses in their state constitutions, they did not ratify the federal ERA.

The National Organization for Women (NOW) has the largest membership of any feminist organization with over 700 chapters throughout the country. Since we were unable to obtain actual membership data, we mapped the number of chapters in 1984 for every 200,000 women

aged 15+ in 1980. The rate is highest in the Rocky Mountain states, with Wyoming leading the way with 12 chapters for every 100,000 women. Lower values (one chapter or less per 100,000 women) were found in the South and Northeast. California, Pennsylvania, Illinois, New York and Florida all have the highest *actual* number of chapters (not mapped), between 34 and 55, while Vermont and the District of Columbia had only one chapter apiece.

We also hoped that circulation rates for *Ms.* magazine would be useful in determining regional attitudes about the women's movement. As a middle of the road feminist publication, it has achieved a national readership. Circulation rates for the February 1984 issue were highest in the Northeast and Northwest. (Since subscriptions accounted for 90% of total sales, the distribution is probably fairly constant throughout the year.) Five states had a circulation rate of less than 100 per 100,000 persons (women and men), while the magazine appeared to be the most popular in Minnesota, Vermont, New York and Alaska with rates of over 300 per 100,000. Minnesota in particular stood as a strong contrast to surrounding states in this regard.

The national party committees formulate platforms on a variety of issues and are instrumental in promoting candidates for political office. It is important that women have a voice in these organs. The map of the Republican and Democratic Party Committees shows for each party how many female members were drawn from each state at the beginning of 1985.

A word of caution is appropriate here. In addition to state members, the map includes in its count *ex-officio* members, members at large, and committee officers who do not necessarily represent a particular area. The higher values for the District of Columbia are a result of the inclusion of women acting in these capacities. Not included were representatives of American women abroad or in U.S. territories.

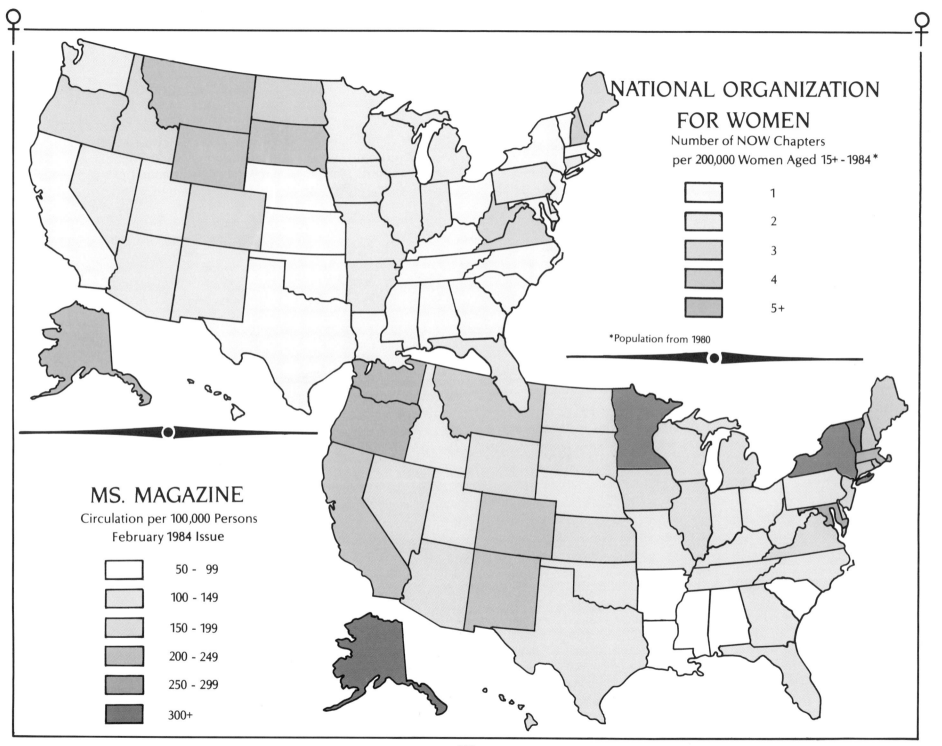

NATIONAL ORGANIZATION FOR WOMEN
Number of NOW Chapters
per 200,000 Women Aged 15+ - 1984 *

	1
	2
	3
	4
	5+

*Population from 1980

MS. MAGAZINE
Circulation per 100,000 Persons
February 1984 Issue

	50 - 99
	100 - 149
	150 - 199
	200 - 249
	250 - 299
	300+

REPUBLICAN AND DEMOCRATIC COMMITTEES

1985

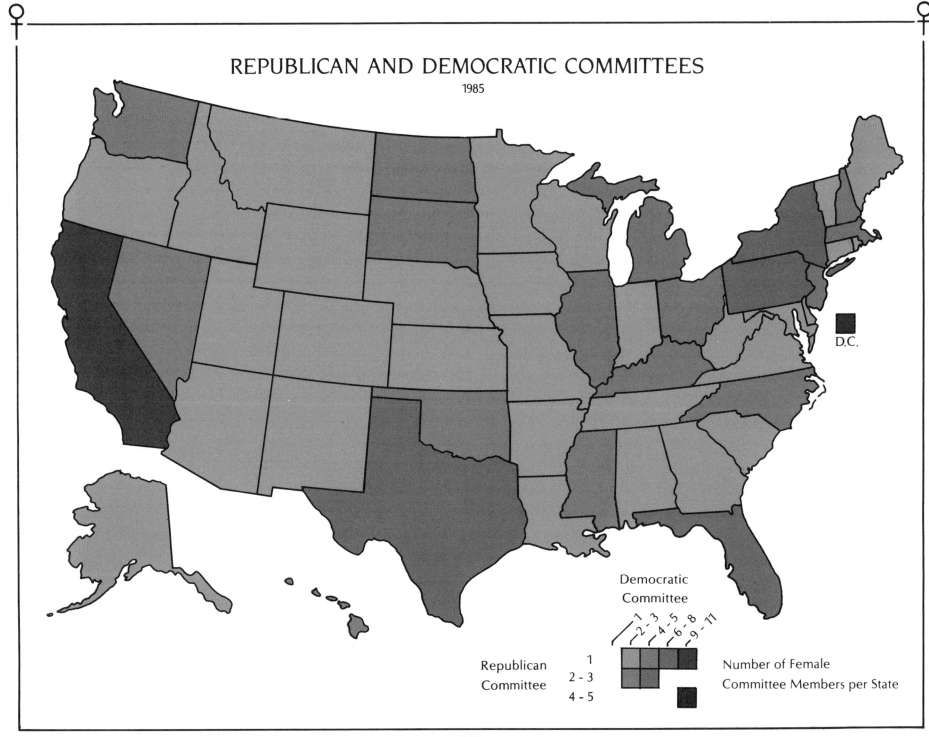

D.C.

Democratic
Committee

1
2 - 3
4 - 5
6 - 8
9 - 11

Republican
Committee

1
2 - 3
4 - 5

Number of Female
Committee Members per State

A striking difference is revealed in the membership of the two parties. There was only one woman member per state for the Republican Party Committee in all but nine states and the District of Columbia. Only two female members came from each of these jurisdictions (the other three D.C. women included two *ex-officio* members and party co-chair). By contrast, the national Democratic Committee averaged three women members per state, excluding at large members. The Democrats also had 13 at large members, seven of whom are residing in the District of Columbia.

The geographic pattern for the Republican Committee shows that those states with more than one female committee member were scattered throughout the country. The Democratic distribution is more clustered. Twelve states had four or more female members on the Democratic Committee, and all but two were east of the Mississippi, concentrating particularly in the Northeast and Midwest. Six states (Nevada, Mississippi, Hawaii, New Hampshire and the Dakotas) had the same number of Democratic and Republican female members.

WOMAN'S PLACE

The Judiciary

According to the Census, the percentage of judges that were women in 1980 ranged from less than 1% in New Hampshire and Hawaii to 40% in Montana. More than one-quarter of judges were women in Vermont, Montana, Alaska, New Mexico and Illinois. Areas with relatively high female-to-male ratios were scattered throughout the country. With the exception of Hawaii and Nevada, the lower values were found from the south-central states to the Northeast.

The highest state-level court of appeals is usually referred to as the state supreme court. In all states but two, the number of judges varies in odd increments between five and nine. Two states, Oklahoma and Texas, have separate courts of criminal appeals, making the total number of judges at this level 12 and 18, respectively. Only Minnesota, with two, had more than one woman state-level supreme court judge. Two-thirds of the states had no female judge at all on the state supreme court.

Three levels of courts are found in the federal judiciary: District (trial) Courts, Circuit Courts of Appeals and the Supreme Court. There are some 90 jurisdictions at the District Court level. A district may correspond with the boundary of a whole state, as in the case of South Carolina, or a portion of a state. Texas, for example, is divided into four districts. At the appeals level, the country is divided into 11 circuits, plus one federal circuit and one for the District of Columbia. The Supreme Court has jurisdiction over the whole country.

We have used a two-dimensional choropleth map entitled "Federal Judiciary" to show the number of female judges versus the total number of judges (not including vacancies) at each level. The use of one legend for all levels permits comparison between, as well as within, the court systems. It is important to study the key carefully so that a clear picture can be formed of the distribution of women judges. Women actually appeared to be slightly better represented at the appeals levels (the Circuit and Supreme Courts) than at the District Court level. Sandra Day O'Connor, the first woman to be so appointed, has served since 1981 on the Supreme Court as one of nine justices. Three out of the 13 Circuit Courts whose jurisdictions correspond roughly to the Plains, Midwest and Middle Atlantic states had no female judges as of 1984. Two-thirds of the District Courts had no female representation. Ten states had no women judges

WOMAN'S PLACE: I. The Judiciary

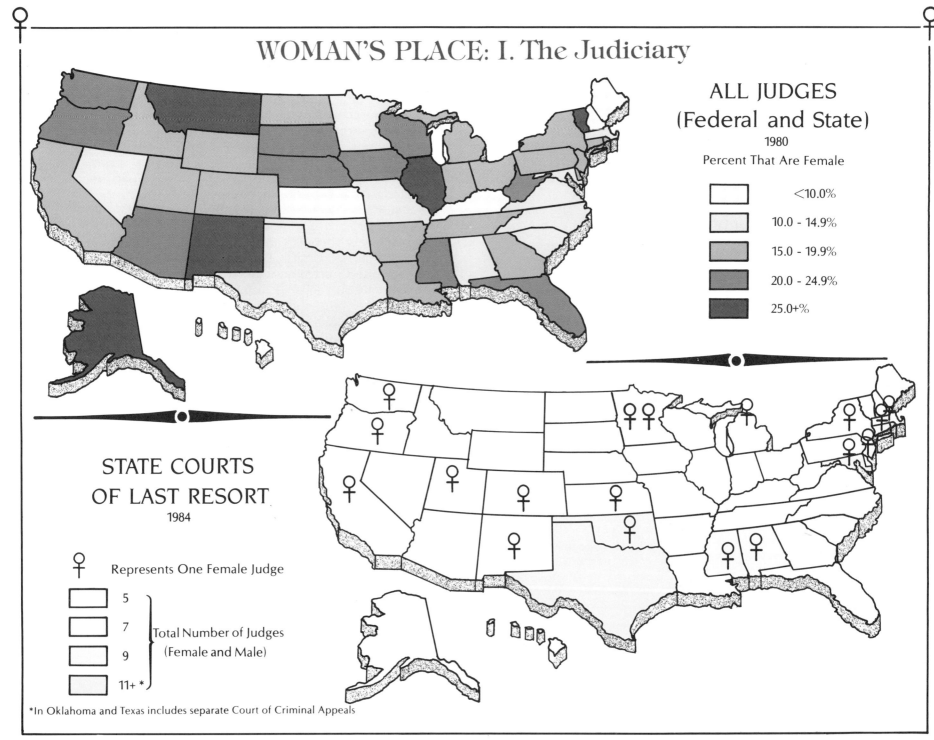

ALL JUDGES
(Federal and State)
1980
Percent That Are Female

- <10.0%
- 10.0 - 14.9%
- 15.0 - 19.9%
- 20.0 - 24.9%
- 25.0+%

STATE COURTS
OF LAST RESORT
1984

♀ Represents One Female Judge

- 5
- 7
- 9
- 11+ *

Total Number of Judges
(Female and Male)

*In Oklahoma and Texas includes separate Court of Criminal Appeals

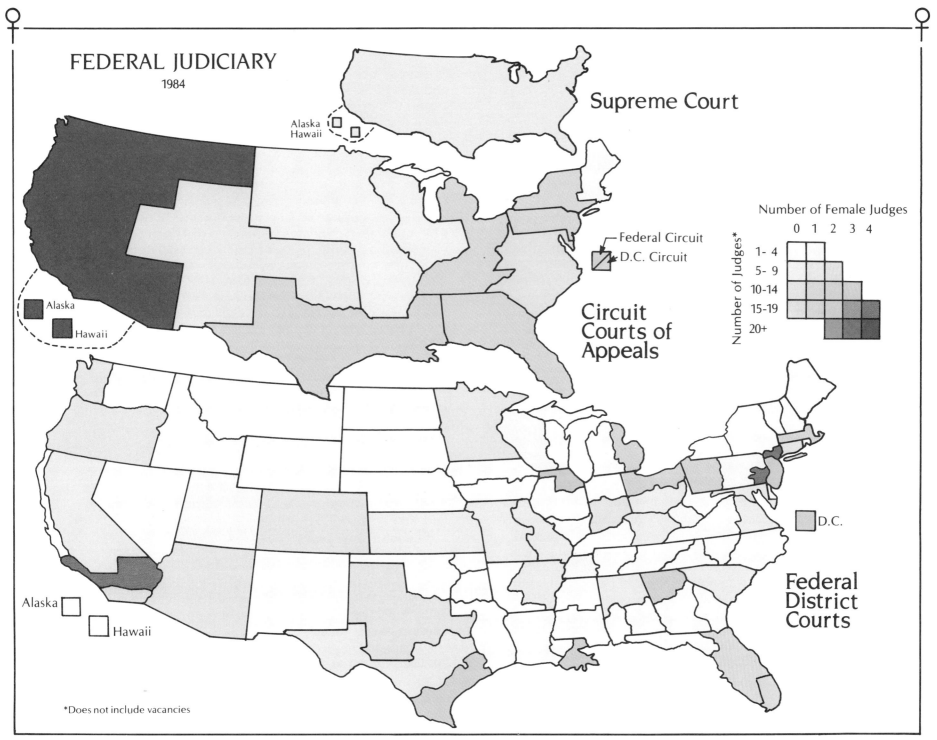

FEDERAL JUDICIARY
1984

Supreme Court

Alaska
Hawaii

Federal Circuit
D.C. Circuit

Alaska

Hawaii

Circuit
Courts of
Appeals

Number of Female Judges

0 1 2 3 4

Number of Judges*

1- 4
5- 9
10-14
15-19
20+

D.C.

Alaska

Hawaii

Federal
District
Courts

*Does not include vacancies

at both the District and Circuit Court levels, and none of these states, except for Maryland, had women on the state courts of last resort.

Although less than one-quarter of all lawyers were estimated to be women in 1980, the number has been steadily increasing. Rhode Island had the lowest percentage of female lawyers (7%), while Maryland (including D.C.) had the highest (21%). It is interesting to note that although Rhode Island had the lowest ratio of female to male attorneys, it was the only state as of 1985 that had a female attorney general (Republican Arlene Violet). Higher percentages of women lawyers were generally found in the Northeast and Far West, while women seemed less well represented in the central portion of the nation. The Dakotas and Arkansas, as well as having no women judges at the higher-court levels (as stated above), also had among the lowest percentages of women lawyers.

The House (and Senate)

The map "Women as Candidates" shows, for the November 1984 state legislative elections, the number of female candidates per 100,000 women and the percentage elected. (Note that in five states—New Jersey, Virginia, Louisiana, Mississippi and Alabama—state elections were not held in 1984 and thus no data was recorded.) Of the remaining states, 16 had less than two women running for state legislative office per 100,000 women. These states are concentrated almost exclusively in the South and Midwest. New York and California are exceptions to their regions. Women were relatively well represented in the northern Rockies, Alaska

and several New England states. New Hampshire and Vermont topped the list with 45 and 28 female candidates per 100,000 women, respectively.

A low rate of women running for office does not necessarily coincide with a low percentage of women being elected. In several states where the rate of women candidates was low, a high percentage of those running did get elected. Illinois, Texas, Missouri and Arkansas are good examples. In fact, in Texas and Illinois, over 84% of female candidates were elected! The percentage of women was also high in four New England states where the rate of women candidates was also relatively high. Pennsylvania, Michigan, New York and California had notably poor showings, both in the rate of female candidates and the percentage elected. Oregon had the lowest percentage of women elected (9%), 13 points lower than second-to-last place Utah.

The next two maps, "State Legislatures," focus on women lawmakers at the state level in early 1985. In Wyoming and Vermont, about one-quarter of the legislators were female, while in New Hampshire that percentage increased to one-third. Sixteen states had fewer than one in 10 female legislators with Missouri, at 2%, taking last place. Other low percentages were concentrated in the South, Midwest and Northeast (excluding New England). The highest ratios of female to male lawmakers were found predominantly in the western states and New England.

All states except Nebraska have bicameral legislatures. While every state in early 1985 had female representatives, three states, Louisiana, Mississippi and Virginia, had no female senators. New Hampshire, Michigan and North Dakota had female presidents of the senate, while only in Washington was a woman serving as speaker of the house.

Looking at the number of female state legislators per 100,000 women in 1985, we see that women tended to

LAWYERS

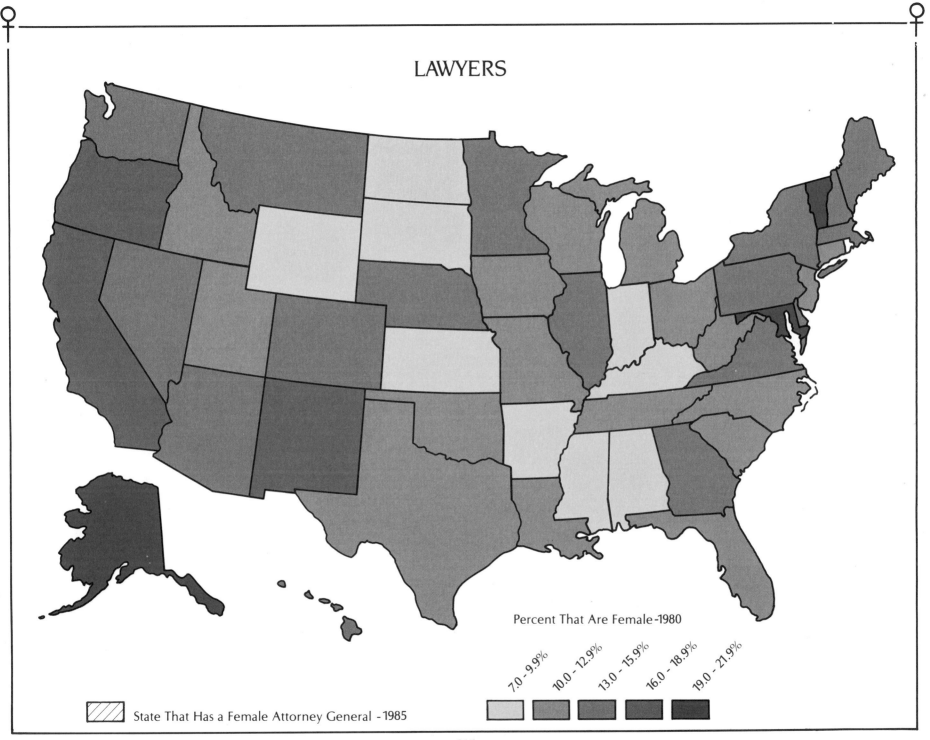

Percent That Are Female -1980

7.0 - 9.9% 10.0 - 12.9% 13.0 - 15.9% 16.0 - 18.9% 19.0 - 21.9%

State That Has a Female Attorney General - 1985

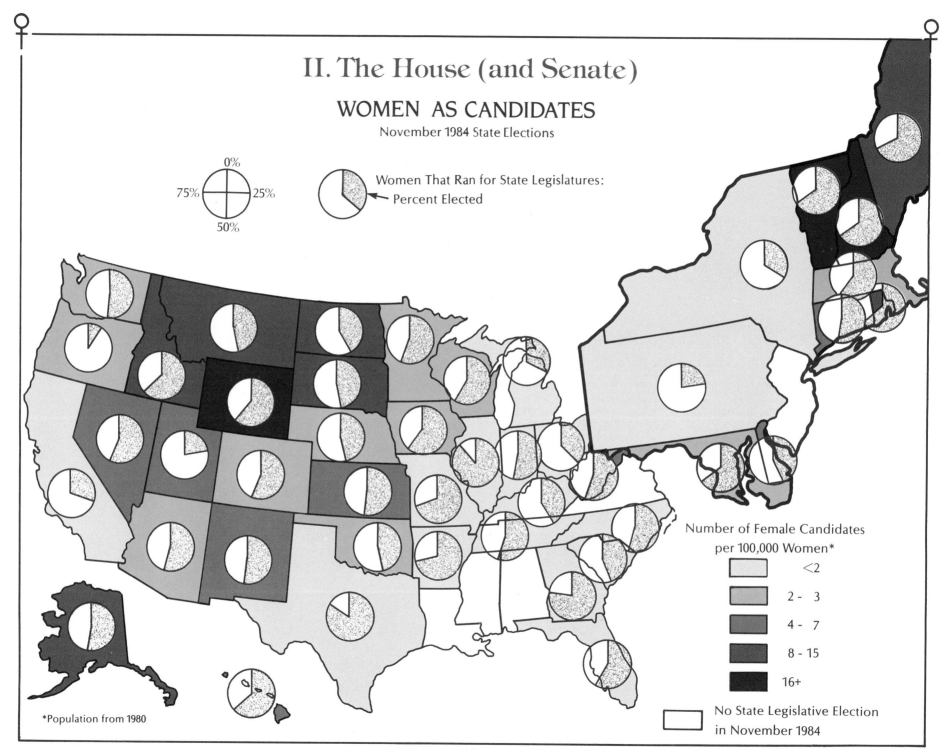

II. The House (and Senate)

WOMEN AS CANDIDATES

November 1984 State Elections

0%

75% 25%

50%

Women That Ran for State Legislatures:
Percent Elected

Number of Female Candidates
per 100,000 Women*

<2

2 - 3

4 - 7

8 - 15

16+

No State Legislative Election
in November 1984

*Population from 1980

STATE LEGISLATURES

1985

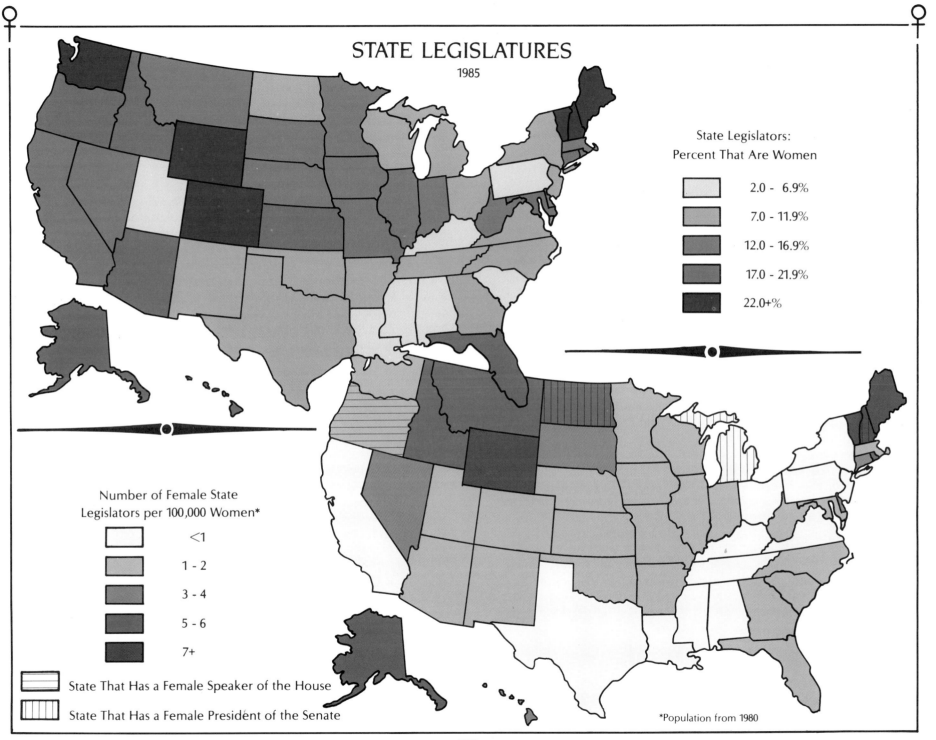

State Legislators:
Percent That Are Women

2.0 - 6.9%

7.0 - 11.9%

12.0 - 16.9%

17.0 - 21.9%

22.0+%

Number of Female State
Legislators per 100,000 Women*

<1

1 - 2

3 - 4

5 - 6

7+

State That Has a Female Speaker of the House

State That Has a Female President of the Senate

*Population from 1980

be best represented in a number of northern states that have low population densities and more rural populations (Rhode Island is a notable exception). Many of the states that had low rates of female representation also had high population densities (New York, New Jersey, Pennsylvania and Ohio). In many of these areas the political machine is powerful and well established, making it more difficult for a non-traditional candidate to break in. Other states with low representation could be found in a band from Ohio to Texas, running through Appalachia.

For the federal government, the map of "Congress Past" shows the total number of women representatives and senators to the U.S. Congress up to and including the 98th Congress, which concluded in January 1985. The symbols are color coded to indicate when the female senator or representative *first* entered Congress. Note that a woman senator or representative may have served in later congresses as well. Fifteen women senators are fairly evenly distributed through all four time periods. Ten of these senators represented states west of the Mississippi while five were from the East. Only four states (Louisiana, Nebraska, South Dakota and Alabama) had two female senators.

The number of female representatives varied between 19 for the first period to 36 for the fourth period. During the second and fourth periods, there were significantly more female representatives in the East. A more even east-west distribution was present during the first and third periods. Ten states never had a woman representative. It is interesting to note that of those ten states, three (New Hampshire, Vermont and Wyoming) currently have a high percentage of female state legislators. California, New York and Illinois have all had eight or more female representatives.

The map on the next page, "Congress Present," shows female representation in both the House and Senate for the 99th Congress. To give an idea of the ratio of female to male lawmakers, we have color coded the states according to the total number of representatives (male and female), a number determined according to each state's population. Remember that some of these legislators initially entered office during an earlier congress and will also be included in the map of "Congress Past."

Two states, Florida and Kansas, have a female senator each. Nancy Kassebaum, the Republican senator from Kansas, is the first woman to be elected to the Senate without having been preceded by her spouse.[10] She was first elected in 1978. There are currently 22 female representatives distributed among 13 states. Two states, California and Maryland, have more than two female House members. Those currently serving in Rhode Island, Nevada, Nebraska and Colorado are the first women from their states to do so.

The Executive Office

As of early 1985, 80 cities with populations greater than 30,000 had mayors who were women. Almost half of these cities had populations between 30,000 and 50,000, while nine had populations of more than 100,000. The largest of these, Houston, has over 15 million people. Two cities with women mayors, Salem, Ore. and Sacramento, Ca., are state capitals. Half of the states have no women mayors of cities this size. However, in viewing this distribution, it is important to remember that many of these states have very few cities with more than 30,000 people in 1980. Montana, Maine, Nevada and Nebraska are examples. Another 12 states have one woman mayor each. The four states with the most women mayors (California with 23, Illinois with seven and Florida and Michigan with six each) are also among the most populous

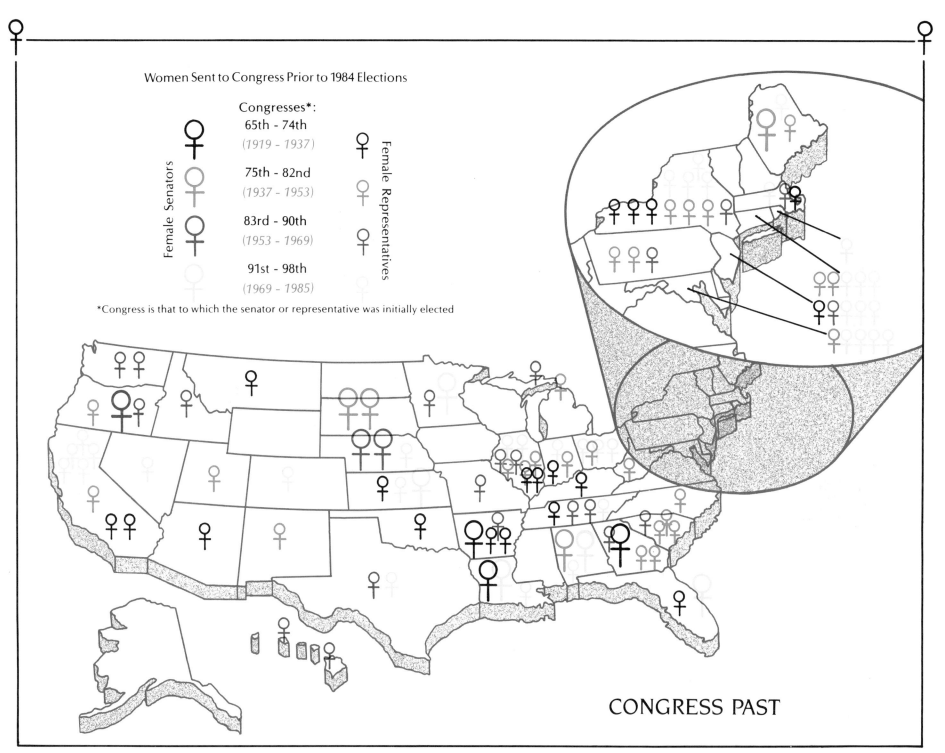

Women Sent to Congress Prior to 1984 Elections

Congresses*:

65th - 74th
(1919 - 1937)

75th - 82nd
(1937 - 1953)

83rd - 90th
(1953 - 1969)

91st - 98th
(1969 - 1985)

Female Senators

Female Representatives

*Congress is that to which the senator or representative was initially elected

CONGRESS PAST

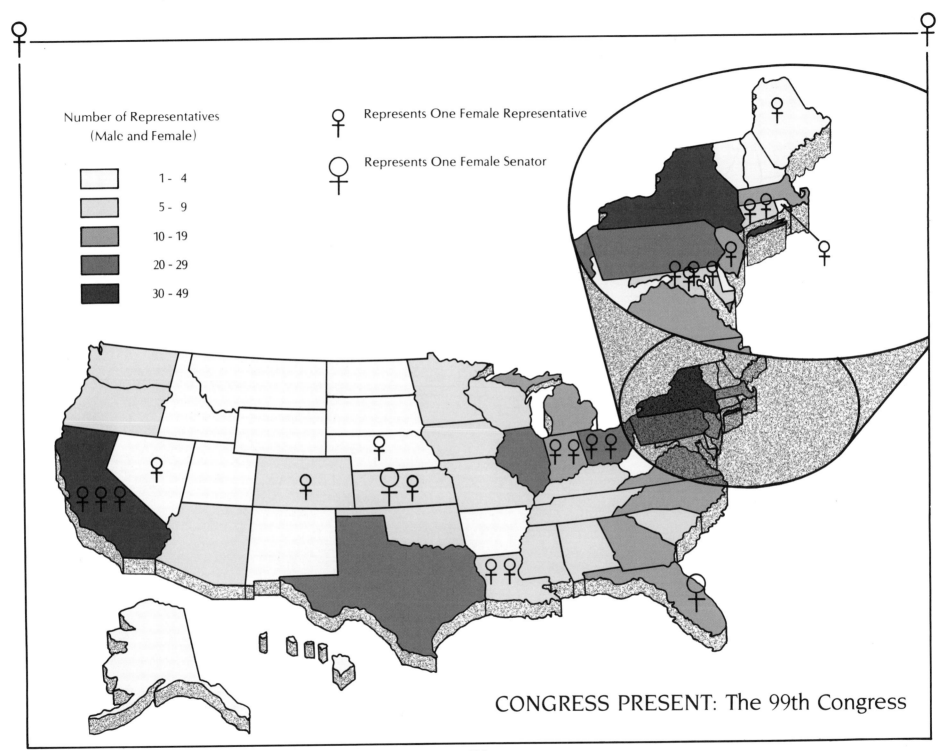

Number of Representatives
(Male and Female)

	1 - 4
	5 - 9
	10 - 19
	20 - 29
	30 - 49

☿ Represents One Female Representative

♀ Represents One Female Senator

CONGRESS PRESENT: The 99th Congress

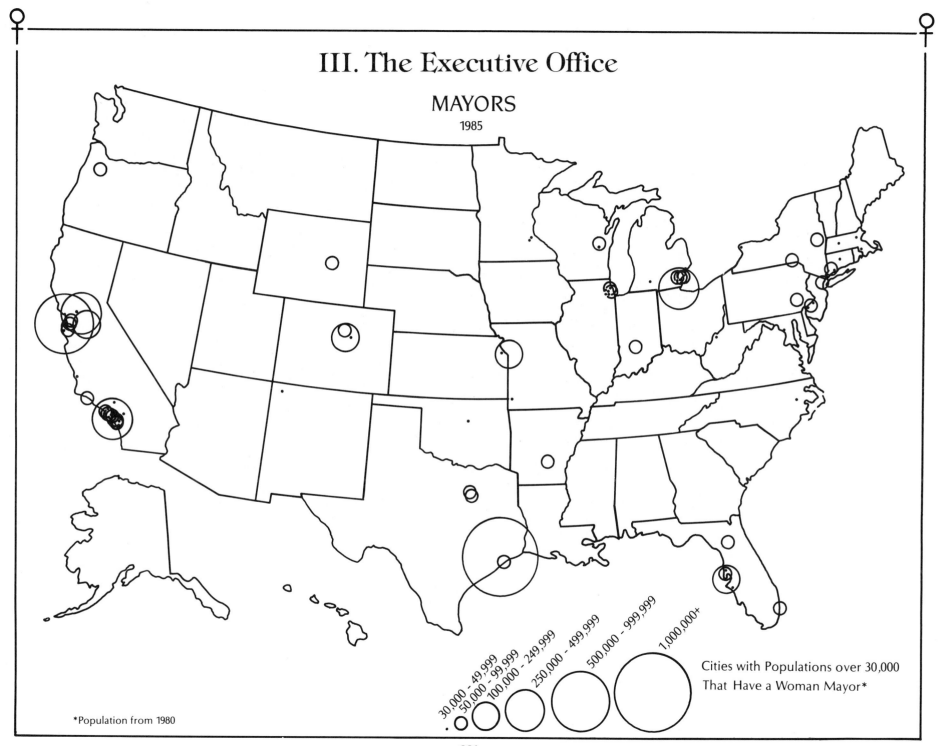

III. The Executive Office

MAYORS

1985

Cities with Populations over 30,000
That Have a Woman Mayor*

30,000 - 49,999
50,000 - 99,999
100,000 - 249,999
250,000 - 499,999
500,000 - 999,999
1,000,000+

*Population from 1980

states. Several clusters of cities stand out, notably those on the fringes of highly urbanized areas like Chicago, Detroit, Los Angeles and San Francisco. One can hypothesize that these women mayors may be from relatively wealthy suburban communities with large numbers of highly educated, politically aware and relatively wealthy women.

Women governors have been rare. At the beginning of 1985, only two states, Kentucky and Vermont, had women governors, both Democrats. Prior to the election five states (Washington, Wyoming, Texas, Alabama and Connecticut) had had one female governor each. Miriam Ferguson and Nellie Taylor Ross became, in 1925, governors of Texas and Wyoming, respectively. Ms. Ross was elected to take over for her husband when he died in office, while Ms. Ferguson's husband had been governor for one term several years prior to her own election. Ms. Ferguson served a second term from 1933–35. When George Wallace could not succeed himself as governor, his wife Lurleen stepped in as governor of Alabama in 1967. Ella Grasso became governor of Connecticut in 1975, the first woman to do so without having been preceded at some time by a spouse. Dixy Lee Ray took office in Washington two years later.

Examining the lower-level state executive offices, we notice five states with women as lieutenant governors in 1985, all but one of which was west of the Mississippi. Vermont and Kentucky, both with female governors, also had female secretaries of state. Sixteen other states, concentrated in three regions, the Southwest, Northeast and the northern Midwest, had women in this office. The position of state treasurer was filled by women in ten states, clustered most noticeably in the country's midsection.

In all, 31 states had at least one woman in higher-level state executive office in early 1985. Colorado and Minnesota had women as lieutenant governor and as secretary of state, and Texas had a woman as treasurer and as secretary of state. No state had women in more than two of these offices at once.

The presidential first lady most commonly is the wife of the president. However, if the president is not married, any other woman of his choice may hold that position. For example, John Tyler designated his daughter-in-law and James Buchanan his niece as first lady. The map of first ladies shows the birthplaces only of those who were married to the president while he was in office. We have also grouped first ladies according to when they held that position. Note how birthplaces moved west as the country matured and the center of population shifted accordingly, although most first ladies were born east of the Mississippi. More first ladies (seven) were from New York than any other state and Ohio takes second place with six. Note that only one first lady, Louise Adams, was born outside of the United States.

The final map of the atlas shows the distribution of the birthplaces of all female presidents and vice-presidents of the United States. We hope that this map speaks for itself!

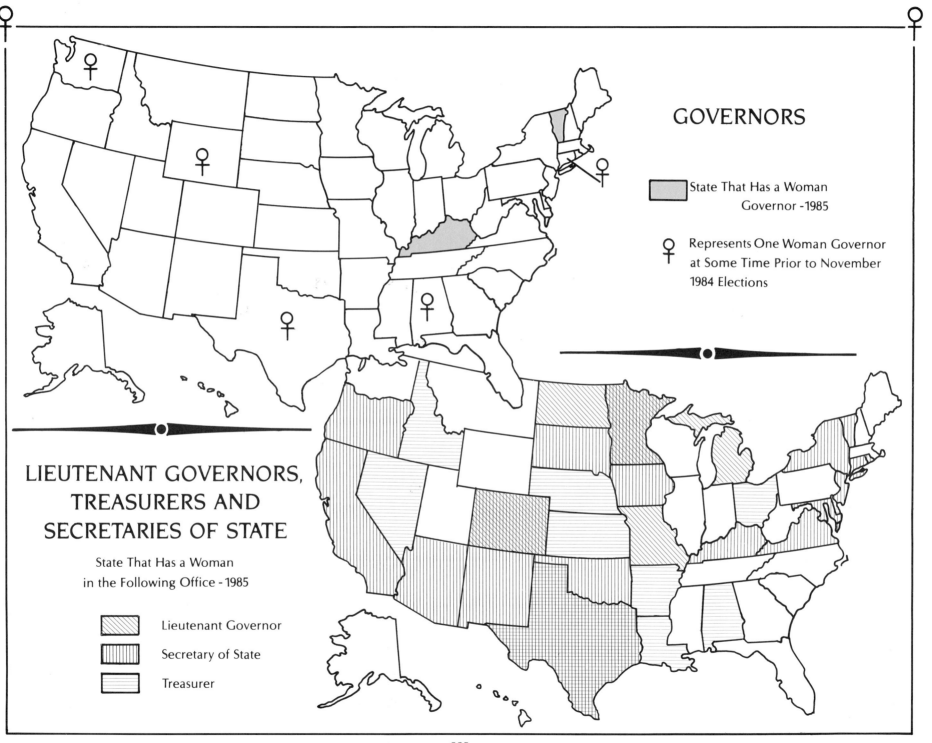

GOVERNORS

State That Has a Woman Governor - 1985

Represents One Woman Governor at Some Time Prior to November 1984 Elections

LIEUTENANT GOVERNORS, TREASURERS AND SECRETARIES OF STATE

State That Has a Woman in the Following Office - 1985

Lieutenant Governor

Secretary of State

Treasurer

FIRST LADIES*

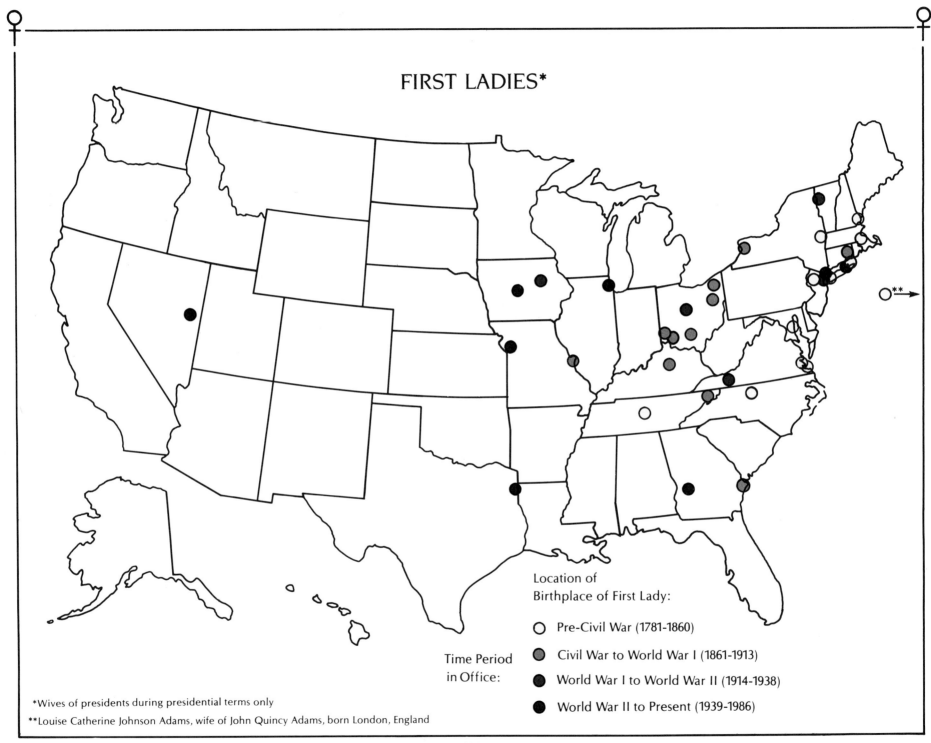

Location of
Birthplace of First Lady:

○ Pre-Civil War (1781-1860)

● Civil War to World War I (1861-1913)

● World War I to World War II (1914-1938)

● World War II to Present (1939-1986)

Time Period
in Office:

*Wives of presidents during presidential terms only

**Louise Catherine Johnson Adams, wife of John Quincy Adams, born London, England

PRESIDENTS AND VICE-PRESIDENTS

• Represents Birthplace of Woman
President or Vice-President

DEMOGRAPHICS

	AL	AK	AZ	AR	CA	CO	CT	DE	FL	GA	HA	ID	IL	IN	IA	KS	KY	LA	ME	MD/DC	MA	MI	MN	MS	MO	MT	NB	NV	NH	NJ	NM	NY	NC	ND	OH	OK	OR	PA	RI	SC	SD	TN	TX	UT	VT	VA	WA	WV	WI	WY	DC
The Most Populous Sex	L			H																																															
Women Vs. Men	L																					H																													
Native American Women	H												L																																						
Asian Women										H															L																										
Black Women											L											H																													
White Women										L																																							H		
Hispanic Women																		L					H																												
Childhood (15)								L																																				H							
The Childbearing Years (15-44)	H							L																																				H							
The Middle Years (45-64)	L																											H																							
The Elderly (65 +)	L							H																																											
Median Age (Women)								H																																				L							
Urban Female Population			H																																									L							

EDUCATION

	AL	AK	AZ	AR	CA	CO	CT	DE	FL	GA	HA	ID	IL	IN	IA	KS	KY	LA	ME	MD/DC	MA	MI	MN	MS	MO	MT	NB	NV	NH	NJ	NM	NY	NC	ND	OH	OK	OR	PA	RI	SC	SD	TN	TX	UT	VT	VA	WA	WV	WI	WY	DC
High School Graduates 25 +	H																																					L													
High School Graduates 18-24																																	H									L									
Women with High School Diplomas	L																																							H											
Men with High School Diplomas	L																																H																		
College Enrollment	H																																																L		
Private Funding																				H																															L
Part-Time College Students	H																																L																		
Women with 4 + Years of College	H		L																																																
Women with 5 + Years of College			L																H																																
Doctorial Recipients	L																									H																									
Medical School Enrollment																											H															L									
Law School Enrollment																													H													L									
Elementary School Teachers			H															L																																	
Secondary School Teachers																									L															H											
College Faculty										L											H																														
Principals													H																													L									

227

EMPLOYMENT

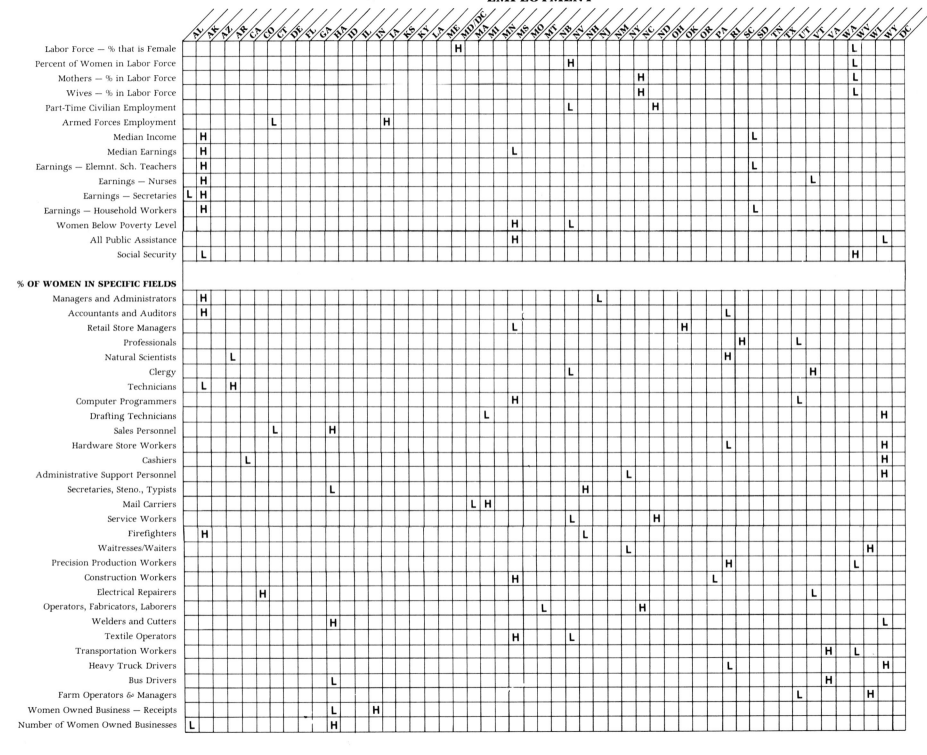

HEALTH

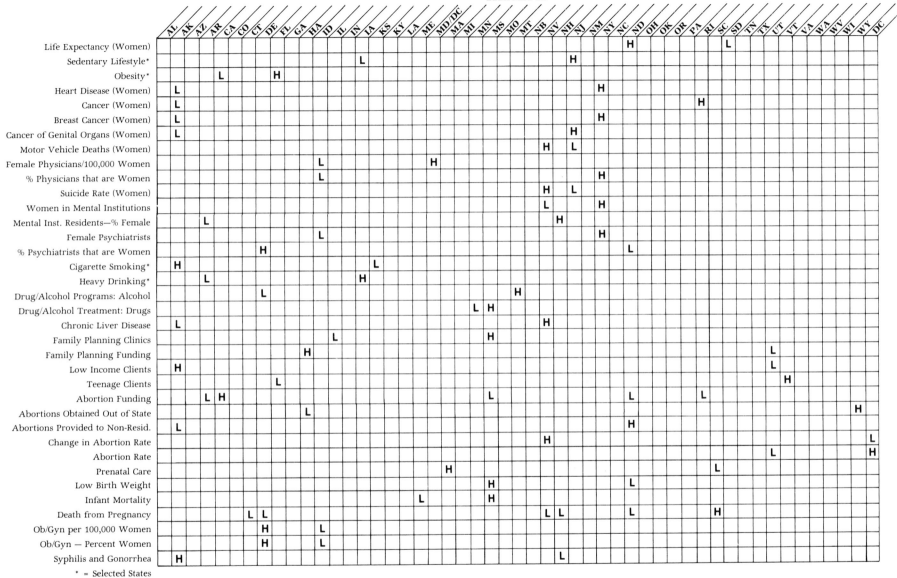

	AL	AK	AZ	AR	CA	CO	CT	DE	FL	GA	HA	ID	IL	IN	IA	KS	KY	LA	ME	MD/DC	MA	MI	MN	MS	MO	MT	NB	NV	NH	NJ	NM	NY	NC	ND	OH	OK	OR	PA	RI	SC	SD	TN	TX	UT	VT	VA	WA	WV	WI	WY	DC
Life Expectancy (Women)																																	H							L											
Sedentary Lifestyle*													L																	H																					
Obesity*			L						H																																										
Heart Disease (Women)	L																													H																					
Cancer (Women)	L																																	H																	
Breast Cancer (Women)	L																													H																					
Cancer of Genital Organs (Women)	L																												H																						
Motor Vehicle Deaths (Women)																											H		L																						
Female Physicians/100,000 Women													L												H																										
% Physicians that are Women													L																			H																			
Suicide Rate (Women)																											H		L																						
Women in Mental Institutions																											L			H																					
Mental Inst. Residents—% Female		L																											H																						
Female Psychiatrists													L																	H																					
% Psychiatrists that are Women							H																										L																		
Cigarette Smoking*	H												L																																						
Heavy Drinking*		L											H																																						
Drug/Alcohol Programs: Alcohol							L																			H																									
Drug/Alcohol Treatment: Drugs																								L	H																										
Chronic Liver Disease	L																								H																										
Family Planning Clinics															L										H																										
Family Planning Funding										H																																			L						
Low Income Clients	H																																												L						
Teenage Clients							L																																								H				
Abortion Funding		L	H																											L								L		L											
Abortions Obtained Out of State									L																																									H	
Abortions Provided to Non-Resid.	L																																H																		
Change in Abortion Rate																									H																									L	
Abortion Rate																																										L								H	
Prenatal Care																			H																		L														
Low Birth Weight																							H													L															
Infant Mortality																			L				H																												
Death from Pregnancy						L	L																				L	L					L									H									
Ob/Gyn per 100,000 Women							H							L																																					
Ob/Gyn — Percent Women							H							L																																					
Syphilis and Gonorrhea	H																											L																							

* = Selected States

CRIME

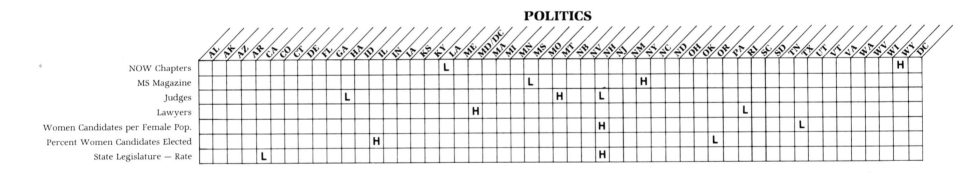

	AL	AK	AZ	AR	CA	CO	CT	DE	FL	GA	HA	ID	IL	IN	IA	KS	KY	LA	ME	MD/DC	MA	MI	MN	MS	MO	MT	NB	NV	NH	NJ	NM	NY	NC	ND	OH	OK	OR	PA	RI	SC	SD	TN	TX	UT	VT	VA	WA	WV	WI	WY	DC
Police Officers	H						L																																												
Correctional Officers—% Female			H	L																																															
Correct. Supervisors—% Female																					L																					H									
Rape Rate																											H						L																		
Rape Clearance Rate								H																	L																										
Homicide (Women's Rate)																											H	L																							
Federal Crimes/100,000 Women					H																							L																							
Federal Crimes — % Female					H																																												L		
Crimes Against Persons/Property					H																																									L					
Murder		H																														L									L										
Robbery																																			H											L					
Aggravated Assault																		H																												L					
Larceny					H																			L																											
Theft					L																								H																						
Motor Vehicle Theft																											H																			L					
Prison Population — Women																											H						L																		
Prison Population — Men																												L				H																			

POLITICS

	AL	AK	AZ	AR	CA	CO	CT	DE	FL	GA	HA	ID	IL	IN	IA	KS	KY	LA	ME	MD/DC	MA	MI	MN	MS	MO	MT	NB	NV	NH	NJ	NM	NY	NC	ND	OH	OK	OR	PA	RI	SC	SD	TN	TX	UT	VT	VA	WA	WV	WI	WY	DC
NOW Chapters																	L																																H		
MS Magazine																							L								H																				
Judges									L													H						L																							
Lawyers																		H																				L													
Women Candidates per Female Pop.																														H												L									
Percent Women Candidates Elected										H																										L															
State Legislature — Rate					L																									H																					

230

FAMILY

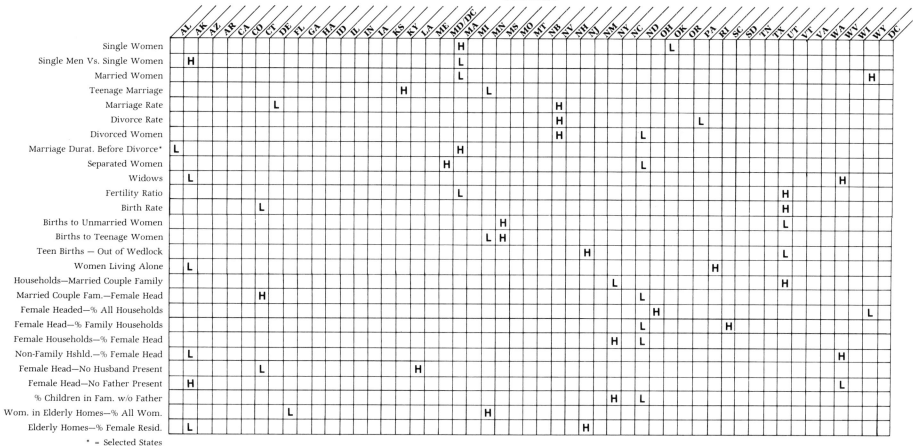

	AL	AK	AZ	AR	CA	CO	CT	DE	FL	GA	HA	ID	IL	IN	IA	KS	KY	LA	ME	MD/DC	MA	MI	MN	MS	MO	MT	NB	NV	NH	NJ	NM	NY	NC	ND	OH	OK	OR	PA	RI	SC	SD	TN	TX	UT	VT	VA	WA	WV	WI	WY	DC	
Single Women																				H																L																
Single Men Vs. Single Women		H																		L																																
Married Women																				L																													H			
Teenage Marriage																	H				L																															
Marriage Rate						L																					H																									
Divorce Rate																											H										L															
Divorced Women																											H				L																					
Marriage Durat. Before Divorce*	L															H																																				
Separated Women																		H													L																					
Widows	L																																																H			
Fertility Ratio																	L																								H											
Birth Rate						L																																			H											
Births to Unmarried Women																						H																			L											
Births to Teenage Women																					L	H																														
Teen Births — Out of Wedlock																													H												L											
Women Living Alone	L																																	H																		
Households—Married Couple Family																											L																H									
Married Couple Fam.—Female Head						H																					L																									
Female Headed—% All Households																																	H																L			
Female Head—% Family Households																											L									H																
Female Households—% Female Head																											H	L																								
Non-Family Hshld.—% Female Head	L																																																H			
Female Head—No Husband Present						L										H																																				
Female Head—No Father Present	H																																																L			
% Children in Fam. w/o Father																												H			L																					
Wom. in Elderly Homes—% All Wom.						L															H																															
Elderly Homes—% Female Resid.	L																											H																								

* = Selected States

231

NOTES

INTRODUCTION

[1] Gloria Steinem, quoted in "A New Egalitarian Lifestyle," *New York Times*, 26 August 1971, as quoted in Elaine Partnow, *The Quotable Woman, 1800–1981* (New York: Facts On File, 1982), p. 420.

CHAPTER ONE—DEMOGRAPHICS

[1] Elizabeth Blackwell with Emily Blackwell, *Medicine as a Profession for Women*, quoted in Elaine Partnow, *The Quotable Woman, 1800–1981* (New York: Facts On File, 1982), p. 45.

[2] U.S. Department of Commerce, Bureau of the Census, *United States Census of Population: 1980*, vol. 1, *Characteristics of the Population*, pt. 1, United States Summary.

[3] *Ibid.*

CHAPTER TWO—EDUCATION

[1] Mirra Komarovsky, *Women in the Modern World* (Boston: Little, Brown and Company, 1953; reprint ed., Dubuque, Iowa: Brown Reprints, 1971), p. 1.

[2] Adrienne Rich, "Toward a Woman-Centered University," in *Women and the Power to Change*, Florence Howe, ed. (New York: McGraw-Hill Book Company, 1975), p. 24.

CHAPTER THREE—EMPLOYMENT

[1] June Jordan, *New Life, New Room* (New York: Thomas Y. Crowell, 1975), p. 38.

[2] Ruth Leger Sivard, *Women: A World Survey* (Washington, D.C.: World Priorities, 1985), p. 11.

[3] *Ibid.*

[4] *Manufactures of the United States in 1860, Compiled from the Original Returns of the Eighth Census*, Vol. III, p. 742; *Twelfth Census of the United States (1900)*, vol. VII: *Manufactures*, pt. I, p. cxxvi, Table XLIIIA, cited in Eleanor Flexner, *Century of Struggle*, rev. ed. (Cambridge: Harvard University Press, The Belknap Press, 1975), p. 134.

[5] U.S. Department of Commerce, Bureau of the Census, Public Information Office, *We, The American Women* (Washington, D.C.: U.S. Government Printing Office, March 1984), p. 7.

[6] U.S. Department of Labor, Women's Bureau, *Time of Change: 1983 Handbook on Women Workers*, Bulletin 298 (Washington, D.C.: U.S. Government Printing Office, 1983), p. 7.

[7] Daphne Spain and Suzanne M. Bianchi, "How Women Have Changed," *American Demographics* (May 1983), p. 23.

[8] U.S. Department of Commerce, Bureau of the Census, *United States Census of Population: 1980*, Vol. 1, *Characteristics of the Population*, pt. 1, United States Summary.

[9] Spain and Bianchi, "How Women Have Changed," p. 23.

[10] U.S. Department of Labor, Women's Bureau, *Time of Change*, p. 20.

[11] *Ibid.*, pp. 55–56.

[12] *Ibid.*, p. 54.

[13] U.S. Department of Commerce, Bureau of the Census, Public Information Office, *We, The American Women*, p. 8.

[14] Spain and Bianchi, "How Women Have Changed," p. 24.

[15] U.S. Department of Commerce, Bureau of the Census, *United States Census of Population: 1980*, Vol. 1, *Characteristics of the Population*, pt. 1, United States Summary.

[16] U.S. Department of Labor, Women's Bureau, *Time of Change*, p. 82.

[17] *Ibid.*, p. 87.

[18] U.S. Department of Commerce (1981), cited in Council on Interracial Books for Children, *Fact Sheets on Institutional Sexism* (New York: Council on Interracial Books for Children, January 1982), p. 5.

[19] U.S. Department of Labor, Women's Bureau, *Time of Change*, p. 100.

[20] *Ibid.*

[21] U.S. Department of Commerce, Bureau of the Census, *Money Income and Poverty Status of Families and Persons in the United States: 1981*, (Advance Report) Current Population Reports, Consumer Income, series P-60, No. 134, pp. 22–28, cited in U.S. Department of Labor, Women's Bureau, *Time of Change*, p. 25.

[22] Children's Defense Fund, *A Children's Defense Budget: An Analysis of the President's FY 86 Budget for Children* (Washington, D.C.: Children's Defense Fund, 1985), p. 270.

[23] U.S. Department of Labor, Women's Bureau, *Time of Change*, p. 100.

[24] *New York Times*, 10 October 1980, cited in Council on Interracial Books for Children, *Fact Sheets on Institutional Sexism*, p. 5.

[25] The Fund for Working Woman (1980) cited in Council on Interracial Books for Children, *Fact Sheets on Institutional Sexism*, p. 6.

[26] *U.S. Department of Labor, Women's Bureau, Time of Change*, p. 183.

Chapter Four—Family

[1] Mary Livermore, *What Shall We Do with Our Daughters?*, quoted in Elaine Partnow, *The Quotable Woman, 1800–1981* (New York: Facts On File, 1982), p. 43.

[2] U.S. Department of Commerce, Bureau of the Census, *United States Census of Population: 1970*, Vol. 1, *Characteristics of the Population*, pt. 1, United States Summary; and *Idem, United States Census of Population: 1980*, Vol. 1, *Characteristics of the Population*, pt. 1, United States Summary.

[3] *Ibid.;* and Daphne Spain and Suzanne M. Bianchi, "How Women Have Changed," *American Demographics* (May 1983), p. 22.

[4] U.S. Department of Commerce, Bureau of the Census, *United States Census of Population: 1970*, Vol. 1, *Characteristics of the Population*, pt. 1, United States Summary; and *Idem, United States Census of Population: 1980*, Vol. 1, *Characteristics of the Population*, pt. 1, United States Summary.

[5] *Idem, United States Census of Population: 1980*, Vol. 1, *Characteristics of the Population*, pt. 1, United States Summary.

[6] U.S. Department of Commerce, Bureau of the Census, Public Information Office, *U.S. Department of Commerce News* (11 October 1983), CB83-159.

[7] U.S. Department of Commerce, Bureau of the Census, *United States Census of Population: 1970*, Vol. 1, *Characteristics of the Population*, pt. 1, United States Summary; and *Idem, United States Census of Population: 1980*, Vol. 1, *Characteristics of the Population*, pt. 1, United States Summary.

[8] U.S. Department of Commerce, Bureau of the Census, *United States Census of Population: 1980*, Vol. 1, *Characteristics of the Population*, pt. 1, United States Summary.

[9] Spain and Bianchi, "How Women Have Changed," p. 19.

[10] National Center for Health Statistics: Advance report of final marriage statistics. *Monthly Vital Statistics Report*, Vol. 32, No. 5, Supp. DHHS Pub. No. (PHS) 83-1120. Public Health Service, Hyattsville, Md., August 1983, p. 4.

[11] National Center for Health Statistics: Advance report of final divorce statistics, 1980, *Monthly Vital Statistics Report*, Vol. 32, no. 3, Supp. DHHS Pub. No. (PHS) 83-1120. Public Health Service, Hyattsville, Md., June 1983, p. 10.

[12] National Center for Health Statistics: Advance report of final divorce statistics, 1980, *Monthly Vital Statistics Report*, vol. 32, no. 3, Supp. DHHS Pub. No. (PHS) 83-1120. Public Health Service, Hyattsville, Md., June 1983, table 5.

[13] *Ibid.*, Table 6.

[14] Spain and Bianchi, "How Women Have Changed," p. 21.

[15] U.S. Department of Commerce, Bureau of the Census, Public Information Office, *U.S. Department of Commerce News* (11 October 1983), CB83-159.

[16] Spain and Bianchi, "How Women Have Changed," p. 21.

[17] *Ibid.*, p. 20.

[18] U.S. Department of Commerce, Bureau of the Census, Public Information Office, *We, The American Women* (Washington, D.C.: U.S. Government Printing Office, March 1984), p. 12.

Chapter Five—Health

[1] Theodore Stanton and Harriet Stanton Blatch, eds., *Elizabeth Cady Stanton*, as quoted in Elaine Partnow, *The Quotable Woman, 1800–1981* (New York: Facts On File, 1982), p. 29.

[2] U.S. Department of Health and Human Services, Health Manpower Bureau, *Characteristics of Physicians, 1979* (1982), Tables 6, 9.

[3] *New York Times* (20 September 1981), as cited in Council on Interracial Books for Children, *Fact Sheets on Institutional Sexism* (New York: Council on Interracial Books for Children, January 1982), p. 20.

[4] Carol Gilligan, *In a Different Voice* (Cambridge: Harvard University Press, The Belknap Press, 1982), ch. 1.

[5] National Center for Health Statistics: Annual summary of births, deaths, marriages, and divorces, United States, 1982. *Monthly Vital Statistics Report*, Vol. 31, no. 13, Supp. DHHS Pub. No. (PHS) 83-1120. Public Health Service, Hyattsville, Md., October 1983, pp. 5, 7 and U.S. Bureau of the Census, *Statistical Abstract of the United States: 1984*, 104th ed. (Washington, D.C., 1983), p. 63.

[6] Population Reference Bureau, *The United States Population Data Sheet*, 2nd ed. (Washington, D.C.: Population Reference Bureau, n.d.).

[7] National Center for Health Statistics: Annual summary of births, deaths, marriages, and divorces, United States, 1982. *Monthly Vital Statistics Report*, Vol. 31, no. 13, Supp. DHHS Pub. No. (PHS) 83-1120. Public Health Service, Hyattsville, Md., October 1983, p. 15.

[8] Centers for Disease Control, Annual summary 1982: reported morbidity and mortality in the United States, *Morbidity Mortality Weekly Report* 1983; 31(54), p. 127.

[9] U.S. Bureau of the Census, *Statistical Abstract of the United States: 1984*, p. 79. National Center for Health Statistics: Advance report of final mortality statistics, 1980. *Monthly Vital Statistics Report*, Vol. 32, no. 4 Supp. DHHS Pub. No. (PHS) 83-1120. Public Health Service, Hyattsville, Md., August 1983, p. 4.

[10] American Cancer Society, *Cancer Facts and Figures: 1984* (New York: American Cancer Society, 1983), p. 14.

[11] U.S. Bureau of the Census, *Statistical Abstract of the United States: 1984*, p. 126.

[12] U.S. Department of Commerce, Bureau of the Census, *United States Census of Population; 1980*, Vol. 1, *Characteristics of the Population*, pt. 1, United States Summary.

[13] U.S. Bureau of the Census, *Statistical Abstract of the United States: 1984*, p. 116.

[14] *Ibid.*, p. 83. U.S. Department of Health and Human Services, National Center for Health Statistics, Division of Vital Statistics, Hyattsville, Md., unpublished data.

[15] U.S. Bureau of the Census, *Statistical Abstract of the United States: 1984*, p. 170.

[16] Jacqueline Darroch Forest and Stanley K. Henshaw, "What U.S. Women Think and Do About Contraception," *Family Planning Perspectives* 15 (July/August 1983): 163.

[17] U.S. Bureau of the Census, *Statistical Abstract of the United States: 1982–83*, 103d ed. (Washington, D.C., 1982), p. 70.

[18] Jacqueline Darroch Forest and Stanley K. Henshaw, "What U.S. Women Think and Do About Contraception," p. 160.

[19] Barry Nestor, "Public Funding of Contraceptive Services, 1980–82," *Family Planning Perspectives* 14 (July/August 1982): 198.

Chapter Six—Crime

[1] Freda Adler, *Sisters in Crime*, as quoted in Elaine Partnow, *The Quotable Woman, 1800–1981* (New York: Facts On File, 1982), p. 415.

[2] Carol Smart, "Criminological Theory: Its Ideology and Implications Concerning Women," in Lee H. Bowker, ed., *Women and Crime in America* (New York: Macmillan Publishing Co., Inc., 1981), p. 10.

[3] Lee H. Bowker, ed., *Women and Crime in America*, p. 3.

[4] Carol Smart, "Criminological Theory: Its Ideology and Implications Concerning Women," p. 12.

[5] Coramae Richey Mann, *Female Crime and Delinquency* (University, Ala.: University of Alabama Press, 1984), p. 3.

[6] U.S. Department of Justice, Bureau of Justice Statistics, *Sourcebook of Criminal Justice Statistics: 1982*, Timothy J. Flanagan and Maureen McLeod, eds. (Washington, D.C.: U.S. Government Printing Office, 1983), p. 399.

[7] *Ibid.*

[8] Coramae Richey Mann, *Female Crime and Delinquency*, p. 31.

[9] U.S. Department of Justice, Bureau of Justice Statistics, *Sourcebook of Criminal Justice Statistics: 1982*, p. 399.

[10] Estelle B. Freedman, *Their Sisters' Keepers: Women's Prison Reform in America, 1830–1930* (Ann Arbor: University of Michigan Press, 1981), chap. 2.

[11] *Ibid.*, p. 62.

[12] Jacqueline K. Crawford, "Two Losers Don't Make a Winner: The Case Against the Co-correctional Institution," in John Ortiz Smykla,

ed., *Coed Prison* (New York: Human Sciences Press, 1980), pp. 262–268.

[13] U.S. Department of Justice, Bureau of Justice Statistics, *Sourcebook of Criminal Justice Statistics: 1982*, p. 309.

[14] George H. Gallup, *The Gallup Opinion Index*. Report No. 172 (Princeton, N.J.: The Gallup Poll, November 1979), p. 22; George H. Gallup, *The Gallup Report*, Report No. 187, p. 7, and Report No. 200, p. 21 (Princeton, N.J.: The Gallup Poll), cited in U.S. Department of Justice, Bureau of Justice Statistics, *Sourcebook of Criminal Justice Statistics*, pp. 211, 213.

[15] U.S. Department of Justice, Bureau of Justice Statistics, *Sourcebook of Criminal Justice Statistics*, pp. 370–371.

[16] *Ibid.*, p. 292.

[17] Coramae Richey Mann, *Female Crime and Delinquency*, p. 133.

[18] Susan E. Martin, "*Police*women and Police*women*: Occupational Role Dilemmas and Choices of Female Officers," *Journal of Police Science and Administration* (1979): 314–323, cited in Coramae Richey Mann, *Female Crime and Delinquency*, pp. 137–138.

CHAPTER SEVEN—POLITICS

[1] Abigail Adams to John Adams, 31 March 1776, *Letters of Mrs. Adams*, quoted in Elaine Partnow, *The Quotable Woman, Eve—1799* (New York: Facts On File, 1985), p. 591.

[2] Eleanor Flexner, *Century of Struggle*, rev. ed. (Cambridge: Harvard University Press, The Belknap Press, 1975), p. 81.

[3] National Women's Party, "Chronology of Action," Washington, D.C. (photocopied).

[4] U.S. Department of Commerce, Bureau of the Census, *United States Census of Population: 1980*, Vol. 1, *Characteristics of the Population*, pt. 1, United States Summary.

[5] Council of State Governments, *Book of the States, 1984–85* (Lexington, KY: Council of State Governments, 1984), pp. 512–536.

[6] Lynda Raby, Staffing Assistant, Administrative Office of the United States Courts, to Anne Gibson, 21 December 1984.

[7] National Women's Political Caucus, *National Directory of Women Elected Officials: 1985* (Washington, D.C.: National Women's Political Caucus, 1985), pp. 11–39.

[8] *Ibid.*, p. 41.

[9] Council of State Governments, *Book of the States, 1982–83* (Lexington, KY: Council of State Governments, 1982), p. 64.

[10] National Women's Political Caucus, *National Directory of Women Elected Officials*, p. 18.

BIBLIOGRAPHY FOR MAPS

As mentioned in the introduction, the publications listed here provided the "raw" data for the maps. Frequently we converted this data into percentages or rates. Information on state laws has been generalized and classified to fit the simplified map format. It was not possible to note qualifications and exceptions to general rules. For detailed and current information, consult the statutes of individual states directly.

In most maps, particularly those of a statistical nature, we have combined data for the District of Columbia with Maryland. An asterisk (*) next to the map name indicates that either information for the District of Columbia was mapped separately or left out altogether. This designation does not pertain to dot maps.

Finally, please note that census data from Tables 1–55 is complete count data, while information from Table 56 on is based on sample estimates.

CHAPTER ONE—DEMOGRAPHICS

"The Most Populous Sex"*
 U.S. Department of Commerce, Bureau of the Census. *United States Census of Population: 1980*. Vol. 1, *Characteristics of the Population*, pt. 1, United States Summary. Table 62.
"Women Vs. Men"
 Ibid., Table 67.
"The Multi-Racial Sisterhood"
 Ibid., Table 62.
"Native Americans"
 Ibid., Table 62.
"Asians"
 Ibid., Table 62.

"Blacks"
Ibid., Table 62.
"Whites"
Ibid., Table 62.
"Hispanics"
Ibid., Table 63.
"Population Pyramid"
Ibid., Figure 7.
"Childhood"
Ibid., Table 67.
"Childbearing Years"
Ibid., Table 67.
"Middle Years"
Ibid., Table 67.
"The Elderly"
Ibid., Table 67.
"Median Age"*
Ibid., Table 67.
"Urban/Rural"
Ibid., Table 63.

CHAPTER TWO—EDUCATION

"High School Aged 25+"
U.S. Department of Commerce, Bureau of the Census. *United States Census of Population: 1980.* Vol. 1, *Characteristics of the Population*, pts. 2–52, Alabama-Wyoming. Table 66.
"High School Aged 18–24"
Ibid., Table 66.
"Female High School Graduates"
Ibid., Table 66.
"Male High School Graduates"
Ibid., Table 66.
"College Enrollment"
U.S. Department of Education, National Center for Education Statistics, Office of Educational Research and Improvement. *Fall Enrollment in Colleges and Universities, 1980.* Washington, D.C.: May 1982. Table B-7.
"Funding Source"
Ibid., Table B-7.

"Program Type"
Ibid., Table B-7.
"4+ Years of College"
U.S. Department of Commerce, Bureau of the Census. *United States Census of Population: 1980.* Vol. 1, *Characteristics of the Population*, pts. 2–52. Alabama-Wyoming. Table 66.
"5+ Years of College"
Ibid., Table 66.
"Doctoral Studies"
National Research Council, Office of Scientific and Engineering Personnel. *Summary Report: 1981, Doctoral Recipients from U.S. Universities.* Washington, D.C.: National Academy Press, 1982. Table 4.
"Medical School Enrollment"
"U.S. Medical School Enrollment in Medicine and Science 1980–81." *Chronicle of Higher Education* 24, 6 (April 7, 1982): 14–15.
"Law School Enrollment"
American Bar Association. Section of Legal Education and Admissions to the Bar. *A Review of Legal Education in the United States: Fall 1980–81.* Chicago: American Bar Association, 1981.
"Women's Colleges"
Women's College Coalition. *Profile II: A Second Profile of Women's Colleges.* Washington, D.C.: 1981; and telephone interview with staff member, December 13, 1984.
"Women's Studies Programs"
"Program Directory." *National Women's Studies Association Newsletter* 2 (Fall 1984): 27–46.
"Elementary School Teachers"*
United States Equal Employment Opportunity Commission. *Minorities and Women in Public Elementary and Secondary Schools.* EEO-5 State Report 1980. Washington, D.C. Table 3.
"Secondary School Teachers"*
Ibid., Table 3.
"Faculty"*
United States Equal Employment Opportunity Commission. *Higher Education Staff Information.* EEO-6. 1981. Washington, D.C. Table 7.
"Women Principals"*
United States Equal Employment Opportunity Commission. *Minorities and Women in Public Elementary and Secondary Schools.* EEO-5 State Report 1980. Washington, D.C. Table 3.
"Women Presidents of Colleges and Universities"
Information obtained from the Office of Women in Higher Education, American Council on Education, Washington, D.C.

CHAPTER THREE—EMPLOYMENT

"Labor Force Participation—percentage of labor force that is female"
U.S. Department of Commerce, Bureau of the Census. *United States Census of Population: 1980.* Vol. 1, *Characteristics of the Population*, pts. 2–52, Alabama-Wyoming. Tables 61, 213.
"Labor Force Participation—percentage of Men/Women 16+ in Labor Force"
Ibid., Table 57.
"Working Mothers"*
Ibid., pts. 2–9, 11–52. Alabama-Delaware, Georgia-Wyoming. Table 57.
"Working Wives"
Ibid., pts. 2–52. Alabama-Wyoming. Table 238.
"Civilian Employment Schedule: Women"
Ibid., Table 213.
"Civilian Employment Schedule: Men"
Ibid., Table 213.
"Armed Forces Employment"
Ibid., Tables 61, 213.
"Median Income"*
Ibid., pts. 2–9, 11–52. Alabama-Delaware, Georgia-Wyoming. Table 61.
"Median Earnings"*
Ibid., Table 222.
"Elementary School Teachers: Median Earnings"*
Ibid., Table 222.
"Registered Nurses: Median Earnings"*
Ibid., Table 222.
"Secretaries: Median Earnings"*
Ibid., Table 222.
"Private Household Workers: Median Earnings"*
Ibid., Table 222.
"Women Below the Poverty Level"
Ibid., pts. 2–52. Alabama-Wyoming. Table 61.
"Social Security and Public Assistance"
Ibid., Table 242.
"(Un)Equal Opportunity"*
U.S. Department of Labor, Women's Bureau. *Time of Change: 1983 Handbook on Women Workers.* Bulletin 298. Washington, D.C.: U.S. Government Printing Office, 1983.
"(Un)Equal Pay"*
Ibid.

"Charting Their Progress"
U.S. Department of Commerce, Bureau of the Census. *United States Census of Population: 1980.* Vol. 1, *Characteristics of the Population*, pts. 2–52. Alabama-Wyoming. Table 217.
"Managers and Administrators"
Ibid., Table 217.
"Accountants and Auditors"
Ibid., Table 217.
"Retail Store Managers"
Ibid., Table 217.
"Professionals"
Ibid., Table 217.
"Natural Scientists"
Ibid., Table 217.
"Clergy"
Ibid., Table 217.
"Technicians"
Ibid., Table 217.
"Computer Programmers"
Ibid., Table 217.
"Drafting Technicians"
Ibid., Table 217.
"Sales Personnel"
Ibid., Table 217.
"Hardware and Building Store Sales Workers"
Ibid., Table 217.
"Cashiers"
Ibid., Table 217.
"Administrative Support Personnel"
Ibid., Table 217.
"Secretaries, Stenographers and Typists"
Ibid., Table 217.
"Mail Carriers"
Ibid., Table 217.
"Service Workers"
Ibid., Table 217.
"Firefighters"
Ibid., Table 217.
"Waitresses and Waiters"
Ibid., Table 217.
"Precision Production, Craft and Repair Workers"
Ibid., Table 217.
"Construction Workers"
Ibid., Table 217.

"Electrical and Electronic Equipment Repairers"
Ibid., Table 217.
"Operators, Fabricators and Laborers"
Ibid., Table 217.
"Welders and Cutters"
Ibid., Table 217.
"Textile, Apparel and Furnishings Machine Operators"
Ibid., Table 217.
"Transportation and Material Moving Workers"
Ibid., Table 217.
"Heavy Truck Drivers"
Ibid., Table 217.
"Bus Drivers"
Ibid., Table 217.
"Farm Operators and Managers"
Ibid., Table 217.
"Women-Owned Businesses"
U.S. Department of Commerce, Bureau of the Census. *Women-Owned Businesses: 1977.* Washington, D.C.: U.S. Government Printing Office, 1980. Table 4.
"Women's Banks"
Flaig, Shirley B., Vice-President and Cashier, The First Women's Bank, New York, NY to Anne Gibson. June 26, 1985.
Polk's World Bank Directory. North American Edition. 178th Issue. Fall 1983. Nashville, Tenn.: R.L. Polk & Co., 1983.
Smith, Flora J., Assistant Vice-President, The First Women's Bank, New York, NY to Anne Gibson. September 5, 1984.

CHAPTER FOUR—FAMILY

"Single Women"
U.S. Department of Commerce, Bureau of the Census. *United States Census of Population: 1980.* Vol. 1, *Characteristics of Population*, pt. 1, United States Summary. Table 65.
"Single Men vs. Single Women"
Ibid., Table 65.
"Single Women in Cities"
Ibid., Table 68.
"Single Men in Cities"
Ibid., Table 68.
"Common Law Marriage and Cohabitation"*

Council of State Governments. *Book of the States, 1982–83.* Lexington, Ky.: Council of State Governments, 1982.
"Our Crazy Legal System". *The Phil Donahue Show.* Transcript #04125. Cincinnati, Oh.: Multimedia Entertainment, Inc., 1984.
"Sexual Intercourse"*
Council of State Governments. *Book of the States, 1982–83.* Lexington, Ky.: Council of State Governments, 1982.
"Marriage Laws"*
California Civil Code. sec. 4101.
Code of Iowa, 1981. sec. 595.2.
Council of State Governments. *Book of the States, 1984–85.* Lexington, Ky.: Council of State Governments, 1984.
Kentucky Revised Statutes. secs. 402.020, 402.210.
Martindale-Hubbell Law Directory: 1983. 115th Edition. 7 Vols. Summit, N.J.: Martindale-Hubbell, Inc., 1982. Vol. 7. *Law Digests.*
"Married Women"
U.S. Department of Commerce, Bureau of the Census. *United States Census of Population: 1980.* Vol. 1, *Characteristics of the Population*, pt. 1, United States Summary. Table 65.
"Teenage Marriage"
Ibid., pts. 2–52. Alabama-Wyoming. Table 205.
"Marriage Rate"*
National Center for Health Statistics: Advance report of final marriage statistics. *Monthly Vital Statistics Report*, Vol. 32, No. 5, Supp. DHHS Pub. No. (PHS) 83-1120. Public Health Service, Hyattsville, Md. August 1983. Table 2.
"Divorce Rate"*
National Center for Health Statistics: Advance report of final divorce statistics, 1980. *Monthly Vital Statistics Report*, Vol. 32, No. 3, Supp. DHHS Pub. No. (PHS) 83-1120. Public Health Service, Hyattsville, Md. June 1983. Table 2.
"Marriage vs. Divorce"*
National Center for Health Statistics: Advance report of final marriage statistics. *Monthly Vital Statistics Report*, Vol. 32, No. 5, Supp. DHHS Pub. No. (PHS) 83-1120. Public Health Service, Hyattsville, Md. August 1983. Table 2.
National Center for Health Statistics: Advance report of final divorce statistics. *Monthly Vital Statistics Report*, Vol. 32, No. 3, Supp. DHHS Pub. No. (PHS) 83-1120. Public Health Service, Hyattsville, Md. June 1983. Table 2.
"Divorced Women"
U.S. Department of Commerce, Bureau of the Census. *United States Census of Population: 1980.* Vol. 1, *Characteristics of the Population*, pt. 1, United States Summary. Table 65.

"Median Duration of Marriage"*
> National Center for Health Statistics: Advance report of final divorce statistics. *Monthly Vital Statistics Report*, Vol. 32, No. 3, Supp. DHHS Pub. No. (PHS) 83-1120. Public Health Service, Hyattsville, Md. June 1983. Table 5.

"Separated Women"
> U.S. Department of Commerce, Bureau of the Census. *United States Census of Population: 1980.* Vol. 1, *Characteristics of the Population*, pt. 1, United States Summary. Table 65.

"Widowed Women"
> *Ibid.*, Table 65.

"Fertility Ratio"
> *Ibid.*, Table 61.

"Birth Rate"
> National Center for Health Statistics: Advance report of final natality statistics, 1980. *Monthly Vital Statistics Report*, Vol. 31, No. 8, Supp. DHHS Pub. No. (PHS) 83-1120. Public Health Service, Hyattsville, Md. November 1982. Table 6.

"Births to Unmarried Women"
> *Ibid.*, Table 14.

"Births to Teenage Women: Percentage of all births*; percentage out-of-wedlock"
> Adapted from Children's Defense Fund. *A Children's Defense Budget: An Analysis of the President's FY 86 Budget for Children.* Washington, D.C.: Children's Defense Fund, 1985, pp. 260–261.

"Cuts in Publicly Funded Childcare"*
> Adapted from Children's Defense Fund. *Children and Federal Child Care Cuts: A National Survey of the Impact of Federal Title XX Cuts on State Child Care Systems, 1981–1983.* Washington, D.C.: Children's Defense Fund, 1983. Appendix.

"Women Living Alone"
> U.S. Department of Commerce, Bureau of the Census. *United States Census of Population: 1980.* Vol. 1, *Characteristics of the Population*, pts. 2–52. Alabama-Wyoming. Table 242.

"Married Couple Families: Percentage of all households"
> *Ibid.*, pt. 1, United States Summary. Table 66.

"Married Couple Families: Percentage with female householder"
> *Ibid.*, Table 66.

"Female-Headed Households"
> *Ibid.*, pts. 2–52. Alabama-Wyoming. Table 21.

"Family Households"
> *Ibid.*, Table 21.

"Non-Family Households"
> *Ibid.*, Table 21.

"A House Divided"
> *Ibid.*, pt. 1, United States Summary. Table 66.

"Female-Headed Households, No Husband Present"
> *Ibid.*, pts. 2–52, Alabama-Wyoming. Table 21.

"Female-Headed Households, No Father Present: With children less than 18"
> *Ibid.*, Table 21.

"Female-Headed Households, No Father Present: Percentage of children less than 18 in this type of household"
> *Ibid.*, Table 21.

"Women Aged 65+ in Homes for the Elderly: Percentage of all women 65+"
> *Ibid.*, Table 207.

"Women Aged 65+ in Homes for the Elderly: Women as percentage of all residents"
> *Ibid.*, Table 207.

CHAPTER FIVE—HEALTH

"Life Expectancy"*
> Population Reference Bureau. *United States Population Data Sheet.* 2nd Ed. Washington, D.C.: Population Reference Bureau, n.d.

"Sedentary Lifestyle"
> Centers for Disease Control. Annual summary 1982: reported morbidity and mortality in the United States, *Morbidity Mortality Weekly Report* 1983; 31(54).

"Obesity"
> *Ibid.*

"Heart Disease"
> U.S. Department of Health and Human Services. National Center for Health Statistics. Division of Vital Statistics. Hyattsville, Md. Unpublished data.
> NOTE: The data for this map (and those listed below from this source) have recently been published in: National Center for Health Statistics. *Vital Statistics of the United States, 1980*, Vol. II, Mortality, Part B. DHHS Pub. No. (PHS) 85-1102. Public Health Service, Washington, D.C.: U.S. Government Printing Office, 1985.

"Cancer"
> *Ibid.*

"Breast Cancer"
National Center for Health Statistics. *Vital Statistics of the United States, 1980*, Vol. II, Mortality, Part B. DHHS Pub. No. (PHS) 85-1102. Public Health Service, Washington, D.C.: U.S. Government Printing Office, 1985.

"Cancer of the Genital Organs"
Ibid.

"Motor Vehicle Deaths"
U.S. Department of Health and Human Services. National Center for Health Statistics. Hyattsville, Md. Unpublished data.

"Physicians: number of female physicians per 100,000 women"
U.S. Department of Health and Human Services. Health Manpower Bureau. *Characteristics of Physicians, 1979.* 1982. Tables 6, 9.

"Physicians: Percentage that are female"
Ibid.

"Suicide"
U.S. Department of Health and Human Services. National Center for Health Statistics. Division of Health Statistics. Hyattsville, Md. Unpublished data.

"Residents in Mental Institutions: Number of women residents per 100,000 women"
U.S. Department of Commerce, Bureau of the Census. *United States Census of Population: 1980.* Vol. 1, *Characteristics of the Population*, pts. 2–52, Alabama-Wyoming. Table 207.

"Residents in Mental Institutions: Percent female"
Ibid., Table 207.

"Psychiatrists: Number of female psychiatrists per 100,000 women"
U.S. Department of Health and Human Services. Health Manpower Bureau. *Characteristics of Physicians, 1979.* 1982. Tables 6, 9.

"Psychiatrists: Percent female"
Ibid., Tables 6, 9.

"Cigarette Smoking and Heavy Drinking"
Centers for Disease Control. Annual summary 1982: reported morbidity and mortality in the United States, *Morbidity Mortality Weekly Report* 1983; 31(54).

"Enrollment in Drug and Alcohol Treatment Programs: Alcohol"*
U.S. Department of Health and Human Services, National Institute on Alcohol Abuse and Alcoholism. *National Drug and Alcoholism Treatment Utilization Survey.* Comprehensive Report. September 1983. Table A-4.

"Enrollment in Drug and Alcohol Treatment Programs: Drugs"
U.S. Department of Health and Human Services, National Institute on Drug Abuse, Division of Data and Information Devel-
opment. *State Statistics 1980.* Series E. No. 22. August 1981. Table 1.

"Chronic Liver Disease and Cirrhosis"
U.S. Department of Health and Human Services, National Center for Health Statistics, Division of Vital Statistics. Hyattsville, Md. Unpublished data.

"Family Life and Sex Education Policy"*
Reprinted/Adapted with permission from "School Sex Ed Required in Three States and D.C., but Most States Allow Local Districts to Decide," *Family Planning Perspectives*, Vol. 12, No. 6, 1980.

"Laws Regulating Contraception"*
Reprinted/Adapted with permission from "Fertility-Related State Laws Enacted in 1982", *Family Planning Perspectives*, Vol. 15, No. 3, 1983.

"Family Planning Clinics"*
Reprinted/Adapted with permission from "Family Planning Clinic Services in the United States, 1981," *Family Planning Perspectives*, Vol. 15, No. 6, 1983.

"Public Funding"
Reprinted/Adapted with permission from "Public Funding of Contraceptive Services, 1980–82," *Family Planning Perspectives*, Vol. 14, No. 4, 1982.

"Low Income Clients"*
Reprinted/Adapted with permission from "Family Planning Clinic Services in the United States, 1981," *Family Planning Perspectives*, Vol. 15, No. 6, 1983.

"Teenage Clients"*
Reprinted/Adapted with permission from "Family Planning Clinic Services in the United States," *Family Planning Perspectives*, Vol. 15, No. 6, 1983.

"Laws Regulating Abortion"*
Reprinted/Adapted with permission from "Fertility-Related State Laws Enacted in 1982," *Family Planning Perspectives*, Vol. 15, No. 3, 1983 and Vol. 16, No. 1, 1984.
Code of District of Columbia. 1973 ed. sec. 22–201.
Weinberg, Roy D. *Family Planning and the Law.* 2nd Edition. Edited by Irving J. Sloan. Dobbs Ferry, NY: Oceana Publications, Inc., 1979.

"Abortion Clinics"*
Reprinted/Adapted with permission from "Abortion Services in the United States, 1979 and 1980," *Family Planning Perspectives*, Vol. 14, No. 1, 1982.

"Abortion Funding"*
Reprinted/Adapted with permission from "Publicly Funded

Abortions in FY 1980 and FY 1981," *Family Planning Perspectives*, Vol. 14, No. 4, 1982.

"Place of Abortion Vs. State of Residence: Percentage obtaining abortions out of state"*

Reprinted/Adapted with permission from "Characteristics of Abortion Patients in the United States, 1979 and 1980," *Family Planning Perspectives*, Vol. 15, No. 1, 1983.

"Place of Abortion vs. State of Residence: Percentage of abortions provided to out-of-state residents"*

Reprinted/Adapted with permission from "Characteristics of Abortion Patients in the United States, 1979 and 1980" *Family Planning Perspectives*, Vol. 15, No. 1, 1983.

"Change in Abortion Rate"*

U.S. Bureau of the Census. *Statistical Abstract of the United States: 1982–83* (103rd edition), Washington, D.C.: 1982. Table 104.

"Abortion Rate"*

Ibid., Table 104.

"Laws Regulating Sterilization"*

Reprinted/Adapted with permission from "Fertility-Related State Laws Enacted in 1982," *Family Planning Perspectives*, Vol. 15, No. 3, 1983; and "Letters from Readers", *Family Planning Perspectives*, Vol. 16, No. 1, 1984.

"Tubal Ligation"

Centers for Disease Control. Annual summary 1982: reported morbidity and mortality in the United States, *Morbidity Mortality Weekly Report* 1983; 31(54).

"Hysterectomy"

Ibid.

"Prenatal Care"*

Adapted from Children's Defense Fund. *A Children's Defense Budget: An Analysis of the President's FY 86 Budget for Children*. Washington, D.C.: Children's Defense Fund, 1985, p. 267.

"Low Birth Weight"*

National Center for Health Statistics. Advance report for final natality statistics, 1980. *Monthly Vital Statistics Report*, Vol. 31, No. 8, Supp. DHHS Pub. No. (PHS) 83-1120. Public Health Service, Hyattsville, Md. November 1982. Table 14.

"Infant Mortality"*

National Center for Health Statistics. Advance report, final mortality statistics, 1980. *Monthly Vital Statistics Report*, Vol. 32, No. 4, Supp. DHHS Pub. No. (PHS) 83-1120. Public Health Service, Hyattsville, Md. August 1983.

"Death from Pregnancy"

National Center for Health Statistics. Annual summary of births, deaths, marriages and divorces. *Monthly Vital Statistics Report*,

Vol. 30, No. 13, Supp. DHHS Pub. No. (PHS) 83-1120. Public Health Service, Hyattsville, Md. December 1982.

U.S. Department of Health and Human Services, National Center for Health Statistics, Division of Vital Statistics. Hyattsville, Md. Unpublished data.

"Obstetricians/Gynecologists (number per 100,000 women 15+) and Midwives*"

Council of State Governments. *Book of the States, 1982–83*. Lexington, Ky.: Council of State Governments, 1982.

U.S. Department of Health and Human Services. Health Manpower Bureau. *Characteristics of Physicians, 1979*. 1982. Tables 6, 9.

"Obstetricians/Gynecologists: Percent female"

U.S. Department of Health and Human Services, Health Manpower Bureau. *Characteristics of Physicians, 1979*. 1982. Tables 6, 9.

"Syphilis and Gonorrhea"

U.S. Department of Health and Human Services, Public Health Service. *Sexually Transmitted Disease Fact Sheet*. Edition 35. Table 2.

Chapter Six—Crime

"Police Officers"

U.S. Department of Commerce, Bureau of the Census. *United States Census of Population: 1980*. Vol. 1, *Characteristics of the Population*, pts. 2–52, Alabama-Wyoming. Table 217.

"Correctional Officers in Adult Systems: percent female"*

American Correctional Association. *1985 Juvenile and Adult Correctional Departments, Institutions, Agencies and Paroling Authorities*. College Park, Md.: American Correctional Association, 1985.

"Correctional Officers in Adult Systems: Percentage of supervisors that are female"*

Ibid.

"Rape Rate"*

U.S. Department of Justice, Bureau of Justice Statistics. *Sourcebook of Criminal Justice Statistics: 1982*. Edited by Timothy J. Flanagan and Maureen McLeod. Washington, D.C.: U.S. Government Printing Office, 1983.

"Rape Clearance Rate"*
U.S. Department of Justice. Federal Bureau of Investigation. Uniform Crime Reporting Program. Unpublished data.

"Marital Rape Exemption"*
National Center on Women and Family Law. "Marital Rape Exemption Chart: State by State Analysis." New York, NY, 1985. Photocopied.

"Homicide: Rate per 100,000 women"
U.S. Department of Health and Human Services, National Center for Health Statistics, Division of Vital Statistics. Hyattsville, Md. Unpublished data.

"Homicide: Men's rate as percent of women's"
Ibid.

"Women Convicted of Federal Crimes: Number per 100,000 women"
Administrative Office of the United States Courts. Federal Offenders in U.S. District Courts, 1980. Washington, D.C., May 1982. Table 4.

"Women Convicted of Federal Crimes: Percentage of persons convicted that are female"
Ibid.

"Women Arrested for Crimes Against Persons and Property"
Alabama Criminal Justice Information Center, Statistical Analysis Center. Montgomery, Al. Unpublished data.

Alaska Department of Law. Crime in Alaska, 1980. 1981. Washington, D.C.: Congressional Information Service, SRI S0325-1, 1981.

Arizona Department of Public Safety. Crime in Arizona, 1980. June 1981. Washington, D.C.: Congressional Information Service, SRI S0505-1, 1981.

Arkansas Crime Information Center. Crime in Arkansas, 1980. Little Rock, Ar. September 1981. Washington, D.C.: Congressional Information Service, SRI S0652-1, 1982.

California Department of Justice, Division on Law Enforcement, Bureau of Criminal Statistics and Special Services. Criminal Justice Profile, 1980, Statewide. Sacramento, Ca. Washington, D.C.: Congressional Information Service, SRI S0910-2, 1982.

Colorado Department of Local Affairs, Bureau of Investigation. Crime in Colorado, 1980. Annual 1981. Washington, D.C.: Congressional Information Service, SRI S1055-1, 1982.

Connecticut Department of Public Safety. Crime in Connecticut: Annual Report, 1980. Meriden, Conn. Washington, D.C.: Congressional Information Service, SRI S1256-1, 1981.

Delaware Department of Public Safety, Division of State Police. 1980 Uniform Crime Report for Delaware. Annual 1981. Washington, D.C.: Congressional Information Service, SRI S1435-2, 1981.

District of Columbia Executive Office of the Mayor. Crime and Arrest Profile: The Nation's Capital. Monograph. September, 1981. Washington, D.C.: Congressional Information Service, SRI S1535-2, 1982.

Florida Department of Law Enforcement. Uniform Crime Reports: 1980 Annual Report. 31 March 1981. Washington, D.C.: Congressional Information Service, SRI S1770-1, 1981.

Georgia Criminal Justice Coordinating Council. Crime in Georgia. Atlanta, Ga. June 1982. Washington, D.C.: Congressional Information Service, SRI S1880-1, 1982.

Hawaii Criminal Justice Statistical Analysis Center. Crime in Hawaii, 1980. 1981. Washington, D.C.: Congressional Information Service, SRI S2048-1, 1981.

Idaho Department of Law Enforcement, Criminal Identification Bureau, Uniform Crime Reporting Program. 1980 Annual Report. Washington, D.C.: Congressional Information Service, SRI S2275-2, 1981.

Illinois Department of Law Enforcement. Crime in Illinois, 1980. Annual, 1981. Washington, D.C.: Congressional Information Service, SRI S2497-1, 1981.

Iowa Department of Public Safety. Iowa Uniform Crime Reports: 1980 Annual Report. Summer 1981. Washington, D.C.: Congressional Information Service, SRI S2850-2, 1981.

Kansas Office of the Governor. Uniform Crime Report: Crime in Kansas, 1980. Annual, 11 August 1981. Washington, D.C.: Congressional Information Service, SRI S2965-1, 1981.

Kentucky Department of Justice. Uniform Crime Reports: 1980 Annual Report. Washington, D.C.: Congressional Information Service, SRI S3150-1, 1981.

Maine Department of Public Safety. Crime in Maine, 1980. Annual, 1981. Washington, D.C.: Congressional Information Service, SRI S3475-1, 1981.

Maryland Department of Public Safety and Correctional Services. State of Maryland Uniform Crime Reports, 1980. Annual, 10 July 1981. Washington, D.C.: Congressional Information Service, SRI S3665-1, 1982.

Minnesota Department of Public Safety. Minnesota Crime Information, 1980. Annual, 1 June 1981. Washington, D.C.: Congressional Information Service, SRI S4230-1, 1981.

Nebraska Commission on Law Enforcement and Criminal Justice. Uniform Crime Reports, 1980, State of Nebraska. Annual, 1981. Washington, D.C.: Congressional Information Service, SRI S4900-1, 1981.

New Hampshire Department of Public Safety, Uniform Crime Reporting Unit. Crime in New Hampshire, 1980. Concord, NH.

1981. Washington, D.C.: Congressional Information Service, SRI S5250-2, 1981.

New Jersey Department of Law and Safety. *Uniform Crime Reports, State of New Jersey, 1980.* Annual, 1981. Washington, D.C.: Congressional Information Service, SRI S5430-1, 1982.

New Mexico State Police. *New Mexico Crime Reports, 1980.* Annual, 1981. Washington, D.C.: Congressional Information Service, SRI S5642-1, 1981.

New York State Executive Department. *New York State Crime and Justice Annual Report, 1980.* Annual, 1981. Washington, D.C.: Congressional Information Service, SRI S5760-3, 1981.

North Carolina Department of Justice. *State of North Carolina Uniform Crime Report, 1980.* Annual, 1981. Washington, D.C.: Congressional Information Service, SRI S5955-1, 1982.

Ohio Office of the Attorney General. *Crime in Ohio, 1980.* Annual, 1981. Washington, D.C.: Congressional Information Service, SRI S6245-1, 1981.

Oregon Law Enforcement Council. *Analysis of Crime in Oregon, 1980.* Annual, 1981. Washington, D.C.: Congressional Information Service, SRI S6627-1, 1981.

Pennsylvania State Police. *Uniform Crime Report: Commonwealth of Pennsylvania, Annual Report, 1980.* Annual, 1981. Washington, D.C.: Congressional Information Service, SRI S6860-1, 1981.

Texas Department of Public Safety. *Texas Crime Report, 1980.* Annual, 1981. Washington, D.C.: Congressional Information Service, SRI S7735-2, 1981.

Virginia Department of State Police. *Crime in Virginia, 1980.* Annual, 1981. Washington, D.C.: Congressional Information Service, SRI S8295-2, 1981.

Washington State Uniform Crime Reporting Unit. *Crime in Washington State, 1980.* Annual, 1981. Washington, D.C.: Congressional Information Service, SRI S8440-1, 1981.

West Virginia Department of Public Safety. *Crime in West Virginia: Annual Uniform Crime Report, 1980.* Annual, August 1981. Washington, D.C.: Congressional Information Service, SRI S8610-1, 1981.

Wyoming Office of the Attorney General. *Crime in Wyoming, January–December 1980.* Annual, 1981. Washington, D.C.: Congressional Information Service, SRI S8867-3, 1981.

U.S. Department of Justice. Federal Bureau of Investigation. Uniform Crime Reporting Program. Washington, D.C. Unpublished data.

"Murder"
Ibid.
"Robbery"
Ibid.
"Aggravated Assault"
Ibid.
"Burglary"
Ibid.
"Larceny"
Ibid.
"Motor Vehicle Theft"
Ibid.
"Women's Correctional Institutions"
American Correctional Association. *Directory of Juvenile and Adult Correctional Departments, Institutions, Agencies and Paroling Authorities, 1982.* College Park, Md.: American Correctional Association, 1982.
"Women on Death Row"*
U.S. Department of Justice, Bureau of Justice Statistics. Bureau of Justice Statistics Bulletin: *Capital Punishment, 1982.* July 1983.
"Security Arrangements"*
American Correctional Association. *Directory of Juvenile and Adult Correctional Departments, Institutions, Agencies and Paroling Authorities, 1982.* College Park, Md.: American Correctional Association, 1982.
"Prison Population: Women"
U.S. Department of Justice, Bureau of Justice Statistics. *Prisoners in State and Federal Institutions on December 31, 1980.* March 1982. Table 9.
"Prison Population: Men"
Ibid.

CHAPTER SEVEN—POLITICS

"The Right to Vote"*
Paulin, Charles O. *Atlas of Historical Geography of the United States.* Edited by John K. Wright. Washington, D.C.: The Carnegie Institution, 1932.
"Equal Rights Amendment"
Council of State Governments. *Book of the States, 1982–83.* Lexington, KY.: Council of State Governments, 1982.

"NOW Chapters"
National Organization for Women. "NOW Chapters in Central Dues Collection States." Washington, D.C.: July 1984. and telephone interview with staff member 4 September 1985.

"Ms. Magazine"
Audit Bureau of Circulations: 30 June 1985 Publisher's Statement.

"Republican and Democratic Party Committees"*
National Women's Political Caucus. *National Directory of Women Elected Officials.* Washington, D.C.: National Women's Political Caucus, 1985.

"All Judges"
U.S. Department of Commerce, Bureau of the Census. *United States Census of Population: 1980.* Vol. 1, *Characteristics of the Population,* pts. 2–52. Alabama-Wyoming. Table 217.

"Judges in State Courts of Last Resort"*
Council of State Governments. *Book of the States, 1984–85.* Lexington, KY.: Council of State Governments, 1984.

"Federal Judiciary"*
Lynda Raby, Staffing Assistant, Administrative Office of the United States Courts to Anne Gibson, 21 December 1984.

"Lawyers"
National Women's Political Caucus. *National Directory of Women Elected Officials.* Washington, D.C.: National Women's Political Caucus, 1985.
U.S. Department of Commerce, Bureau of the Census. *United States Census of Population: 1980.* Vol. 1, *Characteristics of the Population,* pts. 2–52. Alabama-Wyoming. Table 217.

"Women as Candidates"
National Women's Political Caucus. *National Directory of Women Elected Officials.* Washington, D.C.: National Women's Political Caucus, 1985.

"State Legislatures: Number of female legislators per 100,000 women"
Ibid.

"State Legislatures: Percentage of legislators that are female"
Ibid.

"Congress Past"
Ibid.

"Congress Present"
Ibid.

"Mayors"
Ibid.

"Governors"
Encyclopedia Americana. 1980 ed. S.V. Alabama-Wyoming.
National Women's Political Caucus. *National Directory of Women Elected Officials.* Washington, D.C.: National Women's Political Caucus, 1985.

"Lieutenant Governors, Secretaries of State and Treasurers"
National Women's Political Caucus. *National Directory of Women Elected Officials.* Washington, D.C.: National Women's Political Caucus, 1985.

"First Ladies"
Dictionary of American Biography. New York: Charles Scribners Sons, 1933. S.V. "Dolly Payne Madison."
National Cyclopedia of American Biography. New York: James T. White & Company, 1984. S.V. "Sarah Childress Polk;" "Edith Kermit Carow Roosevelt;" "Ellen Louise Axson Wilson."
1979 Hammond Almanac. Maplewood, NJ: Hammond Almanac, Inc. 1978.
Notable Names in American History: A Tabulated Register. Clifton, NJ: James T. White & Company, 1973.
Who's Who in the World, 1984–85. 7th Ed. Chicago: Marquis Who's Who, Inc., 1984. S.V. "Nancy Davis Reagan".

ADDITIONAL REFERENCES AND SUGGESTIONS FOR FURTHER READING

In addition to the following publications, several of the above map sources also are good textual sources of information, especially the two publications sponsored by the Children's Defense Fund, the various *Monthly Vital Statistics Reports,* and the articles in *Family Planning Perspectives.*

American Cancer Society. *Cancer Facts and Figures, 1984.* New York: American Cancer Society, 1983.

Boles, Janet K. *The Politics of the Equal Rights Amendment.* New York: Longman, 1979.

Bowker, Lee H., ed. *Women and Crime in America.* New York: Macmillan Publishing Company, 1981.

Brownmiller, Susan. *Against Our Will: Men, Women and Rape.* New York: Bantam Books, 1975.

Carnegie Commission on Higher Education. *Opportunities for Women in Higher Education.* New York: McGraw-Hill Book Company, 1973.

Deckard, Barbara Sinclair. *The Women's Movement: Political, Socio-economic, and Psychological Issues.* 2nd ed. New York: Harper & Row, Publishers, 1979.

Eisenstein, Sarah. *Give Us Bread, But Give Us Roses: Working Women's Consciousness in the United States, 1890 to the First World War.* Boston: Routledge & Kegan Paul, 1983.

Feldman, Saul D. *Escape from the Doll's House.* New York: McGraw-Hill Book Company, 1974.

Flexner, Eleanor. *Century of Struggle.* Revised ed. Cambridge: Harvard University Press, The Belknap Press, 1975.

Freedman, Estelle B. *Their Sisters' Keepers: Women's Prison Reform in America, 1830–1930.* Ann Arbor: University of Michigan Press, 1981.

Gilligan, Carol. *In a Different Voice.* Cambridge: Harvard University Press, 1982.

Howe, Florence, ed. *Women and the Power to Change.* New York: McGraw-Hill Book Company, 1975.

Jaffe, Frederick S.; Lindheim, Barbara L.; and Lee, Philip R. *Abortion Politics: Private Morality and Public Policy.* New York: McGraw-Hill Book Company, 1981.

Mann, Coramae Richey. *Female Crime and Delinquency.* University, Ala.: University of Alabama Press, 1984.

O'Neill, William, ed. *The Woman Movement: Feminism in the U.S. and England.* Chicago: Quadrangle Books, 1969.

Poole, Keith T. and Zeigler, L. Harmon. *Women, Public Opinion and Politics: The Changing Political Attitudes of American Women.* New York: Longman, 1985.

Sivard, Ruth Leger. *Women: A World Survey.* Washington, D.C.: World Priorities, Inc., 1985.

Smykla, John Ortiz. *Coed Prison.* New York: Human Services Press, 1980.

Spain, Daphne and Bianchi, Suzanne M. "How Women Have Changed," *American Demographics* (May 1983):19–25.

Stewart, Debra W., ed. *Women in Local Politics.* Metuchen, N.J.: The Scarecrow Press, 1980.

United States Department of Commerce, Bureau of the Census. *Statistical Abstract of the United States: 1984.* 104th Edition. Washington, D.C.: 1983.

United States Department of Commerce, Bureau of the Census, Public Information Office. *U.S. Department of Commerce News.* (11 October 1983) CB83-159. Washington, D.C.

———. *We, The American Women.* Washington, D.C.: U.S. Government Printing Office, 1984.

United States Department of Justice, Bureau of Justice Statistics. *Sourcebook of Criminal Justice Statistics, 1982.* Edited by Timothy J. Flanagan and Maureen McLeod. Washington, D.C.: U.S. Government Printing Office, 1983.

United States Department of Labor, Women's Bureau. *Time of Change: 1983 Handbook on Women Workers.* Bulletin 298. Washington, D.C.: U.S. Government Printing Office, 1983.

Walbert, David F. and Butler, J. Douglas. *Abortion, Society and the Law.* Middletown, N.Y.: University Press Books, 1973.

Woody, Thomas. *A History of Women's Education in the United States.* 2 vols. New York: The Science Press, 1929.

INDEX